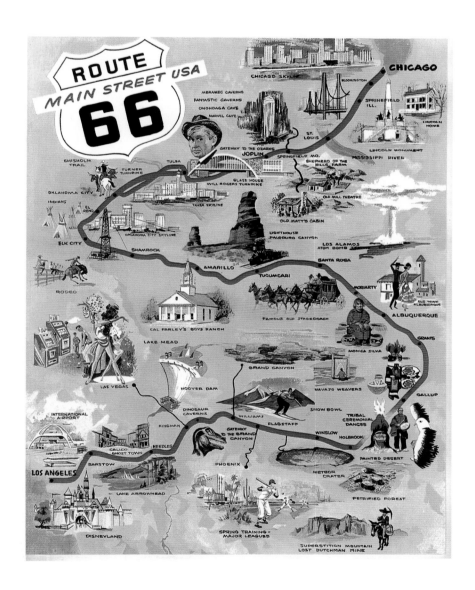

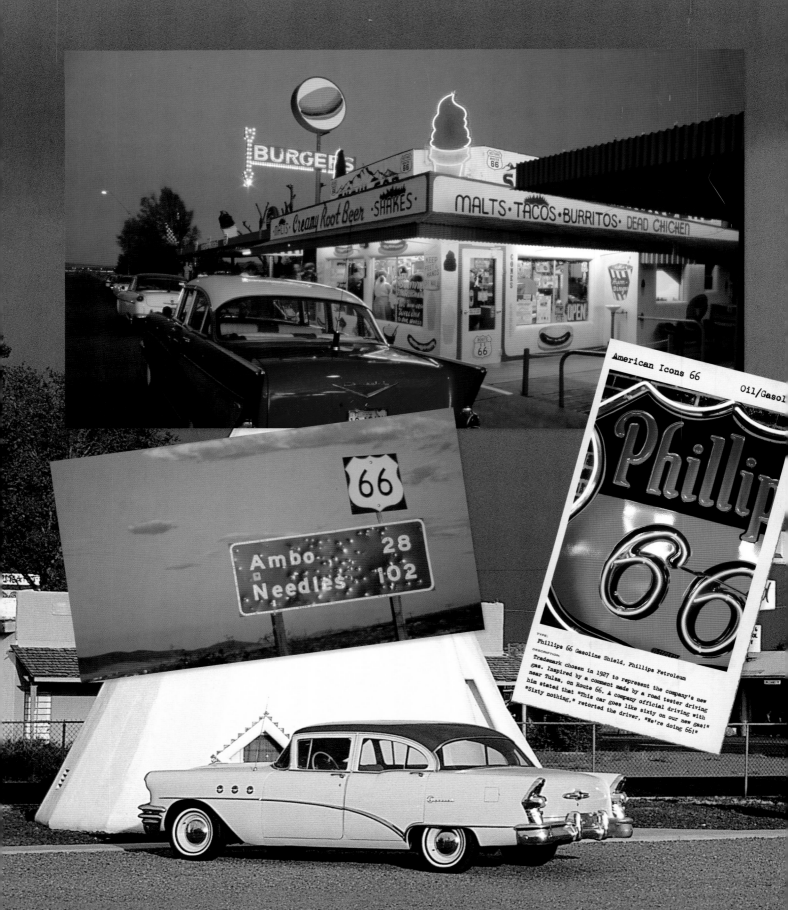

American Icons 66

Oil/Gasol

TYPE:
Phillips 66 Gasoline Shield, Phillips Petroleum

DESCRIPTION:
Trademark chosen in 1927 to represent the company's new gas. Inspired by a comment made by a road tester driving near Tulsa, on Route 66. A company official driving with him stated that "This car goes like sixty on our new gas!" "Sixty nothing," retorted the driver, "We're doing 66!"

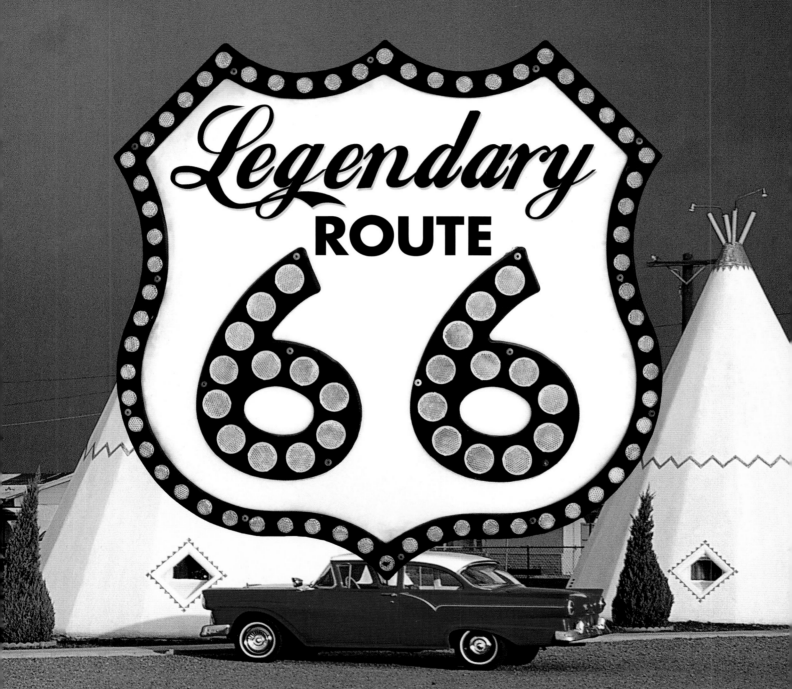

A JOURNEY THROUGH TIME ALONG AMERICA'S MOTHER ROAD

Legendary ROUTE 66

Michael Karl Witzel & Gyvel Young-Witzel

Voyageur Press

Dedication

This book is dedicated to all the displaced Americans who were affected by the Dust Bowl of the 1930s . . . and to the early pioneers of the road who forged the trails and pushed for good roads, making travel over Route 66 possible.

First published in 2007 by Voyageur Press, an imprint of Quarto Publishing Group USA Inc., 400 First Avenue North, Suite 400, Minneapolis, MN 55401 USA

Text © 2007 Gyvel Young-Witzel and Michael Karl Witzel

The information in this book is true and complete to the best of our knowledge. All recommendations are made without any guarantee on the part of the author or Publisher, who also disclaim any liability incurred in connection with the use of this data or specific details.

We recognize, further, that some words, model names, and designation mentioned herein are the property of the trademark holder. We use them for identification purposes only. This is not an official publication.

Voyageur Press titles are also available at discounts in bulk quantity for industrial or sales-promotional use. For details write to Special Sales Manager at Quarto Publishing Group USA Inc., 400 First Avenue North, Suite 400, Minneapolis, MN 55401 USA.

ISBN: 978-0-7603-4605-1

The Library of Congress has cataloged the hardcover edition as follows:

Young-Witzel, Gyvel, 1948-
 Legendary Route 66: a journey through time along
America's Mother Road / by Gyvel Young-Witzel and
Michael Witzel
 p. cm.
 ISBN-13: 978-07603-2978-8 (hardbound w/ jacket)
 1. United States Highway 66. 2. Cultural landscapes—
West (U.S.) 3. United States Highway 66—Collectibles.
I. Witzel, Michael Karl. 1960–II. Title.
 HE356.U55Y68 2007
 388.10973—dc22
 2006102369

On the frontis: Route 66 "Main Street USA" map, circa 1961. In its heyday, U.S. Route 66 was regarded as the central street of everyday America—the common bond that bound together eight states and three time zones into a single tourist collective. *Courtesy Steven Rider Collection*

On the title page, main: The Wigwam Village Number Six, Hopi Drive, Holbrook, Arizona. The motel portion of the business shut down in 1974, but by 1988 a reawakening was stirring. People looking for those long ago days from their youth began to search out the old road and its sights. *©Howard Ande*; **Inset, top:** Juan Delgadillo's Snow Cap Drive-In, Seligman, Arizona, 1985. *©2007 Jerry McClanahan*; **Left:** Road signs along former U.S. Highway 66, 1994. *©2007 Jim Ross*; **Right:** Phillips 66 gasoline shield. *Author's collection*

On the back cover, main: The Blue Swallow Motel, 815 East Tucumcari Boulevard. Its famous sign was installed in 1960. *Courtesy Steven Rider Collection*; **Inset, top:** This bridge was built in 1924 and has remained in constant operation since the old two-lane highway days of U.S. Route 66—with the exception of a brief period during the 1990s. *©2007 Jerry McClanahan*; **Bottom:** *Courtesy Steven Rider Collection/Graphic Art Michael Karl Witzel*

Editors: Margret Aldrich and Leah Noel
Designer: Kou Lor

Printed in China

10 9 8 7 6 5 4 3 2 1

Contents

Acknowledgments

*W*ithout the assistance of certain individuals who took the time to share their Route 66 collections, images, and insights, this unique journey through time would not have been possible. Their input provided the octane to power this project.

With that in mind, a heartfelt expression of thanks goes to authors Shellee Graham (*Tales From the Coral Court*), Russell Olsen (*Route 66 Lost and Found*), and Jim Ross (*Oklahoma Route 66*). Further appreciation is bestowed upon collector extraordinaire Steven Rider, whose images brought the road to life, and to the queen of contacts Doris Weddell, historian of the Dust Bowl Historical Foundation and self-described "little ol' lady with a Rolodex."

No single person could possibly document the evolution of America's Main Street, and for that, a group of talented photographers provided their visual perspective, including Sylvester Allred, Howard Ande, Allen Bourgeois, Bruce Carr, Anne Fishbein, Robert Genat, Dan and Sheila Harlow, Bruce Leighty, Pedar Ness, Jerry McClanahan, Paul Pavlik, Alan Rose, Ron Saari, D. Jeanene Tiner, Mark Trew, Seema Weatherwax, and Jason Weston.

For their thoughtful contribution of personal photos and recollections, we also acknowledge Joy Avery; Phil and Wilma Corrigan, of Phil's Harvest Table; Blaine Davis, of the Catoosa Blue Whale; Angel and Vilma Delgadillo; Debby Funk, of Funk's Grove Pure Maple Sirup; Flossie Haggard; Merle Haggard; Shirley Mills Hanson; Iva Townson Helm; Lillian Haggard Hoge; Mildred "Skeeter" Kobzeff; Gordon Kornblith, of Waggoner's Greasing Palace; Ned Leuchtner, of Cool Springs Camp; John Lewis, of Wigwam Village No. 6; Robert Loudon; Gary Marx; Alan McNeil, of Triangle Motel; Marianne McNeil Logan, of Triangle Motel; Cheryl Hamons Nowka; Andree Pruett, of the Bagdad Café ; Earl Shelton; Marshall Trimble; Frank Yellowhorse, of Yellowhorse Ltd.; and David Yellowhorse, of Two Feathers.

Government agencies also supported this endeavor with their resources (including their employees' time), namely Allen Adon Jr. at the Federal Highway Administration, Department of Transportation; Paul Braun, Texas Department of Transportation; John Fisher, assistant general manager of the Los Angeles Department of Transportation; Janet Foran, Michigan Department of Transportation; Gary Howell, Oklahoma Department of Transportation; Michelle Neubauer, Missouri Department of Natural Resources/Route 66 State Park; Peg Rawson, United States Geological Survey; Bill Shreck, director of communications of the Michigan Department of Transportation; and Richard Weingroff, at the Federal Highway Administration, Department of Transportation.

A long list of organizations and their members also helped to construct this book, including Janie Arvizu, Vineland School District; Jim Bates, superintendent of Lamont School District; Milissa Burkart, University of Tulsa/McFarlin Library; Chrystal Carpenter Burke, Arizona Historical Society; Maxine and Bill Campbell, Arcadia Historical and Preservation Society; Chester Cowen, Oklahoma Historical Society; Viola Davis, Arcadia Historical and Preservation Society; Amy Easton, Illinois Historic Preservation Agency; Sean Evans, Cline Library, Northern Arizona University; Beth Freeman, Oklahoma State University; Rob Groman, Amarillo Public Library; Keith Housewright, Lincoln Library of Springfield; Amanda Lett, Tulsa Historical Society; Curtis Mann, Lincoln Library of Springfield; Cary McStay, Palace of the Governors; Sibel Melik, New Mexico State Records Center and Archives; Jan and Wally Reed, Arvin Tiller/Lamont Reporter; Keith Sculle, Illinois Historic Preservation Agency; Tracey Sculle, Illinois Historic Preservation Agency; Bee Valvo, Cline Library, Northern Arizona University; Nicole Willard, University of Central Oklahoma; and Terry Zinn, Oklahoma Historical Society.

In addition, Route 66 organizations and their members dedicated to road preservation were instrumental in their support, most notably Jim Conkle, Route 66 Preservation Foundation; James "Bozo" Cordovas, Route 66 Auto Museum; Kevin Hansel, California Historic Route Association; Bob Lile, Texas Old Route 66 Association; Johnnie Meier, New Mexico Route 66 Association; David Rushing, Shamrock Chamber of Commerce; Delbert Trew, Texas Old Route 66 Association; and the Historic Route 66 Association of Arizona and the Kansas Route 66 Association.

Additional thanks are reserved for individuals Jay Black, Kevin Corrigan, Mirna Delgadillo, Cyndie Gerken, Carol Schott Martino, Richard McDonald, Mildred Birdsell Pattschul, Tresa Redburn, Toby Siles, Shauna Struby, Tom Thacker, Buz Waldmire, and Matthew Watson. Ditto for the material received from the American Petroleum Institute, the Ant Farm group, Capitol Records, the *Chicago Tribune*, the Coca-Cola Company, Gilbarco Inc., Henry Ford Museum & Greenfield Village, Library of Congress, National Archives, Smithsonian Institution, Southwest Studies, Steak n Shake, Inc., Tulsa Library/Beryl Ford Collection, and United Feature Syndicate/United Media.

Finally, special kudos are awarded to the people that made sure all of the details came together (on the front and back end), including Gyvel Dagmar Berkley, graphic designer; Nicole Mlakar Livingston, photo permissions; and Arna Sylvester, administrative assistant, Coolstock Inc. If anyone was omitted from these acknowledgments, we offer our sincerest apologies. Please know that your assistance was important and your contribution to this effort valuable: Thank you to all.

Foreword

*M*y involvement with this project began when I was contacted as a potential source for photographs. As an incorrigible roadside-culture addict, I have a history with the Witzels that goes back a number of years. Naturally, I was willing and honored when asked later to craft a few words as a sneak preview to this fascinating odyssey called *Legendary Route 66: A Journey through Time along America's Mother Road.*

As the title suggests, what follows is a venture down America's Main Street, but it is one unlike any other. Instead of hearing from the usual suspects, you are about to meet a remarkable ensemble of characters who, for the most part, have been lost in time but whose stories are both compelling and central to the highway's legacy. And instead of images of the usual icons, a delectable photographic smorgasbord awaits, served up steaming and generous from the dishes of past and present alike.

Along the roadside you will meet Seema Aissen Weatherwax, a one-time darkroom technician to Ansel Adams, who toured migrant camps with Woody Guthrie and tells a touching tale of that experience just three months before her passing at the age of one hundred. Actress Shirley Mills, who played Ruthie Joad in the film adaptation of Steinbeck's Pulitzer-prize winning novel, reveals what it was like on the set of *The Grapes of Wrath.* Mildred "Skeeter" Kobzeff remembers working as a carhop at the Airdrome, the first food stand owned by the McDonald brothers in Monrovia, California.

These profiles and others represent an integral part of the highway's biography. While *Legendary Route 66* is not intended to be a historical record, milestone events in the road's evolution are used as sturdy thread to stitch it all together.

Route 66 imprinted itself indelibly on the minds of millions: first as an early hard-surface roadway to western wonders, and later as an avenue of escape from the withered lands of the central Southwest. As the vacation highway of post–World War II America, the Mother Road quickly endeared itself to a new generation of motorists born with a persistent itch to travel or to be "going somewhere."

While the highway's identity was by then deeply rooted, the 1950s rush toward the future brought irresistible pizzazz, including tailfins and tourist traps, motor courts with swimming pools, and boulevards splashed end to end in pulsing neon. For over a decade, the road hummed with boundless opportunity and adventure. Ironically, its popularity soon set into motion the wheels of its own demise.

To explore Route 66 today is to return to an old homestead. The paint may be peeling in places and the roof is

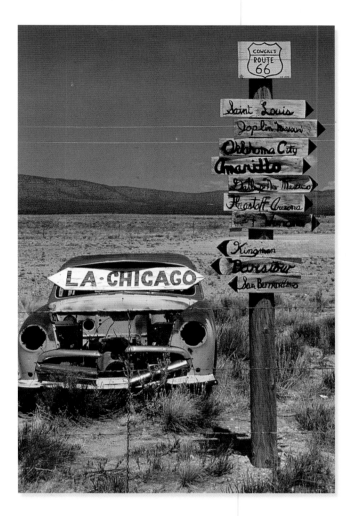

The Cowgill's sign directory at Truxton, Arizona, depicting the different Route 66 directions. ©2007 Jim Ross

sagging a bit, but the electricity works most of the time and there is plenty to reminisce about while strolling the grounds and poking about. Die-hard caretakers are still there, keeping the faith and making improvements. Each year, the pilgrimage grows as family members yearn to relive the glory years and to feel the caress of days gone by. Being there makes you appreciate what used to be. It makes you miss it, too.

So, turn the page now, and let's get started on your own personal journey through time. Some of the highway's most enduring keepers are waiting to make your acquaintance.

—Jim Ross
Arcadia, Oklahoma,
January 2007

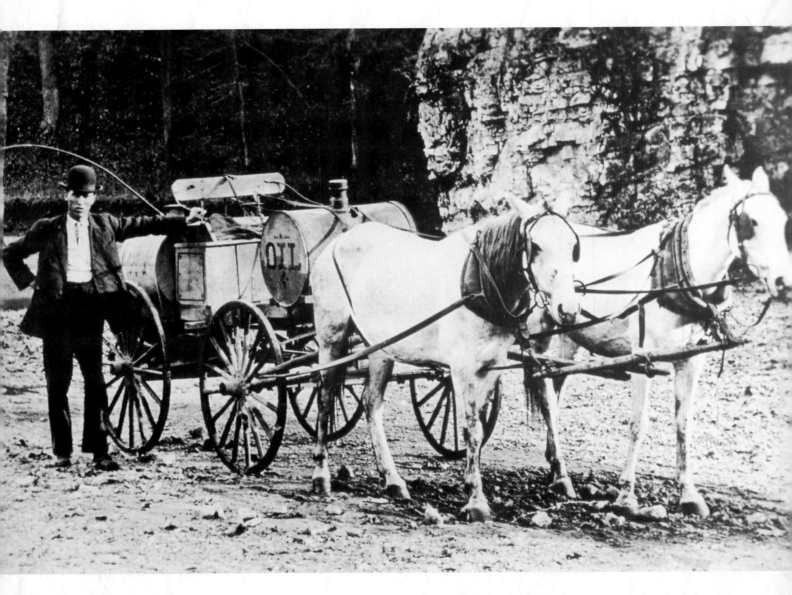

During the early 1900s, when gasoline was still considered by many to be a byproduct of the kerosene refining process, oil and gasoline was transported by horse-drawn methods. The automobile was a novelty and a play toy for those with the disposable income to afford its operation and upkeep. From the Collections of Henry Ford Museum & Greenfield Village

Chapter One

Death Knell of the Horse

"Two or three years ago, a hundred newspapers printed cartoons depicting 'the passing of the horse.' The cartoons were of many designs, but they were all born of the one idea—that the faithful equine was turned out in a pasture to die, while the bicycle glided past and waved him a merry good-by."

—*"Horse is in Favor Again,"*
Chicago Daily Tribune, November 12, 1899

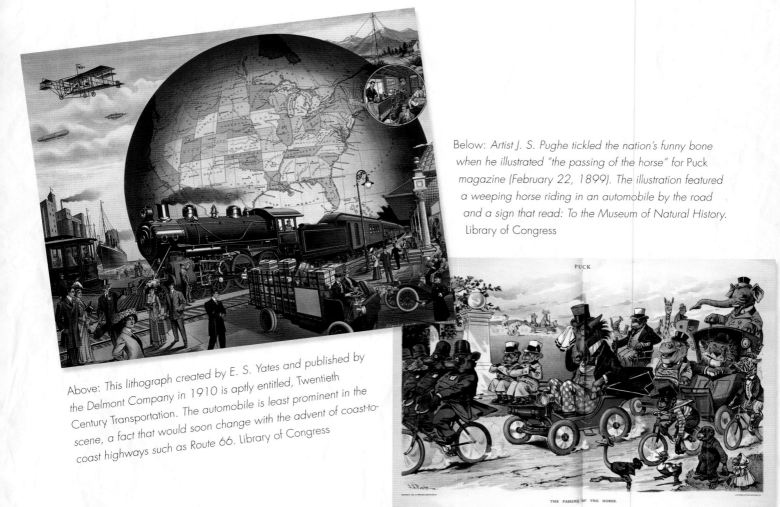

Below: *Artist J. S. Pughe tickled the nation's funny bone when he illustrated "the passing of the horse" for Puck magazine (February 22, 1899). The illustration featured a weeping horse riding in an automobile by the road and a sign that read: To the Museum of Natural History. Library of Congress*

Above: *This lithograph created by E. S. Yates and published by the Delmont Company in 1910 is aptly entitled, Twentieth Century Transportation. The automobile is least prominent in the scene, a fact that would soon change with the advent of coast-to-coast highways such as Route 66. Library of Congress*

icycles, bicycles everywhere! At the turn of the twentieth century, enthusiasm for the two-wheeled contrivance was at an all-time high in both the United States and Europe. The horse was yesterday's news, and those who desired speed and mobility embraced the new-fangled machine. The public soon coined the term "wheelmen" to describe everyday riders, while the moniker "scorchers" described cycling speedsters.

The advent of this new craze for bicycles began in the mid-1800s with the debut of the "safety" cycle. It was a sleek number, with two even-sized wheels that allowed for balance and comfort for the rider. It didn't take long for the public to seek out their local bicycle shops, empty their wallets, and hop onboard the wheeled machines. Almost overnight, thousands of riders turned into hundreds of thousands . . . and then millions!

The number of cyclists grew at such an astonishing rate that newspapers nationwide printed numerous accounts of the phenomenon. It was not altogether good news: One complaint after another expressed a common sentiment, namely that "The bicycle craze in this city has been observed with pain by the more sensitive portion of the community, and the development of the evil has produced no end of annoyance and exasperation. So [as] long as the skeletons on wheels kept to the public streets, the public could stand it. Gradually, however, the bicyclists became emboldened. The streets weren't good enough for them and the bicyclist took to the sidewalk. Now a patient and long-suffering community is righteously angry."[1]

From the cyclist's point of view, the problem had nothing to do with the riding habits of their brethren. It was the quagmire of the streets that caused the problems. Unlike horseback riding, bicycling required a smooth surface to roll freely. No self-respecting wheelman "minded a little slosh," but when it impeded forward motion, he (or she) boldly took to the graded surface of the sidewalks to assert his domain.

Yet, it appeared that even riding in the streets promoted equal offense. Unlike the horse, bicycles moved silently, causing all manner of accidents. As one outraged citizen wrote, "The cyclist is dangerous for the reason that you cannot tell from what corner the infernal machine will come from. I am a victim to the tune of a broken arm and finger on the other hand, caused by a champion of the nuisance running within a foot of my horse and frightening him so that I was upset, with the above result."[2]

The combination of negative publicity and the horrid state of America's roads forced cyclists to band together. Naturally, these new bicycle touring clubs quickly determined that the primary hindrance to their machines was the preponderance of poor roads. Certainly, it would be advantageous to join forces for a single cause: the quest for improved roads.

For this purpose, cycle organizations decided to pedal toward a common goal. They agreed to meet at Newport, Rhode Island, on May 31, 1880, with the idea to form a new organization. Convening at Aquidneck House, the organization voted to be called the League of American Wheelmen (thereafter known as the LAW). Their defining creed was the promotion of good roads and the need to build them. Of secondary importance was the desire to protect their fellow wheelmen from the rising tide of unjust discrimination.

As it happened, the group's founding turned out to be the spark that ignited the formation of additional "good roads" societies at both the city and state levels. In October 1892, the majority of these groups held a congress at the World's Columbian Exposition in Chicago, Illinois. "All farmers' associations and other organizations interested in the subject of good roads are invited to be present," their invitation announced.[3] "The intention is to hold a meeting for the preliminary organization of a national league for road improvement."

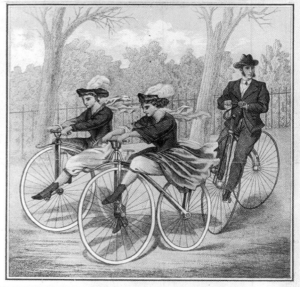

Wooden engraving, 1869. The velocipede, or bone shaker as it was called, made its debut in 1865. Translating into fast foot, the word velocipede was an apt description for this early bicycle because the pedals were attached directly to the front wheel. This model was made entirely out of wood. The velocipedes were a huge hit and created a fad that produced indoor riding arenas (or academies) very similar to the roller rinks of the 1980s. Library of Congress

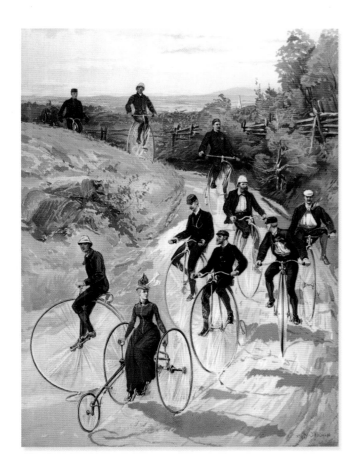

Americans were infatuated with the promise of automotive mobility and the public demanded hard-surface roads to connect their cities and towns. Motorists yearned for traveling conduits that would join the rural with the urban. Some even envisioned coast-to-coast highways to connect the states.

Indeed, the automobile liberated people from their village mentalities and ushered them into a national mindset. No longer were they restricted to travel by rail and steamer, which had been an accessible form of travel for only a few. With a "horseless carriage," a full tank of gasoline, and a clear road to navigate, anyone with an automobile could dream of exploring the countryside and ponder the notion of self-directed vacations to America's scenic wonders.

Before long, the much-heralded "demise of the horse" was thrust back into the spotlight. On September 19, 1906, J. H. Francis—acting president of the Austin Automobile Club—declared that "horses have been supplanted by the more modern automobile and their only remaining point of usefulness on Sundays is to pull carriages at a funeral."[4] Kicked off by the craze for the bicycle and finalized by the ascendance of the automobile, the promise of free travel signaled the final death knell of the horse.

In 1870, the first all-metal bicycle made its debut. The pedals were attached to the front wheel, which featured solid rubber tires and long spokes. The design yielded a smooth ride, but unfortunately, the contraption was rather awkward. If an object prevented the front wheel from turning, the rider would unceremoniously fall on his or her head. Ladies encumbered by long skirts and corsets opted for the much safer, high-wheel tricycle. This aquarelle print was illustrated by Hy Sandham, published by L. Prang and Company, in 1887.
Library of Congress

Chicago, Illinois, 1897. A broken-down bicycle was just as annoying to a wheelman as a broken-down automobile was to a motorist. Unfortunately, bicycle repair shops were few and far between during the late 1800s. In times of mechanical trouble, a visit to the local blacksmith shop was often the only remedy.
Library of Congress

But there was more to come. That same month, the National League of Good Roads was formed, followed in 1893 by the first Good Roads Congress, held in Washington D.C. Much to the wheelman's delight, the Good Roads movement was literally on its way toward paving a better future for their two-wheeled pursuits.

However, progress quickly superseded the desires of the pedal-powered hoards. In fact, it quickly roared past the bicycle era and focused directly on the four-wheeled emissary of the future: the internal-combustion gasoline-engine-powered motor vehicle. Spurred on by the emergence of the automobile, the subject of good roads gained a wider audience than ever before. By the early 1900s, its popularity as a cause was no longer limited to special-interest groups like the LAW. Now, there was much more at stake than just touring roads for cyclists.

Bicycle Fever

The wheelmen were recreational bicycling clubs that often promoted bicycle racing and long-distance tours. This group of wheelmen in California pause at a rest station, circa 1897. On May 31, 1880, the League of American Wheelmen formed in Newport, Rhode Island, with the purpose of protecting their rights against the rising tide of discrimination against bicycles. The group's secondary purpose was the promotion of good roads. Library of Congress

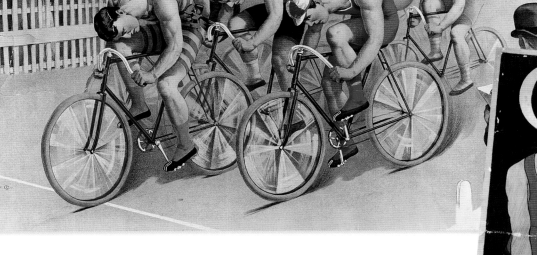

Above: *Distributed by The Calvert Lithograph Company of Detroit, Michigan, this eye-grabbing chromolithograph was published in 1895 to celebrate the bicycle racing sport.* Library of Congress

Right: *Created by artist Edward Penfield in 1895, this evocative bicycle racing poster handily advertises the Waltham Manufacturing Company's brand of Orient Cycles.* Library of Congress

For wheeling around town, an 1893 article in the Chicago Daily Tribune offers this advice: "The question of bicycle gowns is an important one. Women bicyclists" wear short plain skirts . . . that turn under and gathers itself, trouser fashion, just below the knee. A really ideal suit is a gray flannel skirt with a trim jacket of the same material; a soft hat of gray for on her head; and a pair of gray spats around her ankles over low black shoes. Gray gauntleted gloves complete the dress. It is still something of a shock to many persons to see a woman mounted on the tandem wheels . . . " The two-piece riding set shown—complete with hat, gloves, and spats—is featured in a package enclosure distributed by the Pope Manufacturing Company, Hartford, Connecticut, makers of Columbia Bicycles. Lithograph by Gast Lithograph Company, New York, 1894. Library of Congress

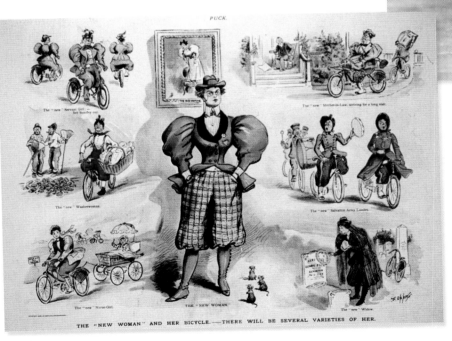

Above: *Madge Lessing, once a popular star of musical comedies on Broadway, was an avid bicyclist. She poses here clad in the proper cycling attire recommended for modern ladies of 1902. The pneumatic tires, same-size rims, comfortable seats, and easy-to-hold handlebars made these models a hit with women. With a bicycle like this, she was no longer confined to riding a tricycle around the park. She could venture out into the streets and ride anywhere she wished. Library of Congress*

Above: *On May 28, 1895, the Chicago Daily Tribune featured a story entitled, "Legs, Bloomers, and Bicycles," raising alarm over the modern woman's approach to her costume. It all began when a ". . . daring woman named Bloomer astonished the community where she lived by making an appearance clad in baggy breeches At first one by one, now dozens by dozens, perhaps it will soon be hundreds and thousands, lovely women, young and old, big and little, thin and fat, is boldly asserting herself on the public thoroughfares in trousers which take the name of the knickerbocker. . . . Is not this the first step toward wearing the breeches at home? As the evolution develops will she wear them to market, in shopping, and, finally everywhere? . . . where will it end?" The June 19, 1895, issue of Puck magazine expresses the same concern in The New Woman, an illustration by F. Opper. Library of Congress*

Illinois along the Eventual Route 66

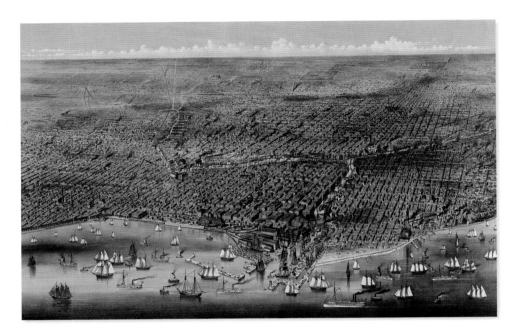

Lithograph, Chicago, sketched and drawn on stone by Parsons and Atwater, published by Currier and Ives, New York, 1874. Chicago was founded as a trading post at the mouth of the Chicago River and was incorporated on August 12, 1833, with a population of 350. By 1870, the railroads helped this settlement grow and boosted it to a population of three hundred thousand. Disaster struck one year later, when the Great Chicago Fire leveled 17,450 buildings. As seen in this lithograph only three years later, rebuilding the city was the primary focus and it was a task the city accomplished quickly. Library of Congress

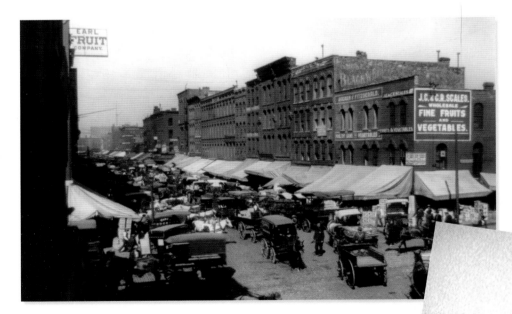

Left: South Water Street, Chicago, Illinois, circa 1899. Chicago's streets had a reputation for being the busiest streets in the world, long before clattering automobiles showed up on the scene. One day, Chicago would become the gateway for U.S. Highway 66, which would carry a steady stream of traffic toward the Pacific Ocean and to all points in between. Library of Congress

Right: Chicago's famed Lake Shore Drive as it was in 1910 and sporting a planked, wooden sidewalk. A steady promenade of carriages and pedestrians dot the popular shoreline. The original 1926 terminus of U.S. Highway 66 was located on Lake Shore Drive, directly at the foot of Lake Michigan. Library of Congress

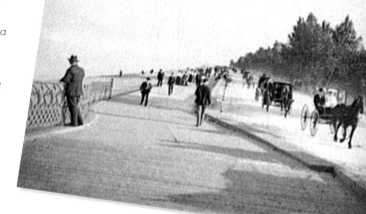

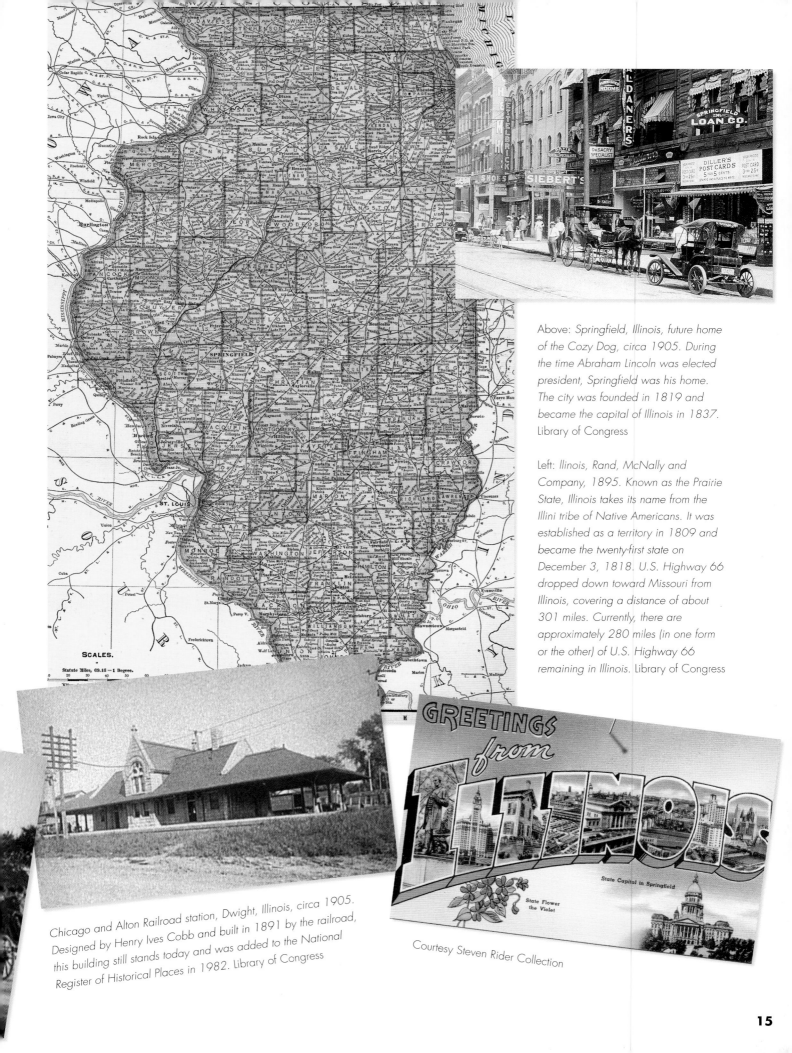

Above: *Springfield, Illinois, future home of the Cozy Dog, circa 1905. During the time Abraham Lincoln was elected president, Springfield was his home. The city was founded in 1819 and became the capital of Illinois in 1837. Library of Congress*

Left: *Ilinois, Rand, McNally and Company, 1895. Known as the Prairie State, Illinois takes its name from the Illini tribe of Native Americans. It was established as a territory in 1809 and became the twenty-first state on December 3, 1818. U.S. Highway 66 dropped down toward Missouri from Illinois, covering a distance of about 301 miles. Currently, there are approximately 280 miles (in one form or the other) of U.S. Highway 66 remaining in Illinois. Library of Congress*

Chicago and Alton Railroad station, Dwight, Illinois, circa 1905. Designed by Henry Ives Cobb and built in 1891 by the railroad, this building still stands today and was added to the National Register of Historical Places in 1982. Library of Congress

Courtesy Steven Rider Collection

Missouri along the Eventual Route 66

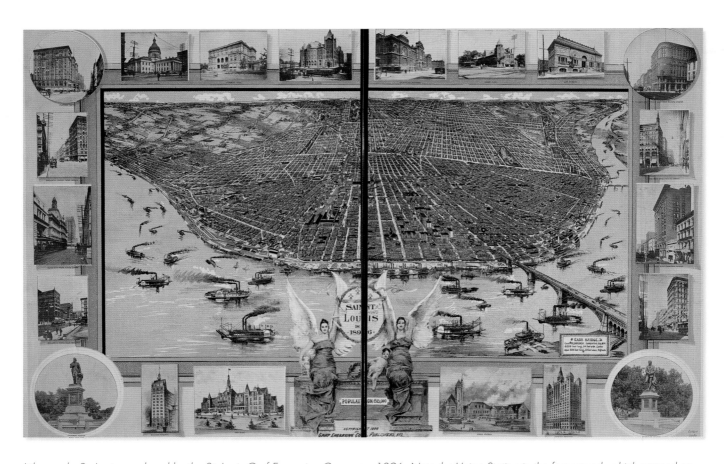

Lithograph, St. Louis, produced by the St. Louis Graf Engraving Company, 1896. Note the Union Station in the foreground, which opened on September 1, 1894. The span across the Mississippi River is the Eads Bridge, completed in 1874 at a cost of more than ten million dollars. In 1764, St. Louis was founded as a trading post by Pierre Laclede Liguest, a New Orleans merchant (along with forty families). In the early part of the nineteenth century, St. Louis emerged as a major center of river traffic. Located between Chicago and Los Angeles, St. Louis is the largest city along Route 66's cross-country route. Library of Congress

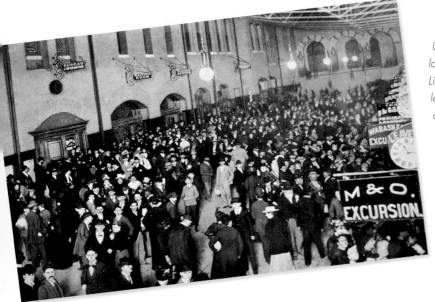

Union Station, St. Louis, Missouri, 1895. At one time, this was the largest railroad station in the country. Designed by Theodore C. Link, it opened in the fall of 1894. The grand hall featured gold leaf, Romanesque arches, a sixty-five-foot barrel-vaulted ceiling, and stained-glass windows. Back then, holiday travel was called an excursion. Union Station continued to operate well into the declining years of railroad travel, with the last train pulling out in 1978. After extensive renovations, it reopened as a retail, restaurant, hotel, and entertainment complex in 1985. National Archives

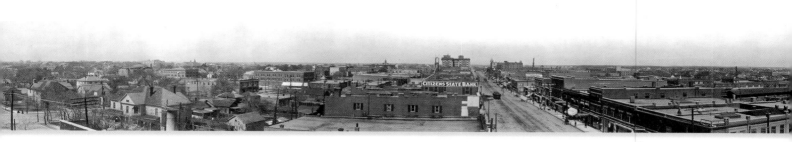

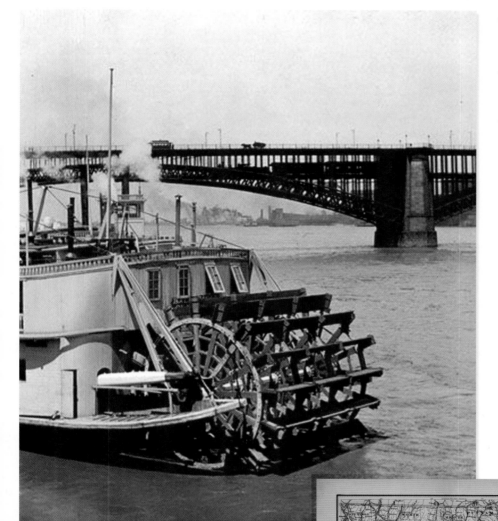

Abovet: Joplin, Missouri, 1910. Long before the song "Get Your Kicks on Route 66" was even a twinkle in Bobby Troup's eye, Joplin gained notoriety as an important mining center. Located on the Ozark plateau, the city that would one day be immortalized in song was settled around 1840 and incorporated in 1873. Library of Congress

Left: Mississippi River paddle wheel boat, circa 1910. St. Louis was second only to New Orleans in steamboat traffic. The bridge in the background is the massive Eads Bridge. The center span is 520 feet long and each of the others span 500 feet. The pedestrian passage was 54 feet wide, with two rail lines below. Library of Congress

Right: An official 1888 railway map of Missouri. In 1812, the territory of Missouri was formed. In 1820, the first state legislature convened in St. Louis to petition for statehood. Missouri was admitted to the union as the nineteenth state on August 10, 1821. Before dipping into Kansas, Missouri's wondrous stretch of U.S. Highway 66 meandered some 317 miles across a myriad of scenic wonders, including the Ozarks. Library of Congress

Kansas and Oklahoma along the Eventual Route 66

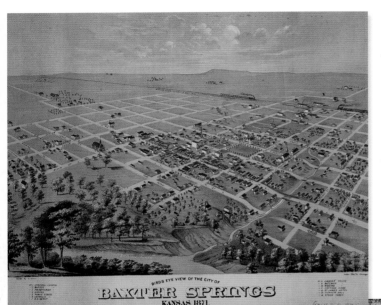

BIRDS EYE VIEW OF THE CITY OF
BAXTER SPRINGS
KANSAS. 1871.

Baxter Springs, Kansas, 1871, drawn by E. S. Glover and published by Union Lithograph Company. This cattle town was founded in 1849 by John J. Baxter, who moved from Missouri to a large plot of acreage he owned near the Spring River. Known as the first cowtown in Kansas, the settlement was the railhead for the railroad and the place where Texas cattlemen drove their herds. Unfortunately, the boom went bust when the railroad moved to Texas and the Kansas stop became obsolete. Library of Congress

Below: Kansas, Rand, McNally and Company, 1895. Kansas is named for the Kansa tribe, meaning People of the South Wind, who once occupied the region. It has also been nicknamed the Sunflower State. In 1824, the Santa Fe Trail was established from Independence, Missouri, through what is now Kansas. Kansas was organized as a territory in 1854 and it became the thirty-fourth state on January 29, 1861. Among the Route 66 states, it sports the shortest trek of highway: thirteen miles of Route 66 still exist in Kansas. Library of Congress

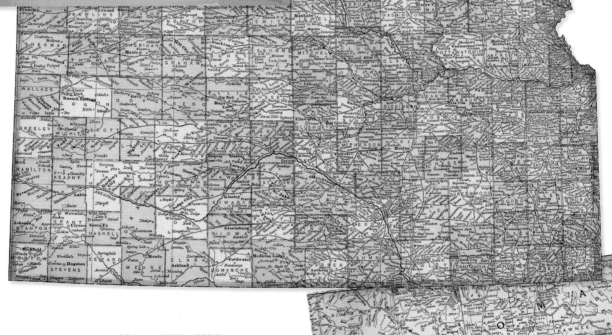

Right: Oklahoma, Hardeman Publishers, 1886. Oklahoma is a combination of two Choctaw Indian words, okla, meaning people, and homma, meaning red. Within the Indian territory, Miami, Vinita, Catoosa, Tulsa, and Sapulpa were already established before the territory assumed statehood. The nickname Sooner State originated in 1889 when the rush for land began. After the U.S. government's purchase of Indian lands, the new territory was opened. However, settlers found that some of the best tracts had already been claimed—some homesteaders entered "sooner" than they had a right to. Oklahoma—home of Cyrus Avery, the founding father of Route 66— was home to 415 original miles of 66, of which there are about 405 today. Library of Congress

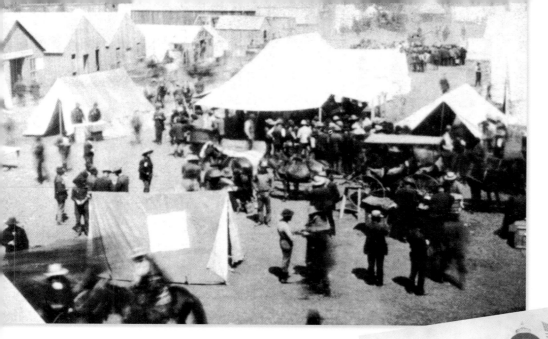

Left: *The Oklahoma land run of April 22, 1889, unfolded in a drama that rivals any Western action movie of today. The rabid hunger for three million acres of "Unassigned Lands" stirred a frenzy that created tent cities in El Reno, Guthrie, Kingfisher, Norman, Oklahoma City, and Stillwater. At the time, Oklahoma City was officially established as a town, although it already had several buildings and a Santa Fe Railway depot.* UCO Archives/Special Collections

Right: *Oklahomans celebrate statehood on November 16, 1907, at the capital in Guthrie, Oklahoma. In 1910, the capital was moved to Oklahoma City.* UCO Archives/Special Collections

Below: *Tulsa, Oklahoma, 1908, poised and ready for the automobile traffic that would one day stream through the heart of the city on Route 66, transforming it into a living, breathing part of America's Main Street.* Library of Congress

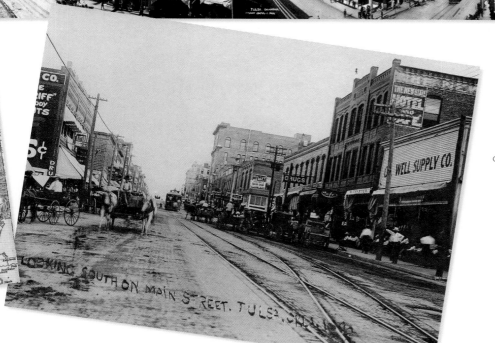

Left: *Main Street, Tulsa, Oklahoma, 1909: A cacophony of horse-drawn carriages, streetcars, and people riding on horseback. Over the next two decades, the pace would quicken—motorcars were coming.* University of Tulsa/Special Collections/McFarlin Library

Texas and Arizona along the Eventual Route 66

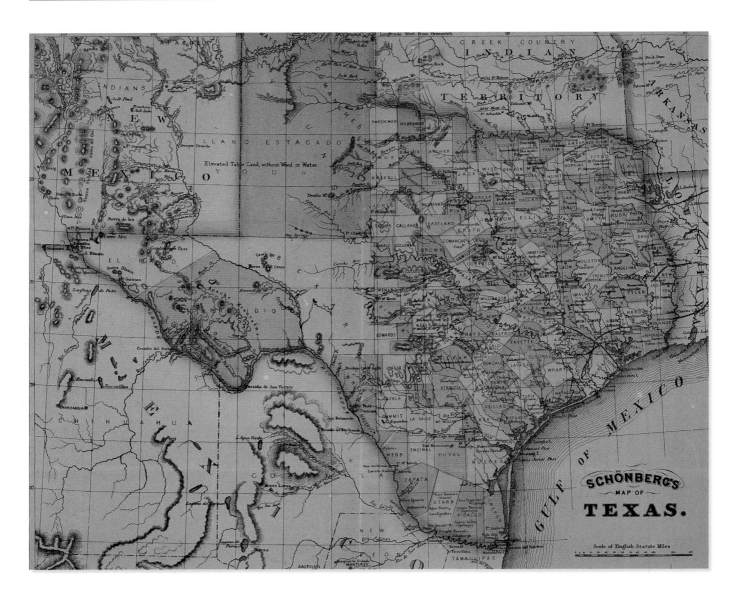

Above: When this Schonberg and Company map was printed in 1866, the area that would one day host Texas Route 66 was occupied by the reputedly hostile Kioway and Comanche Native American bands. Yet, Texas is derived from the Native American word tejas, meaning friends. Texas existed as a separate nation from 1836 to 1845. On December 29, 1845, it became the twenty-eighth state. Unlike other states—which became territories first—Texas was admitted directly by joint resolution of Congress. Although it boasts 267,339 square miles of land, only 186 miles of U.S. Highway 66 cut across the Texas Panhandle into New Mexico. Approximately 178 miles of the road still exist today. Library of Congress

Left: In 1882, this photo depicts the way it was in Flagstaff, Arizona, along what would later be called Santa Fe Avenue. Flagstaff's first permanent settler was Thomas F. McMillan, who built a cabin and corral at the foot of Mars Hill. In 1881, the railroad arrived and a settlement quickly grew up around the bustling railroad depot. Courtesy Southwest Studies

Arizona, Rand, McNally and Company, 1895. Arizona derives its name from the Pima or Papago Indian word *aleh zon,* meaning little spring. It became a U.S. territory in 1863 and was admitted as the forty-eighth state on February 14, 1912. Known as the Grand Canyon State, it holds 14,006 square miles of plateau, mountains, and plains. At one time, U.S. Highway 66 meandered through 401 miles of Arizona, with 376 miles (in one form or the other) still remaining today. In this map, the Atlantic and Pacific Railroad line flows from New Mexico to all the towns that became part of U.S. Highway 66. Library of Congress

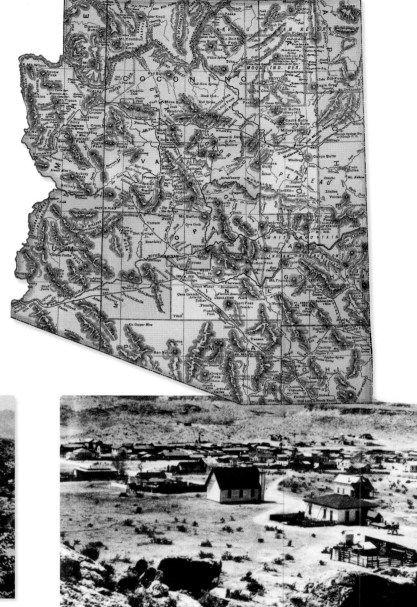

Oatman, Arizona, at the turn of the nineteenth century. Oatman was a town born from gold fever. In 1902, Ben Taddock touched off a mining boom after he discovered gold in the surrounding areas. Originally, the town was named Vivian, after the Vivian Mining Company, but the name was changed to Oatman in 1909. Courtesy Southwest Studies

A view back in time to Kingman, Arizona, 1896, located near the old Beales Spring. In 1883, the town was established as a railroad stop. The location engineer, Lewis Kingman, chose to name the place after himself. Courtesy Southwest Studies

Dirt road of 1912 connecting Flagstaff to Williams, Arizona. Later, this desolate wagon path became the highway known as U.S. Route 66. Courtesy of Cline Library Northern Arizona University

New Mexico along the Eventual Route 66

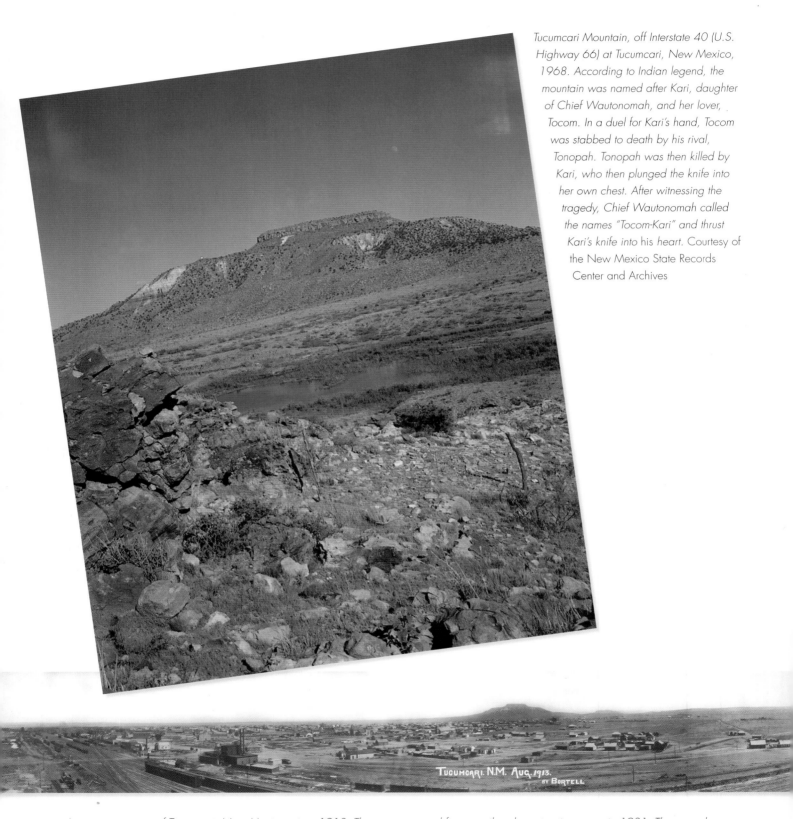

Tucumcari Mountain, off Interstate 40 (U.S. Highway 66) at Tucumcari, New Mexico, 1968. According to Indian legend, the mountain was named after Kari, daughter of Chief Wautonomah, and her lover, Tocom. In a duel for Kari's hand, Tocom was stabbed to death by his rival, Tonopah. Tonopah was then killed by Kari, who then plunged the knife into her own chest. After witnessing the tragedy, Chief Wautonomah called the names "Tocom-Kari" and thrust Kari's knife into his heart. Courtesy of the New Mexico State Records Center and Archives

A panoramic view of Tucumcari, New Mexico, circa 1913. The town emerged from a railroad construction camp in 1901. The camp began life as Six-Shooter Siding, but when the town was incorporated in 1903, the name of a nearby mountain was adopted as a more suitable and respectable moniker. Library of Congress

Above: The Native American petroglyph was one of the first communication tools of our indigenous peoples. Carved by hand into solid rock, this petroglyph existed long before the white man placed his footprint in this arid region. Photo circa 2000. Courtesy Marshall Trimble

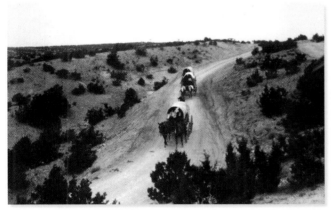

Left: New Mexico, Rand, McNally and Company, 1895. Known as the Land of Enchantment, New Mexico boasts 121,356 square miles with 155 square miles of inland water. In 1848, it became part of the United States with the treaty of Guadalupe Hidalgo. In 1906, an attempt was made to admit Arizona and New Mexico as one state, but Arizona voters opposed it. At one time, there were about 487 miles of U.S. Highway 66 ambling through the state. The Atlantic and Pacific Railroad line weaves from Santa Fe to Albuquerque, and on toward Gallup. Library of Congress

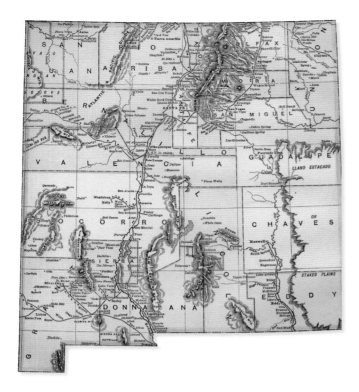

Covered wagons on the Santa Fe to Taos Road, New Mexico, circa 1900. Courtesy Palace of the Governors (MNM/DCA)

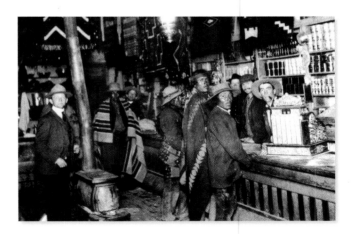

Trading post, Thoreau, New Mexico, circa 1900. This trading post was owned by William Horabin and it sold everything from hardware to groceries. The pawn/credit system conducted with the Native Americans is evident by the displayed rugs. Courtesy Palace of the Governors (MNM/DCA)

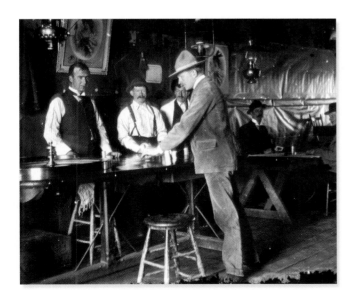

Left: Playing the roulette wheel at Charley Clay's, Santa Rosa, New Mexico, circa 1902. Santa Rosa was a railroad town with a number of saloons and gambling establishments. It was known for a population that worked hard and played hard. Ranching, farming, and the railroad were its main sources of income until U.S. Highway 66 spilled its cornucopia of prosperity. Courtesy Palace of the Governors (MNM/DCA)

California along the Eventual Route 66

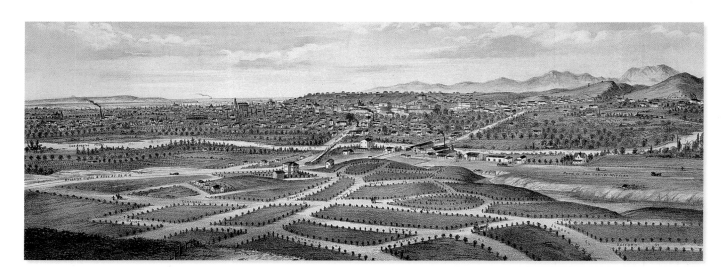

A view of Los Angeles from the east, with Brooklyn Hights [sic] in the foreground and the Pacific Ocean and Santa Monica Mountains in the background. Situated on the Los Angeles River, the city is only fifteen miles from the Pacific Ocean. Los Angeles was established in 1781 by Felipe de Neve and named la Reina de los Angeles. It was populated with forty-four settlers. The town became the final destination on the route to the Pacific for travelers by rail and later by car. From 1926 to 1984, Route 66 connected Chicago, Illinois, with Los Angeles, California. This map was drawn by E. S. Glover and it is an A. L. Bancroft and Company lithograph, published in 1877. Library of Congress

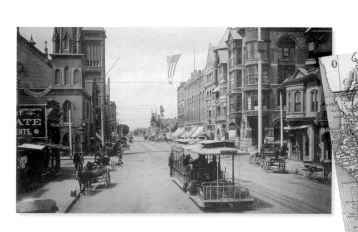

Above: Los Angeles, California, circa 1899. This view is looking down Broadway, in the direction of what would become the original 1926 terminus of U.S. Highway 66 at Broadway and 7th Street. Library of Congress

Right: California, Rand, McNally and Company, 1895. California's name was taken from the Spanish words caliente forno, *meaning* hot furnace. *Its nickname, the Golden State, refers to the gold fields that were once the richest in the world. California became a U.S. territory in 1848, and the thirty-fifth state on September 9, 1850. Despite 155,973 square miles of land area, it hosted only 314 miles of U.S. Highway 66. In this vintage map, the Atlantic and Pacific Railroad line dips from Arizona into Needles, and continue to all the future towns along Route 66. Library of Congress*

Edward Fitzgerald "Ned" Beale
and His Camel Caravan

Edward Fitzgerald "Ned" Beale was born on February 4, 1822, in the District of Columbia. He first served in the U.S. Navy and resigned at the rank of lieutenant on August 3, 1850.

On March 3, 1853, President Millard Fillmore appointed Beale the superintendent of Indian affairs for California and Nevada. He kept this position until 1856. In 1857, President James Buchanan appointed Beale to survey a wagon road from Fort Defiance, New Mexico, to the Colorado River (on the border between Arizona and California) along the thirty-fifth parallel. Since Beale used camels to carry his equipment, his expedition came to be known as Beale's Camel Caravan.

By 1880, the railroad started building tracks along the thirty-fifth parallel between Albuquerque and Arizona, closely following Beale's trail. Today, most towns along present-day Interstate 40 can trace their origins directly back to Beale's trail and the early days of the railroad.

Beale's camels were used for a variety of assignments until 1864, when they were auctioned off. Beale purchased several for his large California ranch and he retired there after the Civil War. However, most of the camels were turned loose in the desert, where they, and their offspring, were sighted until 1907. Today, some denizens of the desert claim that they can still see the camels, on occasion.

In 1876, President Ulysses Grant appointed Beale as minister to Austria-Hungary. His diplomatic work required a residence in Washington, D.C., where he owned a place called the Decatur House. Beale died there on April 22, 1893.

Lieutenant Beale camped at a spring in the Truxton, Arizona, area on October 8, 1857, and provided the town's name—most likely after his brother Truxton or mother, Emily Truxton Beale. The present community of Truxton grew from a gas station and café that were established in 1951. Courtesy Steven Rider Collection

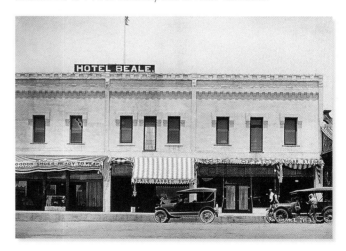

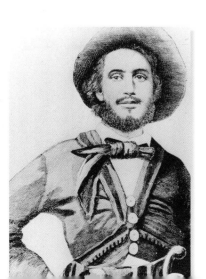

Edward Fitzgerald "Ned" Beale as a midshipman (image circa 1937). Courtesy Southwest Studies

The two-story Hotel Beale dates from 1899 and was the boyhood home of actor Andy Devine. It is named after Edward Beale, who blazed a wagon road from Fort Defiance to the Mojave River, roughly paralleling Route 66, in 1857. Later, Hotel Beale became a popular stop for travelers, including Charles Lindbergh and Greta Garbo. "Garbo stayed right here," said hotel owner Tedi Kinkella about the Greta Garbo Room, in an interview with Tim Vanderpool of the Tucson Weekly (July 6, 2000). "Isn't that something?" The Lindbergh Room featured an old tub that sat right in the middle of the bathroom. Although charming, the neglected seventy-three-room hotel was closed in 2000. Library of Congress

The Santa Fe Trail

A portion of the old Santa Fe Trail near Taos, New Mexico, along Pueblo Creek, circa 1945. This portion of the Santa Fe Trail is one of the few segments of the old trail that has not become part of the modern highway system. Courtesy of the New Mexico State Records Center and Archives

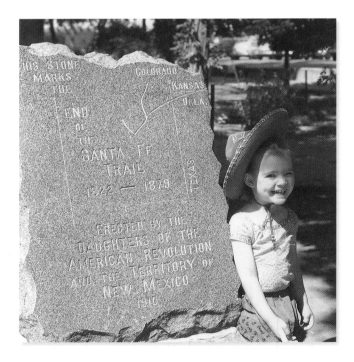

After one hundred years, the wagon ruts of the Santa Fe Trail are still visible near Fort Union National Monument, New Mexico, 1965. Between 1821 and 1880, the Santa Fe Trail operated as a major trading route between Independence, Missouri, and Santa Fe, New Mexico. Portions of this trail became part of the National Old Trails Highway and later, Route 66. Courtesy of the New Mexico State Records Center and Archives

Located in the plaza of Santa Fe, New Mexico, this granite marker marks the end of the Santa Fe Trail. It was erected in 1910 by the Daughters of the American Revolution and the Territory of New Mexico (photo circa 1942). The Santa Fe Trail covered approximately 770 miles and spanned five states, including Missouri, Oklahoma, Colorado, Kansas, and New Mexico. The trail operated from 1821 to 1880, when the railroad took over as the main mode of transportation. Courtesy of the New Mexico State Records Center and Archives

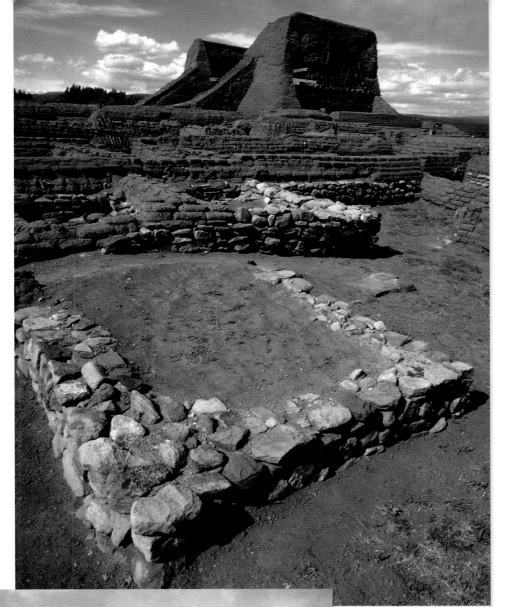

Pecos National Monument along the old Santa Fe Trail, New Mexico. Today, these ruins are all that is left of the ancient pueblo and its mission church. They were once a known landmark to travelers along the Santa Fe Trail. ©2007 Allen Bourgeois

Old Pigeon Ranch, Glorieta Pass, New Mexico. Touted by its proprietors as the "most historical stop," this trading post was located on the Santa Fe Trail. For road-weary travelers, it functioned as the last stop on the trail before reaching Santa Fe. French-American Alexander Valle built the place in the early 1800s and named it after his own nickname, "Pigeon." According to lore, Valle earned the moniker because of his dancing prowess. As the story goes, he enjoyed doing a step called pigeon's wings at some of the local fandangos. Another version explains that he earned the name by speaking broken or "pigeon" English. Courtesy Steven Rider Collection

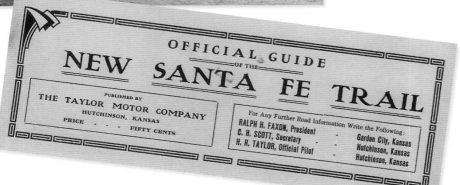

New Santa Fe Trail brochure, circa 1920. Inside, handy strip maps reminiscent of AAA TripTiks provided the mileage and directional information needed by early travelers of the route. Courtesy Steven Rider Collectiona

Santa Fe and Albuquerque

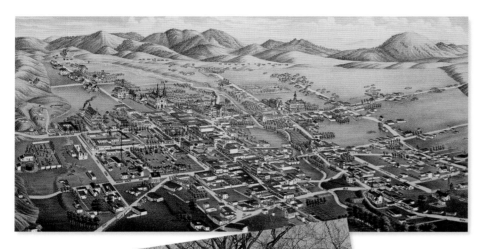

Lithograph, Santa Fe, New Mexico, drawn by H. Wellge and published by Beck and Pauli, 1882. Santa Fe marks the end of the Santa Fe Trail and the start of the Middle Route Trail, which was blazed by Francois X. Aubry, Lorenzo Sitgreaves, Amiel Whipple, and Edward Beale. Santa Fe has a rich Native American heritage that predates the Spanish invasion. Spaniards established a foothold in 1610, when Don Pedro de Peralta founded La Villa Real de la Santa Fe (the Royal City of Faith) on the ruins of an abandoned Tanoan Indian village. However, the Indians managed to drive the Spaniards from the town in 1680, when they seized the existing buildings and constructed their own pueblo around the three sides of the plaza. Twelve years later, the Spaniards re-emerged and reclaimed the town. Later, Water Street (clearly marked) led to the Santa Fe Trail (follow the road and turn right across the bridge at the Santa Fe River). In 1926, this portion of the Santa Fe Trail became part of U.S. Highway 66. Library of Congress

Left: The ancient Palace of Governors in Santa Fe, New Mexico, is located at the end of the Santa Fe Trail. Constructed in the year 1612, the structure is the oldest government building in the United States. This photo was taken in 1939. National Archives

Santa Fe, New Mexico, circa 1947. Alleged to be the oldest house in the United States, this adobe structure is the last remnant of the Pueblo of Analco, dating from A.D. 1200. Over the years, many additions have been made to the structure, including a gift shop in the newer portion of the building. Courtesy of the New Mexico State Records Center and Archives

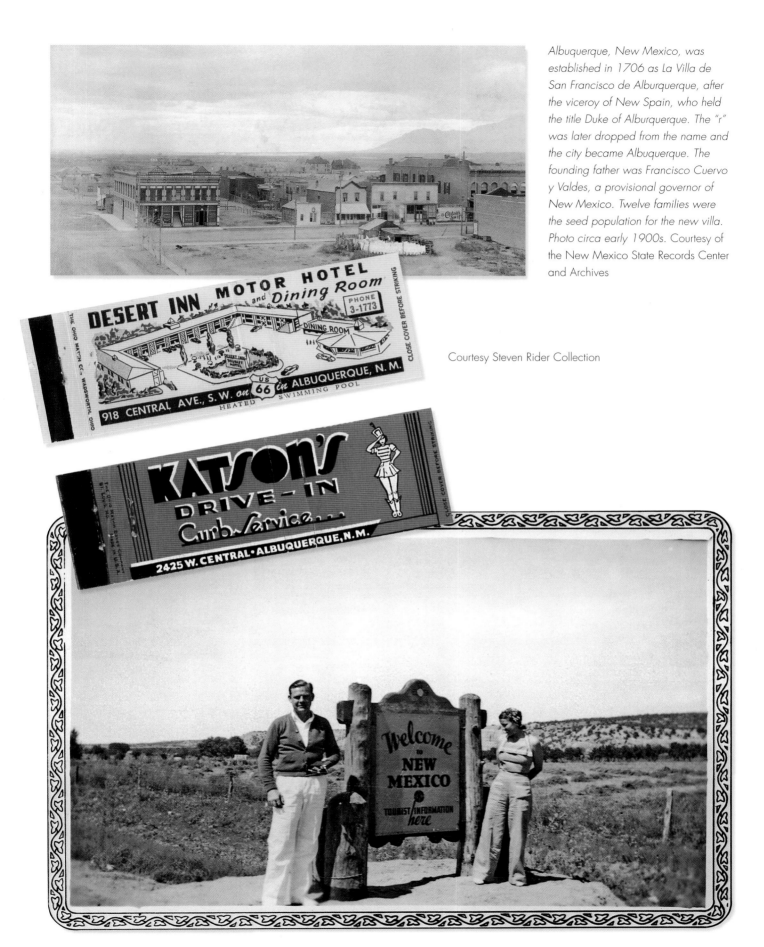

Albuquerque, New Mexico, was established in 1706 as La Villa de San Francisco de Alburquerque, after the viceroy of New Spain, who held the title Duke of Alburquerque. The "r" was later dropped from the name and the city became Albuquerque. The founding father was Francisco Cuervo y Valdes, a provisional governor of New Mexico. Twelve families were the seed population for the new villa. Photo circa early 1900s. Courtesy of the New Mexico State Records Center and Archives

Courtesy Steven Rider Collection

DESERT INN MOTOR HOTEL and Dining Room
PHONE 3-1773
THE OHIO MATCH CO., WADSWORTH, OHIO
CLOSE COVER BEFORE STRIKING
DINING ROOM
918 CENTRAL, AVE., S.W. on US 66 in ALBUQUERQUE, N.M.
HEATED SWIMMING POOL

KATSON'S DRIVE-IN Curb Service....
THE OHIO MATCH COMPANY, ST. LOUIS, MO. MADE IN U.S.A.
CLOSE COVER BEFORE STRIKING
2425 W. CENTRAL · ALBUQUERQUE, N.M.

Welcome to NEW MEXICO TOURIST INFORMATION here

Welcome to New Mexico highway marker, circa 1940. Courtesy of the New Mexico State Records Center and Archives

Francois Xavier Aubry
Explorer of the Thirty-Fifth Parallel

"Allow me to introduce to you the man to whom the telegraph is a fool."

— Weekly Reveille, *September 24, 1848*

On September 12, 1848, Francis Xavier Aubry left Santa Fe, New Mexico, in a swinging gallop on his solo ride to Independence, Missouri. Amazingly, he made the trip in only five days and sixteen hours by traveling at the unheard of rate of 140 miles a day.

"Aubry traveled over eight hundred miles through mud and rain, he broke down six horses, walked twenty miles, slept only a few hours, and ate but six meals," reported the *Santa Fe Republican.* "On Sunday night, September 17, his foaming horse half-ran, half-staggered into Independence."

In an age dominated by steam engines and wooden-wheeled carriages, a horse-powered trip was heralded as the most remarkable long-distance ride ever. "The extraordinary feat of this gentleman transcends the history of traveling," wrote the *Weekly Reveille* on September 23, 1848, and America agreed.

As fast as telegraph keys could tap out the news, Aubry became the nation's new hero. He readily fit the stereotype: Lacking all fear of Indian ambush, border ruffians, or horse thieves, he struck a likeable balance between adventurer and daredevil. With a reputation as "the most intrepid traveler the world has ever produced," people called him "Skimmer of the Plains" and "Prairie Telegraph." The Indians knew him as "White Cloud."

But Aubry was much more than a skilled rider who could travel over land faster than his peers. He was an experienced trader, too—one that leveraged his largess to secure profitable deals to fund his travels. The man who lived "life in the fast lane" along the wagon ruts garnered free publicity wherever he rode by carrying mail and news with him.

The consummate entrepreneur, Aubry decided to combine his talents for over-land trailblazing and trade. He wanted to discover a route from Santa Fe to California and mark a path that was unimpeded by mountain ranges.

On November 16, 1852, Aubry set out on a trip to explore the possibilities. He took ten large wagons, 100 mules, a handful of horses, and a mob of 3,500 sheep. He planned to drive the sheep westward and sell them in the California market. Along the way, he explored the

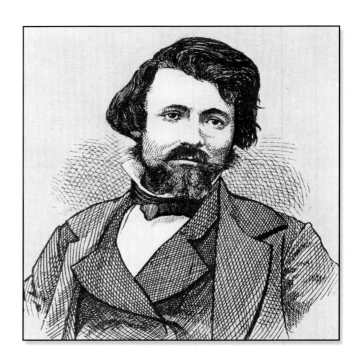

Francois Xavier Aubry was a Santa Fe trader, explorer, and famous long-distance rider. Born a French-Canadian in Maskinonge, Quebec, on December 4, 1824, he left Canada for the United States at the age of eighteen to assist his parents economically. The adventurer led a life unscathed by his travels. Ironically, he died in 1854 after being stabbed in an altercation with former newspaper editor and practicing attorney Richard H. Weightman. Author's collection

terrain in order to find a route that was useable by covered wagons and the railroad.

The following March, Aubry reached Los Angeles, California. Fifteen days later, he sold the sheep in San Francisco and filled his pockets with green. Flush with cash, Aubry announced that he would devote his next trip to the full-time exploration of the thirty-fifth parallel of California, Arizona, and New Mexico.

After spending months gathering information—including meeting with native guides and mountain men about the

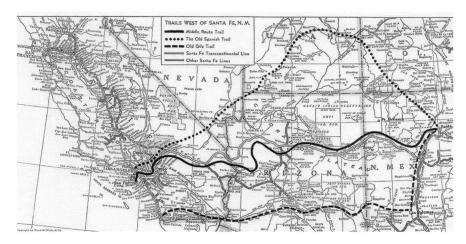

dangers of the Sierra Nevada passes—he organized an exploration team comprised of twenty reliable men, their pack animals, and supplies.

The pace was quick and the group crossed the Sierra Nevada near present-day Kern County, California, a short while later. They pressed on into the Mojave Desert and toward the Colorado River. There, they had to stop and build rafts to cross. The expedition was only a short distance from present-day Boulder Dam, where they forded the river in a spot that was 200 yards wide and 25 feet deep.

Aubry's exploration also included areas around today's Route 66 Arizona towns of Oatman, Kingman, Seligman, Ash Fork, Flagstaff, Padre Canyon, Winslow, Joseph City, and Holbrook.

The trip marked another great feat in the history of long-distance travel, but it was modestly recorded in Aubry's journal: "I set out in the first place, upon this journey simply to gratify my own curiosity as to the practicability of one of the much talked of routes for the contemplated Atlantic and Pacific railroad."[5] Others had ventured along the thirty-fifth

parallel before him (among them Captain Lorenzo Sitgreaves), but Aubry was the first to explore the latitude in its entirety from California to New Mexico.

Unfortunately, Aubry didn't live long enough to see the east meet west via railroad. He was killed in a bar room altercation on August 18, 1854, leaving behind a legacy that left its mark on the growing nation.

Eventually, some of the segments that he mapped during his pioneering escapades were followed by the Atchison, Topeka, and Santa Fe Railway from Albuquerque, New Mexico, en route to Bakersfield, California. A Missouri River steamboat was named after him, too—as were Aubry Cliffs in Seligman, Arizona; Aubry Valley, Arizona; Fort Aubry, Kansas; and towns in Missouri, Oklahoma, and Texas.

Truly, Aubry was one of America's first travel pioneers. He branded the unmarked plains and unforgiving deserts with the heated hoofbeats of horses as he blazed a trail to Los Angeles. Aubry's trail would later become part of the National Old Trails Highway, which became a part of another well-known road: The fabled highway marked 66.

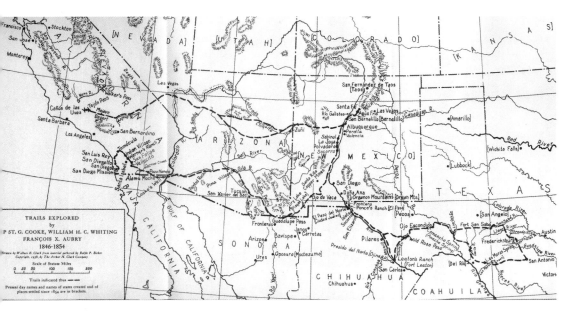

This 1938 map depicts the trails explored by Cooke, Whiting, and Aubry between 1846 and 1854. Aubry's route was from Santa Fe down into Albuquerque, through Zuni, and over the little Colorado River into the Mojave Desert. The two routes through Arizona indicate Aubry's deviation on a return trip from California as he explored a more southern route back to Santa Fe. Author's collection

Other Early Explorers and Trails

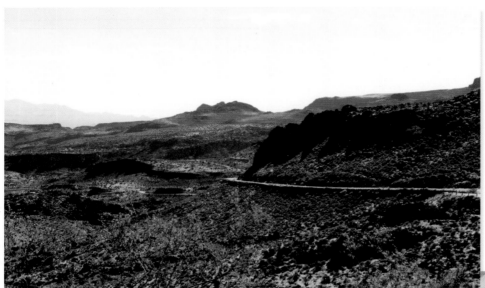

Switchbacks heading to the top of Arizona's Sitgreaves Pass, looking east on the 1930 to 1950s trace of Route 66 (1990 photo). This area was explored for a possible road west by Francois X. Aubry, who later provided information that would guide Captain Lorenzo Sitgreaves and Lieutenant Amiel Whipple over the pass. Aubry made the crossing over this pass on several occasions while seeking a road from Albuquerque to Los Angeles. Sean Evans/Courtesy of Cline Library Northern Arizona University

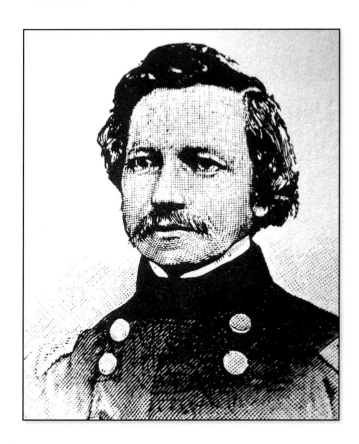

In 1853, Lieutenant Amiel W. Whipple was ordered by the army to make a survey of the thirty-fifth parallel. The survey route was from Fort Smith, Arkansas, to Albuquerque, New Mexico, venturing into what was considered unknown territory until it reached Los Angeles, California. Whipple's expedition passed near present-day Holbrook and Winslow, Arizona. Courtesy Southwest Studies

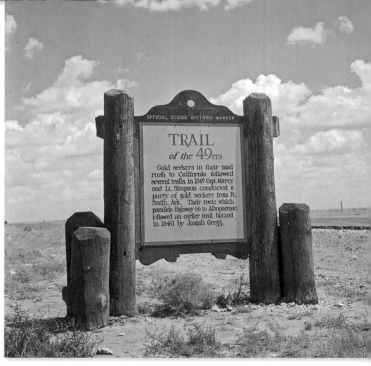

Designating the trail of the 49ers, this official scenic-historic marker erected by the New Mexico State Tourist Bureau is located on U.S. Highway 66 near Santa Rosa, New Mexico (photo circa 1947). Inscription: "Gold seekers in their mad rush to California followed several trails. In 1849 Capt. Marcy and Lt. Simpson conducted a party of gold seekers from Ft. Smith, Ark. Their route which parallels U.S. Highway 66 to Albuquerque, followed an earlier trail blazed in 1840 by Joseph Gregg." The program for marking all points of scenic-historic interest in the state began in 1936. Courtesy of the New Mexico State Records Center and Archives

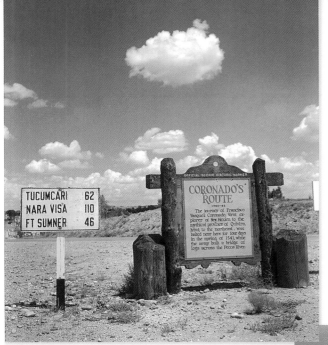

Left: *Coronado's Route, the official scenic-historic marker erected by the New Mexico State Tourist Bureau, is located on U.S. Highway 66 near Santa Rosa, New Mexico (photo circa 1947). Inscription: "The journey of Francisco Vasquez Coronado, first explorer of New Mexico, to the mythical province of Quivira, lying to the northeast, was halted near here for four days in the spring of 1541, while the army built a bridge of logs across the Pecos River."* Courtesy of the New Mexico State Records Center and Archives

Right: *During the 1800s, the Old Spanish Trail functioned as a loose-knit highway between Santa Fe, New Mexico, and Los Angeles, California. Since 1829, it was the primary over-land route between the territory of New Mexico and Old Spanish California, until the war between the United States and Mexico ended. In some places, it was the precursor to Route 66 and linked together a network of other trails, measuring in as the longest historic trail in America with approximately 2,700 miles. However, it wasn't an exact route. It merely served as a path of general direction, from east and west across the deserts of the American Southwest, and from one waterhole to another. This scene was captured in 1947 between Santa Fe and Espanola, New Mexico.* Courtesy of the New Mexico State Records Center and Archives

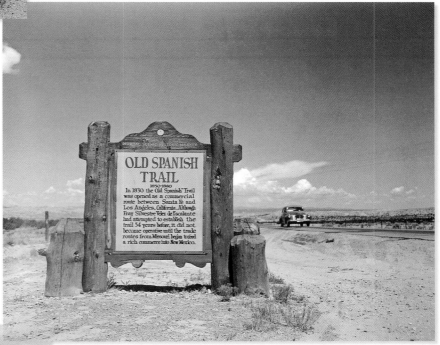

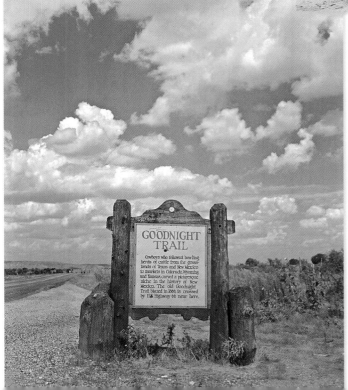

Left: *Near Santa Rosa, New Mexico, 1947. The Goodnight Trail marker was erected by the New Mexico State Tourist Board in 1936. The Goodnight Trail was also called The Goodnight-Loving Trail, named for Charles Goodnight and Oliver Loving. The marker inscription reads: "Cowboys who followed bawling herds of cattle from the grasslands of Texas and New Mexico to markets in Colorado, Wyoming, and Kansas carved a picturesque niche in the history of New Mexico. The old Goodnight Trail blazed in 1866 is crossed by U.S. Highway 66 near here."* Courtesy of the New Mexico State Records Center and Archives

One of the first automobiles to gain notoriety in America was Charles Duryea's one-cylinder converted buggy. The vehicle utilized a tiller control for steering in the 1890s. American Petroleum Institute

Chapter Two

Auto Hailed as Road Builder

"The Automobile Club of America has set out to secure a macadamized road from New York to San Francisco. As yet it is too soon to figure out how many millions it would cost to build 3,500 miles of good macadam road across mountains and prairies, but it is not too early to remark that the automobile promises to be a strong and valuable ally of the bicycle in the great missionary work of securing better country roads throughout the United States."

—"Automobiles and Good Roads,"
Chicago Daily Tribune, March 26, 1900

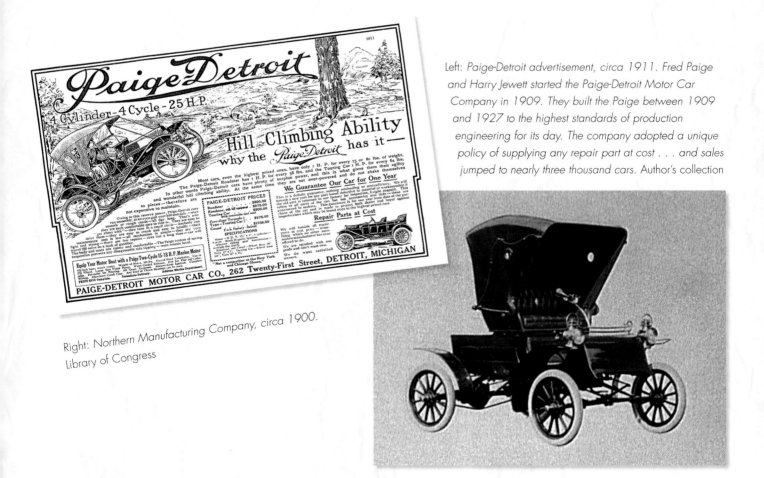

Left: *Paige-Detroit advertisement, circa 1911. Fred Paige and Harry Jewett started the Paige-Detroit Motor Car Company in 1909. They built the Paige between 1909 and 1927 to the highest standards of production engineering for its day. The company adopted a unique policy of supplying any repair part at cost . . . and sales jumped to nearly three thousand cars. Author's collection*

Right: *Northern Manufacturing Company, circa 1900.*
Library of Congress

"Unite for better roads!" So went the hue and cry of the automobile enthusiasts who joined together in Chicago, Illinois, for a common purpose on March 4, 1902. In terms of road planning, this was the big one: Representatives from nine of the largest automobile clubs met to combine forces, set forth plans, and realize their dream of a nationwide network for cross-country travel corridors. The agenda of the day was to launch a new, national organization, while at the same time to revive the American Motor League.

With great exuberance, the representatives convened at the Chicago Coliseum during the much-ballyhooed run of the Chicago Automobile Show. Members from all of the big automobile clubs attended, including those from Illinois, Michigan, New Jersey, New York, Pennsylvania, and Rhode Island.

A brand-new organization was born from this regional conglomeration. It was called the American Automobile Association (AAA). Loyal to its membership from the start, the AAA's first order of business was to promote a transcontinental road that would stretch all the way from New York to California. This was the genesis of all "highways" to come—the start of a long journey toward a system designed to connect America's cities and towns with a cohesive web of roadways, moving from east to west, from north to south, and to all points in between.

By late 1902, there were approximately 11,000 automobiles in America that were[1] all ambling about to the best of their ability—desperate for more good roads to drive upon. Within five years, the number of car enthusiasts searching for good roads increased to 300,000.[2]

As *Chicago Daily Tribune* columnist Hugh Chalmers argued in 1913, "The big factor in developing better roads today is the automobile." Harry R. Radford, president and general manager of the Cartercar Motorcar Company of Pontiac, Michigan, concurred with the observation: "It is my notion, and facts bear me out in it, that the motor driven vehicle has done more than any other agency toward improved highways."

Throughout the early twentieth century, the new-fangled motor vehicle continued to clatter its way into the hearts and minds of those who were eager to break free from the days of horse tails and bicycle chains. Of course, the main obstacle for these "early-adopters" was money. With a price tag from $650 to $5,000, the horseless machines of the age were considered a luxury.

In those days, a good horse and wagon cost only two hundred dollars, which raised the question: Why spend money on a machine restricted by its very nature to recreational use? Common sense, if not economics, dictated that a gentleman should be wise and invest in a decent horse and well-built wagon. If maintained, the investment could provide a good ten years of service.

However, even early on, common sense held no sway when it came to fighting the urge to buy an automobile. Much to the surprise of the automobile manufacturers, car fever was a stronger force than they had counted on. It seemed that none of the fledgling automakers could keep up with demand. With approximately seventy-five

A typical horse-drawn carriage and its passengers, circa 1903. Note the configuration of the side lamp, a design that carried over to the early automobiles of the 1900s. Library of Congress

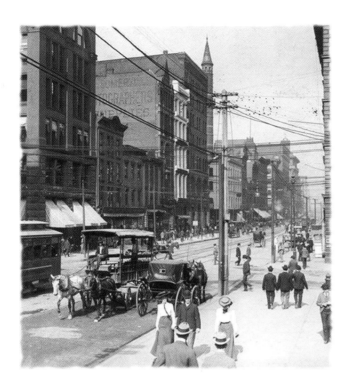

An eclectic mixture of hansoms, wagons, pedestrians, and trolleys jam the streets of St. Louis, Missouri, circa 1905. It was decades before the fabled U.S. Highway 66 would cut its path across America and through the city's bustling corridors of commerce.
Library of Congress

Once America's business sector realized the potential of the motorcar, the demand grew even more. This connection between the car and prosperity was pointedly illustrated by Chicago Mayor Edward Fitzsimmons Dunne on January 7, 1907, with this statement: "As the number of automobiles increases, so has the prosperity of the city and nation increased. The auto is the thermometer which tells of the wealth of a community. By this means, we are led to believe that Chicago is the richest city in the world, for in no city have I seen so many automobiles to the square inch as in Chicago."[4] At the time of his speech, Mayor Dunne did not own an automobile himself, but concluded that if he were re-elected, he would purchase one.

With that, the trinity of the automobile, good roads, and prosperity emerged as the mantra of America's nascent transportation industry. There was no denying that transportation provided Americans with the means to obtain better goods. At the same time, transportation also enabled farmers to move beyond their local sphere of influence and into a national arena. Finally, transportation provided Americans with a way to see their nation and experience its varied landscape firsthand.

In terms of the great social and economic changes that the United States would one day experience through its roads and automobiles, it took great foresight to see the big picture. Fortunately, there were a handful of visionaries who could predict what was coming around the bend. Like the railroad enthusiasts of yesteryear promoted the rails, the automobile boosters promoted roads. America's first transcontinental highway *had* to be built. It would stand as a "proof of concept" project and demonstrate, once and for all, that the notion of fast and efficient coast-to-coast travel was more than just a dream.

automobile builders doing business in America at the time, most were six months behind in filling orders.[3] Many automobile manufacturers discovered that they could charge almost any asking price . . . and get it!

Amarillo, Texas, circa 1917. The McKinney ice wagon delivered ice along the streets of Amarillo, Texas, long before U.S. Highway 66 cut a path through "Yellow," Texas. In the background: The Atchison, Topeka, and Santa Fe Railroad, the economic backbone of most Route 66 towns.
Courtesy Special Collections Department, Amarillo Public Library

From Horse to Automobile

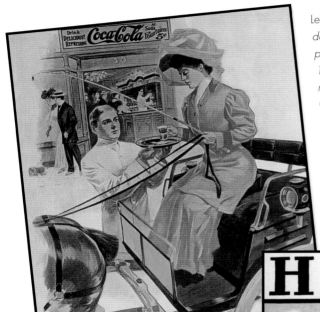

Left: *During the years before the automobile grabbed the reins from domesticated equine, the horse-drawn carriage was the most common and popular form of locomotion. This ad appeared on the back cover of the May 1906 issue of* The Housekeeper. *"Curb service," the preamble to the fast-food restaurant drive-through service window, was already an established courtesy. Courtesy of The Coca-Cola Company*

Below: *Woman driving a horse-drawn carriage,* Harper's *August 1899 edition, created by Edward Penfield. Library of Congress*

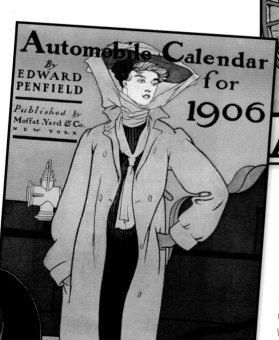

Left: *Automobile Calendar, created by artist Edward Penfield and published by Moffat, Yard & Company of New York, 1906. That year, John Farson of Chicago was elected president of the American Automobile Association (AAA). In March, there was talk of a merger between the AAA and the American Motor League (AML), which were considered rivals. At the time, the AAA was primarily a sporting organization and it promoted events such as the Vanderbilt cup race and Glidden tour. In contrast, the American Motor League followed the old League of American Wheelmen (LAW) creed of plugging for good roads, installing highway signs, and establishing official hotels and repair shops where members could obtain reduced rates. Library of Congress*

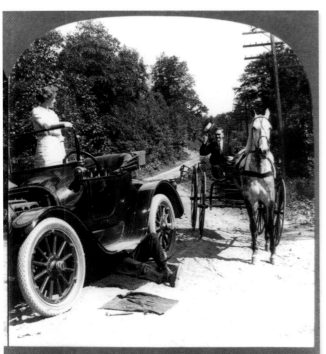

17458—"Why! Good Afternoon! Yes it is a shame He should have fixed that..."

Viewing this 1914 stereo card, it's evident to all concerned that a healthy horse beats a mechanically challenged flivver any day. Back then, a stout horse and wagon cost only two hundred dollars, raising the question: Why spend money on a contraption restricted by its very nature to recreational use? Library of Congress

Below: The Maytag Hill Climber, circa 1911. The Maytag was a product of its day and could take eight people up a fifty percent grade. It was unbeatable by any of its competitors. Founded by Edward Mason and backed by the Duesenberg brothers, the company was joined by F. L. Maytag (of washing machine fame) in 1909 when he purchased controlling ownership. Author's collection

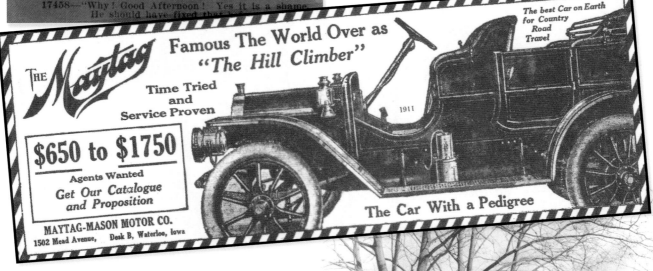

THE Maytag

Famous The World Over as "The Hill Climber"

Time Tried and Service Proven

$650 to $1750

Agents Wanted
Get Our Catalogue and Proposition

MAYTAG-MASON MOTOR CO.
1502 Mead Avenue, Desk B, Waterloo, Iowa

The best Car on Earth for Country Road Travel

1911

The Car With a Pedigree

Pierce Arrow automobile, circa 1906. Pierce Arrow was a former bicycle manufacturer whose marque became synonymous with luxury. The company's first car was manufactured in 1901 and it featured a single-cylinder De Dion engine. In 1904, the company introduced a four-cylinder model that sported Pierce Arrow's own engine and a price tag of four thousand dollars, which made it one of the most expensive vehicles on the market. Library of Congress

Early Auto Enthusiasm

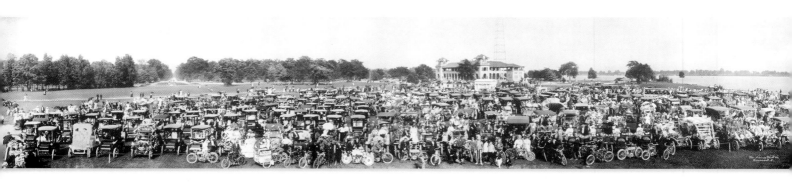

An enthusiastic assembly of automobile and bicycle enthusiasts gather for an outdoor automobile exhibition. They pose for this panoramic image during the July Fourth weekend in 1909. Automobiles, bicycles, and motorcycles festooned in flowers and flags demonstrate the passion of these early automobilists, as does the appearance of Uncle Sam himself. Library of Congress

In 1908, the Chicago Daily Tribune wrote that "the women who find the lure of the auto irresistible range all the way from princesses to shop girls . . . a woman lawyer has attempted to analyze and account for the fascination of the automobile for women, and she decides that there is a psychic effect to reckon with. 'What is the secret of the automobile's influence upon the intellect and will of women?' she asks, and then proceeds to give the answer, 'First, it supplies what humanity ever has sought—thrilling sensations. This makes it a lure not only to the young but the middle aged and old as well. The psychic effect of it is marvelous.'" Circa 1910. Library of Congress

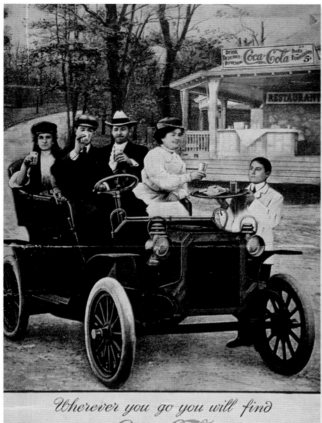

Coca-Cola ad, circa 1912. Sightseeing motorists who whizzed around in smoking, sputtering automobiles liked nothing better than to pull into a roadside restaurant and be served in their seats. At the dawn of the automobile age, eateries accommodated the demand for in-car service. Before too long, the dedicated drive-in restaurant that catered to car customers was born. Courtesy of The Coca-Cola Company

Lithograph, published by Walker Lithograph and Publishing Company, Boston, Massachusetts, 1910. Library of Congress

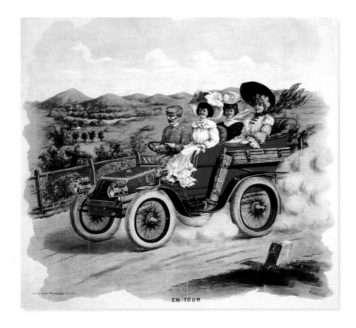

Lithograph, published by F. Vorenberg and Company of Boston, Massachusetts. One of the timeless and enduring motorcar themes: a man taking his lady friends for a drive in the country. Decked out with the latest fashions and equipped with automotive state-of-the-art extras, these joyriders are "En Route" to fun and adventure, circa 1904. Library of Congress

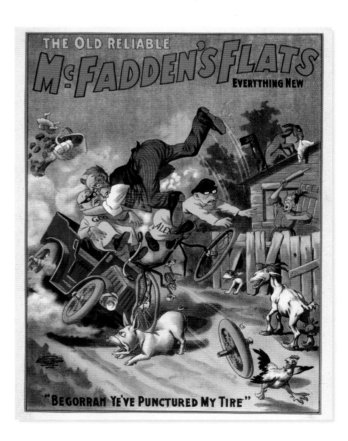

"The yellow kid" in McFadden's Flats—a comic created in 1895 by Richard Outcault—appears in this 1902 lithograph produced by U.S. Lithograph Company. It makes sport of the automobilist's bane: the punctured tire. Library of Congress

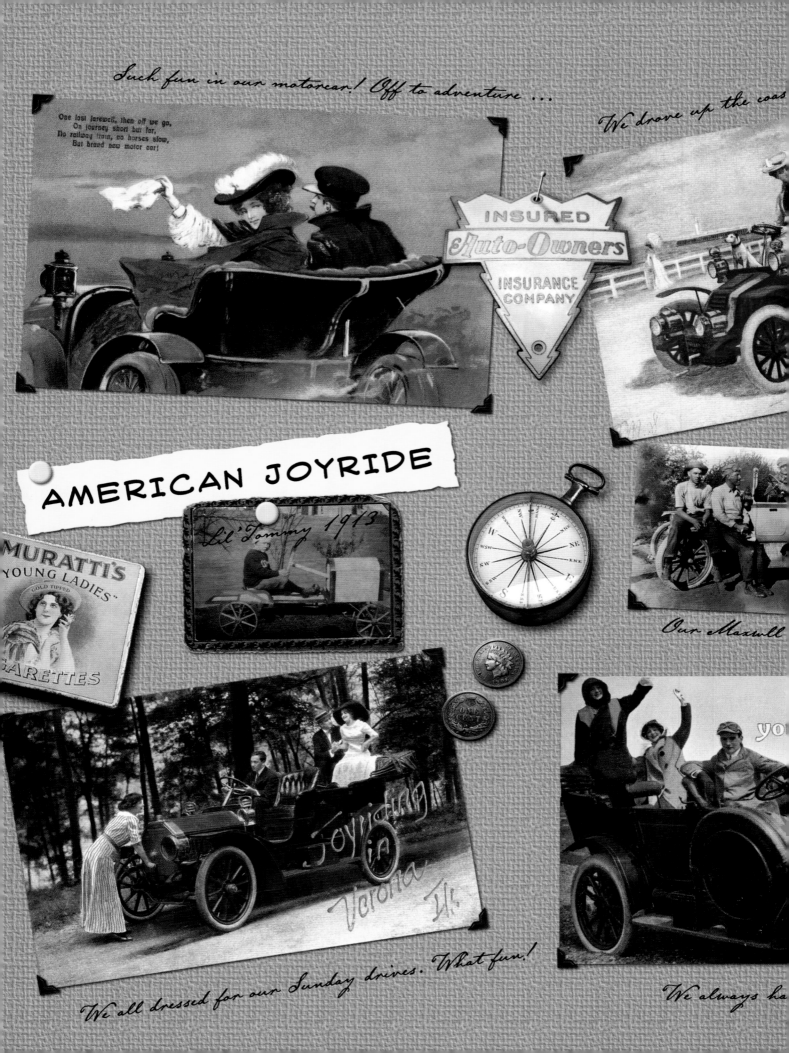

Such fun in our motorcar! Off to adventure ...

We drove up the coas

One last farewell, then off we go,
On journey short but far,
No railway train, no horses slow,
But brand new motor car!

INSURED
Auto-Owners
INSURANCE
COMPANY

AMERICAN JOYRIDE

Lil' Tommy 1913

MURATTI'S
"YOUNG LADIES"
GOLD TIPPED
GARETTES

Our Maxwll

Joyriding in
Verona

yo

We all dressed for our Sunday drives. What fun!

We always ha

...never we could.

Our trip through California looked like this ...

You Auto be with me.

AUTOMOBILE · CLUB · OF · SOUTHERN · CALIFORNIA

GOOD ROADS

THE MOTOR GIRL
SAFETY MATCH
MADE IN...

What a show!

Victor Talking Machine
CONCERT
GENERAL ADMISSION.
ADMIT ONE.

LIBERTY
1910

ONE CENT

IN GOD WE TRUST

1910

...great car

...us -
...on't be sorry.

R.ROUGE
Ford
T 4703

I AM PUTTING ON
SOME SPEED IN
CHICAGO
THE GOOD OLD TOWN

...riding in an open car ...

Chicago roads were busy ... so many cars!

Horatio Earle
The Father of Good Roads

"Strange, indeed, it is that the people gladly pay the prices asked for the perfect horses, engines, wagons, and automobiles; but reluctantly purchase the other, absolutely necessary part of the transporting machine, the good and durable road."

—Horatio Earle,
The Autobiography of "By-Gum" Earle, 1929

oratio Earle was born during the era of the horse and buggy, but his influence extends far beyond those times. His vision bridged the gap to the automotive age, where he came to be known as the "Father of Good Roads." To this day, his influence is evidenced by thousands of miles of highway all across America—yet there are few who are familiar with his name.

Horatio Sawyer Earle was born on February 14, 1855, in Mount Holly, Vermont, and graduated from the Black River Academy in nearby Ludlow. He couldn't afford college tuition, so he worked various jobs—first as a helper in a pulp mill, then as a lumber hauler, and finally as a traveling salesman selling agricultural implements.

During his twenties, Earle moved to Detroit, Michigan, where he took a job as a salesman with the North Wayne Tool Company. Around that time, he invented an improved sickle that he called Earle's Little Giant Grass Hook. With the monetary success of his invention and his salesmanship, he became president of the tool company and later the owner.

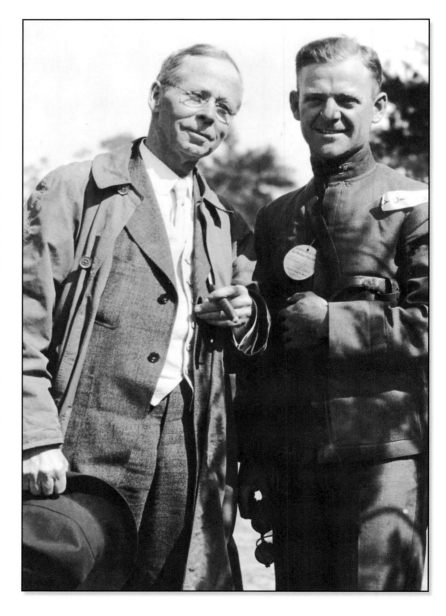

Horatio "Good Roads" Earle (at left), circa 1910. In his autobiography, Earle writes, "I often hear now-a-days, the automobile is the parent of good roads. Well, truth is, the bicycle is the father of the good roads movement in this country." Courtesy of the Michigan Department of Transportation

Horatio Earle (far right) in his office surrounded by memorabilia from his many years as a good roads advocate, circa 1933. His sole mission was to conquer "The Mighty Monarch Mud." Earle was a former state senator and served as Michigan highway commissioner until 1909. The Earl Memorial Highway was named in his honor. Courtesy of the Michigan Department of Transportation

By 1899, he was an avid bicyclist and had earned a reputation as someone keenly interested in furthering the cause of good roads. That year, he was named the "chief consul" of the Michigan Division of the League of American Wheelman (LAW), a group dedicated to the growth and progression of cycling.

Earle had a picture in his mind about what defined good roads and he thought that the group should focus on more serious matters. "There is no more sense in the LAW running bicycle races, than the poultry association, cock fights; or the dairy association, bull fights," he stated.[5] With that said, a vote was passed to eliminate bicycle racing from the group's agenda and to push the good roads activism to the forefront.

In 1900, Earle continued working on his mission to improve roads when he called the first "International Good Roads Congress" to order in Port Huron, Michigan. There, he hooked together a "good roads train" that consisted of forty motorized vehicles—including a traction engine, road roller, sprinkler, and dump wagons—all loaded with two thousand delegates. Accompanied by hundreds of bicycles, the train rolled out to where a sample road was being built and caused quite a stir. After this public event, Earle was known as the "Father of Good Roads in Michigan."

Soon thereafter, he founded and served as the first president of the Michigan Good Roads Association. In 1901, he was also elected as the LAW candidate to the Michigan State Senate. For him, the political post served as nothing more than a platform to promote his vision. "The Legislature of 1901 became my constant good roads convention; and, it was reported, that I found a rule that permitted of my making a good roads speech on every bill," Earle wrote in his autobiography.

During the first year of his term, Earle introduced a Michigan Senate resolution to create a state highway commission. The resolution passed the body the same day and then sped through the house the next day, when it was finally approved by the governor.

highway. The prototype for all roadways to come was located on Detroit's Woodward Avenue, located between Six and Seven Mile roads.[7]

Built for a total cost of $13,537.59, Earle's concrete road was viewed as a modern marvel by automobilists and cyclist alike. Until that time, most Michigan roads were quagmires of sand, mud, and clay that trapped horse-drawn and horseless vehicles. This strip of street was a novelty and a bona fide tourist attraction.

As news of his pristine concrete corridor spread, Earle continued to fight for good roads on a national level. In 1902, he founded yet another group called the American Road Makers (ARM) and continued his personal battle against the "mighty monarch mud, who rules the road to the exclusion of everyone." In 1910, this group was renamed the American Road Builders Association (ARBA), which became the American Road and Transportation Builders Association (ARTBA) in 1977.

By the time Earle died in 1935, the nation was criss-crossed with numerous concrete highways. His work was duly honored with monuments in Cass and Mackinaw City, Michigan, but he really wasn't interested in public flattery. In his autobiography, Earle wrote that "the monument I prize most is not measured by its height, but its length in miles."

If Earle could see the progress his life's work has made possible, he would be pleased: As of 2006, there were 46,876 miles of interstate highway nationwide[8]—a fitting tribute to one of America's unsung highway heroes.

Horatio Earle wrote his biography at the age of seventy-two. It was published in 1929. In a portion of the book, he details his pioneer work in the good roads movement, his involvement in politics, and his business successes. He was a civic-minded man with many outlets for his energy and devotion to causes. Horatio Sawyer Earle died at the age of eighty. Author's collection

Around 1902, the Michigan State Legislature passed a law to create a highway educational department, and Michigan governor Aaron Bliss appointed Earle the commissioner of the highways. Interestingly enough, the state attorney general piped up and declared that the new law was unconstitutional.[6] Earle raised the fact that he had already served for two years as "unconstitutional" commissioner without a salary and paying his own expenses. Then, in 1905, the legislature passed the State Reward Road Law, which was drafted by Earle. At that time, he was officially appointed the "constitutional" state highway commissioner of the state highway department, the precursor to the Michigan Department of Transportation (MDOT).

In 1909, Earle orchestrated a project between the state highway department and the Wayne County Road Commission to pave the nation's first mile of concrete

The first mile of concrete highway built in America was part of Michigan's Woodward Avenue. It was the project of Horatio Earle, then highway commissioner of the Michigan State Highway Department. Built in 1909 at a total cost of $13,537.59, it was considered such a modern marvel that tourists came to look at it from all over the nation. Courtesy of the Michigan Department of Transportation

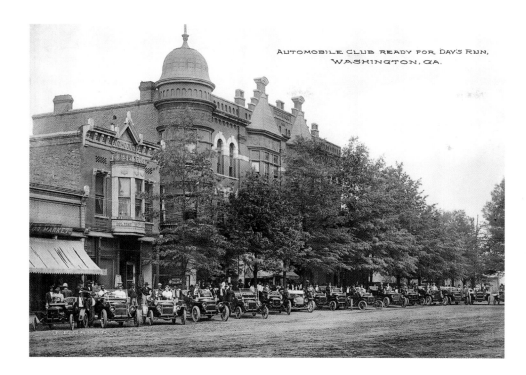

AUTOMOBILE CLUB READY FOR DAY'S RUN, WASHINGTON, GA.

The automobile club is ready for a day's run, circa 1905. During the early years of American travel, automobile clubs were big boosters, and promoters, of good roads. Library of Congress

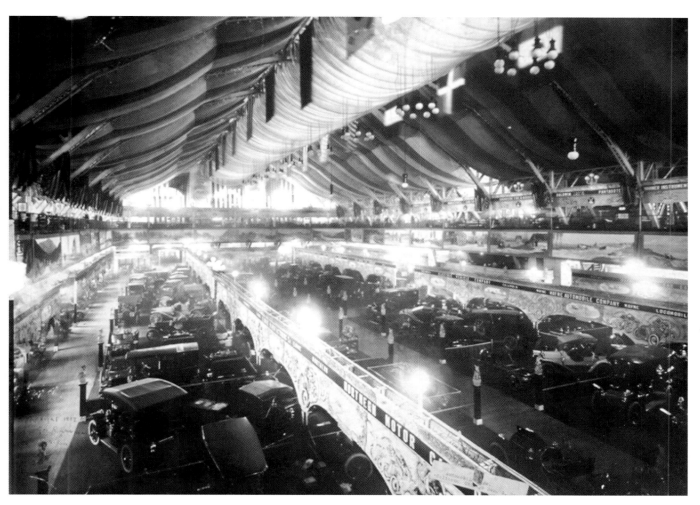

The automobile show held at the Chicago Coliseum, December 3, 1907. On March 4, 1902, nine automobile clubs met at the Chicago Coliseum and a new organization called the American Automobile Association was formed. Its first order of business was to promote a transcontinental road that would stretch all the way from New York to California. Library of Congress

The Railroad

A train stops at Apache Canyon, between Santa Fe and Las Vegas, New Mexico, 1969. The Santa Fe Trail emerges from Glorieta Pass in this canyon. The railroad still uses this route today. Courtesy of the New Mexico State Records Center and Archives

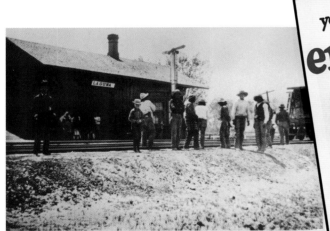

Above: Rail depot, Laguna, New Mexico, pre-Route 66 days, circa 1900. The Laguna Pueblo was established in 1699. The word Laguna means lake in Spanish, but the lake has since dried up, now only a meadow remains. Courtesy Palace of the Governors (MNM/DCA)

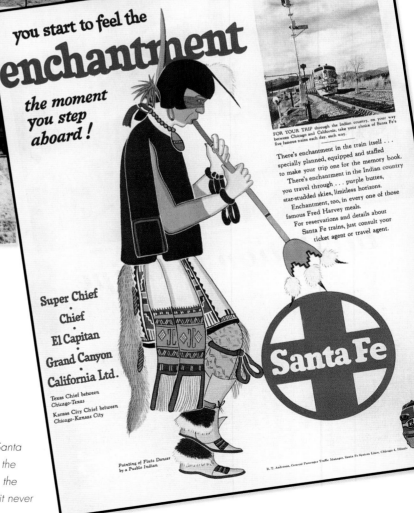

Right: A Collier's, November 29, 1952, advertisement for the Santa Fe Railroad. The rail company was born in 1859 and followed the thirty-fifth parallel route of Aubry, Whipple, and Beale. Although the company took its name Santa Fe from Santa Fe, New Mexico, it never actually served that city. Author's collection

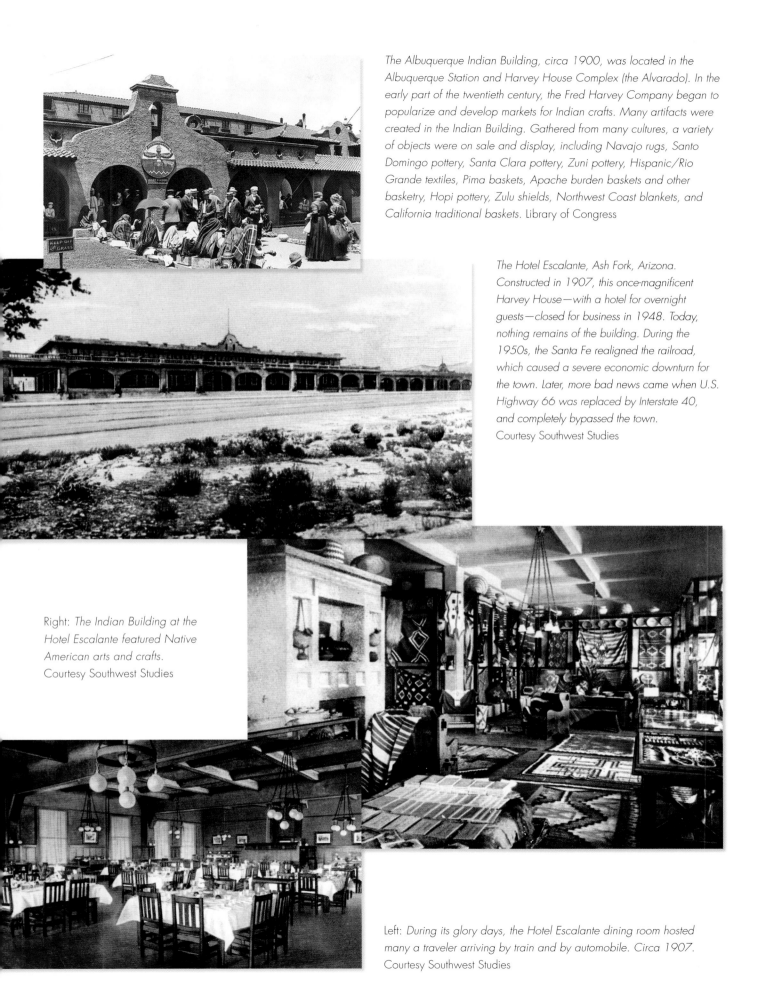

The Albuquerque Indian Building, circa 1900, was located in the Albuquerque Station and Harvey House Complex (the Alvarado). In the early part of the twentieth century, the Fred Harvey Company began to popularize and develop markets for Indian crafts. Many artifacts were created in the Indian Building. Gathered from many cultures, a variety of objects were on sale and display, including Navajo rugs, Santo Domingo pottery, Santa Clara pottery, Zuni pottery, Hispanic/Rio Grande textiles, Pima baskets, Apache burden baskets and other basketry, Hopi pottery, Zulu shields, Northwest Coast blankets, and California traditional baskets. Library of Congress

The Hotel Escalante, Ash Fork, Arizona. Constructed in 1907, this once-magnificent Harvey House—with a hotel for overnight guests—closed for business in 1948. Today, nothing remains of the building. During the 1950s, the Santa Fe realigned the railroad, which caused a severe economic downturn for the town. Later, more bad news came when U.S. Highway 66 was replaced by Interstate 40, and completely bypassed the town. Courtesy Southwest Studies

Right: The Indian Building at the Hotel Escalante featured Native American arts and crafts. Courtesy Southwest Studies

Left: During its glory days, the Hotel Escalante dining room hosted many a traveler arriving by train and by automobile. Circa 1907. Courtesy Southwest Studies

Businesses along the Mother Road

The Babbitt brothers came to Flagstaff, Arizona, in 1886 from Cincinnati, Ohio. They started cattle ranching and opened several businesses in the Northern Arizona area, including a trading post and several mercantile businesses. They also owned Flagstaff's first auto garage, a bank, ice plant, livery stable, beef slaughter house, opera house, and mortuary. Circa 1908. Courtesy Southwest Studies

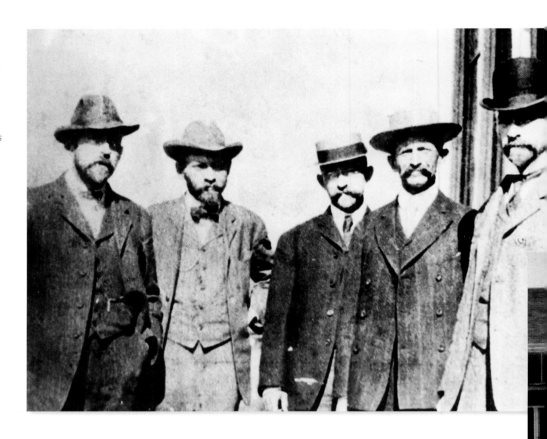

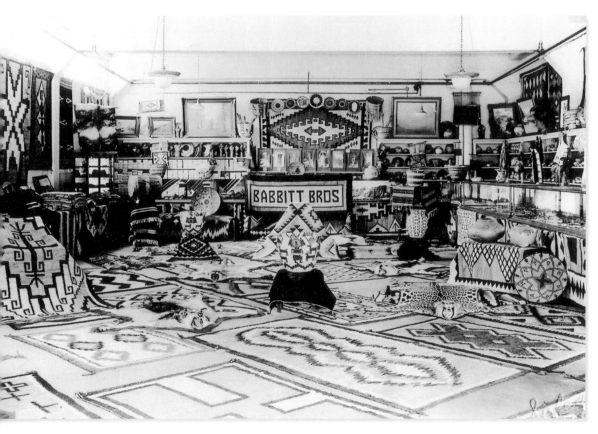

The interior of the Babbitt Brothers trading post reveals an array of Native American crafts and trade goods, circa 1907. At one time, the plunder and sale of exotic animal hides was an acceptable practice in America. Here, animal skin rugs made from wolf, puma, and jaguar carpet the floor as a testimony to the no-holds-barred hunting practices of the past. Courtesy of Cline Library Northern Arizona University

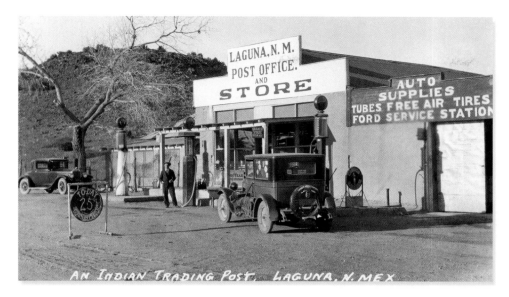

AN INDIAN TRADING POST, LAGUNA, N. MEX.

Laguna, New Mexico, circa 1910s. The Laguna Trading Post, post office, gas station, and garage featured tall, visible register pumps (with glass crucibles) that pumped Conoco gasoline at an affordable rate of twenty-five cents per gallon. There weren't any vending machines here. The air for the tires was free! Courtesy Steven Rider Collection

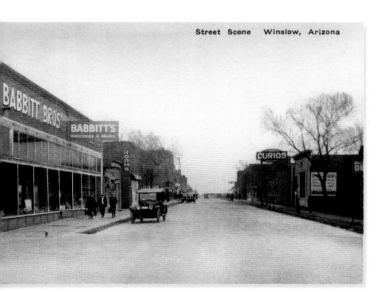

Street Scene Winslow, Arizona

Left: The Babbitt Brothers, Winslow, Arizona, circa 1920s. The curio store across the street was a retail outlet of the barter business with Native Americans. Jim Babbitt, grandson of one of the original founders, said "In the early days there were just two or three trading posts. . . . We had some section in the store building, or somewhere else in the downtown, that was our own retail—we called them curio stores— that sold Indian rugs and silver and pottery." Courtesy Steven Rider Collection

Right: Courtesy Steven Rider Collection

PONTIAC CAFE AND SERVICE STATION ON ROUTE 4, CHICAGO TO ST. LOUIS, PONTIAC, ILL.

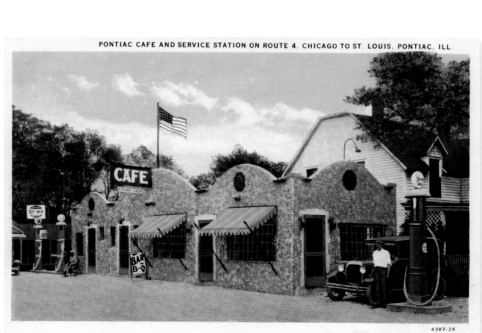

Pre-U.S. Highway 66 roadside automotive and tourist facilities, circa 1919. The visible register pumps at the Pontiac Cafe and Service Station filled cars with Deep Rock gasoline, while the cafe filled tummies with steaks, chops, and barbecue. One day, U.S. Highway 66 would follow the original State Route 4 from Chicago, Illinois, to St. Louis, Missouri. Courtesy Steven Rider Collection

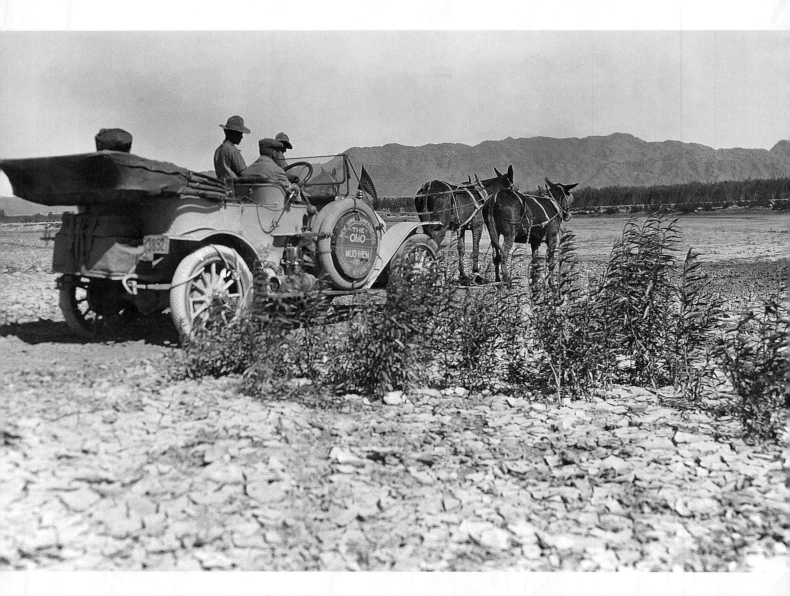

In 1911, Thomas A. Wilby, special agent for the Office of Public Roads, returned from a pioneer tour of the United States. It was a nine-thousand-mile journey that he made in 105 days. Here, his vehicle is drawn across the Gila River by mule. National Archives

Chapter Three

Highway to the West

"A great coast to coast highway stretching from the north Atlantic ports along the southern shores of the great lakes, through Chicago, thence through St. Louis and Kansas City, across the old Santa Fe, California, and Oregon trails to various termini on the Pacific coast, the practical dream again revived by the motor journey lately completed by four Chicagoans."

—*"Motoring from Sea to Sea,"*
Chicago Daily Tribune, November 13, 1910

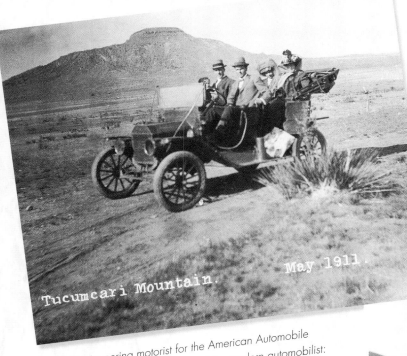

Tucumcari Mountain. May 1911.

Left: The road may have been made of dirt, but that didn't stop this group of adventurers from seeing the sights. Tucumcari Mountain serves as a colorful background for two fine gents and two fine ladies. Photograph by Royal A. Prentice, taken May 1911. Courtesy Palace of the Governors (MNM/DCA)

Right: A pioneering motorist for the American Automobile Association encounters the bane of the modern automobilist: a large rock on what could only be called a bad road, circa 1912. National Archives

hrough the sponsorship of the American Automobile Association, the idea of linking the East Coast with the West Coast by creating a major transcontinental highway became highly visible to the general public. Ever so slowly, the average American began to see what it would mean to travel freely from one end of the country to the other, if there was a practical way to do so.

Still, the doomsayers of the age had to assert their opinions—they were steadfast in the belief that such an enterprise could hardly be profitable. The chief concern of the pundits was that the construction of such a highway would bankrupt the government. Though shortsighted, it was a valid point. No one had ever built such a roadway and, for the time, it was the equivalent of sending a man to the moon. Who would build it? How would it work? Where would all of the money come from for the miles of road?

In 1904, writers at the *Chicago Daily Tribune* threw their hat into the debate when they published a highly critical piece on the plans. "It is reported that an attempt will be made during the coming session of congress to get the support of the national government for a plan for the construction of a great highway across the country," droned the piece. "It is difficult to see what the national government would get to repay any investment in such an enterprise." It was obvious that the writer was oblivious to the mountain of commerce already forming to support a transcontinental highway.

Additional work had to be done to plant the idea of a long-distance motoring route in the public's imagination.

In 1901, Alexander Winton lost a race at Detroit's Grosse Pointe racetrack to Henry Ford. Winton vowed to come back and win, so he produced a car that he called the 1902 Winton Bullet. That year, his new speedster set an unofficial land-speed record of seventy miles per hour (113 km/h) in Cleveland. Nevertheless, the Bullet was defeated by another Ford, driven by the famed racer Barney Oldfield. Winton didn't give up and he built two more derivations of the Bullet race cars. In 1903, Horatio Nelson Jackson made the first successful automobile drive across the United States . . . driving a Winton. Library of Congress

Ordinary people had to make the journey—or at least try—before it became clear that any man could do it. After a handful of adventurers could show that they survived the journey, there would be no turning back.

In the fall of 1910, a ragtag crew of four men from Chicago did just that—they embarked on an unsung mission to prove it was possible to travel across the country by car over long distances. It was their second trip and, this time, it was a planned sojourn heading from the West to the East. They left San Francisco for Chicago by way of lower California, Arizona, and the Santa Fe Trail. The idea was to drive (if that's what you called forging your way over unpaved terrain) the most feasible coast-to-coast route.

The crew was comprised of four intrepid automobile aficionados: H. Pomy, J. Rew (the driver), W. H. Aldrich, and B. Lackey. Their well-equipped Stearns motorcar was outfitted with all of the equipment and supplies necessary for such a trip including three spare tires, six water bags of two-gallon capacity, a soldering outfit and blast torch, one broast drill, one axe, a hand saw, a brace and bits, three hundred feet of three-fourths-inch line, fifty feet of one-inch line, a pinch bar, a shovel, two pulleys, an eight-foot "dead man" (for rigging a block and tackle), and a canvas strip forty feet long by ten feet wide. It was a full load. The vehicle weighed in at over six thousand pounds.[1]

From their point of origin in San Francisco, the first leg of their motor journey was uneventful for the most part. No real obstacles or hardships were encountered; that is, until they reached the more arid region of southern California. It was precisely at that point where the real automobilist was separated from the mere weekend tinkerer.

At Needles, California, under the baking sun, they hit the Colorado River and started the task of trying to cross it. Of course, they did not have commercial bridges or roadways at their disposal—they had to forge their way on their own and make do with the crude ferry that offered to take them across the unforgiving waters. There was not a Howard Johnson available to provide sleeping quarters or McDonalds to provide food. All they had were dusty bedrolls, the hard ground, and beef jerky that they washed down with tepid water.

Once across the great Colorado River, the group decided to drive along an existing railroad freight road, which was originally built to connect the mining center of Gold Roads with the rest of the world. Before they knew it, the team members found themselves in "trackless" territory. Here, there were no trains, wagons, or cars to be found. They were on their own. As night fell, navigation had to be done by acetylene searchlight.

That's when the cross-country outing got serious: Somewhere between Hackberry and Peach Springs, Arizona, they steered left when they should have turned right, or vice versa. Although they were unsure their exact location or where they were going, they knew that they had to

keep at it. Suddenly, their powerful carbide lamp lit up a small tent in the distance. Within moments, a man came out waving and shouting.

"Where are we?" they countered. The man's answer was clear: "Within twenty miles of the Grand Canyon! Turn around." He strongly suggested that they backtrack twenty miles and look for a trail with a right turn. That is, unless they had another way across that great expanse cut out of the rock.

The team erred on the side of caution and doubled back some twenty miles—and then some. With bleary eyes, they scoured the landscape continuously with their big searchlight and eventually stumbled upon a nondescript trace of a trail, although it was almost obliterated by a large herd of cattle. Renewed with a sense of hope, they started toward their destination once again. Tired, hungry, and ready to rest, they rolled their Stearns horseless machine into Peach Springs at two o'clock in the morning.

There were no bands or ticker-tape parades to greet them in Peach Springs, and they pressed onward. They soon discovered that the roads between Hackberry and Peach Springs are steep—both for the automobile and for the railroad line. The group hugged the railroad tracks at the distance of about an eighth of a mile and occasionally flashed the searchlight as they went, thinking nothing of it. In the meantime, an eastbound train passed them at full speed in the opposite direction.

Later, when they finally reached Seligman, Arizona, they happened to meet the engineer of that train, who had made it to town sometime before them. "So, you are those automobile fellows," he exclaimed. "I'd like to look at your lights . . . do you know, when you came down the canyon I saw that light and felt my end was near? I figured that Number 17 was bound my way on a single track, and I came mighty near jumping!"[2] Back then, there were no automobiles out in the boonies and a flashing light ahead could only mean one thing: A train was heading right in your direction.

The next day, the crew traveled to Williams on a fair road and avoided the dangerous Diablo Canyon. At Winslow, they encountered the Shevlin River. Driver Rew shot through the raging waters at a thirty-mile-an-hour clip, and the water rushed up into the carburetor. With water cascading from the engine compartment, the rolling rig landed on the opposite bank and the engine promptly sputtered to a stop.

The next crossing would be at the Puerco River, called "Porky," by the natives. According to Rew, "The Porky runs through a canyon, with the railroad high up on one bank above the washout level. It is sometimes thirty or forty feet deep and at times so incrusted in spots as to make swift negotiation possible. The surface of the arroyo where not incrusted is fine sand, which will stall a car when dry and sink it when wet. It took us eight hours to get out of that hole."[3]

But Albuquerque, New Mexico, was not too far off. It was reached by way of Gallup and once there, the group stayed at a comfortable hotel, which provided "a flop, a splash, and three squares." Despite the difficulties encountered by the adventurers on their way to Chicago, they all agreed that the middle route—following the old trails—would be the most practical highway to connect the East and the West.

A year later, Thomas A. Wilby, special agent for the Office of Public Roads, returned from his pioneer tour of the United States. He made a nine-thousand-mile journey in 105 days. He concurred with the unheralded team of Chicagoans, who had made the journey just twelve months before him: "A National Highway for auto travelers was most feasible across the Middle Western route . . . it is along historical and fascinating trails where real activity is shown in the good roads movement. There is such a wealth of scenic and historic features that the completed highway will veritably prove to be one of the wonders of the world."

Pomy, Rew, Aldrich, and Lackey already knew that. Despite their lack of fame and fortune, they could be content in the fact that they were some of the first explorers to shoot for the moon and drive it. They made one small trip for a man, but it was a big journey for all of America. A coast-to-coast trip by car really wasn't that far away.

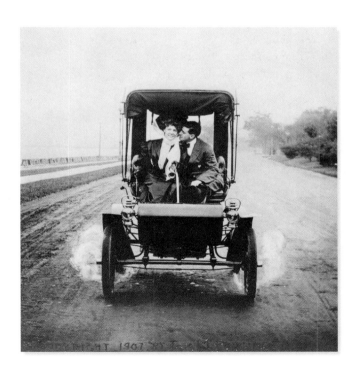

By 1907, romance and the automobile were already linked. This vintage lantern slide was made to accompany the song "In My Merry Oldsmobile." Lantern slides debuted in 1849, ten years after the invention of photography. They allowed photographs to be viewed in an entirely new format. As a transparent slide projected onto a surface, the photograph could be seen by individuals and by a large audience. Library of Congress

Pitfalls of the Road

In 1910, "The Mighty Monarch Mud" was the nemesis of effortless travel and carefree motoring. When the rains came, you could expect to be mired in it on nearly any route. The thin, spindly wheels of early vehicles cut into wet earth with the greatest of ease and rendered roads useless for those unlucky few who followed. Library of Congress

Above: During the days of 1909 motoring, mechanical problems were a do-it-yourself prospect. Car owners routinely carried their own tools, since auto repair facilities as we know them today were still years away in development. Library of Congress

Right: Gilbert & Barker Company introduced its T-1 nonregistering gasoline hand pump early in 1910. The unit operated with a simple up-and-down motion, much like a tire pump. A flexible hose attached to the side allowed an operator to refill the gas tanks of motor vehicles. The vintage auto in the background is tiller-steered. Courtesy Gilbarco Inc.

When America's network of highways was just an outlandish notion, unpaved roads held untold surprises for those brave enough to venture out upon them with an automobile. In 1909, the ditch occupied a place of prominence at the top of the road hazard list, followed by the rock and the flat tire. Library of Congress

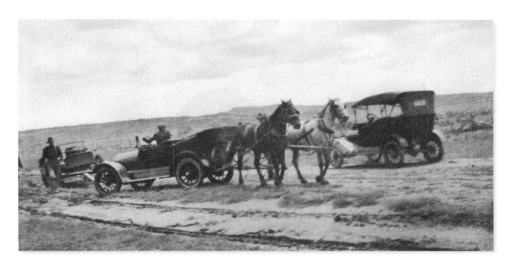

Road conditions being what they were in the early nineteenth century, it was always advantageous to have a pair of sturdy horses handy for emergency towing situations. This photograph is entitled, "Being drawn back to Terra Firma," a common procedure in those days, circa 1913. Courtesy Palace of the Governors (MNM/DCA)

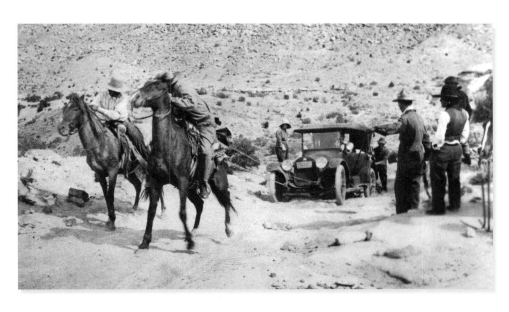

How many cowboys does it take to pull a car out of the Arizona sand? At least a half-dozen, along with a couple of strong horses. This 1910 picture could easily have served as a promotional image to push the practical qualities of owning a horse. In the desert regions of the Southwest, it was painfully obvious that four-footed creatures had the advantage when it came to crossing rugged terrain. Courtesy Southwest Studies

A.L. Westgard
Early Pathfinder

Anthon L. Westgard was the vice president and director of transcontinental highways within the U.S. Department of Transportation. He was appointed by Federal Highway Administration Director Logan Page to attempt a transcontinental automobile trek as research to find locations for the first transcontinental highways.

He also organized the Touring Club of America and was its first president. As early as 1910, Westgard studied the possibilities of transcontinental automobile travel. His Trail to Sunset route through Kansas, Colorado, New Mexico, and Arizona became the popular route for the increasing ranks of tourists seeking adventure by way of automobile.

In 1911, he made the first transcontinental trip in a four-cylinder, thirty-seven horsepower, gasoline-engine truck called the *Pioneer Freighter*, built by the Sauer Motor Car Company of New York. The twenty-four-gallon gas tank allowed a touring range of 168 miles, with a fuel efficiency of 7 miles to the gallon. The front wheels were shod with single 36-inch diameter tires and the rear with dual 42-inch diameter tires, all made of solid rubber.

The tour was comprised of two legs: On March 4, 1911, his truck rolled out of Denver, Colorado, toward the Southwest, through Santa Fe, New Mexico, and then Phoenix, Arizona, where it continued to Los Angeles, California. He arrived there on May 9, after traveling 1,450 miles in sixty-six days. His average speed was only 3.26 miles per hour (as fast as a man could walk).

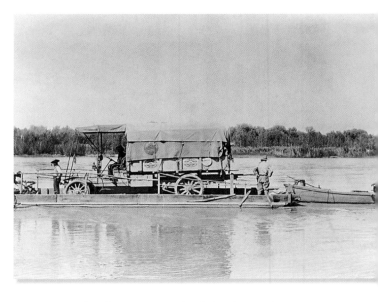

A. L. Westgard and team crossing the Colorado River between Arizona and California by ferry, 1911. Westgard rolled into San Francisco, California, in November 1912, after searching five months for drivable ocean-to-ocean paths. Of his 12,786 mile trek, the Chicago Daily Tribune *reported, "This latest pathfinding achievement indicates that there is no end to the possibilities for improving facilities to 'see America first.'" National Archives*

The eastward, reversed leg of the journey began on June 12, 1911. This time, the truck left Pueblo, Colorado, and arrived in Kansas City, Missouri, on June 18. On this trek, Westgard covered seven hundred miles in just seventy hours of actual running time, an average of ten miles per hour. The trip ended in New York City, where his transcontinental endurance run convened with the first Motor Truck Show at Madison Square Garden.

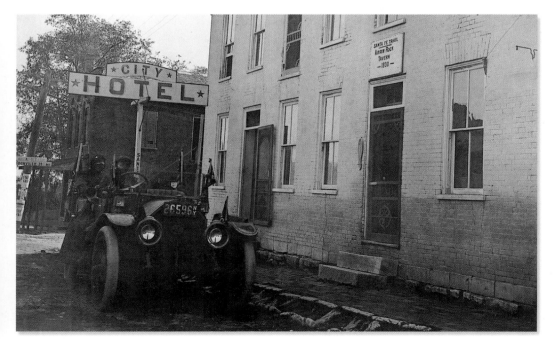

A. L. Westgard's triple-cross-country motor car tour included layovers at many establishments such as this hotel, which was open for business in the year 1912 along the Missouri stretch of the old Santa Fe Trail. For the furtherance of good roads in America and for proving the practicality of the automobile, Westgard mapped routes, brought back reports, published articles on motoring in magazines, and wrote at least three books: Through the Land of Yesterday, Motor Car Camping, *and* Tales of a Pathfinder. *National Archives*

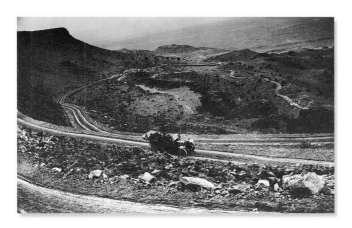

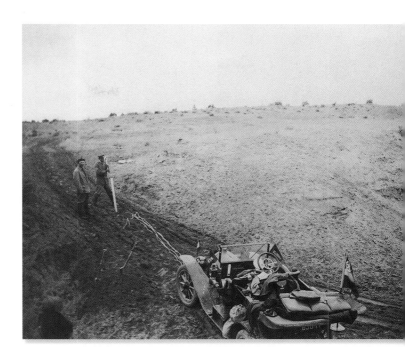

The A. L. Westgard tour, twenty miles south of Santa Fe, New Mexico, near the La Bajada lava cliffs, February 1911. Five years after he made this trip, Westgard returned to New Mexico as part of a "motion picture" tour that covered more than twenty-five thousand miles in a little over a year. Under the auspices of the National Highways Association (NHA) and the U.S. Department of Interior, this enthusiastic 1916 motor tour included every state of the union. Westgard's assignment was to "picture everything worth picturing" and to take moving pictures of government reservations, national monuments, national parks, and forest reserves. He was also asked to point his lenses at "thousands of scenes, industries, and natural curiosities that the general traveling public knows little about." The tour featured two big Paige-Detroit automobiles and was sponsored by the Combitone Picture Company. The films were distributed by The Pathe Company. National Archives

The A. L. Westgard entourage stuck in a sandy arroyo forty miles west of Albuquerque, New Mexico, February 1911. On many of his trips, a block and tackle was used to haul vehicles through desert soft spots like this and to "submarine," or ford, the streams. On Westgard's transcontinental trip, a small supply of lumber was also brought along—just in case there was a need to build a quick bridge to get across creeks and soft roads. The loaded weight of his vehicle: fourteen thousand pounds! National Archives

Historic Van Bidder's Tavern, Boone's Lick Trail, Missouri. This is another historic respite on one leg of A. L. Westgard's 1912 pathfinder expedition. Although he was not the first motor scout to complete a transcontinental voyage by gas-powered vehicle, Westgard's claim to fame is that he was the first to complete the journey by truck. Eventually, the Boone's Lick Trail became part of the National Old Trails Ocean-to-Ocean Highway. National Archives

Cyrus Stevens Avery
Father of Route 66

"In April 1917, a road meeting was held in this city with people in attendance from St. Louis and from as far West as Las Vegas. The purpose of that meeting was to map out a plan for the development of what was, at that time, known as the Ozark Trail. Owing to lack of county organization, state organization, and finance, the only results to be obtained were to paint this trail with the signs adopted in order that the traveling public could get from one community to the other without getting lost."

*—Cyrus Stevens Avery,
personal papers, date unknown[4]*

Long before there was even a highway known as Route 66, Cyrus Avery was interested in roads—good roads—and state-to-state motorways that could be traveled with ease and without the fear of getting lost.

To this end, his first interest was the Ozark Trails: an unorganized system of roads that connected St. Louis, Missouri, to the city of Amarillo, Texas. He was impressed with the works accomplished by the Good Roads movement in Missouri and in 1907, he moved from Vinita, Oklahoma, to Tulsa in order to meet his destiny.

There, he invested in the oil industry and became keenly aware of how roads affected his and other businesses. Five years later, he secured the post of county commissioner by no small coincidence. The position provided him with an opportunity to observe the need for an

The split-log-drag system of road maintenance embraced by Cyrus Avery made roads more navigable by man, beast, and motorized conveyance. Avery also encouraged the planting of clover seeds along the roadside to beautify the roads. Avery's ideas were an early form of highway beautification. Library of Congress

Cyrus Stevens Avery; his wife, Essie; and daughter Helen, circa 1923. Avery was born in Stevensville, Pennsylvania, in 1871. When he was a teenager, his family moved to what was then the Oklahoma Indian Territory. After graduating from William Jewell College in Liberty, Missouri, Avery married Essie McClelland and moved back to Oklahoma where he and Essie lived for the rest of their lives. He died in 1963 at age ninety-one. Courtesy Joy Avery

improved system of highways. And, it gave him a platform from which to promote the idea of improving roads throughout the state.

One of his first acts was to devise an effective way to maintain existing roads. His solution was the "split-log-drag" method, wherein stout horses are used to drag large split logs, attached to long ropes, up and down a road (usually after a rain). The activity tamped down the earth, prevented potholes, and made the road quite navigable. The public appreciated his methods as well, and he was given the title "Father of Good Roads" in Tulsa County, Oklahoma.

In 1913, William Hope Harvey—the builder, founder, and social thinker who established the now-abandoned Ozarks resort of Monte Ne, Arkansas—sent out an invitation to "organize a delegation of commercial clubs, good roads, and automobile associations" with the goal to form a new Ozark Trails organization. Avery was one of the first recipients of the invitation, and he gladly accepted the call.

With Avery onboard, the group gained quick notoriety and became an effective agent for change. "The Ozark Trails Association, embracing the states of Missouri, Kansas, Arkansas, and Oklahoma, is one of the strongest and most active good roads organizations west of the Mississippi river," reported *The Oklahoman* (April 9, 1914). Only one year old, the group had already gathered enthusiastic support from both road boosters and Oklahoma state leaders.

The association planned its second annual convention for May 1914 and soon began scouting out locations for the host city. Aware of the influence that the group might have

on the proceedings if it hosted such an event, the various road associations along the trails competed vigorously to hold the meeting in their town.

But it was no contest: The Tulsa Chamber of Commerce—of which Avery was a member—already had its eye on the prize. Avery's reputation sealed the deal and Tulsa received the honor.

Harvey, who was now the president of the Ozark Tails Association, wanted to create a big spectacle and garner maximum publicity. So, he traveled to the meeting in a most conspicuous manner: on foot! With great gusto, he left his home in Arkansas and traveled the entire distance to the Tulsa convention without aid of motor coach or carriage.

Literally "in the trenches" and carrying with him an ample supply of paints and a brush, he swabbed the existing Ozark Trail markers with a fresh coat of paint. When he deemed it necessary, he even installed new signs on the existing telegraph poles found along the route.

On May 15, 1914, Harvey waltzed into Vinita, Oklahoma, on what would soon become the road numbered "66." After a quick foot soak, he joined Avery and the growing throng of Ozark Trail enthusiasts already there. Together, the group embarked on a zealous mission through "Green Country" to repair old road markers and add new ones all the way to Tulsa.

A few weeks later, the newly marked Ozark Trail saw a revitalized campaign of roadwork and improvements. The method of choice was Avery's brute-force, split-log-drag system.

Bolstered by his Ozark Trails success, Avery was appointed to offices hither and yon. First, he joined the board of directors at the Northeast Oklahoma Chamber of Commerce. Then he became president and founder of the Albert Pike Highway Association. Next, the Associated Highways of America elected him as its president in 1921. The final feather in Avery's cap was announced by

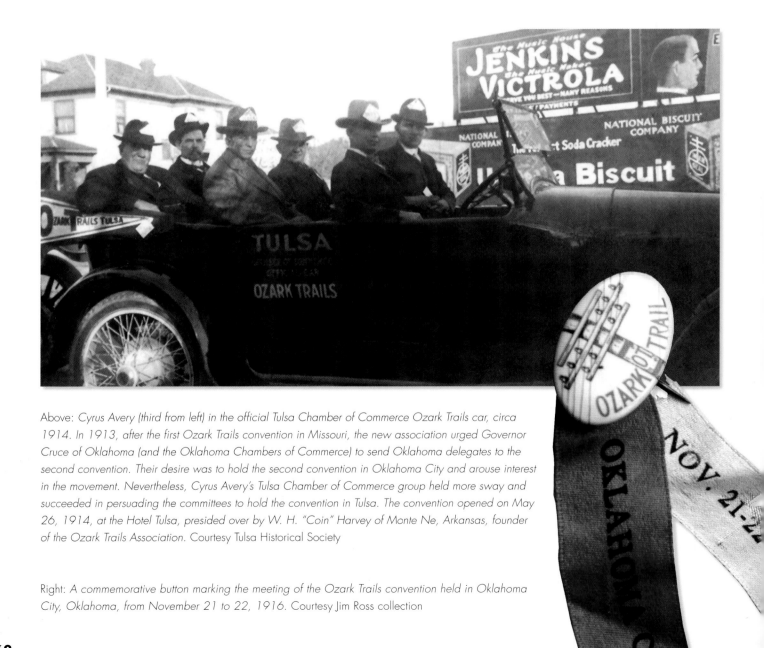

Above: *Cyrus Avery (third from left) in the official Tulsa Chamber of Commerce Ozark Trails car, circa 1914. In 1913, after the first Ozark Trails convention in Missouri, the new association urged Governor Cruce of Oklahoma (and the Oklahoma Chambers of Commerce) to send Oklahoma delegates to the second convention. Their desire was to hold the second convention in Oklahoma City and arouse interest in the movement. Nevertheless, Cyrus Avery's Tulsa Chamber of Commerce group held more sway and succeeded in persuading the committees to hold the convention in Tulsa. The convention opened on May 26, 1914, at the Hotel Tulsa, presided over by W. H. "Coin" Harvey of Monte Ne, Arkansas, founder of the Ozark Trails Association.* Courtesy Tulsa Historical Society

Right: *A commemorative button marking the meeting of the Ozark Trails convention held in Oklahoma City, Oklahoma, from November 21 to 22, 1916.* Courtesy Jim Ross collection

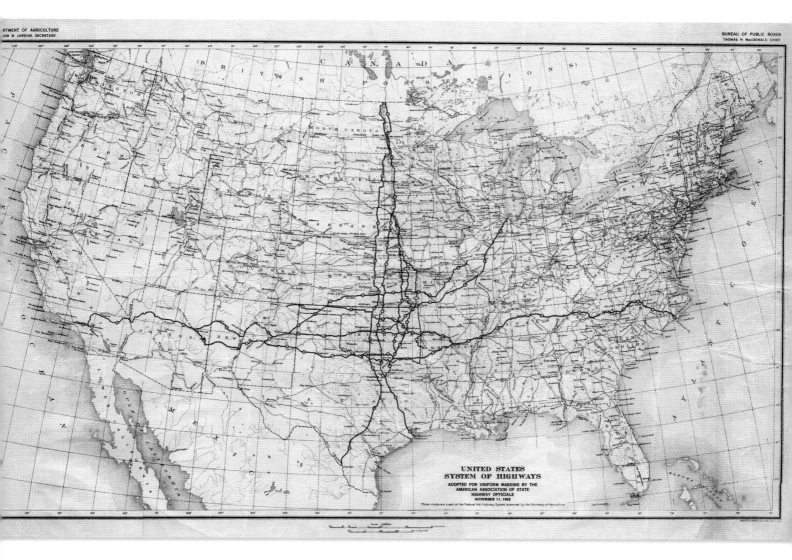

**UNITED STATES
SYSTEM OF HIGHWAYS**
ADOPTED FOR UNIFORM MARKING BY THE
AMERICAN ASSOCIATION OF STATE
HIGHWAY OFFICIALS
NOVEMBER 11, 1926

A Route 66 planning map, 1926. This map was the culmination of Cyrus Steven Avery's efforts to run a major highway—flowing from Chicago, Illinois, to Los Angeles, California—directly through the state of Oklahoma. University of Tulsa/Special Collections/McFarlin Library

The Oklahoman in February of 1924: "Cyrus S. Avery of Tulsa has been chosen by Governor Trapp as the best fitted man in the state for the office of state highway commissioner . . . Avery . . . has been actively identified with state road improvement."

In August 1933, when the section of U.S. Highway 66 into Vinita, Oklahoma, was completed, Avery revisited his former hometown. He presented a speech that detailed a portion of his involvement with what would become Route 66:

"On February 26, 1925, I was appointed by the U.S. Department of Agriculture under the title of 'Consulting Highway Specialist' as one of a committee of 21 for the purpose of laying out, coordinating, and establishing a system of highways with markers and directional signs for a U.S. Inter-State Highway system. Later, I was made one of a subcommittee of five to hang the numbers on these roads, and in that connection, I had the opportunity to render a service to my state, as well as the 48 states of the U.S."[5]

With this duty in mind, Avery proceeded to name—and ultimately rename—Route 66. Initially, the road was designated U.S. 60. However, the governor of Kentucky later insisted on that number for his state's prominent route and a dispute ensued. As the story goes, Avery eventually relented and settled on the number 66 for the Chicago-to–Los Angeles route.

Whether inadvertently or on purpose, Avery chose a number with a certain mystique that could be characterized by the friendly, "droopy-eyed" look of its upside-down commas. The number also was distinguished by its staccato sibilance when spoken aloud. Can a highway number really possess charisma and emotion? Only the father of Route 66, Cyrus Stevens Avery, would know for sure.

City Scenes along the Future Route 66

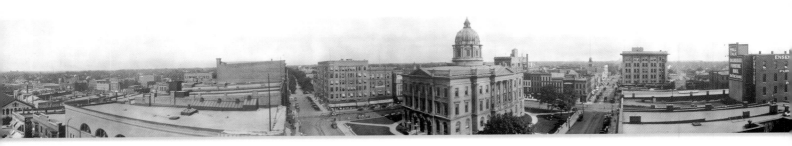

Bloomington, Illinois, 1914. The present site of Bloomington was once occupied by the Native American Kickapoo people. A settlement was started in 1822 by European settlers. The town's original name was Blooming Grove. Library of Congress

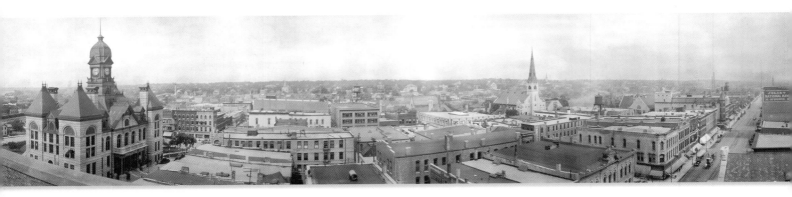

Joliet, Illinois, circa 1914. Joliet was settled in 1831, incorporated in 1845, and chartered as a city in 1859. It was named for the French explorer, Louis Joliet. The railroad made its appearance in Joliet soon after the town was chartered and U.S. Highway 66 was, among many others, an artery road that ran through the city until 1940. Library of Congress

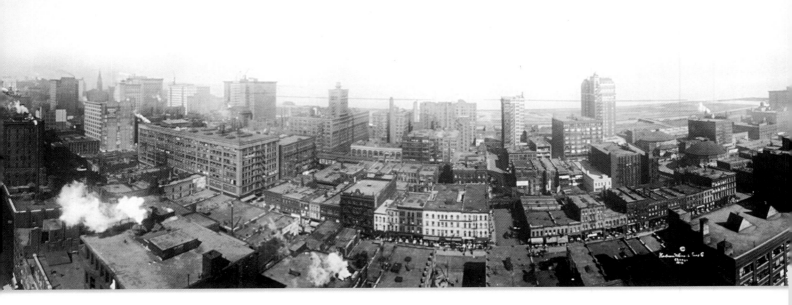

Chicago, Illinois, 1912. Library of Congress

Polk Street, Amarillo, Texas, 1909. In the days before cars became ubiquitous commodities, people did all of their shopping downtown and usually along Main Street. Today, town-square shopping centers are appearing all over the country to remake the twentieth-century shopping experience in the image of small town America. Courtesy Special Collections Department, Amarillo Public Library

By 1912, Amarillo's Polk Street was paved and provided motorists with a safe and reliable surface for driving. The sidewalks—reflecting the demands of the time period—were built with ample room for pedestrian traffic. City streets were once "the mall," and a lack of highways kept citizens close to home. Courtesy Special Collections Department, Amarillo Public Library

Main Street, Needles, California, circa 1920. According to the 1926 National Old Trails Road Guide, "Crossing the Colorado River from Topock, the next 16 miles to Needles is" In 1910, when H. Pomy, J. Rew, W. H. Aldrich, and B. Lackey arrived at Needles in their Sterns automobile, the town was only the start of their real adventure: crossing the Colorado River. They were headed east to Chicago by car, taking what they called the "middle" route by following the old trails. Courtesy Steven Rider Collection

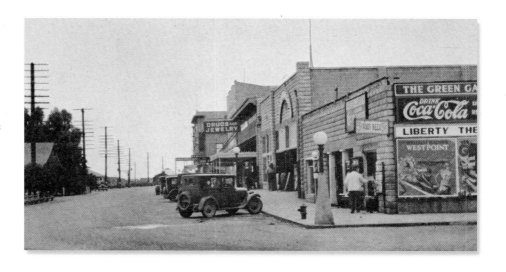

Bridging the Way West

The three-span Spring River (Marsh arch) Bridge spanned the Spring River between Galena and Riverton, Kansas. The bridge was built circa 1922 and was part of U.S. Highway 66 until it was dismantled in 1986. The bridge was the design of James Marsh, creator of the reinforced concrete arch bridge. Marsh's designs are now commonly called Marsh arch "rainbow" bridges. The Kansas portion of U.S. Highway 66 had three Marsh arch bridges: the Spring River Bridge (Galena, demolished 1986); the Willow Creek Bridge (Baxter Springs, demolished 1991); and the Bush Creek (Riverton, preserved). Courtesy Steven Rider Collection

The Neosho River Bridge gave service to U.S. Highway 66 from 1926 to 1937. It was an important part of the highway resurfacing project that was implemented in Ottawa County, from the Neosho River Bridge near Miami, through Narcissa to Afton, Oklahoma, and comprised a total of 15.47 miles. The project was completed March 1, 1922. For 13.33 miles, the pavement was nine feet wide. Courtesy of the Oklahoma Department of Transportation

The Colorado Street Bridge (also called the Arroyo Seco Bridge) is a concrete arch design, built in 1913. It was the answer to many motorists' prayers, since neither horse nor man could cross over the Arroyo Seco without difficulty. Travelers would descend down the steep slope, cross over a smaller bridge, and then climb up the opposite side through Eagle Rock Pass. When U.S. Highway 66 was organized, this bridge became part of the route. It's now listed on the National Register of Historic Places. Courtesy Steven Rider Collection

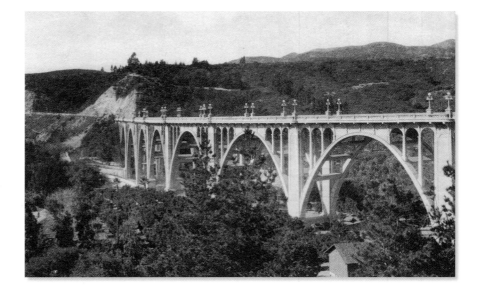

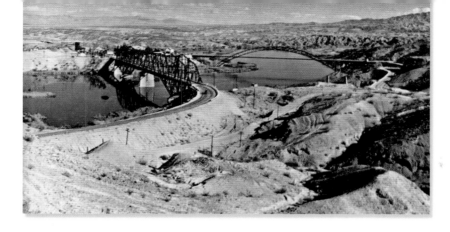

Transcontinental travel following the thirty-fifth parallel meant one thing: Eventually, you would meet up with a raging obstacle called the Colorado River. At first, the only civilized method for crossing the river was by ferry boat. Progress came in 1890, when the railroad spanned the waters with the Red Rock Bridge. Later, in 1919, the Old Trails Arch Bridge was built. Courtesy Steven Rider Collection

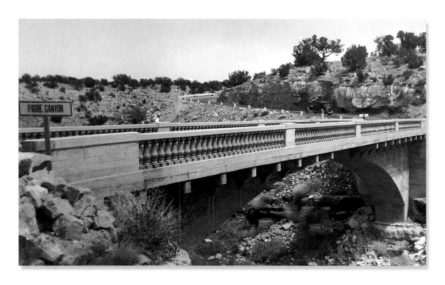

The Topock Bridge, circa 1920. Also known as the Old Trails Arch Bridge, this span was a steel arch design completed in 1916 and used until 1947. Today, the narrow bridge no longer handles cars, but is used to carry a PG & E pipeline. Courtesy Steven Rider Collection

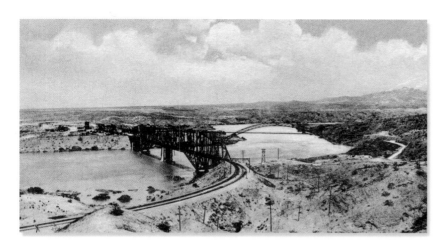

The Padre Canyon Bridge, twenty-five miles east of Flagstaff, circa 1930. The bridge was completed in April of 1914 for a little more than nine thousand dollars. The concrete, single-span bridge was built by the Topeka Bridge and Iron Company, and it became an important part of the Flagstaff-Winslow highway. In 1926, this highway—along with the bridge—became part of U.S. Highway 66, and it served traffic until 1937. Courtesy of Arizona Historical Society/Tucson

Flood waters that would at one time have been impassable rush under a multiple ten-foot box bridge on U.S. Highway 66, east of Kingman, Arizona, circa 1930. Courtesy of Arizona Historical Society/Tucson

Native American Life

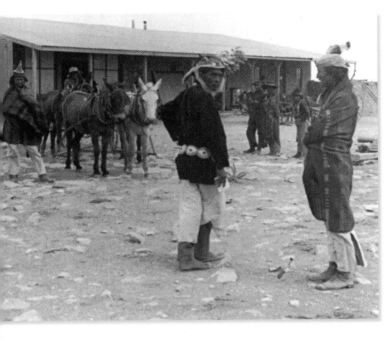

An early Indian trading post at the Cañon Diablo settlement, on the Navajo Reservation, Arizona, 1903. This small settlement was located east of the railroad bridge. Library of Congress

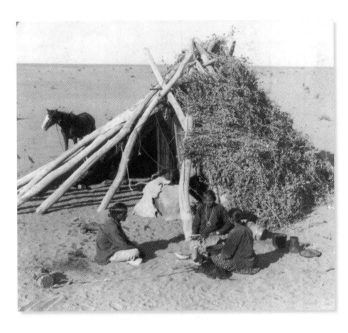

On Arizona's Navajo Reservation, Cañon Diablo, March 26, 1903. Navajo women prepare breakfast directly outside of their wickiup before the day begins, as the male member of the family (along with the family dog) wait to be fed. Library of Congress

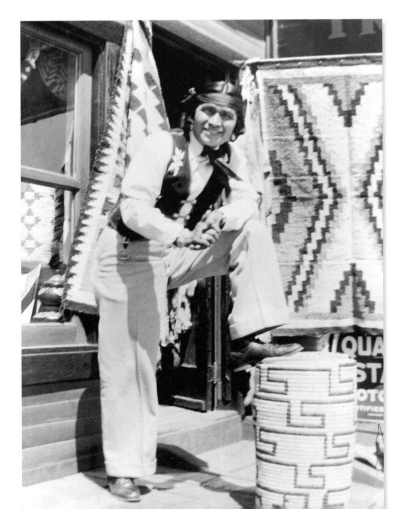

"The Navajo did not accumulate money. His security and his wealth was all put into his jewelry, or livestock. And his status symbol actually was either in the livestock he owned—the cattle, the sheep—or then into the jewelry that he had. This was really how he accounted for money, where he stored his savings account, as I call it. So as long as he had jewelry, he could take it to any trading post, where he'd ever seen a trader in his life, wherever the trading post was, and then he could pawn for anything that he could want." — Elijah Blair, Northern Arizona University, Oral Histories of the Traders. Joe Sakakaku stands next to Navajo rugs and baskets at a trading post on the Navajo Reservation in Arizona (1930). Joe became what few Navajo were: a trader. Courtesy of Cline Library Northern Arizona University

The Ocean to Ocean route included a stop at Laguna Pueblo, located between Albuquerque and Gallup, New Mexico. The pueblo's attractive pottery design was popular with travelers along the early roads. Courtesy Steven Rider Collection

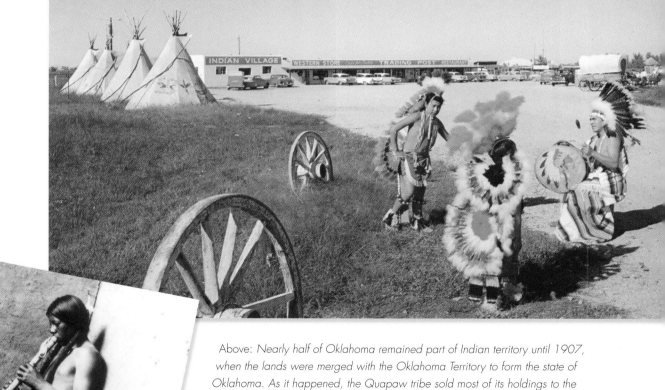

Above: Nearly half of Oklahoma remained part of Indian territory until 1907, when the lands were merged with the Oklahoma Territory to form the state of Oklahoma. As it happened, the Quapaw tribe sold most of its holdings to the U.S. government in the early 1800s. In 1824, the remaining portion of the tribe's land was lost to Uncle Sam in an unfortunate, alcohol-induced transaction. The tribe, virtually landless, regained its dignity in 1890, when a small plot located in the northeastern Indian Territory yielded zinc and lead. By the 1920s, the tribe was earning as much as $1.2 million a year in royalties. Courtesy Steven Rider Collection

Left: Photographer Carl Moon captured Before the Dance, an evocative portrait of Native American culture in 1908 at the Fred Harvey Indian Building in Santa Fe, New Mexico. The Native American performer plays a type of handmade flute before the corn dance begins. Library of Congress

Arizona's Natural Wonders

Above: *The Grand Canyon, Arizona, circa 2000.* ©2007 Ron Saari

Above: *The Grand Canyon, Arizona, circa 1913.*
Around the time that this image was taken, a group of four Chicago trailblazers traveled from San Francisco to Chicago by motorcar and almost ended up driving into the canyon at night. In 1858, Lieutenant Joseph Christmas Ives, with the help of some Indian guides, made his way down to the bottom of the canyon via trails. He became the first white man to stand on the canyon's floor. Library of Congress

Left: Courtesy Steven Rider Collection

Greetings From

ARIZONA

State Capital in Phoenix

State Flower
the Saguaro Cactus

Above: *U.S. Highway 66 and the San Francisco Peaks, as seen between Flagstaff and Williams, Arizona, circa 1960. Courtesy of Cline Library Northern Arizona University*

Left: *Winslow, Arizona, "Wonderland of the West" travel brochure, circa 1940s. Complete with a foldout map detailing Native American points of interest, this promo piece played up the romantic history of the area to attract tourists. Courtesy Steven Rider Collection*

The Petrified Forest, Holbrook, Arizona, 1940s. To protect it from "pilferers," the Petrified Forest was turned into a national monument in 1906. Believe it or not, the treasured forest that "turned to stone" was slowly being decimated by more than just trinket hunters. During the 1890s, a mill actually crushed the ancient stones into industrial grinding powder. The fossilized forest was designated a national park in 1962. Courtesy Steven Rider Collection

A good roads campaign motorist, battling the scourge of ruts and rocks while navigating downhill, circa 1919. Library of Congress

Paving the Future

"Roads to go somewhere is an expression heard incessantly in connection with the country-wide attention to the improvement of highways. A road extending across a township, of course, has value; it has increased value when it goes across a county; it has considerably increased value when it extends across a state, but it is of infinitely more value when it extends from state to state, across the continent."

— Judge Lowe,
president of the National Old Trails Ocean to Ocean Highway, 1913[1]

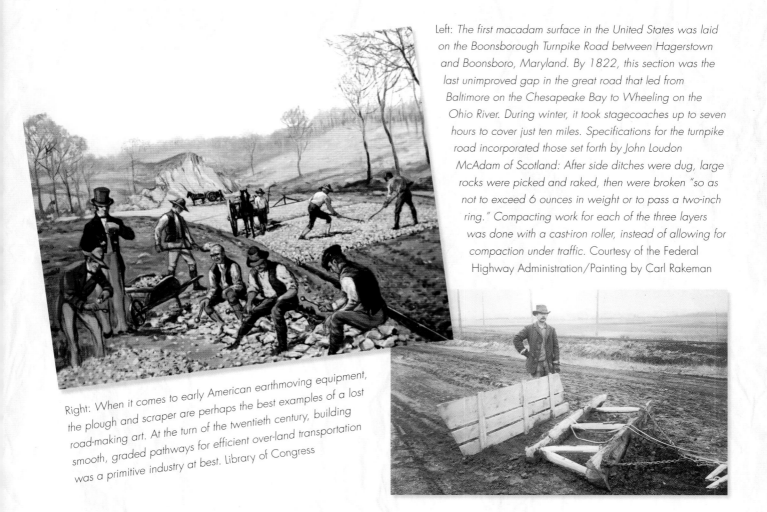

Left: The first macadam surface in the United States was laid on the Boonsborough Turnpike Road between Hagerstown and Boonsboro, Maryland. By 1822, this section was the last unimproved gap in the great road that led from Baltimore on the Chesapeake Bay to Wheeling on the Ohio River. During winter, it took stagecoaches up to seven hours to cover just ten miles. Specifications for the turnpike road incorporated those set forth by John Loudon McAdam of Scotland: After side ditches were dug, large rocks were picked and raked, then were broken "so as not to exceed 6 ounces in weight or to pass a two-inch ring." Compacting work for each of the three layers was done with a cast-iron roller, instead of allowing for compaction under traffic. Courtesy of the Federal Highway Administration/Painting by Carl Rakeman

Right: When it comes to early American earthmoving equipment, the plough and scraper are perhaps the best examples of a lost road-making art. At the turn of the twentieth century, building smooth, graded pathways for efficient over-land transportation was a primitive industry at best. Library of Congress

espite the ongoing debate about the constitutionality of government intervention in the states' road-building efforts, the Federal Aid Road Act passed in 1916. At a White House ceremony attended by representatives of farm organizations, the American Automobile Association, the American Association of State Highway Officials, and members of congress, President Wilson affixed his signature to the bill.

George Diehl, chairman of the AAA, was resolute in his determination to pave America. "The majority of states have provided for definite systems of state highways," he stated, "which they are constructing as rapidly as available means permit. Every effort should be directed now toward having the federal funds apply on these state systems and not frittered away on countless little disconnected local roads."[2]

There was a lot at stake since the program allotted one hundred and fifty million dollars to be spent over the five-year plan term. Apportionment would be decided by highway authorities from the forty-eight states, subject to the approval of the secretary of agriculture. It was hoped that the program would be free of pork-barrel spending, since each state was obligated to match federal funds. "The bill is as big as the great country it represents and as broad as the humanity it would serve," declared *Southern Good Roads* magazine. "Its enactment will take the public highways out of politics and make them thoroughfares for commerce and industry, instead of paths to public office."

The funds were distributed quickly and, as if by alchemy, turned into roads by the individual states. Progress was swift: By October 31, 1920, there were 17,369 miles of highway under some form of construction.[3] Finally, the once rag-tag coalition of road boosters had Uncle Sam on their side, wielding a pick axe in one hand and carrying a top hat full of greenbacks in the other. Yes, the nation was invested and it squarely backed the plan to build a network of roads, state by state, that would connect each to the other and one day become a cohesive network of thoroughfares.

By 1926, roads across the state lines were about two-thirds improved. Now, more than twenty-five states boasted continuously improved roads over their entire length.[4] In fact, the decade of the 1920s was considered to be the "golden era" of road building. Man, beast, and machine joined forces in every state of the union to bring about the new reality of state-to-state interconnectivity. It was a real bricks-and-mortar network in the making and a physical equivalent to today's internet, only populated by cars, trucks, and motorcycles instead of bits and bytes.

As the highway ascended from a mere wish to one of concrete reality, the heady days of finding one's way by luck and pluck were coming to a close. The open road rolled out its welcome mat, and all across America motorists accepted the invitation with gusto. Ma and Pa Kettle were going on vacation and they were ready to see the sights.

What was the scenic route of choice for the growing hoards of enthused drivers? Naturally, it was the Old Trails Highway. "One of the great transcontinental highways extending from the Atlantic to the Pacific is the National Old Trails Road," extolled a 1924 article published in the *New York Times*. "It has been called 'The Broadway of America.' It traverses mountains, plain, and forest, and is rich in varied scenery, while offering splendid road conditions and very little desert country."

Highways like the National Old Trails Road were far more "civilized" than they were during the days when motoring's pioneers jostled and bumped over the no-man's land of unpaved America. In 1924, the well-prepared motorist was reassured that, "it is no longer necessary to carry large supplies of gasoline . . . gasoline stations are found along the road."[5] Furthermore, hotel accommodations and automobile campgrounds were available in every city. Where the going was once slow and cumbersome, the hard-paved surface allowed a clip of eighteen miles per hour. At one time, a coast-to-coast trip took months. Now, it could be enjoyed in twenty to thirty days.

Still, there were some practical considerations for any sort of long-distance trip. Experts in high-mileage motor tours recommended bringing no less than one set of skid chains, a good horn "for use on mountain curves," one set of tools, a jack, good cutting pliers, two extra casings, four extra inner tubes, tube patches, three spark plugs, a one- or two-gallon water bag or canteen, one flashlight, an axe, a small shovel, radiator hose connections, lamp bulbs, a motormeter,

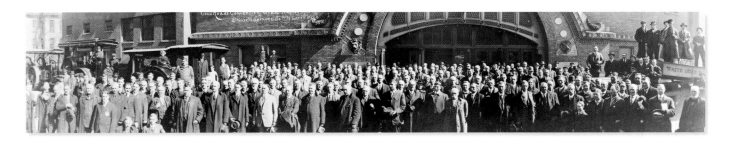

Good roads conventions—like this one held at Grand Rapids, Michigan, circa 1915—were the backbone of the movement to rid America of inferior roads and pave a network of highways across the contiguous United States. Library of Congress

During the 1920s, automobiles were frequently liberated from the mud by horse and cart teams. Despite the advancements in the automotive art, roads were hit-and-miss affairs in those days, especially during inclement weather. National Archives

and one tow rope or short cable.[6] "Better to be safe than sorry" was an early adage of motoring.

As the Roaring Twenties gained speed, the Barney Oldfields and Alexander Wintons stepped aside to make way for a more subdued motoring class, which was exemplified by families who sought to vacation by car. These "tourists" sought the open road and looked for whatever adventure they might find past the outskirts. Their road was tamer than ever before, yet it still exuded an air of mystery. With no exit signs to guide them, nor billboards emblazoned with familiar icons that promised gas, food, and lodging, countless motorists embraced the unknown. Touring by car was a guessing game, a crapshoot, a thrill . . . and a true exploration into new and uncharted territory.

There were clue books available to those who wanted them: In 1924, the Automobile Club of Southern California published a new travel guide that was plainly titled "National Old Trails Road."[7] It featured the entire route from New York to Los Angeles, complete with mileage, description of the highway, historic data, and information about scenic wonders along the way. The book was a handy resource, and it was mailed for free to all motorists who requested it for planning the trip. "Please write to O. W. Lewis, Chairman of the Touring Bureau of the Automobile Club of Southern California, Los Angeles for your individual copy," entreated the AAA. "Have a safe journey!"

The open road was waiting and wheels were pointed to the north, east, south, and west. "Pardon my dust" became the rising chorus, as all of America took to the wheel and claimed the promise of freedom—made possible by determined friends of the road, the federal government, and the gasoline-powered motor coach.

A U.S. Mail truck makes a delivery in Thoreau, New Mexico, circa 1920s, before the arrival of paved roads and the lifeline that would be called U.S. Highway 66. Courtesy Palace of the Governors (MNM/DCA)

The Push for Good Roads

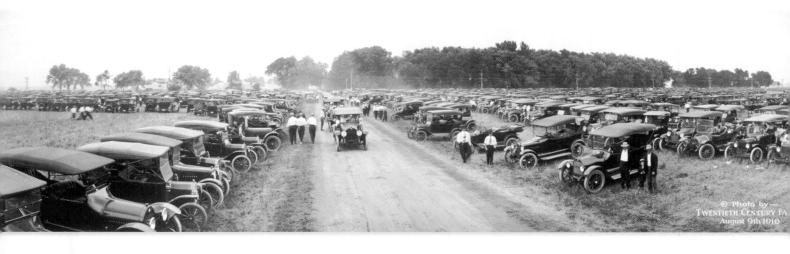

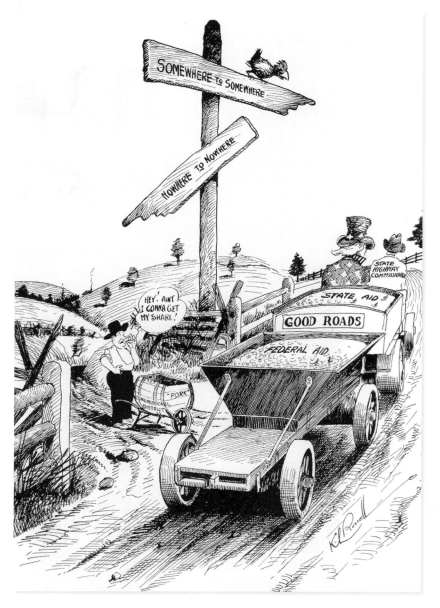

Above: Fremont Tractor Show, Fremont, Nebraska, 1916. In the beginning, the debate between farmers and the good roads movement was heated. Farmers wanted federal aid for farm-to-market roads, but they considered national roads fruitless. The national roads would only benefit the wealthy minority who could afford the luxury of an automobile. Supporters of the good roads movement didn't want federal funds to be frittered away by farm-to-market roads that went "nowhere." Once automobiles became more affordable, the attitude of the farmer quickly changed. According to the Twentieth Century Farmer, August 16, 1916, farmers came to view the automobile not as a luxury, but as an ally. At the 1916 Fremont Tractor Show, farmers were happy to shop for a new automobile, along with a new tractor. Library of Congress

Left: In 1916, the ongoing debate about federal aid—namely, which roads should be improved and which should not—involved the farm roads, which some felt "began nowhere and ended nowhere." George Diehl, chairman of the AAA (American Automobile Association), had his own opinion on the federal aid funds and believed that ". . . Every effort should be directed now toward having the federal funds apply on these state systems and not frittered away on countless little disconnected local roads." Better Roads and Streets, July 1916. Courtesy of the Federal Highway Administration

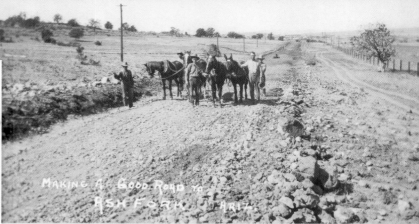

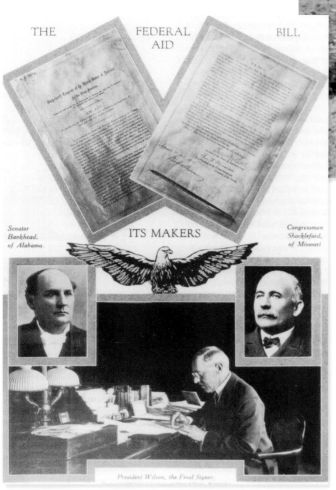

Above: *In the early days, the roads that were intended for automobile traffic were built by manpower, mules, and horses (and a lot of sweat). This rare, circa 1920 view depicts a section of road that would one day become part of U.S. Highway 66 near Ash Fork, Arizona. Courtesy Steven Rider Collection*

Left: *This display celebrates the passage of the Federal Aid Road Act of 1916. In 1912, Representative Dorsey W. Shackleford of Missouri introduced a bill to improve farm-to-market roads to help "get the farmers out of the mud." The bill passed the U.S. House of Representatives, but it died in the Senate. In 1916, Shackleford tried again. After some revisions and a long, difficult battle (including some three hundred pages of debate in congress), the Federal Aid Road Act of 1916 passed both the House and Senate. Dependable Highways magazine, July 1916. Courtesy of the Federal Highway Administration*

The March 1916 cover of Better Roads and Streets *magazine exemplifies the sentiment of the times. By July 1916, the Federal Aid Road Act had passed and the paving of the United States' highways could begin in earnest. The Southern Good Roads magazine reported, "The bill is as big as the great country it represents and as broad as the humanity it would serve." Courtesy of the Federal Highway Administration*

Touring the Country

An automobile touring party in Arizona, photographed after one thousand miles of over-land travel, circa 1920. Courtesy of Cline Library Northern Arizona University

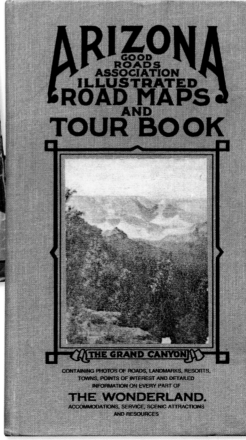

The Arizona Good Roads Association Illustrated Road Maps and Tour Book *provided a wealth of information for pioneer motorists journeying through Arizona. First published in 1913, it included the important data a tourist needed, including maps, a list of accommodations, and scenic sights along the way. To obtain the book's authentic data, cartographers traveled more than ten thousand miles by automobile. Courtesy Russell Olsen Collection*

By 1926, touring clubs were able to present maps that clearly marked paved roads and road distances. That year, more than twenty-five states boasted of continuously improved roads over their entire length. In fact, the decade of the 1920s was considered to be the golden era of road building. This map was produced by the Milwaukee Journal Tour Club in 1926. Courtesy Steven Rider Collection

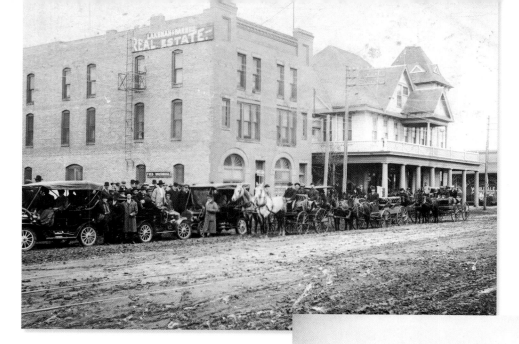

Left: A gathering of vehicles and carriages preparing for a trip, outside of the old Amarillo Hotel, Amarillo, Texas, circa 1904. With a curious mix of Grecian columns and wraparound balconies, the roadside inn (wooden building to the right of the brick structure) at Third and Polk was built in 1889, just two years after the town was founded. Courtesy Special Collections Department, Amarillo Public Library

Right: Hotel Modesti, Agua Caliente Spring, Arizona, November 18, 1911. An A. L. Westgard photograph featuring the Raymond-Whitcomb Trail land cruise group, halfway between Phoenix and Yuma (on north side of Gila River). The Raymond-Whitcomb travel service offered guided land cruises for early automobilists who wanted a flavor of adventure without too much hardship along the way. Note the covered wagon motif on the travel service automobile. National Archives

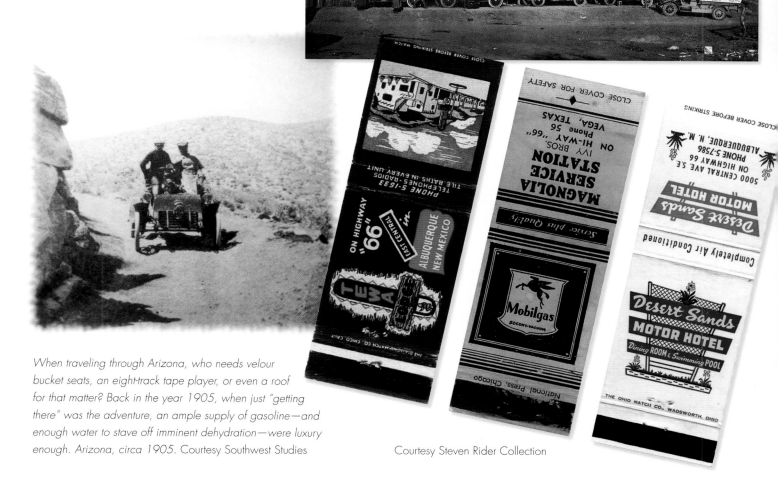

When traveling through Arizona, who needs velour bucket seats, an eight-track tape player, or even a roof for that matter? Back in the year 1905, when just "getting there" was the adventure, an ample supply of gasoline—and enough water to stave off imminent dehydration—were luxury enough. Arizona, circa 1905. Courtesy Southwest Studies

Courtesy Steven Rider Collection

Judge J. M. Lowe and the National Old Trails Road

*J*udge Joseph Macauley Lowe (born December 13, 1844, and died April 16, 1926) proposed the creation of the National Old Trails Road Association in 1910. Unmatched in his enthusiasm, he found himself at the helm of an organization that had a task of advocating the building of a modern road from coast to coast. It would be a road that would follow a string of historic old trails and a precursor to the larger goal of a federally built network of national roads.

"Keep your eyes toward the sunrise and your wagon hitched to a star . . . " he admonished. "We stand upon the threshold of mighty achievements!" To thunderous applause, Lowe galvanized the crowd attending the group's first national convention in Kansas City, Missouri, held April 17 and 18 in 1912 (during which time the organization was incorporated). As the first president of the newly created National Old Trails Road Association, he motivated the organization with his vision of the future.

But it was more than just rhetoric: The National Old Trails Road Association's mission was defined by three major objectives, as reported in the *Kansas City Journal*: First, the group had to convince every state along the route to apply its auto license fund toward constructing better roads. Second, advocates had to recruit one hundred thousand members into the organization to attain the muscle they needed to achieve their long-term objectives.

Judge J. M. Lowe may have been the first person to describe a long-distance highway as the "Main Street of America" when he applied this tag to the National Old Trails Road in 1915. Little did he know that more than a decade later, two new road associations—each promoting roads that incorporated parts of the National Old Trails Road, U.S. 40 and U.S. 66—would also claim this emotionally stirring description for their road of choice. Courtesy of the Federal Highway Administration

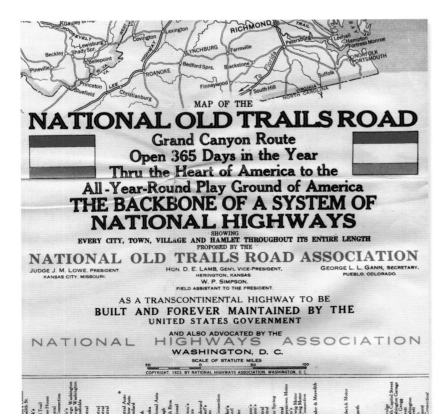

National Old Trails map, circa 1924. The National Old Trails Road (NOTR), also known as the Ocean to Ocean Highway, was established in 1912. It extended from New York, New York, to Los Angeles, California, and it was comprised of parts from the following historic roads: Braddock's Road, the Cumberland Road (or National Pike), Boone's Lick Road, the old Santa Fe Trail, and the Grand Canyon Route. In 1926, the NOTR fragmented when portions of it were absorbed by the new federal highway numbering system. U.S. Highway 66 assimilated the NOTR stretch from Romeoville, New Mexico, to Los Angeles, California. Author's collection

Shown is a 1915 National Old Trails Road Association brochure with the mission statement, A Road from Coast to Coast, *written by T. A. Vaughn. The association "believes that, when established, these national highways will increase the wealth, the power, and the importance of this country as nothing else can do . . ."* Better Roads and Streets, *October 1911. Courtesy Steven Rider Collection*

When pressed to determine where these new members would be found, Judge Lowe answered with all the confidence of a dreamer. "We are going to comb the territory along the trails with a fine-tooth comb," he answered, resolute in the fact that every motorized vehicle owner in America was a target for membership.

The third and most important prong of NOTRA's mission was revealed when Lowe announced: "We are going after federal aid." Lowe claimed 170 congressmen were friendly to the group's ideals. "The Old Trails Road is going to get what it is after," he announced, promising to the attendees that he would make a very strong case before the congressional committee that was charged with determining the merits of several highway association's claims. His road—the precursor to Route 66 (a portion of it)—was poised to become the nation's first federally funded transcontinental highway.

Text adapted from The National Old Trails Road: The Star-Spangled Forerunner of Route 66, *by Steven Rider (National Historic Route 66 Federation's* Federation News, *Winter, 2003).*

With imagery depicting the contrasting modes of transportation yesterday and today, the cover of the 1926 National Old Trails guidebook evokes a strong sense of the road's historical significance. When Judge J. M. Lowe first promoted this route as the main highway across America, he emphasized its centralized accessibility. The southerly route through the western mountain areas also gave the road year-round access. From Kansas City, Missouri, to Los Angeles, California, it paralleled the route of the Santa Fe Railroad, which translated into lower costs for goods and services along its length. Travelers could also take advantage of the Harvey Houses that were already spaced out at convenient distances and offered "unparalleled luxury not found on any other highway." Eventually, part of this highway became interwoven with the Mother Road, U.S. Highway 66. Courtesy Steven Rider Collection

National Old Trails Highway

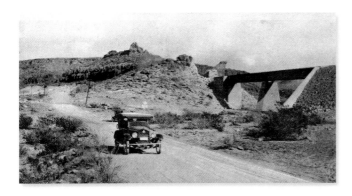

Auto traffic can be seen on the National Old Trails Highway, near Kingman, Arizona, circa 1916. Utilized in large part by the railroads, the "See America First" tourist campaign kicked off in 1906 (notice the tracks to the right). By the early 1910s, the actual automobile became the best advertisement for people to get out and see America. Courtesy of Russell Olsen

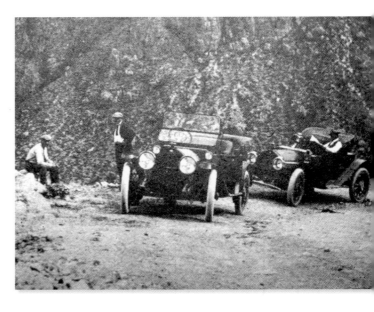

In 1915, the ocean-to-ocean excursion—with the aim to promote better highways in America—stopped for a photo opportunity in Salt River Canyon, Arizona. The National Old Trails Highway, also known as the Ocean to Ocean route, was once considered one of the most scenic highways in America. Courtesy Southwest Studies

Between Oatman and Kingman, Arizona, circa 1926. Established in 1912, portions of the National Old Trails Highway became part of the U.S. highway system in 1926, under the name of U.S. Highway 66. Courtesy Steven Rider Collection

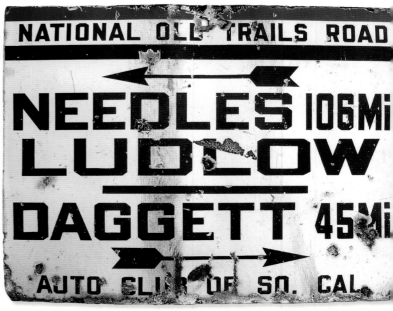

Old Trails Road markers like this were once placed along the route by the Automobile Club of Southern California. In 1914, the Auto Club of Southern California began placing durable, porcelain-enameled red, white, and blue signs along the National Old Trails Road from California to Kansas City, Missouri. Courtesy Steven Rider Collection

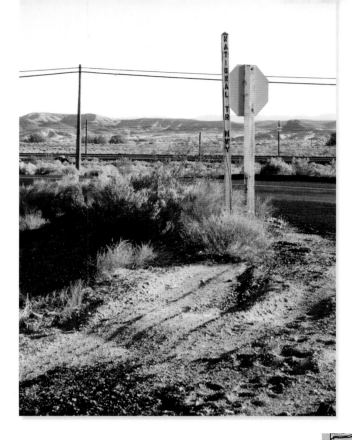

Left: *A wooden post identifying the National Old Trails Highway near Daggett, California, 1989.* Courtesy of Cline Library Northern Arizona University

Right: *The Road Scout featured the western portion of the National Old Trails Road, circa 1920.* Courtesy Steven Rider Collection

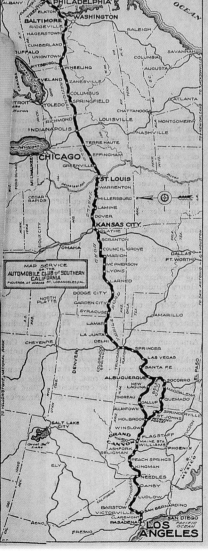

Far left: *In 1924, the Automobile Club of Southern California published a new travel guide. The guide featured the entire route from New York to Los Angeles, complete with mileage, descriptions of the highway, historical data, and information about the scenic wonders along the way. The handy resource was mailed for free to all requesting motorists.* Courtesy Steven Rider Collection

Left: *The interior pages of the National Old Trails Road guide were full of several useful road maps. This example highlights a strip map of the entire National Old Trails Road.* Courtesy Steven Rider Collection

Future Route 66 Downtowns

A quiet scene along the National Old Trails Highway, Front Street, Kingman, Arizona, circa 1920, with the Commercial Hotel and local Ford automobile dealership in view. Courtesy Steven Rider Collection

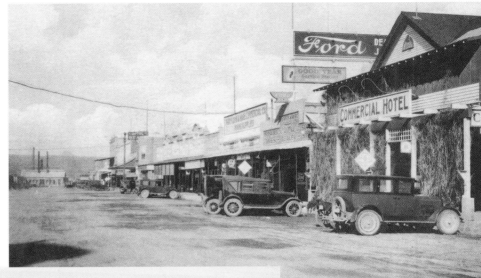

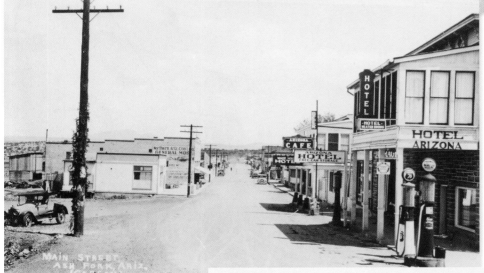

Left: *Ash Fork, Arizona, dirt road Main Street (before U.S. Highway 66 was established), circa 1920. Tourist amenities were available, including hotels, heated rooms, gasoline, and beer. Courtesy Southwest Studies*

Right: *Oatman, Arizona, circa 1920.* National Archives

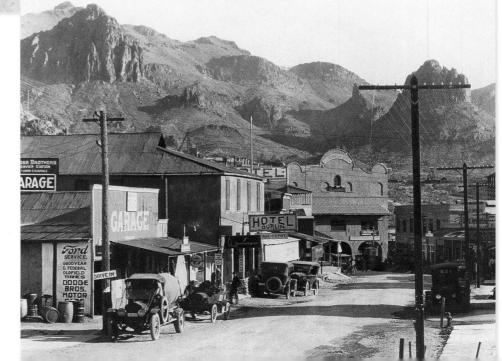

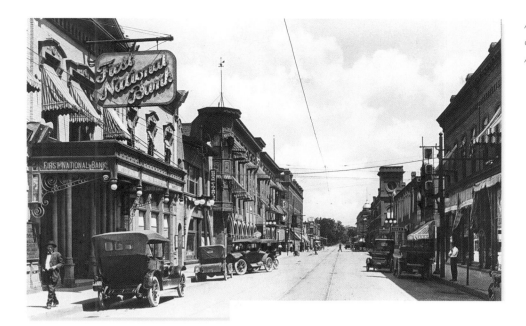

A view looking down Second Street on the future Route 66 town of Albuquerque, New Mexico, circa 1920. National Archives

Right: Downtown Azusa, California, circa 1929, shortly after U.S. Highway 66 was born. This city, located in the county of Los Angeles, was founded in 1887 and incorporated on December 29, 1898. It was originally known as Asuksa-nga, and it is believed that the city took its name from this Native American name for the area. Author's collection

Left: Located at Euclid Avenue and Foothill Boulevard (U.S. Highway 66), the Madonna of the Trail in Upland, California, is one of a chain of twelve monuments across the country that honors the pioneer mothers. The monument is made of algonite stone and weighs five tons. It stands on a pedestal among the beautiful trees in the center parkway. The Madonna of the Trail statue was the design of August Leimbach, a St. Louis, Missouri, architectural sculptor who submitted his proposed design to the Daughters of the American Revolution in 1927. Courtesy Steven Rider Collection

Earl Shelton
Child of the Dust Bowl

*"I don't ever remember going hungry myself, but I know my dad did . . . [he]
was left with a nickel in his pocket. He said, 'Well, I haven't had [a] cup of
coffee in three days. I'm going to use this nickel and have a cup of coffee.'
And he was sitting in the café there, sipping his coffee . . . you can't even
imagine what must have been going through my dad's mind . . . him flat broke,
two kids, and an A Model completely out of gas, with only three tires. . . ."*

*—Earl Shelton
Interview, March 7, 2006*

arl Shelton is an "Okie" and proud of it.
Although he was only seven years old when he
made the journey to California on Route 66, his
memories of the trip and the events that followed remain
vivid. He was born in 1933 on his family farm in Scipio,
Oklahoma, and he was the fourth child of Virgil and Tom
Shelton. Earl's mother died when he was four years
old, and his father—after losing the farm—moved back to
his parents' spread.

Earl's father eked out a living by chopping wood during
the day and hunting at night. In those days, the cured
animal hides brought in ten cents apiece and the meat
was enough to fill his children's stomachs. However, times
were tough and getting tougher. The hardscrabble lifestyle
on the plains was taking its toll.

The promise of relief came during the winter of 1940
when Earl's father saw an advertising flyer for needed crop
pickers in California. It sounded too good to be true: The
California farmers were willing to supply campsites *and*
decent pay. "Well, Dad was convinced that money grew on
trees in California and that was all the encouragement he
needed," Earl said. "We were going."

Earl's older brothers, Charlie (fifteen years old) and
Herbert (thirteen years old), hitched a ride with other family
members and hightailed it straight out to California. Tom
Shelton, Earl's father, soon followed with the other two
boys, Earl and Ray (age ten). In January 1941, he loaded
a 1929 Model A Ford with clothing, some household
goods, and two mattresses tied onto the roof. Jewell
Newby, Tom Shelton's nephew by marriage, joined them
for the ride west. The boys bid a fond farewell to their
grandparents and headed for Highway 66, the so-called

*The Shelton family, clockwise from lower left: Herbert, Virgie, Ray,
Tom, and Charlie. Virgie was pregnant with Earl when this photo
was taken. She died before the family made the move out west,
from Oklahoma to Kern County. Courtesy Earl Shelton*

The Sheltons: Father Tom and sons Charlie, Ray, and Herbert make up the top row, with their youngest son, Earl, in front. Charlie and Herbert went west before Tom, Ray, and Earl. Courtesy Earl Shelton

we could park there. I guess they were used to seeing people stranded out there in the desert. No one seemed to object . . . Dad took the seats out of the car and put the mattresses inside for us to sleep on—it was cold at night out there in the desert."

As it turned out, Jewell hitched a ride to San Francisco, but not before asking Earl's dad for money. The elder Shelton gave his nephew a dollar, which left him with only $1.20. Earl explained their plight: "By the third day, Dad had spent $1.15 on Ray and I, and was left with a nickel in his pocket. He said, 'Well, I haven't had a cup of coffee in three days. I'm going to use this nickel and have a cup of coffee.'

"And he was sitting there in the café, sipping his coffee—you can't even imagine what was going through my dad's mind—him flat broke, two kids, an A Model completely out of gas, with only three tires. . . . Just then a guy came in and asked, 'Who owns the A Model?' Well, Dad thought they were going to ask us to move it, but he answered, 'I do, what's the problem?' The guy asked him, 'You looking for work?' Oh man, Dad couldn't believe what he had just heard—that was a prayer answered!"

The man's name was Mr. West and he worked for the King Cattle Company. He offered the three Sheltons room, board, and $2.50 per day for working from sun-up to sundown. "We all loaded up in Mr. West's 1934 Plymouth and put the two mattresses in there and took what few clothes we had and drove thirty-five miles out of Seligman," Earl added. "We were up in the mountains and our room was a tent and our board was the best 'slum gullion stew' that you ever ate!" There were no leftovers that night, or any other night for that matter."

"My father helped Mr. West dig a well," Earl said. "They were digging a tunnel just like for gold, only they were mining for water. They were going down into the ground using only a pick, shovel, and crowbar. West

road to "the Promised Land." Tom Shelton's pockets were empty . . . but his heart was full of hope.

"We clipped along at twenty-five to thirty miles per hour every day and night until we ran out of tires and money," Earl recalled. "On Route 66, we made it to Seligman, Arizona, on three tires and a rim! Dad had $2.20 in his pocket, two kids . . . and a nephew who had nothing. We were stranded there in Seligman . . . we pulled into a little café, service station combination and Dad asked if

Earl Shelton at the former Arvin Camp recreation hall. Earl lived on and off at Arvin Camp (called Weedpatch Camp in Steinbeck's Grapes of Wrath) for thirteen years. For those fleeing drought and dust, the Farm Security Administration created ten government-run camps where families could set up tents for $1.25 a week. The camps provided modern conveniences for migrant workers. Community facilities had showers with hot and cold running water and flush-toilets. Arvin Camp, now called the Sunset Migrant Camp, continues to operate and house migrants. Preservationists are working to restore the buildings and they plan to add a small historical park. Courtesy Earl Shelton

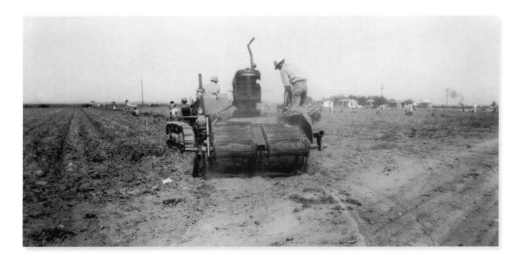

knew the water table wasn't deep, but he had to find the right spot. They also had a team of mules hooked to an old Fresno—a scraper that drags away dirt—and they'd scrape the dirt away with it and continue to dig the tunnel by hand."

But the two boys didn't have much interest in the men's work. They had more important things to do—like exploring. As Earl said, "There was one tree that I could climb and by the time we left there, I had worn the bark off. The bulls would come around and really they'd be pawing to throw dirt up on themselves to get rid of the flies, but Ray and I thought they was going to attack us! We'd be up in the tree with slingshots, and one time Ray cut down on one and hit him so hard the bull burped up his cud. It was so loud that we thought for sure he was going to climb up after us! We ended up staying up in that tree most of the time."

Sometimes, a welcome change of routine came on the weekends, when West took Earl and Ray into town with him. "He treated me and Ray to ice cream," Earl remembered, his voice revealing the simple wonder of that day. "Another time, he bought me a pair of cowboy boots and chaps and a toy pistol. You know, up to then I'd never had anything like that in my life. He also bought Ray a pellet gun."

On the drive back from one of these outings, a real adventure occurred. "We got onto an antelope on the high desert when Mr. West exclaimed, 'Boys we're going to have fresh meat tonight!' Then he'd jump out and shoot, jump back in again and drive another quarter of a mile, then jump out and shoot again. This continued for a good while until the car ran off the dirt road and the radiator cap blew off," Earl said. "West had busted a hole in the old Plymouth's oil pan!"

Mr. West left the boys in the automobile and walked the distance back to camp. Before leaving, he told them, "Don't leave this car! Ray, I'm leaving you the gun, but nothing out here's going to harm you. Stay in the car." They waited in the car, as instructed, and that night the

desert came alive with sound including the howling of coyotes. The boys huddled together and Ray gripped the rifle ever closer. "We thought we were going to die in that desert!" exclaimed Earl.

At four o'clock in the morning, West and their father rode up on mules. "How they found the car out there in the dark, I don't know!" Earl said. The mules pulled the Plymouth, while the men guided the animals and Ray steered. Suddenly, they hit a slope and the car began rolling toward the mule's hindquarters. Fortunately, Ray's dad jumped in and slammed on the brakes. As Earl explained, "It had them old mechanical brakes and Ray couldn't handle them. From that point on, Dad or West steered the car." Fourteen hours later, they were back at camp.

The Sheltons were happy to be part of these adventures, so they lived at the camp in the mountains for eight glorious weeks. "Other than being cold at night, we were having a great time—no school, you know," Earl said. "But Mr. West did require all of us to take a bath every Sunday, which wasn't too popular with us."

Eventually, Tom Shelton had more money in his pocket than he ever had in his life. The family was ready to move on to their destination out west. With a new tire, the Model A was roadworthy and, once again, they headed back out onto Highway 66.

When they reached the Arvin, California, cutoff, they all piled out of the car to take in the view. "We could see the whole valley below us, it was paradise," said Earl. "You could see every vineyard, every orchard, every alfalfa field, every potato field. On the other side of the valley, it was all rough desert, but the valley below us was all green . . . it was irrigated . . . and it was a beautiful sight!"

The Shelton family realized that they had made it so far on so little. The promise of what they saw filled their hearts with new hope. By relying on faith, love, and hope, they knew they could continue the journey and go the distance, wherever Route 66—or life—might take them.

Iva Townson Helm and the Road of Flight

"We'll never see this place again," thought Iva as she looked back at her grandpa's old home place near McAlester, Oklahoma. It was December 6, 1935, and the bleak winter air confirmed the sadness she felt. The Oklahoma dust storms had stripped the landscape bare, and her family was barely able to earn a living. Now, they were all headed for California, the land of promise. If everything went well, they would arrive by Christmas.

There were sixteen of them, all cramped into a car and a large trailer: grandma, grandpa, cousins, sisters, brothers, aunts, uncles, and, of course, mama and pa. Every spare inch of interior space was stuffed with something useful. A stack of mattresses was tied on top of the vehicle. Pots, pans, scrub boards, and washtubs were strapped to the car's sides. They knew they would be entirely dependent on what they could carry.

Between the squeaky springs of the car, the clanging of metal implements, and the squeals of children, there was very little quiet inside the caravan. They rode the two-lane highway known as Route 66 and enjoyed reciting the Burma Shave signs, chuckling at the rhymes, and repeating the verses for miles along the way The road afforded few comforts, but there were places large enough to pull over and make camp for the night.

When the money ran out, the family had to split up. Iva's parents and some of the children stayed at a migrant tent camp in Phoenix, and the rest of the group forged ahead, out to California. "Papa cut lettuce for ten cents an hour," Iva said. "Back then, the migrant had no choice, either work or starve."

To supplement their food, Iva's father found a nearby dairy that was willing to give him skim milk. He hauled the milk back to camp, distributed it to others in need, and kept the rest for his family. With no refrigeration, perishables didn't keep long, so he was forced to make this trip frequently. "He shared and cared for people in need. Papa exhausted himself and became ill. He developed pneumonia and Mama treated him with hot salt bags to relieve pain and release congestion," Iva said.

Death was no stranger to the migrant camps, but one memory stands out in Iva's mind: "My mama, sister, and I visited a neighbor whose baby had died. The mother of the baby made a casket out of an old wooden apple crate. She had lined the crate with a sheet and placed a pillow under the baby's head. It is still vivid in my mind.

The small child lay in the homemade casket, hands folded. This sight bothered me for a long time. I was thankful to God for our family surviving."

Five months after this event, Iva's parents received some good news from the Stevens, friends who were working on a ranch near Bakersfield, California. Believe it or not, a job driving a tractor was waiting for her father at a ranch! The Stevens even sent along six dollars to help out with gas and expenses. With prayers answered, they wasted no time loading up the car, and they left the camp in a cloud of dust.

A short time later, Iva's family arrived at the ranch—there was laughter, smiles, and hugs all around. The Stevens showed the road-weary family their new cabin. This would be the first time that Iva had spent a night inside a building in five months. But even more important, she could attend school again. She had been absent from school for more than six months, and she missed it! Yet, she had learned a great deal from her time spent on the road, and it was more than she could ever glean from books.

Top (left to right): Iva, second row, third from left, at first school in California (1937); front row, Rachel Townson (Iva's sister). Top (right): The Townson children at Lerdo Ranch, near Shafter, California (1937); the baby (middle front) was born in California (1935). Bottom (left to right): Iva's three brothers and family car, Lamont, California (1939); Iva's parents: Edna (holds Rachel) and William (holds Iva, 1927). Courtesy of Iva Townson Helm/Graphics Gyvel Dagmar Berkley

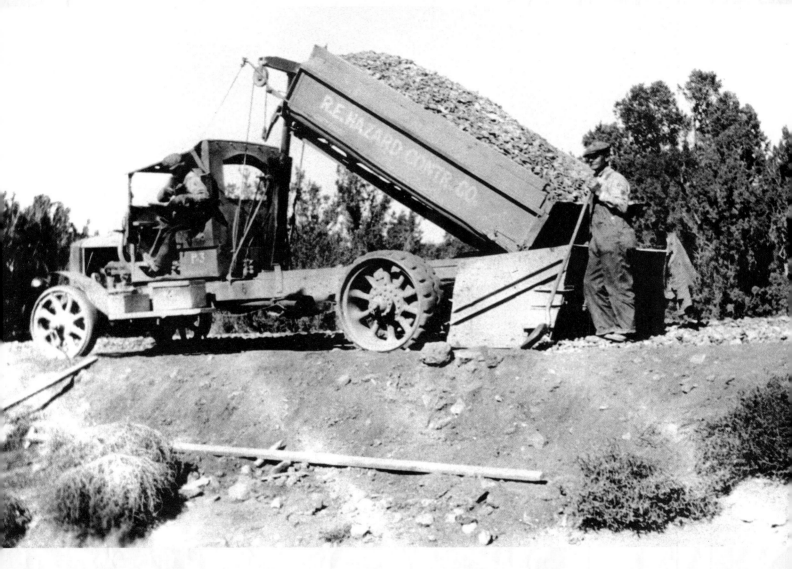

A R. E. Hazard dump truck moves road materials at the site of early U.S. Highway 66 construction. Flagstaff, Arizona, 1926. Courtesy of Cline Library Northern Arizona University

Connecting the Dots

"Mr. Avery wanted that traffic pointed from Chicago to St. Louis to Springfield, Missouri, to Joplin to Tulsa and then across Oklahoma, the Texas panhandle, New Mexico and Arizona to Los Angeles. . . . Mr. Avery got what he wanted, for he announced in Springfield that highway No. 66, which is the official name of the aforementioned route, will be completed in the near future. It is estimated that within a few months, the daily traffic on that highway will be more than 5,000 cars."

—The Oklahoman, January 23, 1927

Left: *On January 1, 1927, the Federal Bureau of Public Roads announced the official adoption of a simple black-and-white shield (with black numerals) to mark America's federal highways. At the time, twenty-two states had already adopted the shields with twenty more states still to follow. A New York Times article reported that "eighty-thousand miles of highways would soon be marked in this manner, resembling a giant checker board—linking section to section, each connecting to the other." Courtesy Jim Ross Collection*

Right: *This 1926 Texas license plate was issued the very same year that U.S. Highway 66 was born. As early as the 1910s, automobile license plates were adopted by most states to register machines that at one time roamed free. Courtesy Jim Ross Collection*

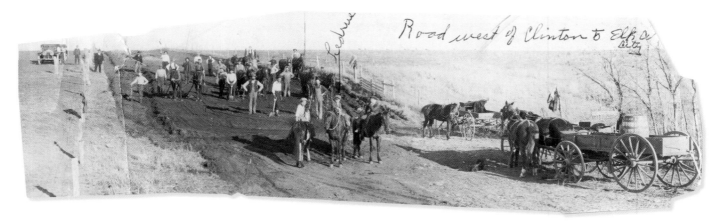

This road was being built the old-fashioned way, west of Clinton to Elk City and along the pre-U.S. Highway 66, circa 1910s. Courtesy of the Oklahoma Historical Society

On New Year's Day, 1927, the Federal Bureau of Public Roads announced a revolutionary new road-marking system that would forever change the way the public navigated America's roads. Uniform marking for U.S. Highways had arrived, proclaimed the *New York Times* on January 2. The feature story reported that eighty-thousand miles of highway would be marked in a manner resembling a giant checkerboard to link section to section and connect each section to the other.

The heady days of having to remember trail names, color bands, insignias, and other varied designations were over. Instead, a simple black-and-white shield with bold, black numerals provided all the route information that the motorist would need. At the time, there were twenty-two states with identification shields already in place. Twenty more markers followed to prepare the roadways for the 1927 automobile touring season.

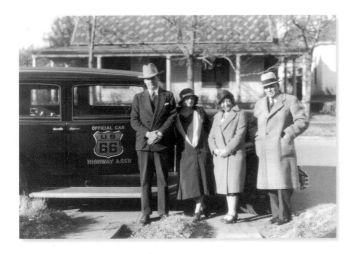

Members of the U.S. Highway 66 Association pose for a publicity picture at El Reno, Oklahoma, circa 1932. Left to right: Guy Weadick, Mabel Tompkins, Florence Weadick, and Charley Tompkins. Courtesy of the Oklahoma Historical Society

Now, motorists could determine—simply by looking at the highway number—which road they were traveling on and which direction they were going. The beauty of this synchronized system was in its simple numbering scheme: Main transcontinental lines received even numbers from ten to ninety, in multiples of ten. North-to-south routes were designated with odd numbers such as one, twenty-one, and thirty-one.

The single exception to the multiple-ten numbering rule was U.S. Highway No. 66. This significant anomaly did not escape the *New York Times* journalist who predicted that "No. 66 is a highway that is expected to prove of great importance."[1]

The numbering system proved to be an instant success, and it spawned a proliferation of new road maps, guidebooks, and tourist literature. Familiar names were still used to describe the best routes in all of these publications, but official highway numbers were added for clarity. As one guide informed, "The recommended route is the National Old Trails Road, as it has been known for years. This is now a combination of United States Routes 40, 50, 350, 85, and 66."[2]

As fast as the public could snap it up, the deluge of promotional material spurred a renewed wanderlust in Americans who promptly demanded (and then took) longer vacations. No longer satisfied with the standard two weeks per year, the emerging tourist "rebels" began to stake their claim to a four-week reprieve from their frenetic urban life. Folks with automobiles wanted leisure time . . . and plenty of it.

Newspapers of the day agreed with the notion that touring required a great deal of time and planning. As one *New York Times* vacation adviser wrote, "Most important, is the factor of time, a month at least, or perhaps a whole summer should be devoted to such a tour." There was a lot to see out there in the way of scenic wonders. It took far more than fourteen days to drive the most favored circuits.

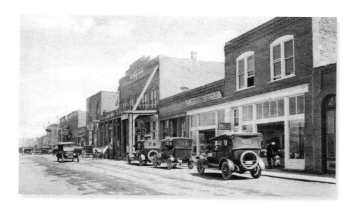

An unpaved Railroad Avenue is seen in 1926, the year it became part of U.S. Highway 66 in Gallup, New Mexico. As the years rolled by, Gallup came to life with neon signs. The new neon signs added miles of burning color to replace the painted signboards that are seen here. *Courtesy Steven Rider Collection*

Of these, the National Old Trails Road remained the most popular route for traveling east to west. The reasons were obvious, since this cross-continent path included America's most picturesque scenery. "It is celebrated for the wide diversification of its scenery, especially in the Southwest," continued the *Times*. "Along or near this highway are located the Grand Canyon of the Colorado River, the Petrified Forest, Painted Desert, the cliff dwellings and Indian pueblos, the Mohave [sic] Desert, Raton Pass, Walnut Canyon National Monument, and many other points of special interest."

Despite a tumbling stock market and a slumping economy, the 1930 tourist season broke all records: Forty-five million Americans headed for the highway. In July of that year, a national parks record was established with 1,142,141 visitors driving in during a single week.[3] In fact, traffic at the national parks and monuments was so high that twelve out of twenty-one opted to remain open year-round. The decision paid off for the Southwest, where parks experienced the heaviest traffic during the winter months.

At the same time, roadside entrepreneurs soon discovered that where tourists wander, so do their wallets. It wasn't pennies from heaven that were dropping down on businesses, but dollar bills. They added up fast and amounted to a whopping $3.5 billion in a single year.[4] Anyone who thought they had a gimmick that they could turn into cash jumped up on the running board of this money-making machine. Soon, a new racket called the "tourist trap" marked the American roadscape. It was an enterprise that was specifically designed to coax tourists to part with their money.

Ad men even found a way to bring in the customers who were speeding past in their automobiles. They unveiled an entirely new twist in advertising. The solution was simple, if not attention-getting: Roadside showmen employed the services of larger-than-life dinosaur sculptures, garish colors, immense billboards, far-fetched claims and slogans, grandiose promises, and oddly-shaped buildings to pique the interest of the consumer.

With all of the cars and all of the hoopla, the competition heated up quickly in all facets of roadside services. Hotels, motels, cafés, auto camps, diners, drive-ins, hot-dog stands, filling stations, repair garages, and other related businesses battled it out in the streets. All of them were competing and receiving their slice of the business.

William Bryant, chairman of the Detroit AAA was right on target when he said, "The large expenditure on motor vacations has a financial significance to the whole country."[5] Indeed, it did. When the roadside cake was finally divided up, the pieces were apportioned into hefty bites: $61.5 million was gobbled up by the restaurants and cafés; $51.9 million tucked in by hotels; $34.5 million wolfed down by garages and filling stations; $30 million taken away by public carriers; and $25.5 million laughed off to the bank by places of amusement.[6]

"Competition for the dollar of the traveler has to be one of the keenest struggles on the national arena . . . perhaps keen as anything business or industry has witnessed in the history of the world," said Bryant. The marker shields of Route 66 and other well-worn routes could easily have replaced the presidential portraits on our national currency. Money talked (and drove in cars) and suckers walked. Suddenly, life was very good for everyone who lived and worked along the highway that was officially designated as Route 66.

An unpaved stretch of U.S. Highway 66 at Flagstaff, Arizona, 1927. During the 1920s, some of the major roads in the United States were barely wide enough to accommodate two standard-sized passenger vehicles that were passing each other in opposite directions. *Author's collection*

Early Road Maps

Left: *The 1929 Best Roads of All States map booklet took motorists across the continent and provided them with paved road and road distance information. At this time, paved roads were still an anomaly.* Author's collection

Right: *The new federal highway numbering system proved to be an instant success and a well-organized guidance system that motorists of the day desired. Although a proliferation of new road maps, guidebooks, and tourist literature were published featuring the new highway numbers, familiar names were often used to describe the best routes. This 1932 combination National Old Trails Road and U.S. Highway 66 map was published by the Automobile Club of Southern California.* Courtesy Steven Rider Collection

The Official Western Road Map published by the Chicago Motor Club from 1932. The Chicago Motor Club was part of the American Automobile Association that formed in 1902, when nine motor clubs formed one large national organization. Like all regional offices of the AAA, each office provided travel information and road assistance for its members. It's a service that the AAA still provides today. Courtesy Steven Rider Collection

A Rand McNally atlas of the United States, circa 1920s. The National Old Trails Road is marked on telephone poles in red, white, and blue. By the 1920s, many states had adopted a uniform road marking and numbering system that aided the motorist's journey across the continent. Courtesy Steven Rider Collection

Mildred Pattschull and an All-Girls Cross-Country Trip

n 1932, Mildred Pattschull joined her friends Emily, Hazel, and Lucille to take a road trip. Not just any road trip or Sunday outing, mind you—but a cross-country journey that would take them all the way across America to the Pacific Ocean. The plan was to leave Clear Lake, Iowa, head west on Highway 65 through Missouri, and hook up with Route 66 in Oklahoma City.

"At first, I really didn't have a strong desire to go. California seemed a million miles away at the time," reminisced Mildred. "But my three friends were just dying to go, so I finally agreed to drive my car until it quit running Then we would just scrap it and come home."

It was a zany idea, especially during the Depression, but the four friends (ages nineteen to twenty-two) hit the road anyway. They were well prepared; each girl had a stash of a hundred dolors in her pocket—an enormous amount of cash for the time. Says Mildred, "I don't remember how we were able to save that amount . . . but we did. Even so, my mother was convinced she'd never see me again! Both of my parents openly cried in the front yard the day we drove off. They just didn't understand," said Mildred.

The worries of their elders weren't unfounded: At the time, most of the roads across America were rutted dirt lanes. There were few services and amenities afforded for the motorist. Nevertheless, Mildred and her friends were undeterred. They were up for a grand adventure and were out to "get their kicks on 66," regardless of the road conditions on the fledgling highway.

With great excitement, the fearless foursome "motored west and took the highway that's the best," to live out the words and imagery of the Bobby Troup song, "Get Your Kicks on Route 66," long before it was even thought of or written. The travelers had the time of their lives, and went through Oklahoma City "looking mighty pretty," then on to Amarillo, Texas; Gallup, New Mexico; Flagstaff, Winona, and Kingman, Arizona; Barstow, and San Bernardino, California.

Along the way, the foursome stayed in tourist cabins for a dollar per night and rented single rooms with a bed. Usually, toilet facilities were outdoors and the showers were in another building. They also saw little human contact on the stretches of empty road between towns. Arizona had only been a state for twenty years when they drove through it and it had a population of fewer than 500,000. Thankfully, *Ben Hur* chugged along faithfully mile after dusty mile, and averaged about twenty miles per hour.

"There was nothing—not one living thing—except sagebrush and sand along much of our trip," said Mildred. "It was a real no-man's land out there, and it took about three hours to drive between any signs of civilization—if you could call some of these tiny towns along Route 66 civilization.

"Even so, I'd really love to do that trip all over again today," she confides with a gleam in her eye. "That trip was a highlight of my life. Even though we were only gone a month, I felt as if I'd been transformed into adulthood when we got back." Changed for the better, the road opened up their world. Four friends made it to Los Angeles, California, in just eleven days, racked 3,900 miles on the car . . . and lived to tell the tale.

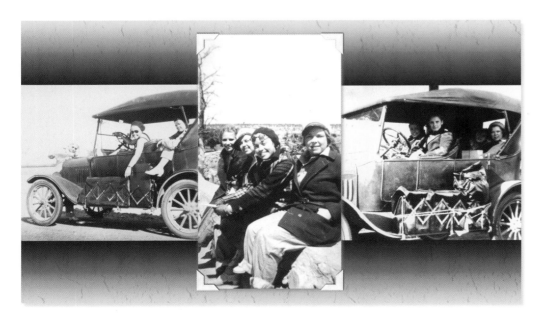

Mildred Pattschull sits behind the wheel (in right photo) of a Ford Model T that she purchased for $75—her friends Emily, Hazel, and Lucille look on in anticipation of their trip, 1932. Courtesy of Mildred Pattschull/Graphics Gyvel Dagmar Berkley

Effie Marx and Her Route 66 Tips

*E*ffie Marx got her tips along Route 66 longer than anyone else . . . and that's exactly why she was inducted into the Illinois Route 66 Hall of Fame in 1993. At the time, she was seventy-five years old and still pouring coffee and serving up roast beef and gravy sandwiches with a smile—always stopping for a friendly chat with locals. She began serving in 1931, five years after U.S. Route 66 became an official highway. Outside of an eight-year break (to raise her children), she continued slinging hash and waiting tables well past her retirement age.

While the highway is remembered with great fondness by others, the Dwight, Illinois, locals looked upon Effie as a celebrity in her own right. As one stated in a *Chicago Tribune* interview in 1995, "The only ones who don't know

Effie are strangers or foreigners. There isn't a native around here who doesn't know Effie."

During her long career, she worked for only four bosses, starting at the Colonial Inn (when she was fourteen). Next, she took a job at Virgil's Café where she met future husband Paul Marx. After the children came, she donned her apron once again and slipped right back into waitressing at the Sip n' Bit in downtown Dwight. She worked there until the 1970s when the interstate came through and traffic was drained off from old 66.

From there, she went on to work at Phil's Harvest Table.

Effie was the consummate people person. She always had a friendly smile for everyone. Sure, customers came in for the great food, but many came in to see their good friend Effie, too. She became a Route 66 fixture, someone the locals came to know and love as family.

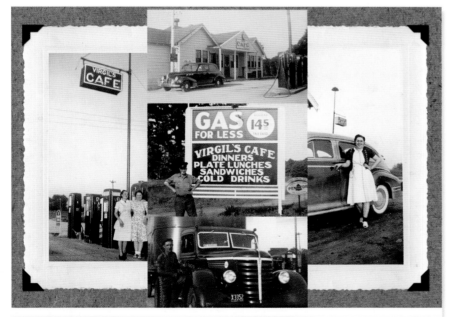

Top Group: *Effie Marx (far left) with sister-in-law Eileen McNamara at Virgil's Café gas pumps, a truck stop and motel along Route 66, circa 1940. Effie's brother-in-law Virgil Adams (center, front of sign) ran it. Eileen (far right) and center (below), a typical 1940s truck. Bottom: Effie Marx serving up a smile and coffee at Phil's Harvest Table, intersection of former Route 66 and Interstate 55, 1995.* Courtesy of Gary Marx/Graphic Art Gyvel Dagmar Berkley (top group), Chicago Tribune photo.

Bridges of Route 66

The Topock Bridge (also known as the Trails Arch Bridge) spans the Colorado River at Topock, Arizona, circa 1940. That year, the landmark bridge was featured in the film The Grapes of Wrath, where it was used by the Joad family as they drove their sputtering jalopy across it to enter the promised land of California. Courtesy of Arizona Historical Society/Tucson

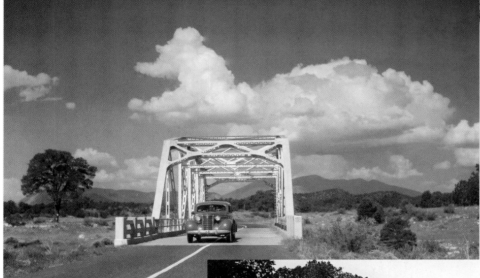

Located on the original alignment of U.S. Highway 66, the Walnut Canyon Bridge was typical of the simple roadway spans that traversed rivers and other geographical features in 1933. Courtesy of Arizona Historical Society/Tucson

The 1932 Parker Pony truss bridge that served U.S. Highway 66 traffic just west of downtown Wellston in Lincoln County, Oklahoma, still exists today and provides a safe crossing for modern cars and trucks. Courtesy of the Oklahoma Department of Transportation

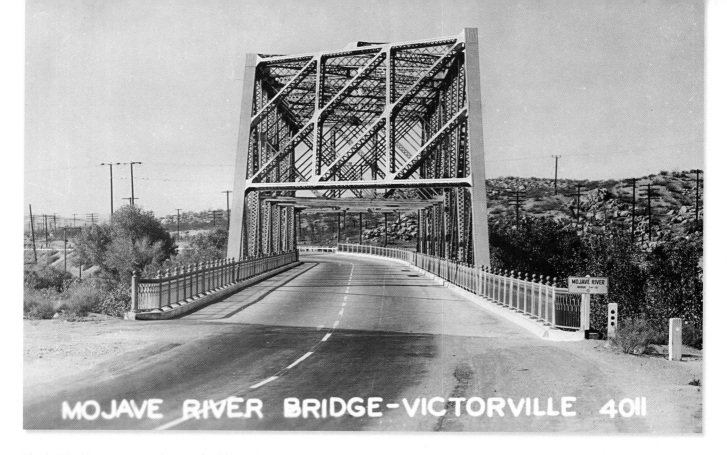

MOJAVE RIVER BRIDGE-VICTORVILLE 4011

The 1930s Mojave River Bridge—a durable steel truss design—spans a river that for the most part flows beneath the surface. The river rises in the San Gabriel Mountains, then flows northeast for about a hundred miles through Victorville and Barstow, California, before burying itself in the sand. This stretch follows the National Old Trails Road route. Courtesy Steven Rider Collection

Above: According to the Federal Aid Project records, this steel and concrete bridge once carried U.S. Highway 66 traffic on the Claremore to Chelsea stretch in Roger County, Oklahoma. Courtesy of the Oklahoma Department of Transportation

Right: With thirty-eight engineered spans, the Pony Truss Bridgeport Bridge was completed on July 1, 1933. It was one hundred feet in length, and the structure crossed the South Canadian River. It was believed to be Oklahoma's longest truss bridge. Sadly, the completion of the span and the subsequent bypass sealed the fate of Bridgeport, which turned into a ghost town (with Calmut and Geary). From 1921 to 1933, a suspension structure called the Key Bridge carried traffic into Bridgeport. Courtesy of the Oklahoma Department of Transportation

Gas Stations of the Mother Road

The Marland Oils Service station at U.S. Highway 66 in El Reno, Oklahoma, circa 1926. In those days, it was full service all the way, with "wiping the windows and checking the oil" included. Courtesy of the Oklahoma Historical Society

Camp Jackson, located at 3300 Lincoln Boulevard (U.S. Highway 66), Oklahoma City, Oklahoma, circa 1929. The tidy, four-pump station served up a mix of Phillips 66 fuel, groceries, and, of course, barbecue. Courtesy Steven Rider Collection

The Route 66 town of McLean, Texas, was born from the railroad in 1901. As it happened, the Choctaw, Oklahoma, and Texas Railroad Company drilled a well and the resulting community that sprouted up named itself after W. P. McLean of the Texas Railroad Commission. This 1929 station served Mobiloil gasoline. By 1948, it was one of sixteen service stations pumping fuel in McLean. Courtesy Steven Rider Collection

Above: *The Cliff House in Newberry Springs, California, circa 1929 provided full service for the long-distance traveler, including Mobiloil gasoline, cabins, and free air for the tires. Newberry Springs was located along the National Old Trails Road. Its aquifer was a source of water for desert residents and the steam-powered railroad trains.* Courtesy Russell Olsen

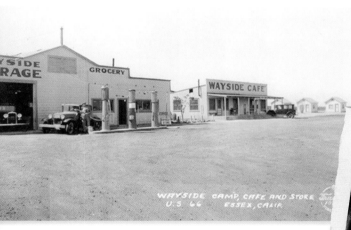

Above: *Wayside Camp, café, and store along U.S. Highway 66, located in Essex, California, circa 1929. This is an early example of the full-service travel center along the roadside. It was places like this that built the American tourist trade from scratch and paved the way for the mega truck stops of today.* Author's collection

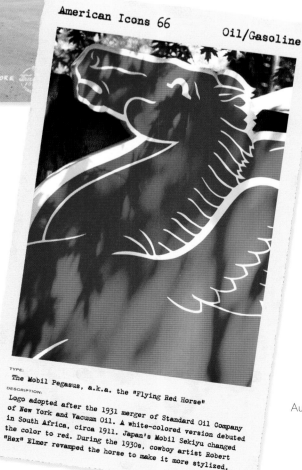

American Icons 66

Oil/Gasoline

TYPE:
The Mobil Pegasus, a.k.a. the "Flying Red Horse"

DESCRIPTION:
Logo adopted after the 1931 merger of Standard Oil Company of New York and Vacuum Oil. A white-colored version debuted in South Africa, circa 1911. Japan's Mobil Sekiyu changed the color to red. During the 1930s, cowboy artist Robert "Rex" Elmer revamped the horse to make it more stylized.

Author's collection

Tourists Welcome Here

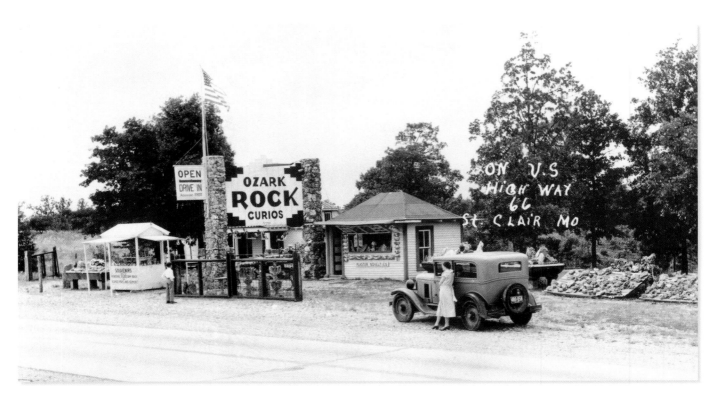

In 1929, American tourists spent $3.5 billion. Some of it was surely spent at a place called the Ozark Rock Curios, St. Clair, Missouri, circa 1929. Roadside entrepreneurs discovered that where tourists wander, their wallets go with them. New advertising twists were needed to bring in the motorists. At the Ozark Rock Curios, it was the "Drive In—Admission Free" slogan that lured tourists out of their cars. The shop offered "mineral blossom rock" and "shaped Portland cement," along with other delights. Courtesy Russell Olsen

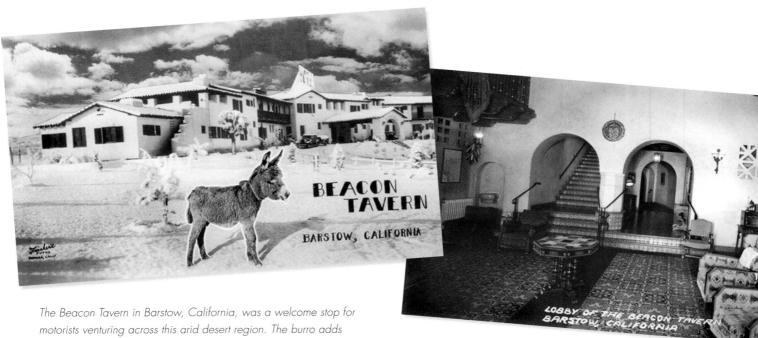

The Beacon Tavern in Barstow, California, was a welcome stop for motorists venturing across this arid desert region. The burro adds another whimsical element that is intended to capture the imaginations of tourists and fulfill their fantasies for what they thought a place should be. Author's collection

The lobby of the Beacon Tavern in Barstow, California, was a great place to sit, read, and relax. Author's collection

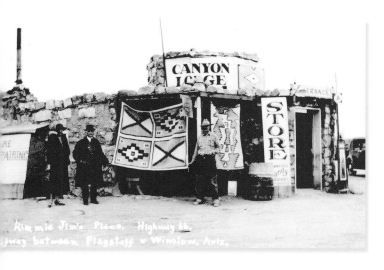

"Rimmie Jim's Place, Highway 66 halfway between Flagstaff and Winslow, Arizona," was another roadside attraction that was designed to slow the speed of passing motorists and capture their imaginations with never-before-seen, local curiosities. Circa 1920s. Courtesy of Cline Library Northern Arizona University

The Amboy Crater, California, circa 1934. The Amboy Crater is a 250-foot volcanic cinder cone that remains a popular tourist attraction along U.S. Highway 66. According to popular theory, the immense cone experienced volcanic activity some five hundred to six hundred years ago. Courtesy Steven Rider Collection

Left: Mitchell Caverns featured a variety of amazing mineral formations that made it a bona fide tourist attraction along U.S. Highway 66. Courtesy Steven Rider Collection

Below: Mitchell's Caverns, called Eyes of the Mountain by Native Americans, was named for Jack Mitchell, its first promoter. During the late 1920s, Mitchell staked out several claims in the area after realizing that there was potential for a tourist attraction. He moved his family to the location and opened up a "resort." The first cavern tours were conducted in 1932 using kerosene lamps and railroad flares. In 1956, the caverns and the surrounding land were acquired by the California Department of Parks and Recreation to become the only limestone caverns in California's state park system. Courtesy Steven Rider Collection

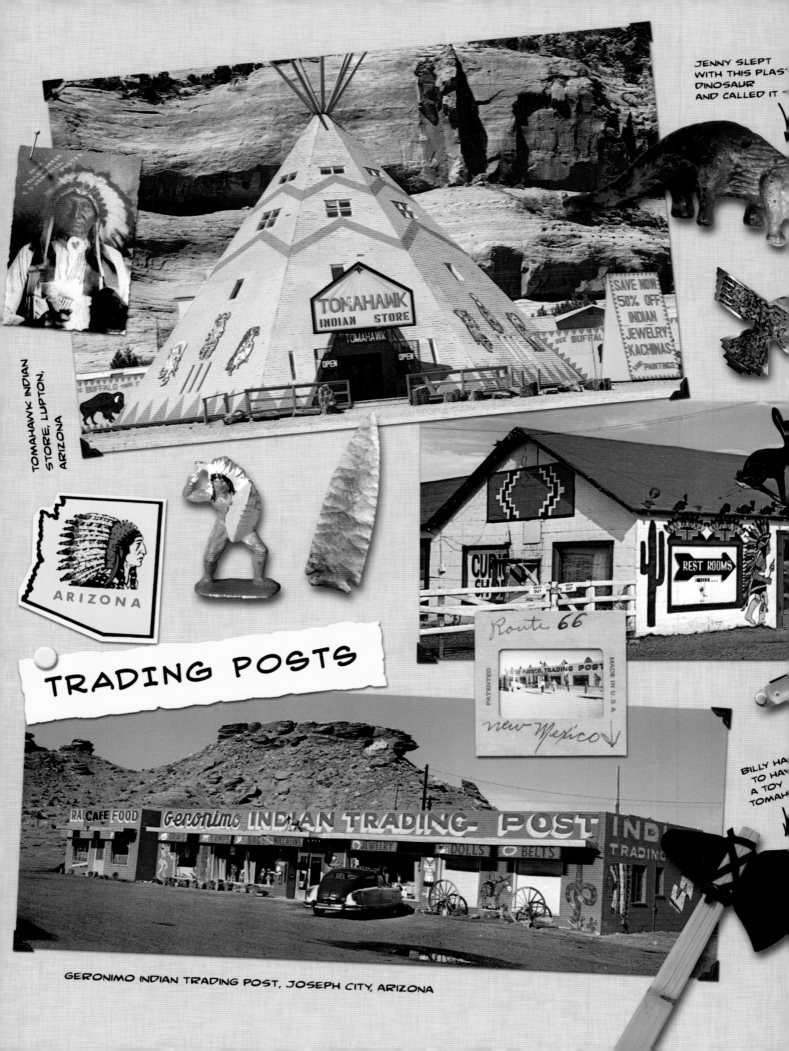

JENNY SLEPT
WITH THIS PLAST
DINOSAUR
AND CALLED IT "

TOMAHAWK INDIAN STORE, LUPTON, ARIZONA

ARIZONA

Route 66

new Mexico ↓

TRADING POSTS

BILLY HA
TO HAV
A TOY
TOMAH

SAVE NOW!
50% OFF
INDIAN
JEWELRY
KACHINAS
SAND PAINTINGS

CURIO
SHOP

REST ROOMS
INSIDE...

RA CAFE FOOD Geronimo INDIAN TRADING- POST IND
TRADING
JEWELRY DOLLS BELTS

GERONIMO INDIAN TRADING POST, JOSEPH CITY, ARIZONA

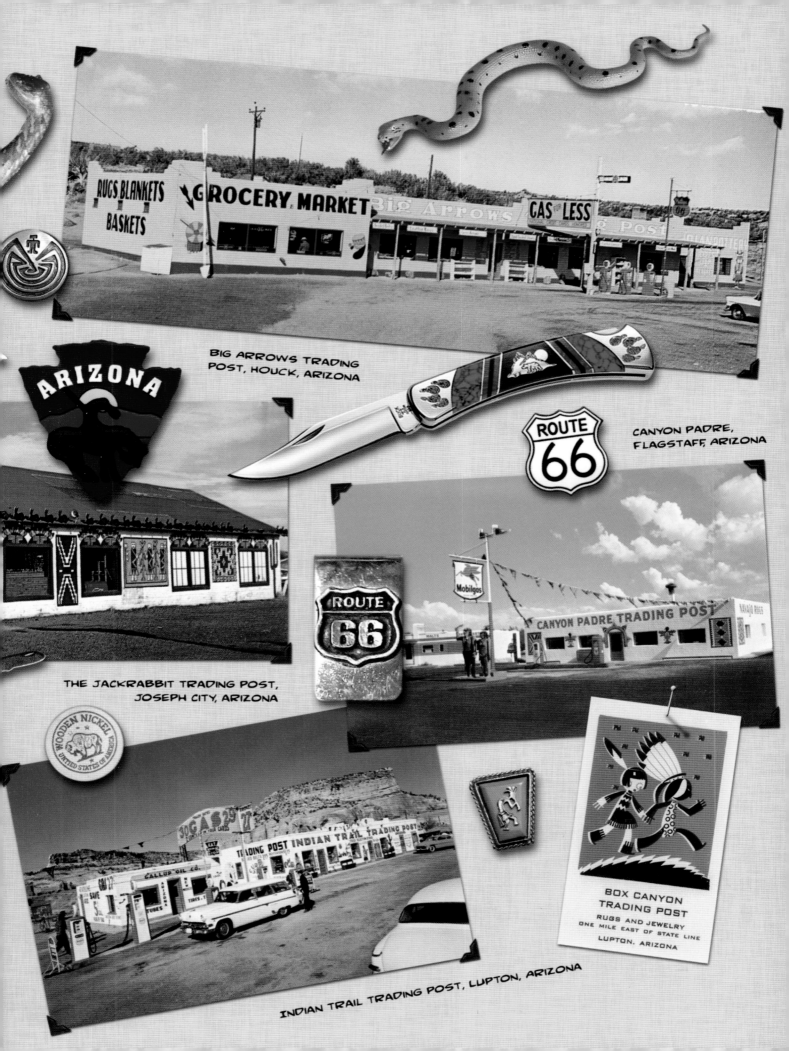

BIG ARROWS TRADING POST, HOUCK, ARIZONA

CANYON PADRE, FLAGSTAFF, ARIZONA

THE JACKRABBIT TRADING POST, JOSEPH CITY, ARIZONA

BOX CANYON TRADING POST
RUGS AND JEWELRY
ONE MILE EAST OF STATE LINE
LUPTON, ARIZONA

INDIAN TRAIL TRADING POST, LUPTON, ARIZONA

Early Lodging along Route 66

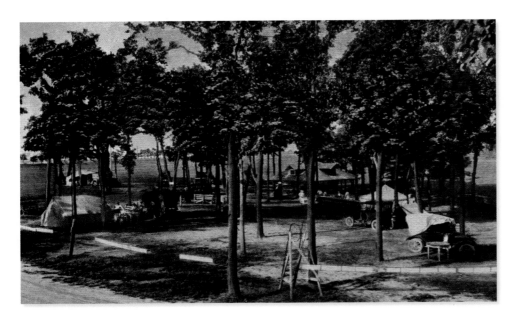

The free campgrounds at Schifferdecker Park in Joplin, Missouri, circa 1929. Historical marker: "Schifferdecker Park, Formerly Electric Park (1909–1912), is traced to a multi-acre dairy farm in the 1890s. Charles Schifferdecker acquired the land in the early 1900s. On November 1, 1913, he deeded forty acres to the city of Joplin. Schifferdecker Park eventually expanded to 160 acres. Schifferdecker Municipal Golf Course opened in 1922. In 1931, a concession stand was converted into the Tri-State Mineral Museum . . . " Courtesy Steven Rider Collection

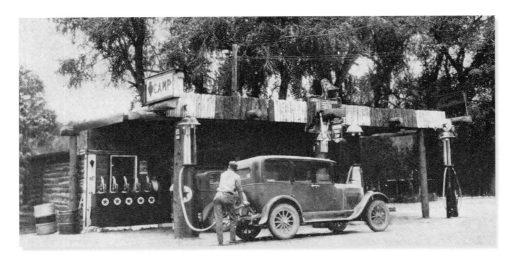

Arrow-Head Camp on U.S. Highway 66 was located twenty-two miles east of Santa Fe, New Mexico, circa 1929. To the left of the building are Texaco oil lubesters. Back then, motor oil didn't come packaged in disposable plastic. Glass oil containers with long, metal spouts were filled with the bulk lubricant that was pumped from these units. Courtesy Steven Rider Collection

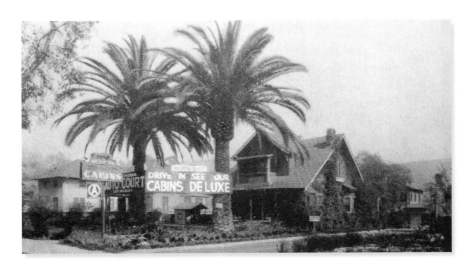

The Modern Cabins, located on U.S. Highway 66 in Los Angeles, California, was owned and operated by Mr. and Mrs. Charles Servais. By the late 1920s, cabin owners had transitioned from the role of the auto camp owner to the more genteel role of innkeeper. This one was proud to offer all the amenities of home. It wasn't always like that; in the beginning, many proprietors hesitated to offer simple necessities such as beds and tables for fear that the unpredictable tourist might steal anything that was not tied down. Courtesy Steven Rider Collection

Gate City Auto Camp, San Bernardino, California, circa 1929. By way of its numerous amenities, this "camp" was transformed into what came to be known as a "motor court." The cabins featured hot and cold running water, private toilets, and beds with Simmons mattresses. Rooms were equipped with gas ranges, heaters, and electricity. The camp offered a playground, fully stocked grocery store, and an ice depot. Richfield gas and oil were available, along with crank case and battery service. Courtesy Steven Rider Collection

Courtesy Steven Rider Collection

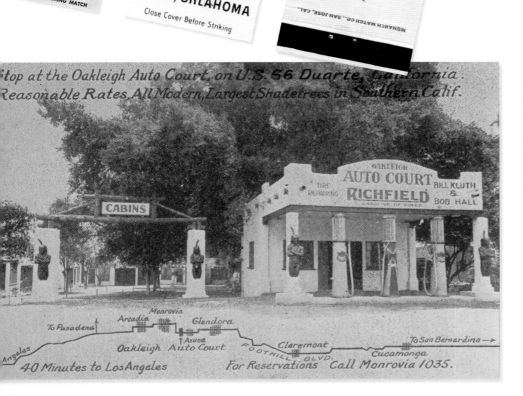

The Oakleigh Auto Court, Duarte, California, circa 1929. This overnight accommodation featured Native American touches, most notably its pueblo-style architecture. The portion of U.S. Highway 66 shown on this card followed the National Old Trails Road. Courtesy Steven Rider Collection

Route 66 Scenic Views

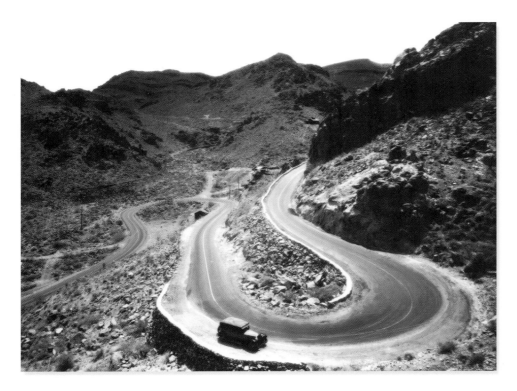

One of the most treacherous stretches of the old road was U.S. Highway 66 at Gold Roads in Oatman, Arizona. To navigate these hills, you needed a good engine, sturdy tires, and a sound radiator. Courtesy of Arizona Historical Society/Tucson

Below: A park road at the Grand Canyon, open to tourist traffic in 1929. In 1917, the U.S. Park Service distributed 83,000 automobile guidebooks in order to promote tourist visitation. That year, more than 55,000 cars entered the parks. By 1926, the number of auto tourists entering the parks had reached 400,000. Park roads served to attract tourists and also controlled them by restricting motorcars to certain portions of the park. Courtesy of Arizona Historical Society/Tucson

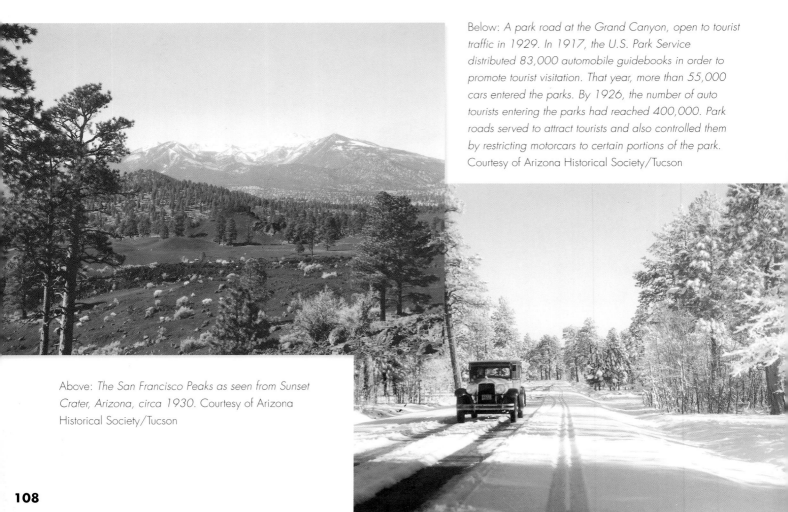

Above: The San Francisco Peaks as seen from Sunset Crater, Arizona, circa 1930. Courtesy of Arizona Historical Society/Tucson

Until 1915, national parks were not open to motorists and visitors were not even allowed to hike in the parks. The only way to go sightseeing in the parks was through government concessions such as horse-drawn stages. The American Automobile Association organized a fight against the government's rules that prevented citizens from seeing the very parks that were preserved for their enjoyment. Once the barricades for motorcars and tourists were removed, the parks experienced a throng of touring motorists. The park visitors were all clamoring to see sights like the Eagle's Nest at the Petrified National Park, Arizona, shown here circa 1933. Courtesy of Arizona Historical Society/Tucson

U.S. Highway 66 crosses the Arizona–New Mexico state line, circa 1940. Courtesy of Arizona Historical Society/Tucson

A view of U.S. Highway 66 located between Williams and Parks, Arizona, shows old oil pavement (tarmac) before reconstruction of the road began, circa 1933. Courtesy of Arizona Historical Society/Tucson

Seema Aissen Weatherwax
Photographer and Assistant to Ansel Adams

". . . I always carried my camera with me. Because I always thought, well, I might run into something interesting. And I was into photography, that was my favorite . . . I was just seeing what I saw, and I wanted to keep a memory for myself and others—for you know—later years."

—Seema Aissen Weatherwax
Interview, March 29, 2006

There was nothing common about Seema; her petite frame exuded an effervescent spirit that reached across political, racial, and economic boundaries. She had a passion for life and living; she endued even pedestrian matters with an artistic character. Seema Aissen Weatherwax, photographer, equal-rights supporter, and political activist, died on June 25, 2006. She was nearly 101 years old.

Some said that Seema was a late bloomer. Two days before her one hundredth birthday, her biography *Seema's Show: A Life on the Left,* written by Sara Halprin, was released. At the age of ninety-five, she held her first one-woman photography show. By then, she had been honored with a variety of awards and recognized for her work, including being named 1999 Woman of the Year by the California State Assembly. Age, it appeared, was no obstacle.

"There was nothing in sight except this couple walking with a little baby . . . That is when I took my first picture . . . because the scene was so dramatic." —Interview, Seema Weatherwax, 2006. ©2007 Seema Weatherwax

Neither was gender. From 1938 to 1941, she worked as the darkroom technician for Ansel Adams. Still in its infancy, photography was a revolutionary art form and a male-dominated discipline. But that didn't stop Seema, who painted with a camera as skillfully as the rest.

"Ansel had no idea how much photography I was doing," she said. "He occasionally saw a print of mine and liked it—he felt I had the 'feeling,' which is why he trusted me, but when I went with him and Edward Weston, I was seen as a friend and not a third photographer, even though I was there taking photographs, too."

In 1941, Seema traded her darkroom oath for marriage vows to John Weatherwax, a Los Angeles writer and journalist. Shortly thereafter, she found herself on the road to adventure when she joined her new husband and Woody Guthrie on a trip to Camp Shafter in Bakersfield, California. They were planning to meet with Fred Ross, the camp's administrator, to invite the residents to a fundraiser benefit in their honor. However, the events on the road that day were equally—if not more—interesting than what later occurred at the camp.

The three left Los Angeles for Bakersfield, and soon Woody and John broke out in song. Seema remained silent, but she listened to the songs' words and enjoyed the camaraderie. She was excited to be involved in something solid to help the Dust Bowl victims, and she relished the idea of meeting and speaking with the camp's population.

Unlike Dorothea Lange, she had no plans to document the events. "I was not thinking photographically, except I always carried my camera with me," Seema explained. "Because I always thought, well, I might run into something interesting. And I was into photography, that was my favorite. There wasn't actually any kind of story or anything, I was just seeing what I saw, and wanted to keep a memory for myself and others, for—you know—later years."

About twelve miles before Bakersfield, they encountered a couple carrying a baby. Seema described the scene: "There was nothing in sight except this couple walking with a little baby. We drove past them without thinking at first and then realized that they're hitchhiking, and decided we better pick them up and find out where they're going. That is when I took my first picture . . . because the scene was so dramatic."

The couple gladly accepted the ride. They settled into the backseat and it was then that their sad plight came to light. They were from Oregon and the man had lost his

Woody Guthrie (left) with Fred Ross, the administrator of the government camp at Bakersfield, California, in 1941. Woody often sang at migrant camps and had a deep affinity for "Okies," because he was one of them. Born on July 14, 1912, in Okemah, Oklahoma, he left in 1931 for the panhandle town of Pampa, Texas, where he married and had three daughters. The mid-1930s dust storms covered the panhandle and drove Woody out to California. In 1935, he joined the throng of Dust Bowl refugees who were seeking a better life in California. He left his family behind, hopped freight trains, hitchhiked, and walked until he reached "the promised land." ©2007 Seema Weatherwax

sawmill job of twenty years. He was diagnosed with silicosis, a disease caused by lung damage. The company paid him two hundred dollars and forced him to sign a document that released them from all future damage. After that, they fired him. When the money ran out, the couple headed to California to seek a friend who might direct them to work.

"He was tall, probably a good-looking man when he was okay," Seema continued. "But it was obvious that something was wrong with him, he was quite pale and had red splotches on both cheeks. They had this little baby, about a year old . . . a lovely, smiling little baby, clean as a whistle, dressed in a cotton dress, and she was pregnant with another child. They'd been traveling with only a little money, enough for a little bread and milk."

She added, "But they hadn't been in touch with this couple for some time. So I was starting to get a little worried, here they were coming with a pregnant wife, no job, and obviously very sick. So we decided to go with them right to the motel."

When they arrived at the motel, Seema, John, and Woody stood by as the man from Oregon awkwardly knocked on the door. A man opened up and said, "Hello," but his voice dropped when he saw the couple. "Nice to see you, where are you going to?" he continued. The man from Oregon replied, "Well, we were hoping that we could stay here while I get a job." The other man responded, "What are you going to do?" And the man from Oregon

Seema Weatherwax was born in the Ukraine in 1905. In the words of Jason Weston, the great-grandson of Edward Weston, "Seema loved cultivating relationships and made efforts to bring people from all different areas of her life together. What is left is a huge network of people who all know each other because of her." Seema, a friend and colleague of Ansel Adams and Edward Weston, exuded an effervescent spirit that reached across political, racial, and economic boundaries. ©2007 Jason Weston

said, "We were hoping we could stay overnight and tomorrow I'll go looking for a job."

But his friend replied, "Well, we have no rooms. They're taken." That's when Woody stepped in and told the man, "Look, they've been sleeping outside, they haven't had any rest, why I'm sure they're happy to sleep on the floor here. It would be much better than what they've been doing. They came from Portland, Oregon, all the way to Bakersfield, you can image how much stress they could have had." The friend replied, "Well, we don't usually do things like this."

Seema continued, "We had to negotiate for the man because he was so abashed. It finally sounded like the 'quote unquote friend' said okay. At that point, we really had to leave because we were holding up the other people at the camp. After we were about ten miles down the road, I looked in the backseat and saw her purse."

When they returned to the motel to return it, they discovered that the man from Oregon and his wife were gone. The couple had decided to take to the road over

their unwilling host's living room floor. Although the trio drove for several miles in all directions looking for the couple, they were not to be found.

In the hope that the purse might offer some contact information, Seema and her companions opened it. "Inside, there was a handkerchief, and some little toy for the baby, and a little wad with coffee grounds in it, and less than a dollar in change," Seema said. "That was all there was in her purse." They drove back to the motel and left the purse with the unwilling host in the hopes that the couple might return and retrieve it.

At last, the group arrived at Camp Shafter. While Woody went off to sing, Seema set up her camera. Her poignant portraits tell the bittersweet story of that day—revealing the renewed hope of a group of people that were considered society's outcasts and the heartbreak of a couple who hitchhiked from Oregon to California, only to be rejected by a person they thought was a friend. Seema captured on film—for all eternity—a day that will live on forever.

Dust Bowl days, Liberal, Kansas, 1936. ". . . when the dust piled up to the window sills, then began to stack up against the panes, the old settler moved out. His wheat had been blown into the gritty heavens, anyway. He used to have a farm: now it was pretty near a desert."

—The Oklahoman, 1935.
Arthur Rothstein/Library of Congress

Chapter Six

The Road of Flight

"Harry Wahlgren dusted his instruments and predicted a gradual quieting of the angry northwestern gale, which spread a saffron shroud over Oklahoma Wednesday afternoon, blotting out an eerie blue sun and giving a new impetus to the exodus of the weary, discouraged farmers from the ravaged Oklahoma panhandle."

— The Oklahoman, *April 11, 1935*

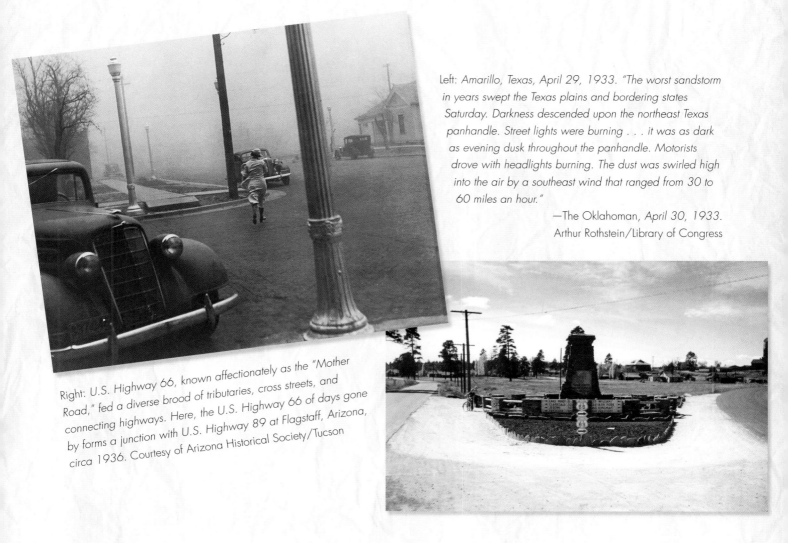

Left: *Amarillo, Texas, April 29, 1933. "The worst sandstorm in years swept the Texas plains and bordering states Saturday. Darkness descended upon the northeast Texas panhandle. Street lights were burning . . . it was as dark as evening dusk throughout the panhandle. Motorists drove with headlights burning. The dust was swirled high into the air by a southeast wind that ranged from 30 to 60 miles an hour."*

—The Oklahoman, *April 30, 1933.*
Arthur Rothstein/Library of Congress

Right: *U.S. Highway 66, known affectionately as the "Mother Road," fed a diverse brood of tributaries, cross streets, and connecting highways. Here, the U.S. Highway 66 of days gone by forms a junction with U.S. Highway 89 at Flagstaff, Arizona, circa 1936. Courtesy of Arizona Historical Society/Tucson*

By 1933, the final paved twelve miles of U.S. Highway 66 between El Reno, Oklahoma, and the east end of the new Canadian River bridge near Bridgeport was open to traffic. Paving from Bridgeport westward to Clinton had been completed in 1931. The highway was almost entirely surfaced; the only remaining stretch was a three-mile gap of in-progress paving between the west end of the bridge and the town of Bridgeport.[1]

Under different circumstances, this significant occasion might have been cause for Oklahomans to celebrate. Yet, the festivities were squelched by winds that were beginning to whistle under the windowsills of many farmhouses. The eerie howling foretold of a climate that was changing. Within a few short years, America's central states would experience the most severe drought of the twentieth century.

It all began with a few rain-starved years that dried up the landscape, turning green into yellow and spawning choking billows of dust. By 1935, dry regions stretched from New York and Pennsylvania across the Great Plains and into California. What came to be called the Dust Bowl covered about fifty million acres in the south-central plains.[2]

In Oklahoma, the tumbleweed became a familiar sight as winds whipped through the panhandle, wearing down crops, trees, and even houses. Nature literally sandblasted the land with relentless gusts of air that stripped fields bare, scraped off topsoil, and deposited tons of dust upon the fragile earth. As far as the eye could see, the only thing visible was barren, white, sickly soil.

The dunes of white were unyielding to the plow, and neither man nor beast could force food from the unfertile soil. "I quit my farm and I'm going to town to try and find something to do," declared one farmer. "I've just had nine hundred acres of wheat blown out in a dust storm. Fifth crop failure in a row. It ain't worth it."[3]

Thousands of jackrabbits—doomed to starvation—swarmed like two-eared locusts to find whatever tidbits of food that remained. They devoured any stubble that grew from the ground and turned their attention to the meager crops that farmers coaxed from the anemic earth.

"The rabbit hunt is now a community affair," reported the 1935 *Panhandle Gazette.* "In the panhandle they hunt with clubs, though more prosperous neighbors in counties farther east use guns. The rabbits are fed to the hogs and chickens—nothing that represents food is being wasted in the panhandle."

As farmers battled the invasion of lepus, a sinister new disease called "dust pneumonia" was born as a result of the unceasing winds. The *Kansas City Star* reported "At Palco, Kansas, 2 month-old Shirley Ann Frazier and her sister, Bernita Ann, 13 years old, were dead of pneumonia, caused by breathing dust a few days ago. A tiny baby's death also was laid to complications resulting from the dust." Doctors were perplexed. There were no known remedies for the condition except to advise people to remain indoors and to wear masks over their noses and mouths.

But there was even more suffering to come. One by one, farmers saw their hope of a future decimated. One man who had lived on the edge of Oklahoma's Cimarron County since the turn of the century boasted that he "was darned if he'd move." But each year, the sand blew a little

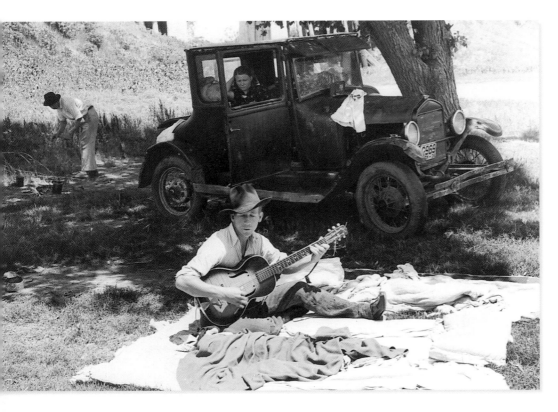

Roadside Oklahoma, 1939. "It was hard riding in that there car, working in the fields all day, but at night I had my guitar and that I wanted to play. It put a song in my heart and lifted my spirit and so that tired feeling—well it went plum away." Russell Lee/Library of Congress

Automobile from Texas, 1936. With failed crops and dust storms dogging them, Texas drought refugees fled the panhandle for California in 1936. One year later, their plight was reported in Life *magazine, which portrayed ". . . the Texas panhandle as a wasteland from which farmers are fleeing while buzzards perch on fallen buildings." The paintings that accompanied the article were captioned, "As Desert Conquers Texas Prairie." Dorothea Lange/Library of Congress*

It sounded like a perfect match. The Dust Bowl refugees were willing to work . . . and to work hard. Proud Oklahomans, Missourians, Arkansans, and Texans would do anything to earn their place in the sun again. They yearned to live where the crops would grow and to be, at long last, shed of the dust scourge.

Decrepit Model Ts that were overloaded with household belongings and people turned westward. The vehicles sputtered and bounced on sagging springs, and filled many feeder roads that joined up with the central artery, the lifeline, and the new transcontinental route—the "Mother Road."

Route 66 cradled them and took them into her arms. She became more than just a thoroughfare that hosted vacationers and those out to see the sights. Sixty-six was the escape route that guided the throngs of dispossessed safely to a new land. For the refugees of the central states, the hope—the promise—of a fresh and better life was just over the horizon and up around the bend.

more and became a little denser. Finally, the winter of 1935 blew in such terrific sand storms that it became too much for him. "When the dust piled up to the window sills, then began to stack up against the panes, the old settler moved out," reported *The Oklahoman* in 1935. "His wheat had been blown into the gritty heavens, anyway. He used to have a farm: now it was pretty near a desert."

On Wednesday, April 11, 1935, the worst dust storm on record pushed all of the remaining holdouts over the edge. The storm remained unabated for two days and dumped tons of silt upon the land. A sobering headline printed in *The Oklahoman* declared, "Record Barrage of Dirt Sends Families Out of Panhandle in Search of Homes Elsewhere."

Visibility throughout central Oklahoma was cut to one-fifth of a mile, but as the article explained, "this was mild compared to the northwest sections of the state, where dismayed housewives could not see from living room to kitchen, and walking left footprints on dust-covered floors."

Farmers could only look wistfully at once-rich wheat fields that were transformed into desert wastelands. Now what would they do? Where would they go? With nothing left but hope, they gathered together, loaded their furniture into trucks, and formed a ragged caravan of cars. The road offered the only escape route and alternative: exodus.

Some had heard of a distant place called "the Promised Land." Folks said California was lush, green, and filled with ripe crops—they even had oranges there! Best of all, there was work to do and available jobs. California farmers needed field hands to help pick all those ripe vegetables, succulent fruits, and fluffy cotton.

Roadside California, 1935. "It was a two-lane highway, but there were places we could pull over and camp at night . . . we had fried potatoes and chopped wieners. We all had a portion, but we didn't pig out." — Interview, Iva Townson Helm, 2006 (speaking about her family's 1935 journey from Oklahoma to California along Route 66). Dorothea Lange/Library of Congress

Fleeing the Dust Bowl

Cimarron County, Oklahoma, April 1935. The worst "roller," or dust storm on record struck Oklahoma without mercy on Wednesday, April 11, 1935. Throughout the night, tons of silt swirled thousands of feet into the air from parched wheat lands and then it slowly settled back down, hundreds of miles away. Devoid of rain, the dirt-filled clouds turned everything dark. For Woody Guthrie, an ominous cloud like this became the inspiration for a new song, "So Long, It's Been Good To Know You." When he witnessed a roller over Pampa, Texas, he thought the end of his life was near. Arthur Rothstein/Library of Congress

Known as Weedpatch Camp in John Steinbeck's The Grapes of Wrath, California's Arvin Migrant Labor Camp welcomed tired agricultural workers in 1936. At one time, government camps were a safe haven for many displaced refugees and their children. When this photograph was taken in 1936, the camp housed about three hundred people. Dorothea Lange/Library of Congress

Left: *A picturesque scene of California orange groves and snowcapped mountains, 1930. After winding through the "good mountains," as Steinbeck called them in his novel* The Grapes of Wrath, *Route 66 wound gracefully down through a pass, where all the splendor of the California dream was visible, for all new arrivals to see. Waiting below was a beautiful valley with orchards, vineyards, houses, and a city—a lush, inviting paradise.* Courtesy Steven Rider Collection

Right: *A twenty-four-year-old father and seventeen-year-old mother hitchhike to look for work as field laborers in California, circa 1936. "The droughts came and dried the land, which the wind then blew away, and began the great migration still talked about today. Families left with nothing but dry and barren farms, desperation in their hearts, hungry babies in their arms." — Ron Langely,* Ode to the Weedpatch Woman. Dorothea Lange/Library of Congress

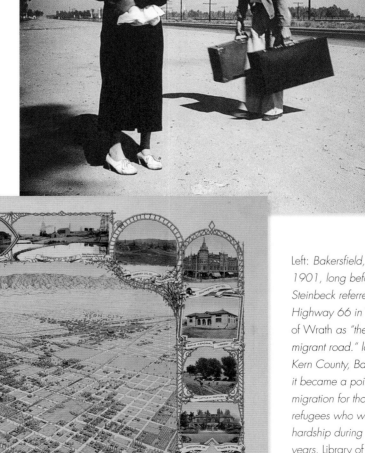

Left: *Bakersfield, California, 1901, long before John Steinbeck referred to U.S. Highway 66 in* The Grapes of Wrath *as "the main migrant road." located in Kern County, Bakersfield and it became a point of migration for thousands of refugees who were fleeing hardship during the Dust Bowl years.* Library of Congress

Dust Bowl Refugees

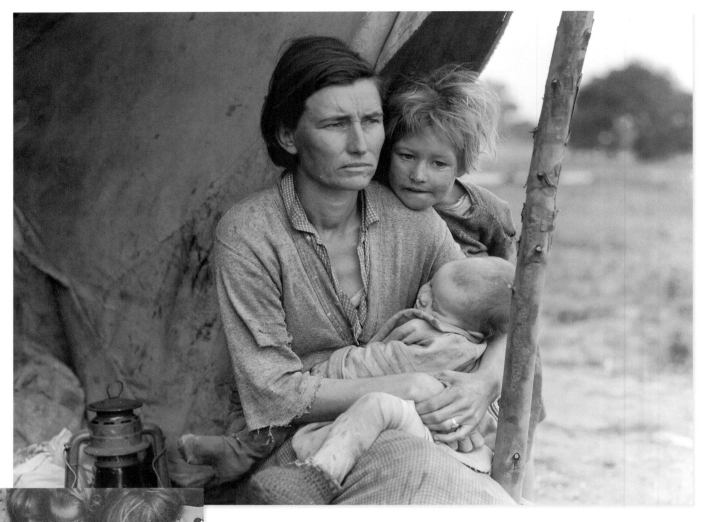

Above and top of next page: *Nipomo, California, 1936. Entitled Migrant Mother, this classic photograph epitomizes the plight of women during the times of the Dust Bowl and Great Depression. Florence Thompson was a full-blooded Cherokee and a thirty-two-year-old mother of seven. After the car overheated and broke down, her family was stranded and reduced to living in a tent. When photographer Dorothea Lange introduced herself and asked if she could take some photos for the Farm Security Administration (FSA), Florence reluctantly agreed. Lange assured her that the images were not for publication. Nevertheless, the poignant photograph of Florence made it directly to the front-page news on the very next day. The picture inspired locals to visit the camps and provide food, clothing, and care for those in need. Ironically, Florence wasn't there to see it—she and her family had already moved on. Dorothea Lange/Library of Congress*

Left: *Preschool children and baby, Arvin Migrant Labor Camp, California, 1936. When John Steinbeck's fictional Joad family finally reached California in The Grapes of Wrath, they didn't receive the welcome that they had hoped. Living conditions were rough and the jobs were few. It wasn't until they found a government-run migrant camp like this one that life could return to some semblance of normality. Dorothea Lange/Library of Congress*

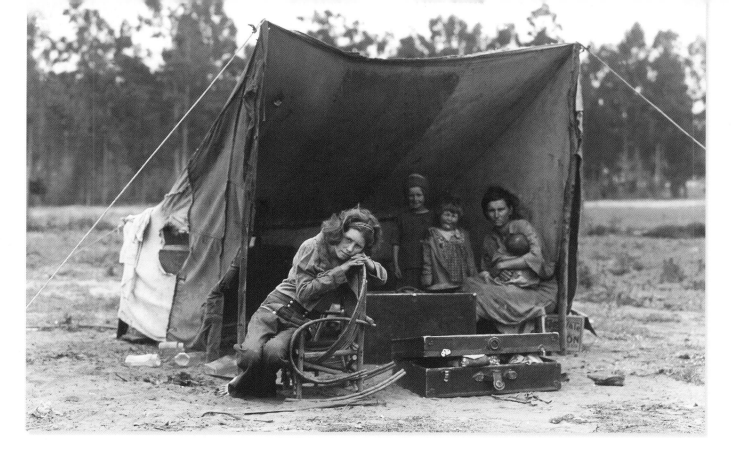

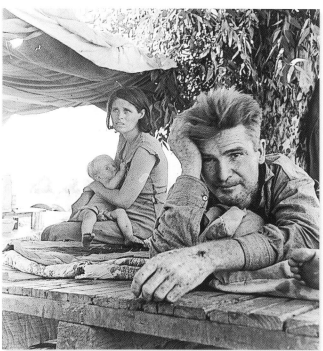

Left: *Blythe, California, August 1936. Drought refugees from Oklahoma camp by the roadside. "When deep in your chest, there's an undying pain, and the sky was a dark shade of gray, when God didn't answer your prayer for rain, those were the Dust Bowl days."* — Ron Langely, Those Were the Dust Bowl Days. Dorothea Lange/Library of Congress

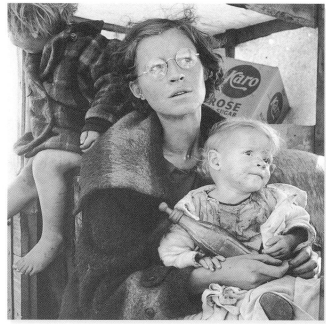

Right: *New arrivals in California, after spending one month on the road, 1939. "We watched the devil wind come, blowin' harder day by day, picking up the top soil and blowin' it away. Dryin' up the corn and cotton and destroyin' our well. No, we have not forgotten the great dust storm from hell. So daddy said we'd have to leave, and my mama, meek and mild, tried not to show how much she grieved, and I became a migrant child."* — Ron Langely, Migrant Child. Dorothea Lange/Library of Congress

Migrant Camps

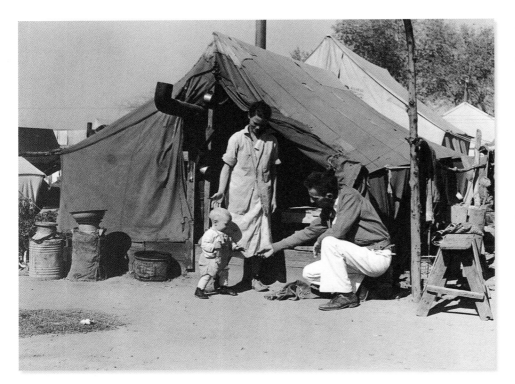

Arvin Migrant Labor Camp, 1936. In 1938, John Steinbeck was conducting research for the San Francisco News *on the Dust Bowl refugees. He came to visit the Arvin Camp, where manager Tom Collins (right) gave him a complete tour of the facility and took him to see the nearby squatters' shacks that consisted of weeds, cardboard, and pieces of tin. Steinbeck was so impressed with the government camp that he later returned. Ultimately, Collins provided Steinbeck with enough background material about the language and everyday behavior of the Okies to bring* The Grapes of Wrath *to life.* Dorothea Lange/Library of Congress

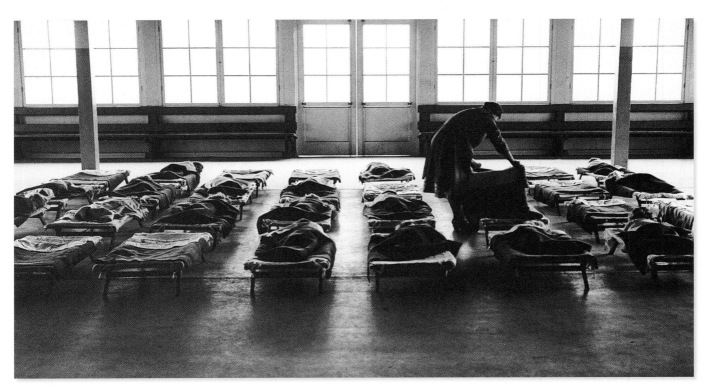

Camp Shafter, Kern County, California, 1939. ". . . the next thing that I saw around the camp (Shafter) was in the big recreation room where there were a bunch of little mattresses and on each little mattress was a little preschool child lying down taking an afternoon nap. It was beautiful to see these little creatures there, so comfortable and so happy and so relaxed. They didn't have to sleep cramped up in a car anymore." — Interview, Seema Weatherwax, 2006. Dorothea Lange/Library of Congress

Camp Shafter, Kern County, California, 1939. "And then, later on they had lunch, they all sat at little tables in the big rec room, all the little people, and lunch got served. So they had one full meal a day, government supplied." — Interview, Seema Weatherwax, 2006. Dorothea Lange/Library of Congress

Right: A message board at Camp Shafter is shown with "leaving for Oklahoma" and "leaving for Missouri" messages posted. In 1938, after hearing that the rains were drizzling in Oklahoma and that the flood waters were subsiding in Missouri, some refugees started heading for home. By 1941, the Okies were returning from the West and the "Grapes of Wrath" route was flowing in reverse. Some still drove the same old jalopies, creaking and rattling along U.S. Highway 66, in a strange, unending procession. Dorothea Lange/Library of Congress

The cooperative store at Camp Shafter, Shafter, California, 1940. Migrant workers of the Dust Bowl era had to fend for themselves. Without social welfare programs, providing for your family meant that you worked, and moved when and where the jobs were available. With little leisure time, camp stores like the one at Camp Shafter provided a modicum of convenience for tired farm workers (along with fair prices). Arthur Rothstein/Library of Congress

The Grapes of Wrath

After his initial research process, John Steinbeck gave himself one hundred days to complete his novel, The Grapes of Wrath. His wife Carol provided the title for the book. She was inspired by the lyrics of The Battle Hymn of the Republic, specifically, the line: "Mine eyes have seen the glory of the coming of the Lord; He is trampling out the vintage where the grapes of wrath are stored . . . " She also worked transcription and typed up the manuscript as Steinbeck wrote. Author's collection

John Steinbeck's *The Grapes of Wrath* quickly became an American classic after its initial publication in 1939. That year, it sold nearly a half million copies and garnered the praise of many critics. In his *New York Times* book review, Charles Poore wrote that "Mr. Steinbeck has created his best novel. It is far better than *Of Mice and Men* . . . Here, his counterpoint of the general and the particular—the full sweep of the migration and the personal affairs of all the Joads—has the true air of inevitability."

The following is an excerpt from Steinbeck's legendary novel:

Highway 66 is the main migrant road. 66—the long concrete path across the country, waving gently up and down on the map, from Mississippi to Bakersfield—over the red lands and the gray lands, twisting up into the mountains, crossing the Divide and down into the bright and terrible desert, and across the desert to the mountains again, and into the rich California valleys.

66 is the path of people in flight, refugees from dust and shrinking land, from the thunder of tractors and shrinking ownership, from the desert's slow northward invasion, from the twisting winds that howl up out of Texas, from the floods that bring no richness to the land and steal what little richness is there. From all of these, the people are in flight, and they come into 66 from the tributary side roads, from the wagon tracks and the rutted country roads. 66 is the mother road, the road of flight."

—Chapter 12, from The Grapes of Wrath by John Steinbeck, Copyright 1939, renewed ©1967 by John Steinbeck. Used by permission of Viking Penguin, a Division of Penguin Group (USA) Inc.

An elderly woman finds refuge at "Weedpatch Camp," 1936. ". . . Within recent years thousands upon thousands of people like the Joads in The Grapes of Wrath *have been rolling westward, carrying all they own in perilous cars of strange vintages, hungry, restless, the children riding on top of the tents and the blankets and the cooking pots, their desperate elders hanging on wherever they can. —* New York Times *book reviewer Charles Poore*

U.S. Highway 66 running through Gallup, New Mexico, circa 1936. Gallup was a film location for The Grapes of Wrath. Filling stations were a common thread throughout the movie, and a couple of memorable scenes were played out at the pumps. One scene features a gas station where the owner asks whether or not the Joads have money to pay for their gas. Another scene was a favorite of Shirley Mills (Ruthie Joad): It plays out in a filling station with a diner, where Pa Joad, Ruthie, and Winfield enter to purchase a loaf of bread. Realizing they are down on their luck, a kindhearted waitress obliges the kids with cheap, penny candy. Courtesy Steven Rider Collection

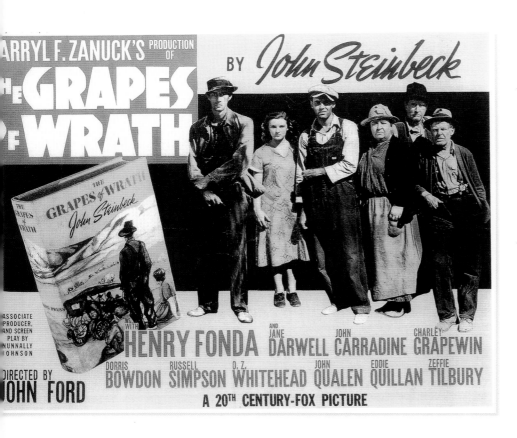

The Grapes of Wrath is acclaimed by some as director John Ford's most famous work. With screenwriter Nunnally Johnson's faithful adaptation of John Steinbeck's Pulitzer Prize-winning novel and the stark journalistic cinematography of Greg Toland, the profound story of a dispossessed Midwest family came to life. Interestingly enough, the film was shot in only seven weeks and nominated for seven Academy Awards. It won two: Jane Darwell for Best Supporting Actress and John Ford for Best Director. Henry Fonda was nominated for Best Actor and Nunnally Johnson for Best Screenplay. The film was also nominated for Best Sound Recording and Best Film Editing. Author's collection

Shirley Mills Hanson
Ruthie Joad, *The Grapes of Wrath*

"At least once a week, John Ford would call us all on the set and he would say, 'You know, there's something we must remember as we're filming this: You are not bums, you are not thieves, you are not people who are out just to make a buck off of somebody. These people are victims of terrible circumstance . . . and you represent the Joad family with that representation speaking for all those who are displaced because of losing their farms and going through the Dust Bowl. . . .'"

—Shirley Mills Hanson
Interview, July 29, 2006

By the time thirteen-year-old Shirley Mills received the casting call to test for a movie called *High-way 66*, she was already a veteran actress. Lauded as "Seattle's Shirley Temple," little Shirley was a regular on the Bert Levy vaudeville circuit. After she won a screen test for MGM Studios in 1937, her family moved to Hollywood.

There, Shirley's new agent Evelyn Byrd kept her busy. Shirley quickly landed a role in her first movie, *Child Bride,* which was followed by *The Under-Pup,* a film that impressed director John Ford. He phoned Byrd and requested to screen test Shirley for the role of Ruthie Joad in the film based on John Steinbeck's novel, *The Grapes of Wrath.*

In 1939, Shirley tested with six other girls and was asked to perform the crying scene at Grandpa Joad's burial. The scene was improvised, but it came easily for Shirley. "All I did was think about my own grandfather, whom I just adored," she said. John Ford later confided in her, "I could see you were really crying. Your shoulders were even shaking." Her acting ability impressed Ford enough to call Shirley's agent again.

Shirley recalls the day that she went to Twentieth Century Fox with her mother. A studio car with a driver picked them up. When they arrived at the lot, she saw an assortment of odd-looking automobiles that were riddled with rust and loaded down with mattresses, a hodgepodge

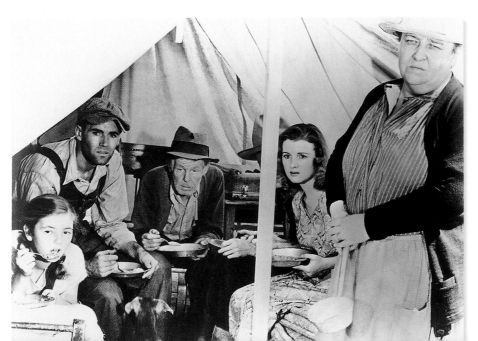

Portions of The Grapes of Wrath *were shot at the "Weedpatch Camp" (the Arvin Migrant Camp—also known as the Sunset Camp). This particular scene was shot at the main studio back lot and Ruthie Joad can be seen at the front left. Author's collection*

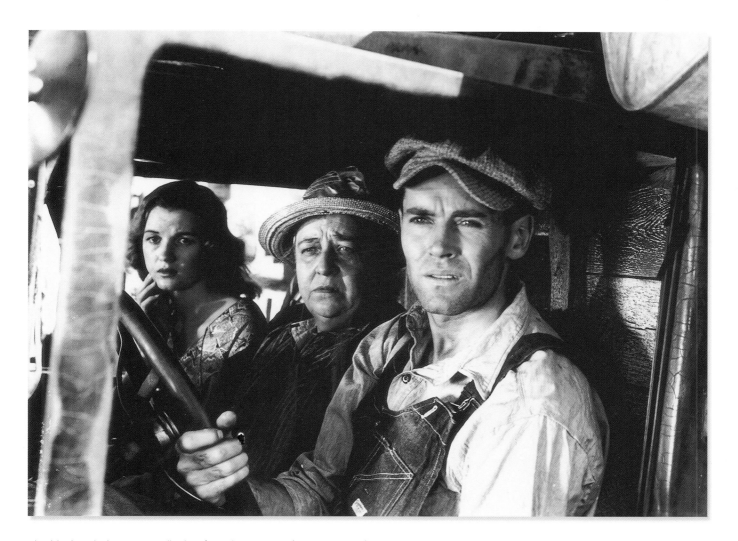

This black-and-white movie still taken from The Grapes of Wrath *truly reflects that a picture is worth a thousand words. Tom Joad (Henry Fonda) is driving, Ma Joad (Jane Darwell) is seated next to him, and Rose-of-Sharon (Dorris Bowdon) is seated at the far left.* Author's collection

of furniture, and household belongings. Shirley looked at the jalopies in amazement and asked, "Mother, what are they going to do with these funny-looking cars?"

Before she could answer, the driver dropped them off in front of the wardrobe department. When Shirley entered, two costume ladies were already waiting for her. "Here comes Ruthie!" they cried in unison. "Oh no, my name is Shirley," she replied. "Well, it's Ruthie now!" they exclaimed. "You mean I got the part?" asked Shirley. A thrill ran through her body; her new adventure had just begun.

Due to the controversy surrounding author John Steinbeck's book, the filming of *The Grapes of Wrath* took place on a closed set. Twentieth Century Fox was very protective about all aspects of the film: No cast member had a complete script and no cameras were allowed on the set for snapshots.

"The first time I walked into the set to start shooting, they handed me a card and a password. Outside the studio a red light flashed on and off, and no one could get into where they were filming without a pass," Shirley said.

"Outside the main Twentieth Century Fox gate, there were always people picketing and sometimes the police would come by. It was a very difficult situation for everybody, especially for Darryl Hickman [Winfield Joad] and me. Just kids, we were rather unsophisticated about what was going on at the time."

Filming continued for seven weeks, and Shirley recalled that most of the scenes were emotionally charged and challenging. "Some itinerant camp scenes were shot right on the Fox backlot . . . the takes were difficult, heavy . . . so much going on: trucks, a beating scene, police, a woman shot, and so on—so many emotions."

Thankfully, Shirley and Darryl were excluded from many of the film's more dramatic moments. "Remember, Darryl and I were children and we had to go [to] school three hours a day," she added. "Also, we couldn't be on the set longer than seven hours total."

But Shirley and Darryl soon discovered their niche in the film's cast and crew as comic relief. Scampering in and around the old jalopies, they made everyone laugh with

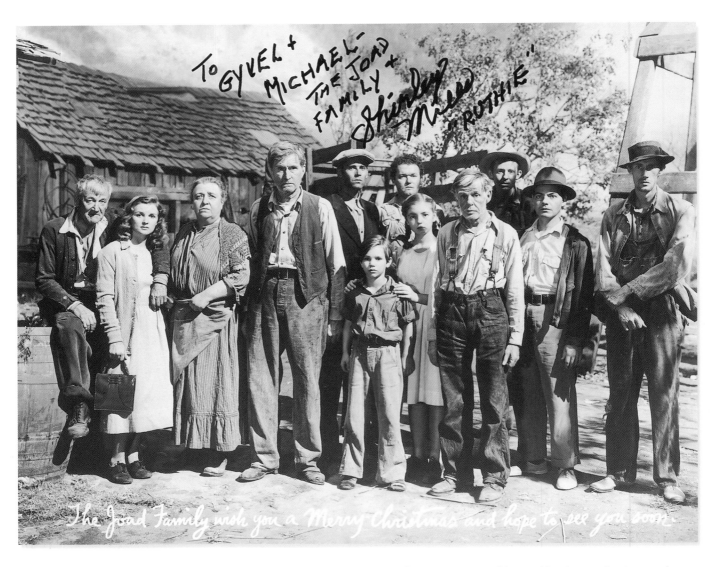

A promotional photograph sent out by Twentieth Century Fox for Christmas 1939 features a portion of the Joad family cast. The Grapes of Wrath opened on February 21, 1940. Shirley Mills recalls that ". . . at least once a week John Ford would call us all on the set, and he would say, 'You know, there's something we must remember as we're filming this: You are not bums, you are not thieves, you are not people who are out just to make a buck off of somebody. These people are victims of terrible circumstances . . . " Courtesy of Shirley Mills Hanson

their childlike curiosity and joy. Watching children just be children was a welcome release from the tensions of filming.

Director John Ford tapped into this youthful exuberance with many of the scenes, including the "Weedpatch Camp" discovery of indoor plumbing. Ruthie, eager to show Winfield that she knew exactly what to do with a toilet, enters the bathroom stall with Winfield in tow. Suddenly, there is a roar of water and Ruthie leaps away from the toilet. "You done it! You went and broke it. I seen you," she says. Both children run wildly out of the building, with a few of the camp's dogs yapping at their heels. "Ford did every scene to perfection," Shirley said.

But Shirley's favorite scene was in the diner where Ruthie and Winfield are confronted by the temptation of penny candy. "For the scene, all I remember Ford saying to me as the camera moved in on my face, 'Just keep thinking

about how long it's been since you had a piece of candy, but think even harder about how little your dad has and how far you still have to go to California,'" she said. The scene ends on a happy note with each of the children receiving a piece of candy, thanks to a kind-hearted waitress.

Shirley remembers Ford's integrity, too. He impressed upon the cast that they were playing people who were not "bums," but that, "the Joad Family had been an example of hardworking, homespun farmers whose fate had been changed by the relentless cruelty of nature. This family—as was the case with other displaced Okies and unfortunates from surrounding states—were proud and respectable people. Their roots were in the strength of holding a family together."

Ford also insisted on the appearance of cleanliness. Although the family endured hardship and misfortune,

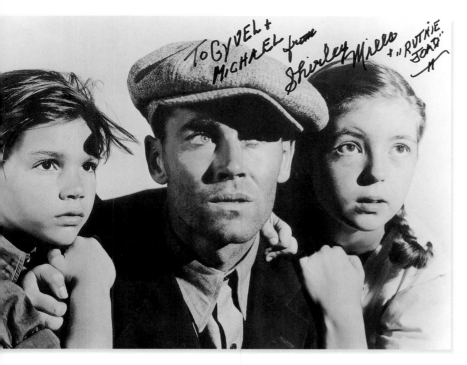

Left to right: Winfield Joad, played by Darryl Hickman; Tom Joad, played by Henry Fonda; and Ruthie Joad, played by Shirley Mills (Hanson). Darryl was nine years old (he celebrated his ninth birthday on the set) and Shirley was thirteen. On the final day of filming, the two ventured forth with autograph books in hand to find Henry Fonda: "It was the last day of shooting and everything around us was in chaos," Hanson said. "We both decided that we should really ask Mr. Fonda for his autograph but we were feeling a little shy about it. Well, we tiptoed up to Mr. Fonda's trailer and knocked on the door. He opened it—he's tall you know, he's very tall and we were small—and looked down at us. I thought 'Oh boy, now we're in trouble!' But instead, he said, 'I knew it! I knew before this movie ended that you would both come and ask for my autograph.' He invited us in and we talked a little and went on our way. He was very nice, a real sweetheart." Courtesy of Shirley Mills Hanson

they retained a respectable appearance with clean clothes and freshly scrubbed faces (particularly Darryl and Ruthie). He also insisted that Ruthie's hair must be neatly braided before each scene. "After being such a society snob in *The Under-Pup*, I was eager to play Ruthie, without pretense, only two outfits, but always clean," Shirley said.

On February 21, 1940, the controversial film opened in an unusual double premier: One played in New York City and the other opened in Hollywood. The double premier was Fox's insurance policy. If any disturbance or picketing shut down one of the theaters, the other could continue. Shirley attended the Hollywood premier at the Four Star Theater on Wilshire Boulevard. "I had my picture taken there with Darryl. I wore a beautiful little blue coat my mother had made special with a pink satin lining. Darryl was in his cute short pants," she said.

Shirley Mills, who was born in 1926—the same year as Highway 66—remains happy to this day for the experience of acting in such a historic film. Not only was she able to work with John Ford, but also other notable stars such as Henry Fonda, Jane Darwell, and John Carradine. Although she went on to act in many more films, her role as Ruthie Joad still holds a warm place in her heart.

In 2003, a special tribute at the Alex Theatre in Glendale, California, honored the only three living cast members of the "Joad family." They were Dorris Bowden (Rose-of-Sharon), Darryl Hickman, and Shirley Mills Hanson. "Leonard Maltin interviewed us, and as we left the stage, we received a standing ovation from the packed theater," Shirley said. "Tears, joy, and exhilarated gratitude filled me down to my soul. For the rest of my life, little Ruthie Joad will always be alive and well and living in my heart."

Shirley Mills Hanson—who by coincidence was born in 1926, the same year as Highway 66—remains happy to this day for the experience of acting in The Grapes of Wrath, a film of great historical significance. Not only was she able to work with director John Ford, but also notable stars such as Henry Fonda, Jane Darwell, and John Carradine "For the rest of my life, little Ruthie Joad will always be alive and well and living in my heart," she said. Courtesy of Shirley Mills Hanson

The Haggard Family

*I*n 1935, James and Flossie Haggard packed up their 1926 Chevrolet sedan and homemade trailer to leave Checotah, Oklahoma, for California. With them were daughter Lillian, 14; and son, James, 12. The trailer had just enough room for two trunks and Flossie's prized sewing machine. The journey on 66 was nothing new—the couple had made the trip to Los Angeles before. But this was no joy ride because a new life awaited them in Bakersfield.

"We came straight to Bakersfield and rented a house. And then immediately Dad got a job with the Santa Fe Railroad. We met a lady who had this boxcar sitting out on a lot north of town and when she found out Dad worked for the railroad she asked him about the possibility of converting it into a house."

As Lillian Haggard explained, "In those days there was no such thing as a house trailer, or any kind of mobile home that you could pull onto property to live in while you were building. But my father thought it was a great idea, so he started working on the boxcar in his extra time. By September we moved in."

James Haggard eventually purchased the lot. Since the boxcar was located toward the back, he planned to live in the conversion and build a home at the front of the property. To start, he built a ten-foot square bedroom at the front of the boxcar. At one end, he built a bathroom and at the other, a kitchen and a dining nook. Finally, he added a porch at the back When he finished his remodeling, the salvaged boxcar was essentially converted into a two-bedroom, one-bathroom home.

"Few houses were contracted back then, and my parents never borrowed money; they paid for things as they lived," Lillian said. "So . . . they figured we'll live in this as a temporary house and we'll build a house out front. Well, my dad made it very comfortable and livable for us."

As they settled in, good news came to the Haggard family. On April 6, 1937, a little surprise was born into the world, a boy they called Merle Ronald Haggard. When the baby arrived, both Lillian and James Lowell were well into their teenage years. By the time little Merle was three years old, Lillian was already married and James Lowell was in the Marines.

Still, father James continued his house building plans. He continued to purchase lumber over the years and stored it on the vacant lot next to their home. In 1946, when Merle was nine years old, the ground preparations were at long last laid for the house. Unfortunately, fate had other plans and tragedy struck: James was injured in

When Merle was twelve years old, his brother James Lowell gave him his first guitar and Merle taught himself to play it. Despite his obvious musical ability, Merle had a restlessness that eventually landed him on the wrong side of the law. Yet, he managed to turn himself around. By 1966, he was a national music star.

His merits as a singer/songwriter are described in this quote from The Arvin Tiller, 1997: "In his drive to celebrate the virtues of hard working 100 percent Americanism, Haggard explored his own heritage and in the process resurrected a subject lost to public scrutiny for two decades. In 1969, he recorded the first of his Dust Bowl ballads, a loosely autobiographical song called 'Hungry Eyes,' that went back to the themes of poverty, prejudice, and struggle that formed the core of the Okie experience.

'A canvas-covered cabin, in a crowded labor camp, stands out in this memory I revive. 'Cause my daddy raised a family there with two hardworking hands and tried to feed my mama's hungry eyes. He dreamed of something better there, and my mama's faith was strong. And us kids were just too young to realize that another class of people put us somewhere just below. One more reason for my mama's hungry eyes.'" Courtesy Capitol Records/Merle Haggard

an automobile accident and died a few months later of a cerebral hemorrhage. He was only forty-six years old.

Despite this setback, Flossie eventually finished the home that she and her husband had planned. But she kept the little boxcar house that Merle Haggard grew up in on the property and in the family until the Haggard home was sold in 1989.

Top (left to right): Lillian Haggard, rest stop, Albuquerque, New Mexico (1935); James and Flossie Haggard, Chicago, Illinois (1928); Lillian Haggard and James Lowell, 1926 Chevrolet. Bottom (left to right): The Haggard trailer on U.S. Highway 66, headed to California (1935); James Lowell, rest stop, Albuquerque, New Mexico. Trip Photos by Flossie Haggard, Courtesy of Lillian Haggard Hoge/Graphics Gyvel Dagmar Berkley

Bakersfield, California, 1936 (unidentified children on front step). The little boxcar Merle grew up in is still standing today. Today, the Smithsonian houses some of the Haggard family objects from their journey on U.S. Highway 66 to California, including Flossie Haggard's camera and sewing machine. Courtesy of Lillian Haggard Hoge

Business along Route 66

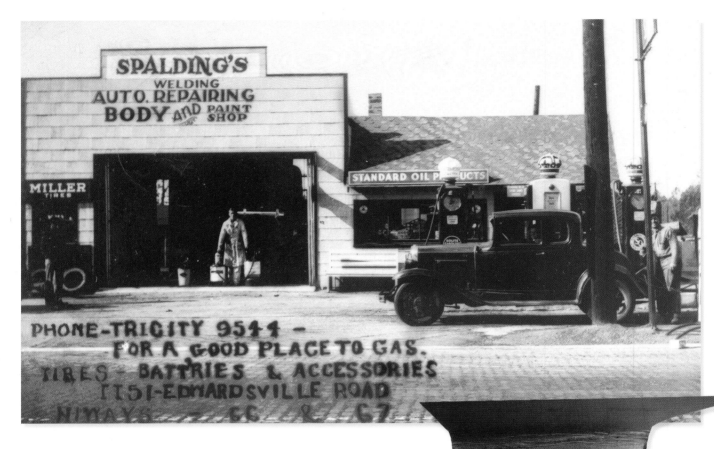

Above: *Spalding's Welding and Auto Repair, located at 1151 Edwardsville Road (U.S. Highway 66) in Madison, Illinois, circa 1935. Sporting Red Crown brand pump globes, this style of "clock face" fuel pump was first introduced during the early 1930s. It offered multi-speed nozzle operation and a maximum of fifteen gallons pumped per minute. Red Crown was a product of the Standard Oil Company. Courtesy Steven Rider Collection*

Right: *Park-O-Tell Motel Matchbook. The Park-O-Tell "America's Finest Tourist Hotel" was located on Lincoln Boulevard (U.S. Route 66) and Highway 77 in Oklahoma City, Oklahoma. In its prime, the motel ferried overnight guests around town in a woody station wagon for complimentary sight-seeing tours. Courtesy of Jim Ross Collection*

The Park-O-Tell, Oklahoma City, Oklahoma, May 1936, located on Lincoln Boulevard (U.S. Highway 66) near the Oklahoma State Capitol building. Back then, oil wells were still operating nearby. Courtesy of the Oklahoma Historical Society

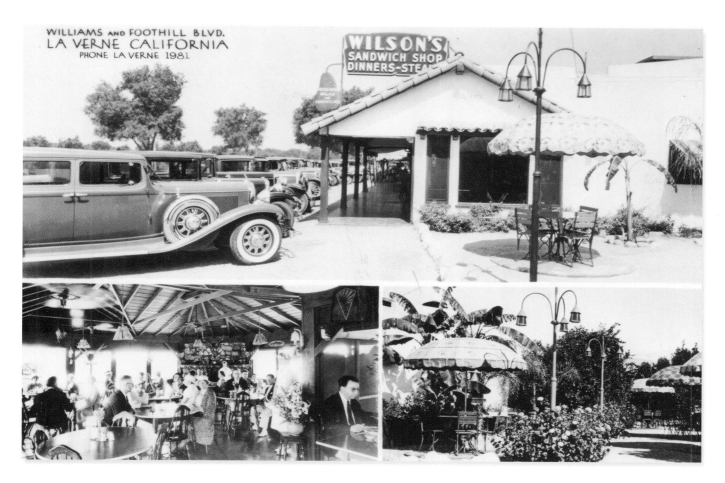

Wilson's Sandwich Shop was located at Williams and Foothill Boulevard (U.S. Highway 66) in La Verne, California, circa 1930s. This eatery offered a scrumptious menu that included avocado salads and rainbow trout dinners. They also packed oranges, grapefruit, avocados, and other fruits to order. Courtesy Steven Rider Collection

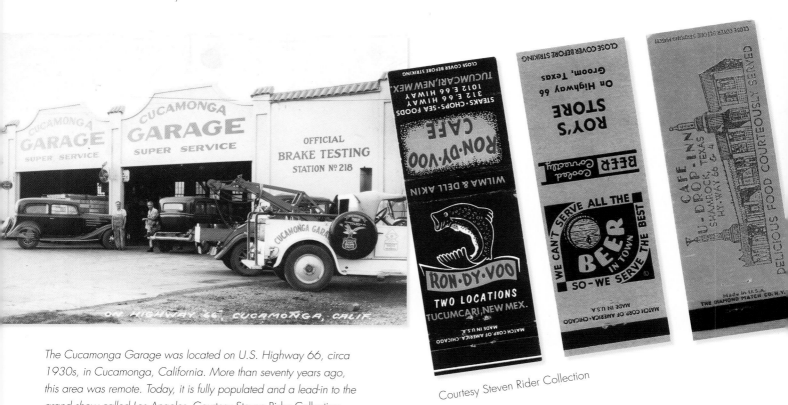

The Cucamonga Garage was located on U.S. Highway 66, circa 1930s, in Cucamonga, California. More than seventy years ago, this area was remote. Today, it is fully populated and a lead-in to the grand show called Los Angeles. Courtesy Steven Rider Collection

Courtesy Steven Rider Collection

At the Movies

The Elk Theatre is resplendent in all the glory of its Art Deco architecture, Elk City, Oklahoma, circa 1936. Courtesy of the Oklahoma Historical Society

Right: *The Criterion Theatre, El Reno, Oklahoma, circa 1939. A French Revival–style structure with Art Deco interior, this classic movie house was designed by the Boller brothers and built in 1921. Located at 118 West Main Street, it experienced the gradual demise of small town America and the flight to the shopping malls. It was destroyed in 1973. Courtesy of the Oklahoma Historical Society*

Left: *The El Caro Theatre, El Reno, Oklahoma, circa 1939. With Spanish Renaissance–style architecture, this Paramount theatre was built as a single-screen, 468-seat capacity movie house. The exterior featured whitewashed brick, accented with geometric windows, and heavy metal doors. Outlining the marquee, bright yellow tracer lights created an exciting visual effect. Today, the theatre still stands, but it serves as a retail shop. Courtesy of the Oklahoma Historical Society*

This rare photograph features the opening week of the Coleman Theatre in Miami, Oklahoma, in 1929. Note the marquee: In those days, it was all about vaudeville shows and "talking pictures." Today, the Mission Revival–style building (with single screen and seating for sixteen hundred) is still standing. The theatre is located at 103 North Main Street, and it was donated to the city in 1989. Courtesy of the Oklahoma Historical Society

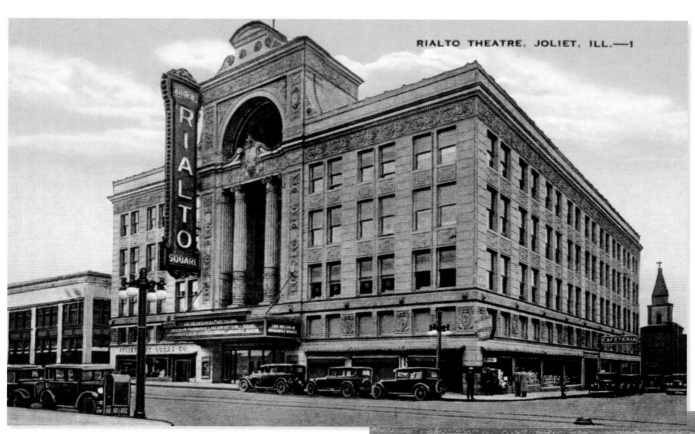

Above: Rialto Square Theatre located on 102 North Chicago (U.S. Highway 66), Joliet, Illinois, circa 1929. This theater opened May 24, 1926, which was the same year that U.S. Highway 66 became official. The French Renaissance building was built for the Rubens Brothers Theatre Company and designed by architects C. W. and George L. Rapp of Chicago. It was the largest vaudeville theater outside of Chicago in Illinois. It closed during the 1970s, but was rescued from demolition and restored in 1980. It reopened a year later as a performing arts center. Courtesy Steven Rider Collection

Right: Aerial photograph of U.S. Highway 66 and the 66 Drive-In Theatre, Tulsa, Oklahoma, August 23, 1948. Today, outdoor theaters like this are nearly extinct as multi-screen cinemas and the trend towards home theaters renders them obsolete. Courtesy of the Oklahoma Historical Society

Road repair in front of Copp's Corner, Springfield, Illinois, circa 1948. It is possible that this image—showing Copp's Corner roadwork—is part of the widening and resurfacing of the original eighteen-foot slab of Route 66. The narrow slab was widened to twenty-four feet in 1948. Courtesy of Sangamon Valley Collection at Lincoln Library, Springfield, Illinois

Chapter Seven

The Trouble with Highways

"U.S. 66 is a dangerous route from the time it leaves the loop in Jackson Boulevard and then leaves Chicago by way of Ogden Avenue and the Joliet Road. In the heart of the metropolitan area is the most urgent need for death-proof construction. This is the conclusion of Thomas H. McDonald, chief of the United States Bureau of Public Roads, in his study pending in congress recommending a total of 27,000 miles of superhighway in America, 1,069 of it in Illinois."

—"U.S. Route 66 Still Menaces Heavy Traffic,"
Chicago Daily Tribune, December 8, 1939

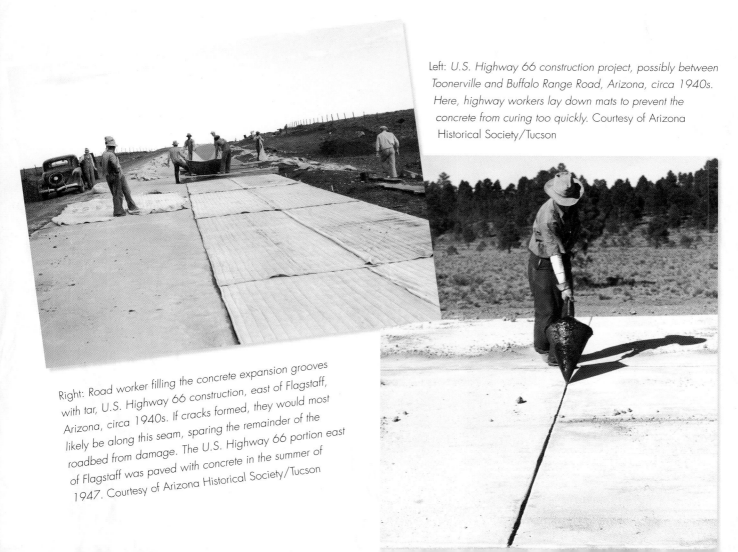

Left: *U.S. Highway 66 construction project, possibly between Toonerville and Buffalo Range Road, Arizona, circa 1940s. Here, highway workers lay down mats to prevent the concrete from curing too quickly. Courtesy of Arizona Historical Society/Tucson*

Right: *Road worker filling the concrete expansion grooves with tar, U.S. Highway 66 construction, east of Flagstaff, Arizona, circa 1940s. If cracks formed, they would most likely be along this seam, sparing the remainder of the roadbed from damage. The U.S. Highway 66 portion east of Flagstaff was paved with concrete in the summer of 1947. Courtesy of Arizona Historical Society/Tucson*

No one wanted to drive on a "tombstone" highway. Unfortunately, Route 66 had that kind of reputation, particularly in states such as Illinois, where it was the most heavily traveled cross-state route. With an average of 3.09 casualties per mile, it was classified as one of the deadliest highways in the state.[1] Even the politicians agreed: After making an inspection tour of the three major roadways in Illinois, Governor Dwight Green concluded that "No. 66 is the most important, and it needs much improvement."[2]

Fortunately, upgrades were on the way. On June 27, 1939, the Illinois House Roads and Bridges Committee voted twenty-one to twelve in favor of passing Chicago's "superhighway" legislation.[3] The bill allocated thirty billion dollars to revitalize the road-building industry. The plan was to funnel traffic into a system of four-lane superhighways that circumvented motorists around small cities and towns. These "bypass" routes would reduce traffic in the areas most likely to become congested.

With the needed funding in place, the roads became thick with highway machinery and work crews as road repair became the main activity of the day. For the frustrated Chicago motorist, unwanted detours and slow-moving traffic jams became a daily ritual.

On December 9, 1939, Hal Foust of the *Chicago Daily Tribune* summed up the local sentiment toward all of this roadwork when he lamented that, "another construction season has ended and U.S. 66 is still the congested and dangerous highway that has been the subject of improvement resolutions and petitions for the last ten years. In driving the 297 miles here today in the *Tribune* road car, it was found that the state highway department is making spotty improvements here and there along U.S. 66, but that these betterments are merely dabbles." More serious work was needed.

By 1941, the plan to build the promised superhighway ran into an unexpected roadblock: Much of the original, pre-Route 66 roadbed between Joliet and Springfield, Illinois, was crumbling.[4] The pavement was originally laid between 1921 and 1924, which made it over twenty years old. It was too narrow to safely accommodate the increased girth of modern automobiles, and it was packed with more two-way traffic than ever before. All of these factors contributed to its rapid deterioration.

The most exhausted area of highway was between Dwight and Pontiac, Illinois, where the patches placed on top of patches were failing to hold together the twenty-year-old slab. The battered quilt of concrete was so bad near the intersection of 66 and Illinois 48 that the ruts actually interfered with the motorists' steering on the bridge approach.

Only a new road could alleviate the problems. The proposed solution was to lay down a new section of two-lane concrete right next to the old concrete. By doing so, the existing traffic could move unimpeded—without detours—while the new section was being built. The construction plan would be repeated mile by mile until there were two new slabs in place, separated by a parkway, and each could carry one-way traffic. Based on the original survey of the old road, the replacement scheme was required along the entire route from St. Louis to Chicago (with the exception of nineteen miles at Illinois 104 and 48).[5]

In spite of these plans, in 1942, the federal government ordered a halt to all nonessential road construction throughout the nation. Two years later, the promised superhighway was once again dusted off and re-examined, this time by the federal government. National leaders had recognized the need

Heavy machinery operator driving a Caterpillar bulldozer to plow up roadbed for planned U.S. Highway 66 construction, east of Flagstaff, Arizona, circa 1940s. Courtesy of Arizona Historical Society/Tucson

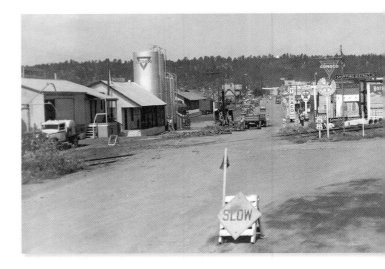

U.S. Highway 66 construction at the junction of 66 and 89, west of Flagstaff, Arizona, circa 1940s. In his 1946 publication A Guide Book to Highway 66, *author Jack Rittenhouse describes the Flagstaff area of the route: "US 66 goes down the main street of Flagstaff, and soon you are on the road among the tall pines again." Courtesy of Arizona Historical Society/Tucson*

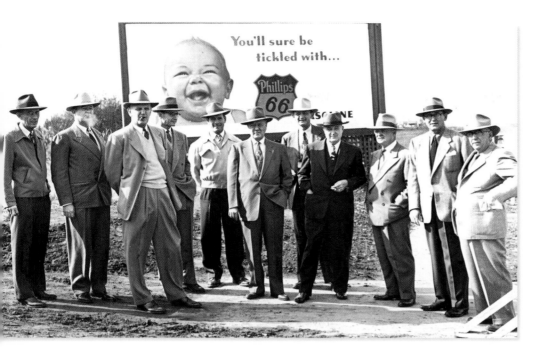

Top dignitaries were invited to attend the opening of the new four-lane highway at Yukon, Oklahoma, including senators, road boosters, and the directors of highway departments. Here, a group of Phillips 66 officials pose in front of a Phillips 66 billboard located along the newly widened U.S. Highway 66 at Yukon. C. A. "Bud" Stoldt, highway director, emphasized in his speech at the highway opening that "eventually, 66 must be four-lane all across the state." Courtesy of Oklahoma Historical Society

for good roads, particularly during states of emergency. *Chicago Daily Tribune* columnist Robert Howard announced the good news to jubilant residents of Illinois with the statement, "The old two lane U.S. 66, almost a casualty of the war time truck traffic, is now being rebuilt at the request of the federal government. By late 1945, the new two lane pavement will be completed."

Wesley W. Polk, Illinois' chief highway engineer, officially confirmed the plan when he announced that "The improvements consist of a 24 foot pavement. . . . As fast as the new sections are completed, the old are abandoned except for short stretches needed for local service. After the war, the abandoned pavement will be reconstructed, converting the highway to a four-lane divided type."[6]

Ironically, by 1947, the business community came to realize that the so-called superhighway was actually a death noose for the smaller cities that populated the busy route.

These fears were well grounded in Oklahoma, where grand plans were being rolled out for toll roads, turnpikes, and other express thoroughfares. Frank S. Gilmore, a Kansas City consulting engineer on the Oklahoma City and Tulsa toll road (later known as the Turner Turnpike), tried to counter this sentiment by saying that "if the cities immediately affected knew what the actual superhighway would accomplish, they would be as enthusiastic as Oklahoma City and Tulsa."[7] The truth was that the big cities *would* benefit, albeit at the expense of less significant villages along the way.

The worry that small towns would wither away and die in the wake of the superhighway was growing. Residents of Sapulpa, Bristow, and Chandler, Oklahoma, filed protests on February 26, 1947, against the new route that would ultimately remove the Route 66 designator from their beloved road. "We will dry up," stated a Bristow council member. Yet, engineer Gilmore was quite insistent that "these cities won't dry up and they won't be retarded."[8]

Of course, time—and miles of new, high-speed highways—proved him wrong. It soon became clear that his words would come back to haunt him. Once-thriving villages and hamlets along old Route 66 turned into ghost towns. Yes, the multi-lane highways and high-speed interstates made sure of that. No one wanted to drive a tombstone highway anymore, and it became a bypassed route known as 66.

On November 15, 1951, Yukon and El Reno citizens rolled out the carpet to celebrate the six miles of four-lane paving on Route 66 that ran from Yukon west to Banner, Oklahoma. The new road was built at a cost of $1,200,000. Featuring a progression of wagons to vintage cars, a Parade of Progress followed. In a speech, Senator Mike Monroney called U.S. 66 "The Main Street of America." Courtesy of Oklahoma Historical Society

Dangerous Road Conditions

U.S. Highway 66 presented many challenges for the early automobile traveler, including snow and ice in the colder regions. For example, this shrouded stretch of road looking west over Pittman Valley, Williams, Arizona, circa 1933. Courtesy of Arizona Historical Society/Tucson

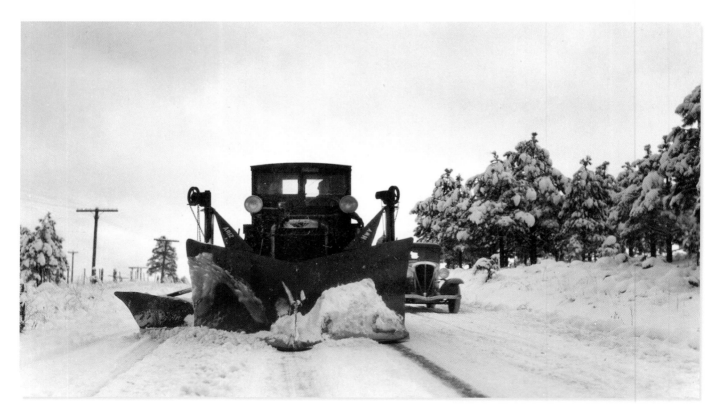

A snow plow clears the road of accumulated snow on U.S. Highway 66 in Flagstaff, Arizona, November 29, 1933. The average automotive tourist might think that Arizona is all sun, sand, and cacti. On the contrary: During the winter season, the northern regions of the state can turn quite cold. Courtesy of Arizona Historical Society/Tucson

U.S. Highway 66, December 21, 1937. A slippery pavement accident, located approximately two miles west of Padre Canyon, Arizona. Courtesy of Arizona Historical Society/Tucson

U.S. Highway 66 traffic jam, approximately three miles west of Williams, Arizona, caused by a vehicle sliding into a ditch, due to the complications of snow, ice, and a narrow road, 1942. Courtesy of Arizona Historical Society/Tucson

U.S. Route 66 looking west toward Flagstaff (1.5 miles east), Arizona, 1945. This overturned truck found its resting place in front of the Cactus Garden Cabins and Gas, directly on Route 66. Courtesy of Cline Library Northern Arizona University

Route 66 automobile accident, Arizona, U.S. Highway 66, 1940. In the first seven months of 1940, there were 17,240 automobile fatalities nationwide, a 5 percent increase over the same months during the previous year. U.S. Route 66 was one of the major contributors to the grim statistics. Courtesy of Arizona Historical Society/Tucson

Roadside Advertising

Burma Shave, a brushless shaving cream, was a 1920s concoction of the Burma-Vita Company, owned by Clinton Odell. Poor marketing almost killed the cream, but son Alan Odell had an idea: roadside signs! By 1925, Odell purchased secondhand boards, cut them into thirty-six-inch lengths, and painted them. At first, the messages didn't rhyme, but over the years, the slogans became more humorous.

During their heyday, the rhymes built suspense until the fifth sign and focused the motorist's attention on reading the full series. Like a good joke, the payoff came at the end—along with the Burma Shave name and logo (the slogan in this image is from 1947). Eventually, the rhyming signs spread to almost every state, but came down in 1963 when the company was sold to Phillip Morris. Today, a full set of signs is housed in the Smithsonian Institution. Author's collection

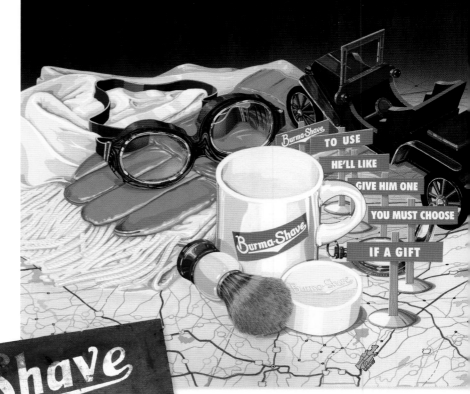

Left: Burma Shave advertising sign, circa 1950. This original sign was one of a series, a verse that read: These signs/We gladly/Dedicate/To men who've had/No date of late/Burma-Shave. In 1964, the Burma-Vita Company was sold to Philip Morris, Inc., and crews removed some thirty-five thousand signs like this planted along America's roadways. No doubt, more than a few "collectors" were spurred on to quietly make off with whatever signs they could. Courtesy of Jim Ross Collection

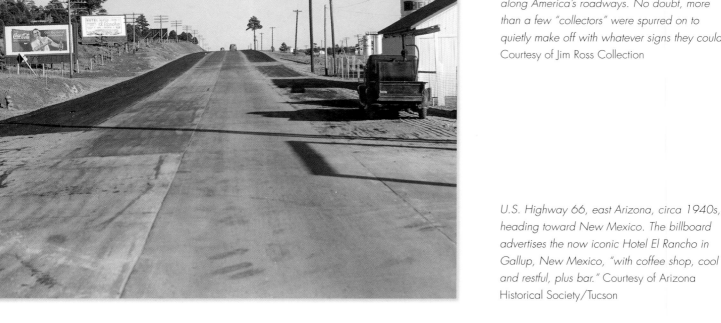

U.S. Highway 66, east Arizona, circa 1940s, heading toward New Mexico. The billboard advertises the now iconic Hotel El Rancho in Gallup, New Mexico, "with coffee shop, cool and restful, plus bar." Courtesy of Arizona Historical Society/Tucson

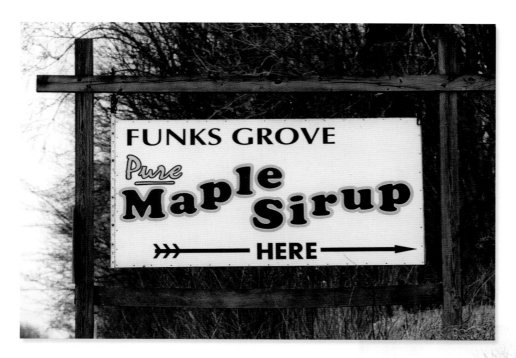

Located between Bloomington and McLean in Shirley, Illinois, the Funks Grove Sirup farm is one of the tastiest stops along old U.S. Highway 66. The Funks marketing strategy remains a simple one: just a sign on U.S. Highway 66, which happens to cut a path right through the family farm. Amazingly enough, the syrup has never been sold in any other stores besides those operated by the family. They have always relied on Route 66 for customers. ©2006 Alan Rose

Right: *Frankoma Pottery billboard, U.S. Highway 66, Sapulpa, Oklahoma, 1950. John Frank founded the company in Norman, Oklahoma, when he was head of the ceramic art department at the University of Oklahoma. "Frankoma" was the combination of his last name and the last three letters of his adopted state. By 1936, Frank was ready to expand his business. He had his sights set on Tulsa, but as fate would have it he stopped at a roadside diner in Sapulpa where the owner was pouring water for customers from one of his Frankoma pieces. Frank was so moved by this that he opened his Frankoma Pottery in Sapulpa, directly on U.S. Highway 66. Courtesy of Oklahoma Historical Society*

Chicken in the Rough, The World's Most Famous Chicken Dish, advertisement, 1937. Author's collection

Beverly's Chicken in the Rough road sign, U.S. Highway 66, Oklahoma City, 1949. Beverly Osborne started Chicken in the Rough in 1921. The second location was on 2429 North Lincoln, the original alignment of the Will Rogers Highway (U.S. Highway 66). Originally, the restaurants were known for Beverly's secret recipe pancakes. That changed in 1936 after he hatched a plan to serve unjointed chicken, fried to "pan style" perfection. Courtesy of Oklahoma Historical Society

Eat, Drink, and Sleep along the Way

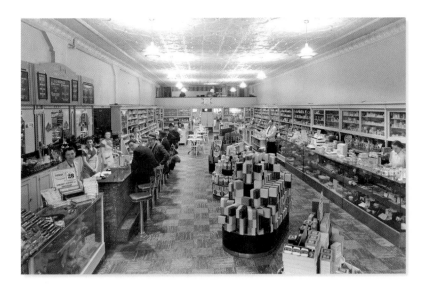

City Drug Store (March 28, 1939, at the dinner hour), 617 South Polk Street, corner of U.S. Highway 66, Amarillo, Texas. Owner Earl D. Barnt came to Amarillo in 1926 when he purchased the original City Drug Store, located just down the street. In 1935, he moved one block up, relocating in direct proximity to U.S. Highway 66. His was one of the first businesses in Amarillo to have air conditioning. Courtesy of Special Collections Department, Amarillo Public Library

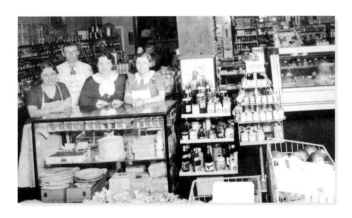

Grocery store interior, 3200 South Sixth Street (U.S. Highway 66), Springfield, Illinois, circa 1940. Courtesy of Sangamon Valley Collection at Lincoln Library, Springfield, Illinois

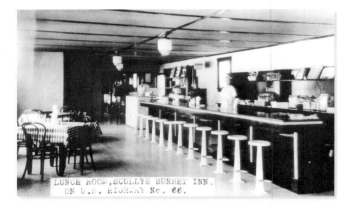

Scully's Sunset Inn interior, U.S. Highway 66, west of St. Louis, Missouri, circa 1939. Courtesy of David Young/Missouri Department of Natural Resources/Route 66 State Park

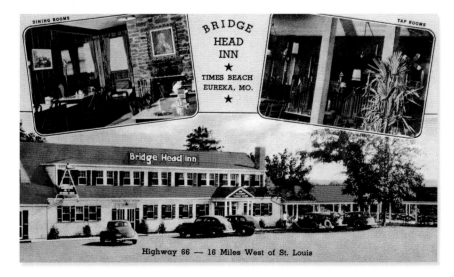

The Bridgehead Inn, Eureka, Missouri, circa 1939. The inn first opened in 1935 at Times Beach, Eureka, Missouri, as a restaurant located on a limestone bluff above the river. The popular inn featured a bar, a dance floor, and overnight accommodations upstairs. Restaurateur Edward Steinberg purchased the inn in 1946 and renamed it Steiny's. In 1972, the building was purchased by William and Jeanette Klecka. The Kleckas revived the Bridgehead Inn name. During the 1980s, it became the Gallery West, and today it exists as the visitor center for the Route 66 State Park. Courtesy of Missouri Department of Natural Resources/Route 66 State Park

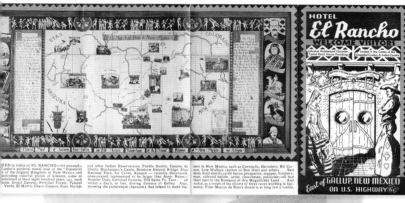

Brochure, Hotel El Rancho, 1940s. Joseph Massaglia Jr.'s distinctive hotel touted itself as the "World's Largest Ranch House" with a capacity to accommodate four hundred guests. It was built in 1937 by Hollywood movie magnate R.E. Griffith to house the flock of film stars working on Western movies filmed in New Mexico. During this time, John Wayne, Ronald Reagan, Humphrey Bogart, Henry Fonda, and a list of others were all guests. Author's collection

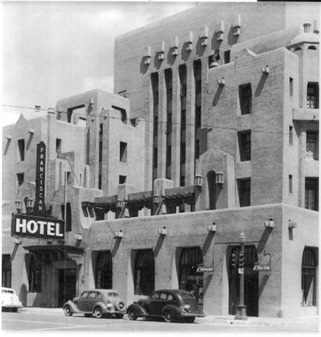

The Hotel Franciscan, Albuquerque, New Mexico, circa 1940. Courtesy of the New Mexico State Records Center and Archives

Stevie's Latin Village, owned by Steve Crifasi, was a popular Italian food restaurant. It served customers at 620 North Ninth Street (U.S. Route 66 City) in Springfield, Illinois, from circa 1950 to 1974. Courtesy of Sangamon Valley Collection at Lincoln Library, Springfield, Illinois

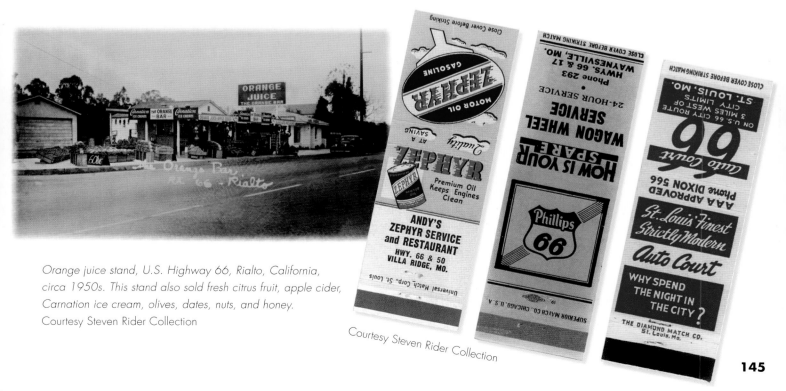

Orange juice stand, U.S. Highway 66, Rialto, California, circa 1950s. This stand also sold fresh citrus fruit, apple cider, Carnation ice cream, olives, dates, nuts, and honey. Courtesy Steven Rider Collection

Courtesy Steven Rider Collection

Lucille Hamons
Mother of the Mother Road

The 1940s dawned with renewed hope for many Oklahomans. Gone were the Dust Bowl days, the hard-scrabble conditions that drove so many out. In fact, many Okies were leaving California by 1941 and heading back home. At the same time, U.S. Highway 66 was touted by newspapers and magazines as the most vivid and versatile of the routes to the coast.

It seemed like the perfect time to buy a business along the route and that's exactly what Carl and Lucille Hamons did. In 1941, they chose a combination gasoline station and tourist cabin stop, located directly on U.S. Highway 66 in Provine, Oklahoma. Certainly, it appeared on the surface to be a wise investment of the inheritance money that Carl had received.

Unfortunately, the timing was off. Until now just a rumor, America's involvement in World War II became a reality. Even worse, neither Carl nor Lucille had any business experience. Built in 1927, the place relied on hand-cranked pumps and needed updating. With the war on, there was a freeze on all non-war–related manufacturing and gas was rationed. Nevertheless, the Hamonses rode out the economic downturn: Carl had the good fortune of being an independent trucker and that helped.

Lucille's heart was big, even if the coffers were low. The tourist cabins were made available to everyone—even those who had no money. She laid out dinner for the hungry

and bought so many broken-down cars that "people thought I had a salvage yard out here!" (—*The Oklahoman*, May 27, 1990)

Somehow, they survived the war years. In the meantime, Lucille worked as the cook, gasoline jockey, and cleanup crew for the tourist cabins. By the 1950s, she was checking the oil, washing windshields, changing headlights, and even fixing flats. Finally, business was booming: All the tourist cabins were rented and the gas flowed freely. Meanwhile, she raised three children—along with a small menagerie of ducks and chickens.

As the 1960s bloomed, Lucille knew that the heyday of U.S. Highway 66 was drawing to a close. The interstate highways were coming. To hedge her bet, she opened a restaurant in Hydro, hoping to stave off the inevitable

Lucille, "Mother of the Mother Road," poses with the Hamons Court sign that is now part of the Smithsonian Institution "America on the Move" exhibition, 1997. Lucille was born April 13, 1915, and died August 18, 2000. Despite numerous health issues, she kept Lucille's open until the day she died. ©2007 Toby Siles, Courtesy of Cheryl Hamons Nowka

Carl Robert and Lucille Arthurs Hamons, circa 1940s. They were married in 1934 and divorced in 1962. Lucille kept the business running through all the ups and downs of the highway and the economy. She gave the Mother Road more than fifty years of unwavering devotion, and in 1999, she was inducted into the Oklahoma Route 66 Hall of Fame at the age of eighty-four. Courtesy of Cheryl Hamons Nowka

The Route 66 icon as it appeared in 1941, when Carl and Lucille Hamons purchased it. The family living quarters were upstairs and downstairs, directly behind the customer service area. The five tourist cabins are seen here in the background. Cheryl Hamons Nowka, Lucille's third child, was born on Route 66, in the upstairs room of the station. Courtesy of Cheryl Hamons Nowka

"bust" when the traffic dried up. But she only worked the operation for a few years. Her failing health prohibited her from continuing. She resolved to stay with the station and "try to make it on the old lonely Highway 66 somehow." And lonely it was: Interstate 40 swallowed up all the humanity that remained on U.S. Highway 66.

After the highway was decommissioned, it appeared that there was no hope left. Despite that, the business tried to stay afloat. When the old Hamons Court sign blew down, she replaced it with a more simple moniker: Lucille's. After all, she was the driving force that held it all together.

Suddenly, a trickle of traffic began to flow and slowly it turned into a steady stream. By 1990, Lucille Hamons had re-emerged from her roadside chrysalis as a Route 66 celebrity. Now, highway enthusiasts and nostalgia seekers sought her out, arriving from all over the world, tracking down the people and places they had read about. A great number stopped at Lucille's—hoping to catch a glimpse of the spunky woman whose life was linked to 66.

Although the gas pumps were shut down in 1986, a different type of fuel was being served up at Lucille's, the stuff that powered and revived memories, things like T-shirts, souvenirs, postcards, and commemorative maps. Of course, Lucille welcomed the visitors with open arms. ". . . Now I've got business from all over the country," she declared in a 1990 interview for *The Oklahoman.* "You wouldn't believe the people I've heard from. I have people come by and take my picture. The women hug me."

Once again, the road was alive with life and Lucille stayed open seven days a week. Interviewers, photographers, and television crews came by. Mail orders poured in for Lucille's T-shirts, caps, and bandanas. The telephone rang. She was working on a book of her Route 66 memoirs, too! Her health may not have been up to par, but she had no time to indulge herself in being ill. Life along Route 66 was once again busy!

The famous landmark was placed on the eBay auction block in August of 2001, but the sale fell through. Now, the station is undergoing renovation by preservation-minded new owners. It was built in 1927 by Carl Ditmore and placed on the National Register of Historic Places in 1997. Shauna Struby ©2006, Courtesy of Cheryl Hamons Nowka

Mildred "Skeeter" Kobzeff and The Airdrome

"I was an usher, making twenty-five cents an hour, at the Beacon Theater in Glendora. That is where I met the McDonald brothers, because they were leasing the theater. No one seemed to have any money to attend the shows, because of the Depression. But every night, everyone would go to Walt Wiley's food stand on Grand Avenue and Alosta. Wiley had these carhops jumping about, and Mac said to Richard, 'You know the kids always seem to have money for Cokes and hamburgers.'"

— Mildred "Skeeter" Kobzeff
Interview, March 17, 2006

During the 1930s, Mildred Kobzeff made a lifelong connection with Route 66 and became witness to the birth of the American fast-food industry. She was just nineteen years old—a young girl with stars in her eyes—when she hired on as an usherette for the Beacon Theater. The theater was a small movie house located on Glendora Avenue, which was a busy cross-street of the Route 66 Highway that cut through Glendora, California.

That is where Mildred's brush with greatness began: It was post-Depression America and a pair of enterprising brothers by the names of Richard and Maurice "Mac" McDonald had just rented the small theater for one hundred dollars per month. "Originally, the brothers moved out from New Hampshire and started working at odd jobs on the movie sets," Kobzeff said. "They shoved around props and backgrounds at Columbia Studios and also drove delivery trucks."

It was a good thing that they both had day jobs, since the fledgling theater located right off the path of 66 didn't pack in the crowds as they had hoped. In the wake of the 1929 stock market crash, disposable income was at an all-time low.

Neither teenagers nor adults had the extra money to spend on frivolous things like movie tickets. But the McDonald brothers didn't call an intermission yet: "Every night after the last picture show, they went down to Walt Wiley's food stand on Grand Avenue and Alosta, which happened to be Route 66 in Glendora. Wiley had these carhops jumping about, and Mac said to Richard, 'You know, the kids always seem to have money for Cokes and hamburgers.' That's how it all started," Kobzeff said.

After the McDonalds learned that a local Sunkist orange packing plant was tossing out bruised fruit that wasn't saleable, they put their plan into action. They could make juice out of those discarded oranges and sell it to passing motorists on Route 66. The streets connecting Arcadia, Glendale, Monrovia, Azusa, Pasadena, Santa Monica, and other growing California towns had plenty of potential customers, too.

In 1937, the McDonald brothers made a deal with Sunkist to buy the fallen fruit at the price of twenty-five cents per twenty-dozen. They needed a visible venue to sell the juice, so they got their hands on some borrowed lumber and built a tiny, octagonal stand on Huntington Drive in Arcadia. Because it was right across the street from the Monrovia airport, they decided to call their place the "Airdrome."

Mildred—or "Skeeter" as her friends called her, so nicknamed by her mother because she was always skittering about like a skeeter bug—became one of the first carhops to work at the Airdrome. "I worked at the Airdrome as a carhop, cook, and cashier all by myself out on the highway," Kobzeff said.

Kobzeff attended college at the time, and her days were filled with work and study. "The brothers opened up the shop for me in the evening, about six o'clock. On weekends it was earlier, of course. I worked there until they closed up the show for the day over at the Beacon Theater. After a long day at the movie house, the McDonalds came over to work the night crowd with me at the Airdrome."

Skeeter recalls the McDonald brothers and the times she had back then with fondness. She remembers all of the

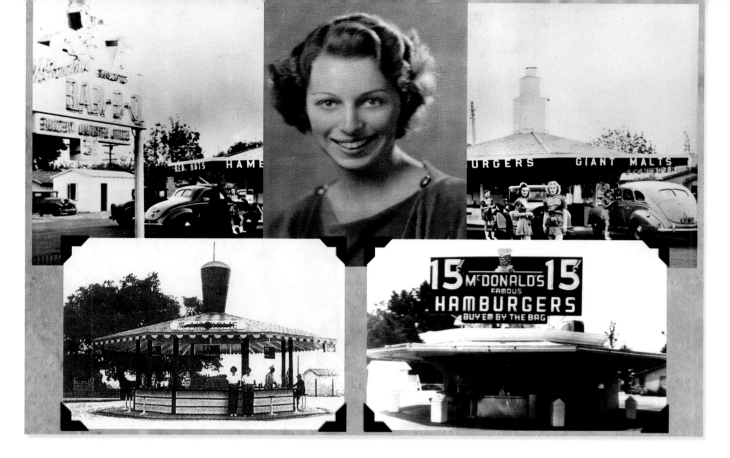

Top left and right: *In 1940, the McDonald brothers sliced their Airdrome orange juice stand in two pieces and transported it to a new site at Fourteenth and E streets (Business U.S. 66) in San Bernardino, California.* Courtesy of Richard McDonald. Top center: *Mildred "Skeeter" Kobzeff around the time that she worked for the McDonald brothers.* Courtesy of Mildred Kobzeff. Bottom left: *The McDonald brothers' Airdrome, U.S. Highway 66, Huntington and Shamrock, Arcadia, California, 1937.* Courtesy of Mildred Kobzeff. Bottom right: *In the fall of 1948, the McDonald brothers closed down their San Bernardino drive-in and fired all the carhops. A new plan based on what they called the "Speedy Service System" was born.* Courtesy of Richard McDonald/Graphic Art Gyvel Dagmar Berkley

interesting people she met and the funny situations that came about from working a roadside orange juice stand near the now-historic highway called 66.

"I often borrowed my parents' car to get to work. One day when I got home, my father found a pair of men's boxer shorts lying in the back seat," she said with a laugh. "Believe me, I had quite a difficult time trying to explain to him where on earth that pair of underwear came from." She never did find out who played the joke on her, and the shorts eventually became part of her dad's wardrobe. These days, her daughter cringes whenever she tells the tale, but Kobzeff enjoys a hearty chuckle every time.

On another night, a chauffeur drove in with two silent movie stars sitting in the backseat. He asked Mildred to do him a special favor. "He stepped out of the car and said to me on the side, 'This is a movie star. I'll give you a dollar extra tip if you say Priscilla Lane when I ask you who your favorite movie actress is.'" It was just like a scene from the film-noir movie *Sunset Boulevard*, where the aging silent movie actress played by Gloria Swanson is sheltered by her driver from the unforgiving real world.

Kobzeff filed away the pleasant memories of her Airdrome experiences in a special place and eventually moved on with her own life. By the time the McDonald brothers disassembled, moved the stand to San Bernardino, and got the attention of milkshake mixer man Ray Kroc, she had left the carhop business for good.

By then, her husband Peter (people called the couple "Pete and Skeet") demanded more of her time and her duties became "domestic." Later, she found employment in the insurance booking department of a local hospital and kept quite busy raising two sons and one daughter. Four grandchildren keep this ex-carhop busier than her customers ever did.

In Glendora, she is regarded by the locals as the unofficial Glendora historian. She is an active member of city clubs and historical groups. In 2000, the mayor and city council awarded her a certificate of recognition for serving on the town's historic preservation committee. Equipped with boundless wit, wisdom, and knowledge of local history, she has served as a staff writer for the *Glendoran Magazine* since it started back in 1982.

Kobzeff is retired now, but occasionally you can still catch her "skeeting about" on historic Route 66 in southern California. If you run into her, she'll gladly tell you all about the early years along California 66, the days of the McDonalds, and the birth of fast food.

Gas Stations of the Mother Road

American Icons 66 Oil/Gasoline

TYPE:
DX Gasoline Neon Sign, Sunray DX Oil Company (now part of Sunoco)

DESCRIPTION:
The DX trademark was used by organizations that began as Mid-Continent Petroleum, founded in 1916 by Josh Cosden. In 1933 Diamond introduced a new non-Ethyl grade, "lubricating" motor fuel. Combining the Diamond name with a "mystery" additive identified only as "X", the product debuted as "Diamond DX Lubricating Motor Fuel".

Left: Author's collection

Below: *Stine's Sinclair Gasoline Station, City U.S. Highway 66, Springfield, Illinois, circa 1948. In 1948, the Chicago Daily Tribune reported that estimated costs to reroute ten miles of Route 66 would top more than $110 million. At the time, the 107-mile stretch from Springfield to East St. Louis was still more than two-thirds unimproved. South of Springfield to the intersection of Route 48, the original 1929 slab was worn and crumbling, and only eighteen feet wide.* Courtesy of Sangamon Valley Collection at Lincoln Library, Springfield, Illinois

Left: *George Tiley Sinclair Motel and the 6th St. Grill, Springfield, Illinois, U.S. Highway 66, circa 1948.* Courtesy of Sangamon Valley Collection at Lincoln Library, Springfield, Illinois

Shell Oil Station, U.S. Highway 66, Springfield, Illinois, circa 1949. In the day when gas was still nineteen cents a gallon, the Shell Oil Company employed the more homespun version of its clamshell logo. Courtesy of Sangamon Valley Collection at Lincoln Library, Springfield, Illinois

Left: *Norm Boente Shell, U.S. Highway 66 and North Grand, Springfield, Illinois, 1948. With twenty-four hour service, station attendants are shown performing the standard station duties of the day: wiping the windows and refueling the automobiles. Courtesy of Sangamon Valley Collection at Lincoln Library, Springfield, Illinois*

Norm Boente's Shell, under new ownership as Ted's Shell Service, 1949. Candy-striped canopies have been added to the windows and the entrance. Otherwise the gas station is unchanged; service is still around the clock. Courtesy of Sangamon Valley Collection at Lincoln Library, Springfield, Illinois

Casey's Cities Service gasoline station, U.S. Highway 66, Springfield, Illinois, circa 1945. The Central Illinois Light Company sign is shown at the back and the National Cash Register Company sign is in view. Courtesy of Sangamon Valley Collection at Lincoln Library, Springfield, Illinois

Route 66 Beginning and End

The Buckingham Fountain, Grant Park, Chicago, Illinois, circa 1927. The original starting point of U.S. Highway 66 was considered to be at this fountain, which was built in 1927. It was donated by Kate Buckingham in memory of her brother Clarence Buckingham, a director of the Art Institute of Chicago. It was designed by Jacques Lambert and is acclaimed as one of the largest fountains in the world. The four sea horses around the base represent the four states that border Lake Michigan. It has more than 130 jets, and it sprays about fourteen thousand gallons of water per minute. The water feature is now computer controlled—and at night, the water sprays are synchronized to lights and music. Library of Congress

Left: *Chandler, Oklahoma, August 27, 1940. The self-proclaimed "Pecan Capital of the 'World," Chandler became host to U.S. Highway 66 in 1926. Before it was designated with the U.S. Highway 66 name, the brick-paved Manvel Avenue was already the busiest downtown strip of road when it came to commerce. There, the Odeon operated until 1955. Farther up the block and across the street, the historic H & S Theatre also welcomed moviegoers.* Courtesy of the Oklahoma Historical Society

Right: *Manvel Avenue, Chandler, Oklahoma, July 26, 1940, by night.* Courtesy of the Oklahoma Historical Society

View of U.S. Highway 66 on the 1952 alignment from Kingman to Topock, Arizona, twenty-five miles from Yucca, circa 1952. Courtesy of Arizona Historical Society/Tucson

U.S. Highway 66, as Main Street, Barstow, California, featuring directional signs. Originally called Fishpond and Waterman Junction, the town's name was changed to Barstow in 1886, in honor of William Barstow Strong, president of the railroad. Courtesy Russell Olsen

Santa Monica Pier, Santa Monica, California, circa 1926. After sixteen months of construction, the 1,600-foot wooden structure opened on September 9, 1909. In 1916, Charles Loff (builder of Coney Island's first carousel) built the landmark Hippodrome building alongside the Municipal Pier. Loff's pier housed numerous rides such as merry-go-rounds, the Blue Streak Racer, the Whip, and Aeroscope. In 1936, when U.S. Highway 66 was extended from Los Angeles to Santa Monica, the pier became the symbolic western terminus of the fabled road. Courtesy Steven Rider Collection

Santa Monica Pier, circa 1928, the symbolic western terminus to U.S. Highway 66. On June 17, 1935, U.S. Highway 66 was extended. Eventually, the highway ran through the cities of Los Angeles and Beverly Hills all the way to the intersection of Santa Monica Boulevard. By 1936, its end was the newly constructed Olympic Boulevard. Today, where Santa Monica Boulevard dead-ends at Ocean Boulevard, a brass plaque commemorates Route 66 at Palisades Park. Courtesy Steven Rider Collection

A Lonely Road

La Bajada Hill Road, New Mexico, showing the approach on the former U.S. Highway 66, August 1941. Serving as a portion of U.S. Highway 66 from 1926 to 1932, this section of the former route was never paved. Courtesy of the New Mexico State Records Center and Archives

La Bajada Hill Road, from a safer vantage point, south of the old Santa Fe "loop," New Mexico, 1941. Courtesy of the New Mexico State Records Center and Archives

Left: New Mexico, U.S. Highway 66 looking east, at Lava Beds historical marker, circa 1940: "This great lava flow is one of the most recent in the United States, occurring between 1,000 and 2,000 years ago. It extends approximately 40 miles south and west." Courtesy of the New Mexico State Records Center and Archives

Right: U.S. Highway 66 view looking toward the east, Topock, Arizona, October 16, 1947. Café, cabins, gasoline, and accessories—everything the highway traveler might need in a rest stop. Courtesy of Arizona Historical Society/Tucson

This view of U.S. Highway 66 traversing a portion of the Ash Fork, Arizona, grade reveals the dramatic steepness of the road in that area and the monumental task of building it for easy travel via automobile, early 1940s. Courtesy of Arizona Historical Society/Tucson

Oatman, Arizona, Route 66 looking east, approaching Oatman, 2005. This alignment of the highway was in use up until 1952 when Route 66/IH 40 was routed through Yucca to Kingman. Courtesy of Cline Library Northern Arizona University

Gallup Inter-Tribal Ceremonial

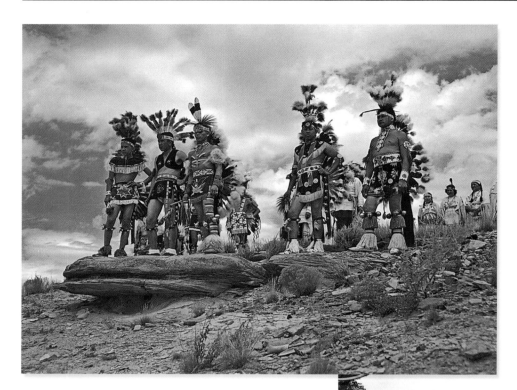

Hoop dancers and war-bonneted Indians at the Gallup Inter-Tribal Ceremonial, circa 1940. The event was established in 1922 by local businessmen and Indian traders for the encouragement of Indian crafts and to promote and preserve the dances, customs, and traditions of Native Americans. Courtesy of the New Mexico State Records Center and Archives

Below: Tony White Cloud, famous dancer of the Jemez Pueblo of New Mexico, performs the intricate hoop dance during the Inter-Tribal Ceremonial at Gallup, New Mexico, in 1941. Courtesy of the New Mexico State Records Center and Archives

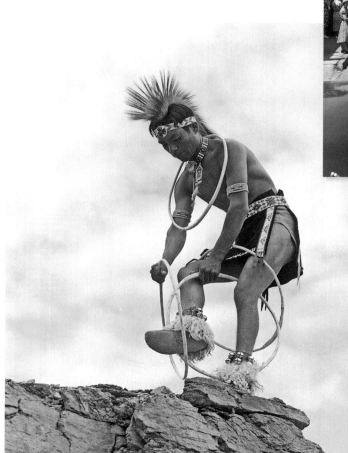

Above: The Navajo wagons on Coal Avenue in Gallup, New Mexico, Inter-Tribal Ceremonial parade, circa 1940. The Inter-Tribal Ceremonial was obviously a huge draw for tourists. Coal Avenue parallels U.S. Highway 66 (Main Street) one block south. Both these streets were the town's primary cultural centers, featuring shops, trading posts, and galleries. Courtesy of the New Mexico State Records Center and Archives

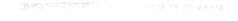

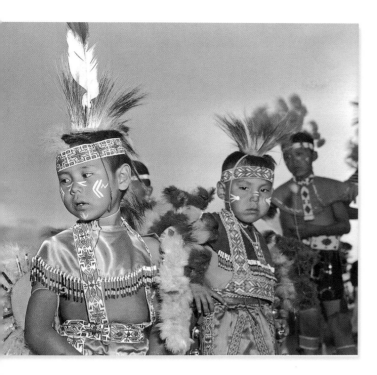

Navajo boys in war dress costume at the Inter-Tribal Ceremonial at Gallup, New Mexico, circa 1940s. Courtesy of the New Mexico State Records Center and Archives

Blue Sky Eagle, dancer from the Acoma Pueblo, at the Gallup, New Mexico, Inter-Tribal Ceremonial, 1954. Courtesy of the New Mexico State Records Center and Archives

An Aztec dancer from Mexico captured on film at the Inter-Tribal Ceremonial, Gallup, New Mexico, 1958. Courtesy of the New Mexico State Records Center and Archives

An Apache Indian Crown Dancer strikes a dramatic pose at the Gallup, New Mexico, Inter-Tribal Ceremonial, 1954. Courtesy of the New Mexico State Records Center and Archives

Above: *A cannon stands as a solid reminder of the 250 years of history that have unfolded in the plaza of Old Town, right in the heart of Albuquerque, New Mexico, 1958.* Courtesy of the New Mexico State Records Center and Archives

Right: *There seemed to be no end to the fiesta celebration along the Main Street of America. In 1968, the Old Town Plaza in Albuquerque, New Mexico, offered such rich cultural fun, it was difficult for visitors not to get into the act.* Courtesy of the New Mexico State Records Center and Archives

Chapter Eight

The Vacationland Route

"U.S. 66—sometimes called the Main Street of America—not only is one of the most important highways between Chicago and the West Coast, but it is also one of the nation's most rewarding vacation routes."

—"U.S. 66 Is Rewarding Holiday Route,"
Chicago Daily Tribune, November 24, 1957

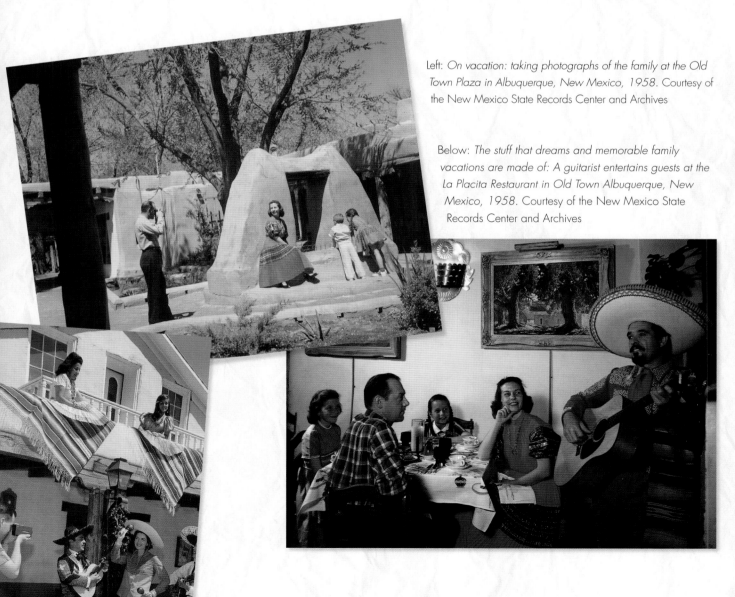

Left: *On vacation: taking photographs of the family at the Old Town Plaza in Albuquerque, New Mexico, 1958. Courtesy of the New Mexico State Records Center and Archives*

Below: *The stuff that dreams and memorable family vacations are made of: A guitarist entertains guests at the La Placita Restaurant in Old Town Albuquerque, New Mexico, 1958. Courtesy of the New Mexico State Records Center and Archives*

Some say that the decade of the 1950s was America's "golden time." It was an era that dawned with a hint of promise, and that promise was soon fulfilled: Americans had more leisure time, more money, and an improved system of highways (thanks to a renewed road-building effort in the mid-1940s).

The combination of extra time, extra cash, and extra roads meant only one thing: travel. During the decade of the fifties, an estimated 100 million tourists traveled around America and the automobile was recognized as their preferred conveyance. And why not? Travel by car was cheap, convenient, and—most of all—fun. America and the 2,225[1] miles of highway known as Route 66 became one huge playground that catered to the tourists who traveled around in their cars.

So let's travel back in time and follow the route! The adventure begins in Illinois' bustling city of Chicago. This land of Lincoln takes you straight through the apple pie of America's heartland. Dwight, the city that claims it's "not just a bump in the road," greets you. In Normal, you stop for an original Steak n Shake steakburger, made the same way Gus Belt did when he invented it there in 1934. Passing through Bloomington, you stop at Funks Grove for famous maple "sirup" and on into Lincoln. Next, 66 passes through the state capital of Springfield, which was home to Abraham Lincoln. Along the roadside, images of honest Abe are everywhere.

After leaving Illinois through Mitchell, U.S. 66 runs southward to the suburbs of St. Louis, Missouri, a city teaming with industrialism and eighteenth-century lore. Pleasant farming country in the Missouri Meramec River valley eventually turns into the wooded hills of the Ozark Mountains. If you make a detour for the Lake of the Ozarks, you can break in your new Jantzen swimsuit. It's a folksy place with plenty of antique shops, but shopping isn't the only attraction. There are caves aplenty to be explored, a hilly golf course, or if you prefer, a small mountain to climb that's just perfect for a family picnic.

Next, Highway 66 weaves past Joplin, Missouri, where the road just nips the southeastern corner of Kansas, and then rolls into the serious Oklahoma lead-mining regions around Miami. Motor on for an hour or more, and you will find yourself in the city of Claremore, Oklahoma, where the Will Rogers Memorial, abundant lake recreation, and mineral wells chime in as the state's top tourist attractions.

Now, the "real West" begins. The road unfurls with all its majesty across the seemingly endless farmlands, through cattle prairies and ranches, and over the famous Staked Plains. The highway cuts across the flat desolation of the Lone Star State, zipping by the towns of Shamrock (known as the Texas Main Street City) and McLean, "where time stands still." Next are the towns of Alanreed, Groom, Conway, Amarillo, Vega, Adrian, and Glenrio. In Amarillo, where the two Texas institutions of oil and cattle mingle

like friendly cowhands in a saloon, y'all can toss in a lil' old side trip. A drive south through Palo Duro Canyon offers a fleeting glimpse of unusual, old Native American homes.

Soon, the plains of Texas give way to the varied hues of the New Mexico landscape. Check your 1957 traveler's guide and read how "the dull browns of the desert and hazy purples of distant mesas and mountains create phantasmal landscapes." It doesn't take much of an imagination to visualize a band of Indians, mounted atop proud horses, silhouetted against a cloudless blue New Mexican sky. Now, you have entered the very heart of Native American Indian country.

Take a short jaunt to Santa Fe and you will learn that it's well worth your while. But be careful: Your entire vacation could be spent at this location. Its picturesque, narrow streets fan out from the old plaza, wandering in all directions, like children scurrying about at a family picnic. Indeed, Santa Fe is a veritable picnic for the eyes with its snow-capped mountains and pueblo-style architecture. Enjoy the charms of Albuquerque "spreading like a prairie fire across its mountain rimmed valley." Take a walk around the Old Town and enjoy enchiladas at La Placita.

From Albuquerque to Gallup, New Mexico, the roadside of Route 66 offers numerous sights, including Native Americans dressed in tribal costume. Bring your wallet, for their hand-crafted rugs, pottery, and trinkets are all for sale. Side trips include the Laguna Pueblo and Acoma, the Sky City. The latter perches 357 feet above the plain, atop a sheer-walled, seventy-acre mesa, and it is the oldest continuously occupied village in the United States.

Some miles further, you drive through the northern fringe of lava beds that stretch—black and desolate—for more than fifty miles to the southwest. Nestled beneath, some twenty-five miles south from Grants on NM 174, you'll discover the Desert Ice Box, a perpetual ice cave that is one of nature's more clever handiworks. After a one-hour drive west

Fairyland Park, Lyons, Illinois, 1941 postcard (June 29, 1950, postmark). Built to delight children, the park was located directly off Route 66 (Joliet Road) at 40th Street and Harlem Avenue. Courtesy Steven Rider Collection

Huffman's Ozark Souvenirs, U.S. Highway 66, circa 1950s. For the 1950s traveler, the Ozarks were a bargain vacation destination. The area was particularly popular among residents of Chicago, Illinois. Courtesy Steven Rider Collection

Go slowly through the Painted Desert country. Hues of curry, saffron, and eggplant cover every hill and mesa. This is the land of hot days and cool nights, of Native Americans tending their burros and sheep, and of endless space and beauty. Turn here! You are off to visit the Meteor Crater, where a space rock punched a giant hole into the earth.

Let your radiator cool down in Flagstaff and take off your shoes to rest a spell. On the next morning, you can head out for your first view of nature's greatest masterpiece: The Grand Canyon. "Don't let anyone tell you that you'll be disappointed at your first sight of the Grand Canyon," penned writer Kent Ruth. "You can't be. No matter how hard you've tried to picture it . . . it's deeper, broader, more beautiful, more breath-taking than you've ever dreamed it could be. . . ." Soon, you will see for yourself.

Back on Route 66, between Kingman, Arizona, and Barstow, California, you spy a long stretch of sagebrush and desert dotted with prickly cacti. West of Barstow, Highway 66 follows the Mojave River and pushes upward through the Cajon Pass, then coasts ever so gently down into San Bernardino, where the emerald and gold citrus groves sparkle. It's an exhilarating sight after miles and miles of the barren desert.

This is California! Ease up on the gas, and roll by the vineyards and fruit farms, through towns with melodious names such as Monrovia, Arcadia, and Pasadena. Before you know it, you're entangled in the spider web of the Los Angeles highways.

At the road's terminus, Santa Monica punctuates the route with the Pacific Ocean's crashing waves. Go ahead, you've traveled many miles and seen many things. Walk out onto the pier, accept this gift, and dip your toes into the ocean. This is the land of movie stars and big dreams. Your journey along the Route 66 highway is over, but surely the memories you made along the way will last you and your family a lifetime.

to the El Morro National Monument, you will arrive at Inscription Rock, the social register of the seventeenth century with Spanish explorers' entries dating back as far as 1605.

With justification, Gallup, New Mexico, calls itself "The Indian Capital." Here, some thirty Native American tribes from all over the country gather annually for the famous Inter-Tribal Ceremonial. Explore the curio shops and enjoy the hospitality.

Fill your tank with gasoline and be sure to top off your water bag: In seventy-five miles, you will pull into Holbrook, Arizona. Here, you're off for another excursion, this time to the Petrified Forest National Monument to revel in the wonder of eighty-five thousand acres of the most abundant (and colorful) petrified wood in the world. Please don't take a souvenir here. It's illegal, and what will be left for the next tourists to see?

During the summer of 1968, free swimming, fishing, and picnicking were the draw at Santa Rosa's Park Lake in New Mexico. A springboard pier, bath house, and slide were just a bonus. Courtesy of the New Mexico State Records Center and Archives

Route 66's Natural Wonders

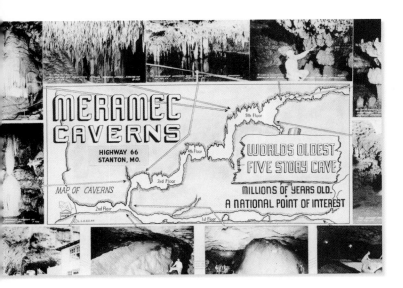

Lester Dill was the driving force behind the popularity of both the Meramec Caverns and Onondaga Cave. He was involved with the cave business since he was a child. He ran Fisher and Mushroom caves, and during the 1930s he developed Saltpetre Cave into a place for tourists. The newly renamed Meramec Caverns were opened to the public in 1935. Under Dill's guidance, they became a leading roadside attraction. Today, the Meramec Caverns are still privately owned. Courtesy Steven Rider Collection

Courtesy Steven Rider Collection

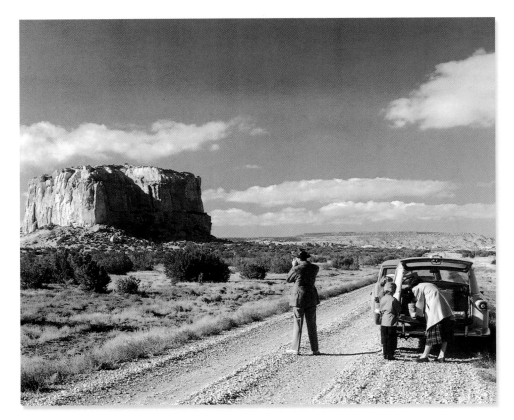

A vacationing family stops to photograph the Enchanted Mesa, near the Acoma Pueblo, New Mexico, 1953. This huge monolith looms at almost four feet above the valley. It is considered sacred by the Acomans. Courtesy of the New Mexico State Records Center and Archives

METEOR CRATER
THE GRAVE OF ARIZONA'S GIANT METEOR

Courtesy Steven Rider Collection

The biggest Route 66 attraction is not a building, animal farm, or souvenir stand. It's Meteor Crater, located south of the old U.S. Highway 66 between Flagstaff and Winslow, Arizona. In 1902, Philadelphia mining engineer Daniel Moreau Barringer filed a mining claim to explore it. For the next twenty-five years, he embarked on a campaign of scientific study to prove that the crater was formed by the impact of a meteor. It wasn't until sophisticated measuring devices were employed that evidence of a meteorite surfaced: 10 percent of the object was located under the crater's south rim—exactly where Barringer was forced to end his search. ©2006 Ron Saari

Tourists admire the Desert Ice Box, a perpetual ice cave that is located twenty-five miles south from the Route 66 town of Grants, New Mexico, 1959. Courtesy of the New Mexico State Records Center and Archives

Above: Visitors arriving by automobile at the Gallup Red Rocks area north of Thoreau, New Mexico, 1953. Courtesy of the New Mexico State Records Center and Archives

Left: The El Morro National Monument, also known as "Inscription Rock." The social register of the seventeenth century with Spanish explorers' entries going back as far as 1605 is located forty-three miles southwest of Grants, New Mexico, circa 1950. Courtesy of the New Mexico State Records Center and Archives

Roadside Oddities

The teepee-styled motel units that became a Route 66 icon were the brainchild of Frank Redford, who built his first wigwam-styled filling station and café in Horse Cave, Kentucky. The stylized structure opened in 1933 and drew rave reviews from tourists. In 1935, Redford added six "sleeping rooms" to his growing fantasy village. He patented the design in 1936.

The exterior of the teepees was built with a wood timber framework arranged to form a multi-sided cone. The cone was covered with tar paper and then plastered with stucco to create a faux "buffalo" skin. The artfully sculpted doorway created the illusion of a rolled-back flap. The cozy interior provided the traveler with modern-day conveniences, including electricity and a full-size bath. Adorned with authentic Apache blankets and Navajo rugs, the decor exuded real Western charm. The furniture was made from hickory wood, with the bark still in place. Courtesy Steven Rider Collection

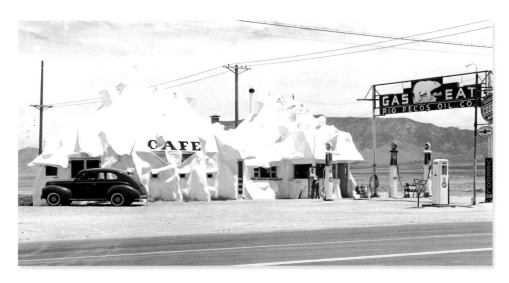

Left: The Iceberg Service Station, Albuquerque, New Mexico, circa 1940. The Iceberg lived out its life in multiple locations. Here, it is shown after its move to 5219 East Central Avenue, still outfitted with the original gas pumps from the 1930s. National Archives

Right: The El Sombrero Restaurant, shortly after it was built, circa 1949. Open twenty-four hours a day, the popular drive-in restaurant was located at 4415 East Central Avenue (U.S. Highway 66) in Albuquerque, New Mexico. Courtesy of the New Mexico State Records Center and Archives

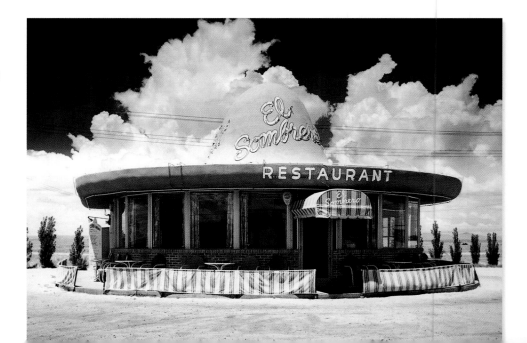

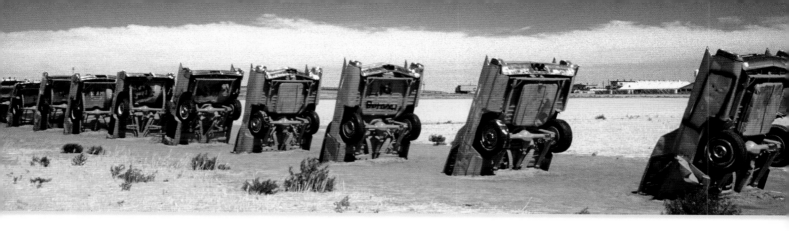

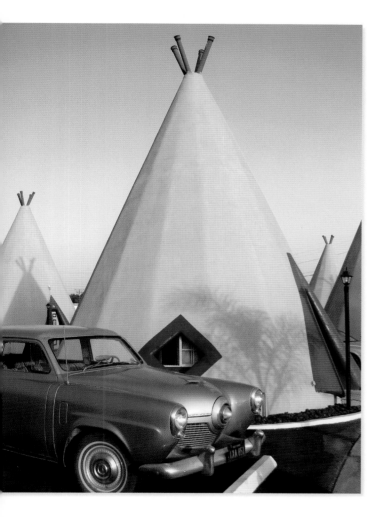

Above: *Cadillac Ranch, Amarillo, Texas. The outdoor sculpture celebrated its twentieth birthday in June 1994. In a 1994 interview, Doug Michels noted that he remembered the moment that the group of artists known as the Ant Farm pulled off the interstate just eight miles west of Amarillo to examine a stretch of panhandle plain. "Chip Lord, Hudson Marquez, and I were standing in a wheat field off Route 66 in the rain," Michels said. "And you know how the wheat waves and ripples in the wind? Well, suddenly we imagined a dolphin tail fin sticking up out of the wheat. Then the dolphin tail fin became a Cadillac tail fin. That was it. There was Cadillac Ranch." (— Texas Monthly, July 1994). In the summer of 1997, Stanley Marsh 3 moved his pop art shrine two miles west. ©2007 Bruce Carr/Cadillac Ranch sculpture by Ant Farm (Lord, Michels and Marquez), copyright 1974*

Left: *Wigwam Motel unit, San Bernardino (Rialto), California, 2005. Shown here after the renovation effort, the teepees are now open and ready for new business, taking reservations, offering classic rooms complete with Wi-Fi service, satellite television channels, a refrigerator, an air-conditioner, and a heater. Sometimes, the present is just a little bit more comfortable than the past. The car in the photo is a 1951 Studebaker Champion. ©2007 Jim Ross*

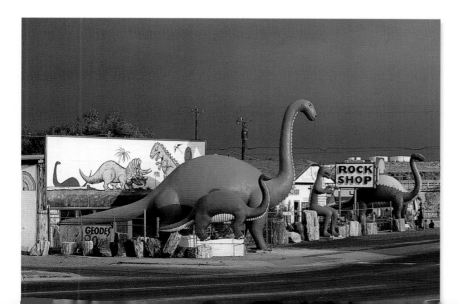

Rainbow Rock Shop, 101 Navajo Boulevard. (Route 66), Holbrook, Arizona, 1998. The seven encircling dinosaurs were designed and sculpted by shop owner Adam Luna. It took him almost twenty years to complete them, using cement and reinforcing rod. The tallest one is almost twenty-five-feet high. The area around Holbrook is known for its dinosaur sculptures, some made of petrified wood, while others are formed with chicken wire and concrete. Visitors and locals enjoy the company of these giant creatures. In fact, residents take a certain pride in the area's "dino" heritage. ©2007 Howard Ande

ROCK SHOP

RAINBOW

LUMBERJACK CAFE
ON U.S. 66 & 89
FLAGSTAFF,
ARIZONA

AMPLE OFF-STREET PARKING

LUMBERJACK
CAFE
FLAGSTAFF, ARIZONA

BROWN & BIGELOW, DENVER

LUMBERJACK CAFE,
FLAGSTAFF, ARIZONA

The
ROUTE
America Travels

TRAVEL
US
66

RAINBOW ROCK SHOP,
HOLBROOK, ARIZONA

1868

The Blue Whale

OUR STATION
WAGON
OVERHEATED
HERE ···

Kodachrome
TRANSPARENCY

CURIOS

PROCESSED BY Kodak

DL

'AVERNS Entrance
CURIO
SHOP

Old Route 66 Highway, Catoosa, Oklahoma

THE BLUE WHALE, CATOOSA, OKLAHOMA

DINOSAU

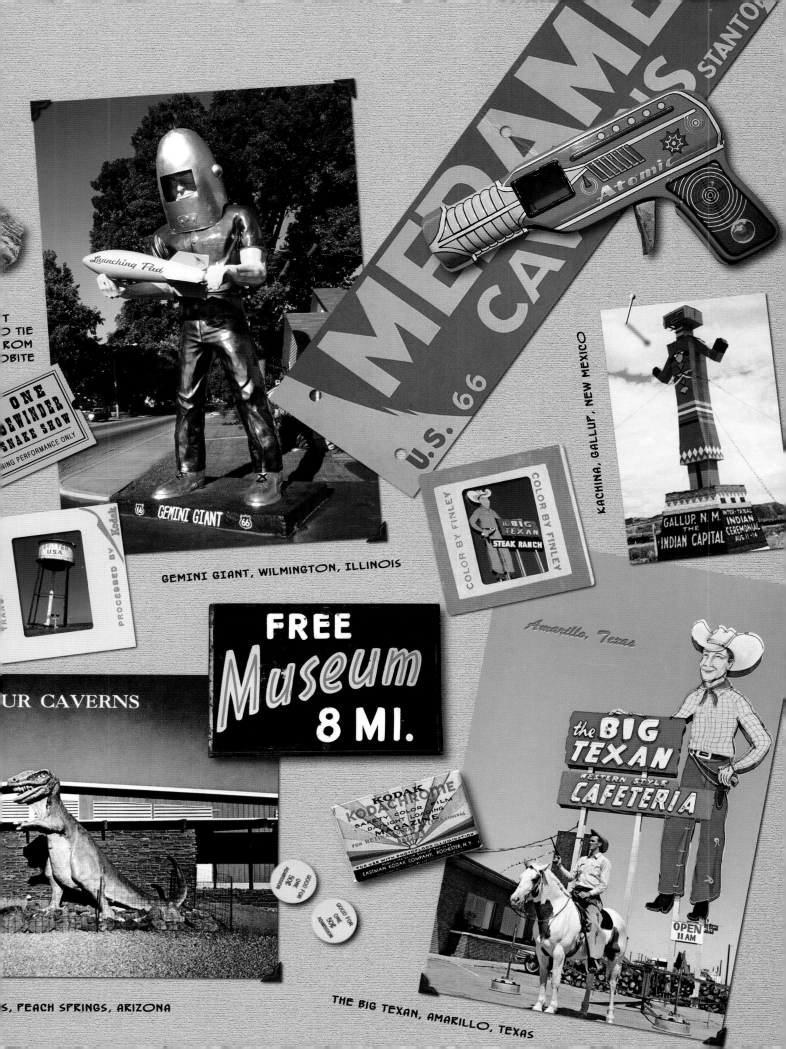

ONE
SIDEWINDER
SNAKE SHOW
EVENING PERFORMANCE ONLY

GEMINI GIANT, WILMINGTON, ILLINOIS

KACHINA, GALLUP, NEW MEXICO

GALLUP, N. M.
THE
INDIAN CAPITAL
INTER-TRIBAL
INDIAN
CEREMONIAL
AUG. 11-14

MEDAME'S STANTON
CAVE
U.S. 66
Atomic

COLOR BY FINLEY
THE BIG TEXAN
STEAK RANCH
COLOR BY FINLEY

FREE
Museum
8 MI.

R CAVERNS

Amarillo, Texas

KODAK
KODACHROME
SAFETY COLOR FILM
DAYLIGHT LOADING
MAGAZINE
FOR RETINA CAMERAS
TYPE A
FOR USE WITH PHOTOFLOOD ILLUMINATION
EASTMAN KODAK COMPANY, ROCHESTER, N.Y.

the BIG
TEXAN
WESTERN STYLE
CAFETERIA

OPEN
11 AM

S, PEACH SPRINGS, ARIZONA

THE BIG TEXAN, AMARILLO, TEXAS

Frank Yellowhorse and Yellowhorse Trading Post

"So my dad would hang around the train depot and people would come back from the Petrified Forest tour and say, 'We've seen the most beautiful place in world . . . but we couldn't even get one chip.' That's when my dad got to thinking. He knew a place where there was all kinds of petrified wood on private property that didn't belong to the protected forest. So, he just started collecting that petrified wood, hauling it out, and stockpiling it. When my dad was finished, he had tons of it. He had big piles of all kinds of petrified wood . . . the cream of the crop!"

—Frank Yellowhorse
Interview, February 14, 2006

The Yellowhorse trading post business began in Arizona with a chunk of petrified wood. As Frank Yellowhorse tells the tale, his father, Arthur Beasley, took people who pulled into the Dead River train depot on tours of the Petrified Forest. When they returned to catch the Santa Fe home, they would bemoan the fact that they had seen "the most beautiful place in the world filled with petrified wood," but they "couldn't even get one chip."

"That's when my dad got to thinking," Yellowhorse said. "He knew a place where there was all kinds of petrified wood on private property that didn't belong to the protected forest. So, he just started collecting that petrified wood, hauling it out, and stockpiling it." Amazingly, the local ranchers didn't want the stuff on their land because it kept their grass from growing!"

"When my dad was finished, he had tons of it," Yellowhorse added. "He had big piles of all kinds of petrified wood . . . the cream of the crop! He also had a place where he graded, cut, and polished the rock. He loaded his fossilized wares into saddlebags and rode his horse out to the Adamana train station. Then he sold the petrified wood souvenirs to people directly through the windows of the train."

By the mid-1930s, Beasley realized that he had found his niche in life: selling trinkets to the tourists who passed through this remote region of Arizona. With the help of his wife Anna Yellowhorse (a full-blooded Navajo Indian) and a piece of land that she obtained from her tribe, he

Frank Yellowhorse in full war bonnet, posing for the camera in 1997. Frank was born on February 14, 1931. Courtesy of Frank Yellowhorse

opened his first serious trading post in Querino Canyon. It was right on old 66, about fourteen miles west of the Arizona border (between Houck and Sanders).

To make his place unique, Beasley put up ornate fencing that surrounded a small trio of hogans—pyramid-like domes made with stick framework and covered with packed mud or adobe. The hogans provided the living quarters for the family. Out in front, there was a small roadside stand that they used to sell Navajo rugs to the tourists. "He would go down to Mexico and bring back big loads of Mexican blankets. Then he'd string them up on long lines for one hundred feet on each side," says Yellowhorse. Locals referred to the roadside attraction as the Navajo Castle.

Eventually, three of the Beasley boys jumped into the trading post game and made their own way on Route 66. During the 1960s, brothers Juan, Frank, and "Shush" got together and built a place about eight miles west of the Arizona border, on a Navajo business site lease. On the north side of the highway, along the westbound lane, they quickly put up a small wood structure and a two-story teepee. Frank did silver jewelry work, Shush did the sandpainting, and Juan handled design. The fourth brother, Johnny, answered a different calling and went off to college.

Of course, "Beasley" wasn't exactly a catchy name when it came to an Indian trading post, so the brothers decided to take advantage of a more exotic moniker from their mother's side of the family—namely, their grandfather, "Cut-hair" Yellowhorse. Juan was already well known by the nickname "Chief," so they decided to combine the two. "Stop at Chief Yellowhorse," proclaimed the new signs, "Friendly Navajo Ahead!" It would be the first of many Route 66 trading posts to carry the memorable Chief Yellowhorse name.

Fort Chief Yellowhorse is located about seven hundred yards up the road from the Yellowhorse Trading Post. It was built in 1979 after the original teepee trading post structure burned down in the early 1970s. Courtesy of Cline Library Northern Arizona University

Unfortunately, the Yellowhorse brothers overestimated the bravery of the white tourist. People speeding across the desert along Route 66 didn't want to take a chance, even if the Navajos were friendly. As a result, many didn't slow down their cars for a stop. After the brothers began asking the customers *why* they stopped, they learned that many were initially leery of the place. Like it or not, the general public was afraid to come in.

So, Juan and Frank Yellowhorse hatched a clever scheme to install funny advertising signs all along Route 66 to pull in the business. In the same spirit as the famous

The Chief Yellowhorse Trading Post in 1998. Frank Yellowhorse recalls his father telling him, "This highway [U.S. 66] is paved with gold. Treat people well and help them as much as you can. The road will provide you a living!" And it has been doing that for the entire Yellowhorse clan, bypass survivors, and traders on Route 66. Courtesy of Frank Yellowhorse

The Beasley clan, working the petrified wood trade along U.S. Highway 66, circa 1957. Back row, right to left: Arthur Beasley, Anna Yellowhorse Beasley, Maryann, Jane, Artie, and Gloria. Front row, left to right: Johnny, Frank, Betty (little girl in middle), Shush (Bear), and Juan. Courtesy of Frank Yellowhorse

Burma-Shave billboard campaign, they painted two-foot-square sheaves of plywood with their signature black, yellow, and red color palette and installed them every fifty miles or so along the road.

Now, instead of trying to convince people that they were friendly, they *showed* them they were . . . with humor. Instead of the standard line, "we sell Indian blankets and jewelry," their signs issued a satirical warning: "Indians Ahead, Welcome. We No Scalpum Pale Face, Just Scalpum Wallet!" The brothers came up with a quiver full of clever slogans that all played on the Indian stereotype. By the time a station wagon full of visitors made it across the New Mexico border, the name Yellowhorse was branded onto their brains. They had to stop!

The good times on Route 66 didn't last forever for the Yellowhorse clan. During the late 1960s, the last leg of Interstate 40—or what some residents referred to as the "Mojave Freeway"—cut a wide swath through Arizona, directly through their store. The brothers moved to a new location, some two hundred yards from the Arizona–New Mexico border. This time, a larger-than-life, five-story teepee became the core of a new trading post.

Unfortunately, the structure burned down during the early 1970s and the Yellowhorse brothers ended up going their separate ways. By 1979, they realized that their strength came from family, so they tried to regroup, yet again. They found a piece of land that could be seen directly from I-40 and built an attraction they called Fort Yellowhorse. Sadly, the complete vision for the roadside stockade went unrealized, but Juan did set up a small stand that eventually included a store. He replaced the word "Fort" with "Chief" on the signs and commenced to trade in the shadow of I-40 for many moons, until his passing in 1998.

Meanwhile, Frank Yellowhorse built the most recent incarnation of the Yellowhorse trading posts, now known as Yellowhorse Ltd. Today in Lupton, Arizona (*Hoozdo*

Hahoodzo in Navajo)—right under the dramatic red cliffs of the I-40 exit 359—he plys his trade selling one-of-a-kind jewelry, collectible knives, and inlaid Zippo lighters. Yes, the highway politics of Route 66 caused the old Chief Yellowhorse traders to move again; hopefully, this will be the final venue to conduct their family business.

When it comes right down to it, location was never the most important aspect of the many Yellowhorse trading posts. Anywhere along Route 66 was prime for business, as long as you treated the customers right. "This highway is paved with gold," Frank Yellowhorse's father often said. "Treat the people well and help them as much as you can. The road will provide you a living!" And it did provide for the entire Yellowhorse clan of bypass survivors and traders on 66.

At the age of nine David Yellowhorse was already a full member of the trading post enterprise. He was encouraged to give tourist children burro rides. This photograph was taken in 1965 when the original teepee was still standing. Courtesy of Frank Yellowhorse

Totem Pole Park

Totem Pole Park, Foyil, Oklahoma. Foyil is located off former U.S. Highway 66 on Highway 28A, but its location didn't stop Edward Nathan Galloway from designing and building what would one day become a one-of-a-kind tourist draw in itself.

In 1938, the former industrial arts instructor began crafting what he envisioned as a giant three-dimensional sculpture shaped like a giant totem pole. The concrete-clad monolith was made with twenty-eight tons of cement, six tons of steel, and one hundred tons of sand and rock (hauled from a nearby river). It took eleven years to finish the sculpted spire, but the results were fantastic: 200 detailed carvings depicting famous Indian chiefs, mythical raptors, flowers, fanciful fish, and other symbols were finished off with rainbow hues of colorful paint.

When Galloway died in 1962, his unique creation was soon neglected and forgotten. With no one to attend to them, the totem poles were subjected to vandalism, and the park became a local teen hangout. But changes for the better came in 1990 when the Galloway family donated the fourteen-acre site to the Rogers County Historical Society. ©2007 Michael Karl Witzel

The Trading Post

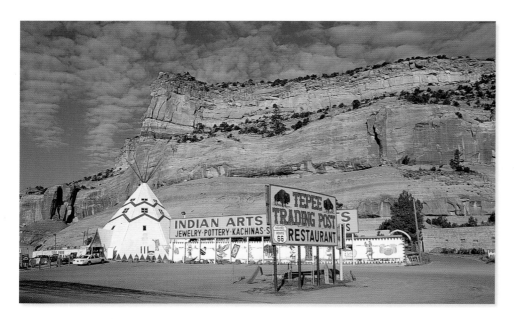

Tee Pee Trading Post, IH 40 and Grant Road, Lupton, Arizona. By 1995, businesses along the former U.S. Route 66 were proudly displaying signs that proclaimed their Historic Route 66 location. This trading post has been conducting business along Route 66 since the road was first commissioned and continues to do a strong business today. Part of the reason for its survival during the interstate bypass era: a close proximity to interstate highway ramp. ©2007 Howard Ande

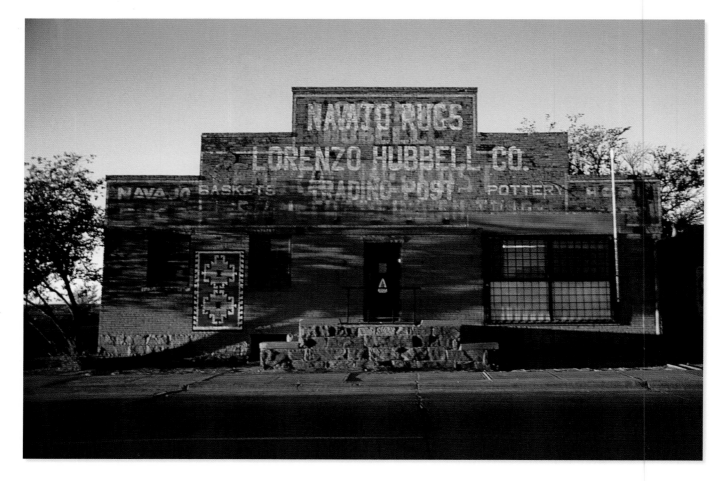

Lorenzo Hubbell Trading Post, Winslow, Arizona, 1990. The Hubbell trading post empire included wholesale stores, trading posts, and curio shops stationed from New Mexico to California. The Winslow operation opened in 1924 and remained in business as a trading post until 1948. ©2007 Sheila Harlow

Painted Desert Trading Post, former U.S. Route 66, between Carrizo and Navajo, Arizona. Dotch and Alberta Windsor opened the trading post in the early 1940s, selling the standard fare in Native American curios and pumping gasoline from a pair of gravity-fed visible register gasoline pumps out front. After U.S. Route 66 was relocated, widened, and designated as Interstate 40 in the late 1950s, this lonely outpost was abandoned. ©2007 Russell Olsen

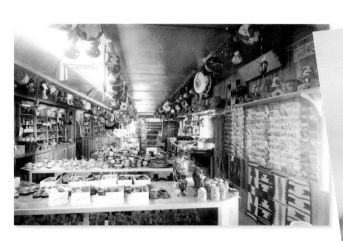

Interior, Twin Arrows Trading Post, U.S. Route 66, Arizona, February 1954. This rare glimpse into the interior of a working trading post reveals boxes filled with moccasins lining the top of the counter, the ceiling draped in drums, and a variety of pottery stacked along the shelves and counters. Cactus lamps, made from the dried-out spines of various desert cacti, are offered at the price of $4.50 and up. Courtesy of Cline Library Northern Arizona University

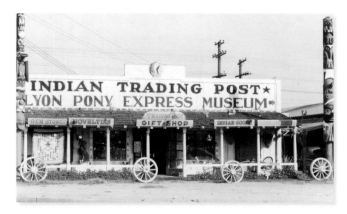

The W. Parker Lyons Pony Express Museum and Indian Trading Post, Arcadia, California, circa 1949. The museum was located on Huntington Drive, across from the Santa Anita Race Track. It was dismantled in 1955 to make way for the Flamingo Hotel, built at 130 W. Huntington Drive. The Pony Express Indian Trading Post building was moved to the Arcadia County Park for use as a museum. Courtesy Steven Rider Collection

Formerly called the Canyon Padre Trading Post, the Twin Arrows Trading Post consisted of a service station, a trading post, and a Valentine Diner. The appeal of this U.S. Highway 66 tourist stop continued through the interstate era, since its location near an I-40 off-ramp guaranteed its survival. It shut down in the early 1990s and reopened briefly in 1995. Since then, the trading post has remained closed. ©2007 Jim Ross

Native American Arts, Crafts, and Culture

Tourists stop to admire Laguna Indian pottery, U.S. Highway 66, 1941. The historical marker: "Lava Flow establishes this as U.S. Highway 66 looking to the West past the small village of Santa Maria, New Mexico." Courtesy of the New Mexico State Records Center and Archives

Above: *Zuni pottery women parade their handiwork proudly at the Inter-Tribal Ceremonial, circa 1950. Courtesy of the New Mexico State Records Center and Archives*

Left: *Southwest pottery from the Acoma, Zuni, and Hopi is some of the most sought after pottery in America. The essence of the clay is highly valued (and often difficult to dig out), because it affects the overall look of each piece. The method used is hand-coiling, which takes both time and an artistic approach. Here, Hopi potter Winged Ant is working her prized clay and forming it into a work of art at the Gallup, New Mexico, Indian Inter-Tribal Ceremonial in 1956. Courtesy of the New Mexico State Records Center and Archives*

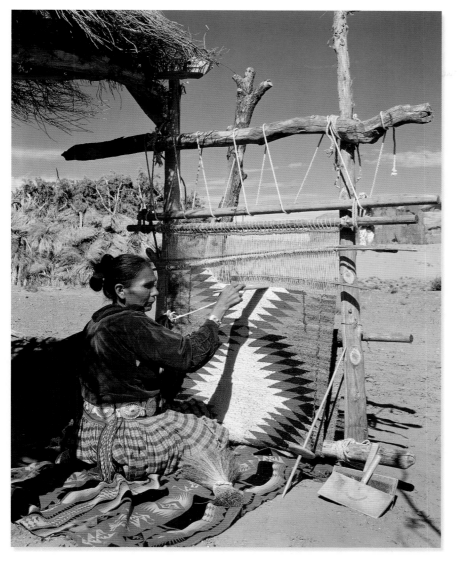

"In the very early days, going way back, the Navajo people learned weaving probably from the Pueblo people, over on the Rio Grande. They had never woven before they met up with the Pueblo people. Well, being so adaptable and doing things so well, as they do, they picked up this weaving art and turned it into something uniquely their own, and wonderful. But in the early days, anyway—and by 'the early days,' I'm meaning the early or mid-1800s maybe—they were weaving for a utilitarian purpose. That is, they were weaving wearing garments. . . . At some point or another, they figured out that they could sell wearing garments to Anglo people for a big price. . . . I will never forget hearing from some of the real old-time Navajo people talking about that, and about their complete inability to grasp what happened when they would sell these wearing garments to the Anglo people. They said the Anglo people would take them and do a thing that they never could understand. They said they would throw them on the floor and walk all over them! And I think they had a big joke about that for a long time. Of course, they became rugs, and we all know what happened." — Interview, Jim Babbitt of Babbitt Brothers trading posts, at the Navajo Reservation, Arizona, 1955, Northern Arizona University. Photograph of Navajo Indian Weaver, Arizona, circa 1955. Courtesy of Cline Library Northern Arizona University

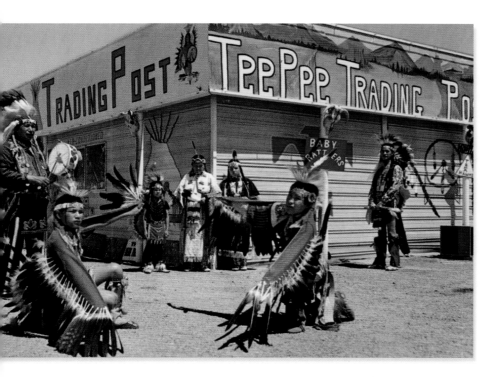

The Tee Pee Trading Post and Standard Station provided Indian ceremonials each evening in the summer by the "Great Lightning" Bison and family. Native American dances were also featured in the morning and afternoon. The business was located on East U.S. Highway 66 in Sayre, Oklahoma. Courtesy Steven Rider Collection

Gas Stations of the Mother Road

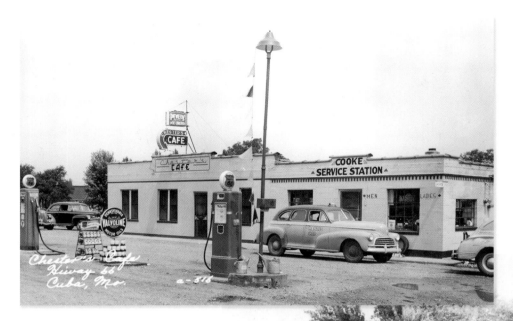

The center of Cuba Missouri's business district moved from its spot near the railroad track to where the action was: along U.S. Highway 66. The Cooke Service Station and Chester's Café were located right along the traffic route. Courtesy Steven Rider Collection

Right: C&A Chevron service station, U.S. Highway 66, Needles, California, circa 1950. Courtesy Steven Rider Collection

Above: The Outpost was located at the junction of U.S. Highways 66 and 395, about thirteen miles west of Victorville, California. In addition to offering café vittles, it also pumped gasoline and sold its share of souvenirs and novelties to the denizens of the highway. Courtesy Steven Rider Collection

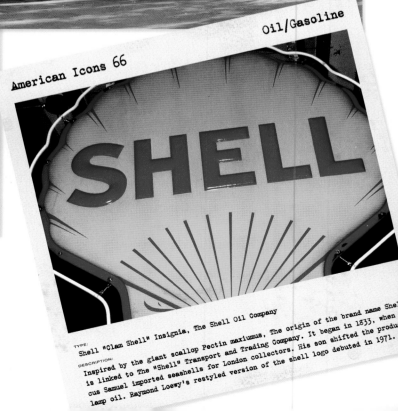

Oil/Gasoline

American Icons 66

TYPE: Shell "Clam Shell" Insignia, The Shell Oil Company

DESCRIPTION: Inspired by the giant scallop Pectin maxiumus, The origin of the brand name Shell is linked to The "Shell" Transport and Trading Company. It began in 1833, when Marcus Samuel imported seashells for London collectors. His son shifted the product to lamp oil. Raymond Loewy's restyled version of the shell logo debuted in 1971.

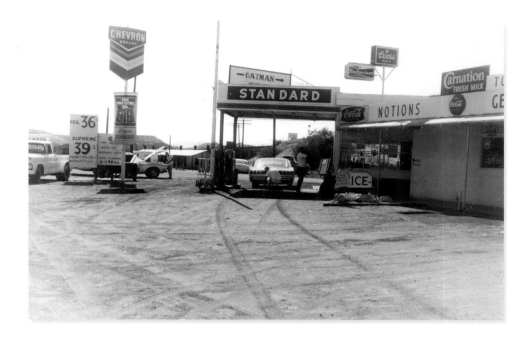

Chevron Gasoline and Service Station, Topock, Arizona, 1968. Here, the route heads west toward California. A sign for Oatman, Arizona (located on top of gas station), points travelers north to the 1926 alignment of Route 66. Courtesy of Cline Library Northern Arizona University

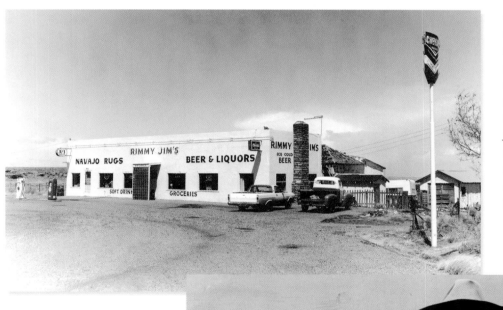

Original owner "Rimmy" Jim Giddings opened this second gas station/trading post along U.S. Highway 66, after the highway (east of Meteor Crater Road) was realigned in 1949. Rimmy Jim's was located on Route 66 at the Meteor Crater Junction. This 1969 scene was recorded by the Arizona Highway Department as part of the Interstate 40 project. Courtesy of Cline Library Northern Arizona University

Right: "Rimmy" Jim Giddings became a self-made legend along U.S. Highway 66. The former cowboy turned entrepreneur received his nickname from the type of saddle (referred to as a rig) that he used. It was a Rimmy rig ("rim-fire" or center-cinched rig), made in Texas. Courtesy Steven Rider Collection

Opposite: Author's collection

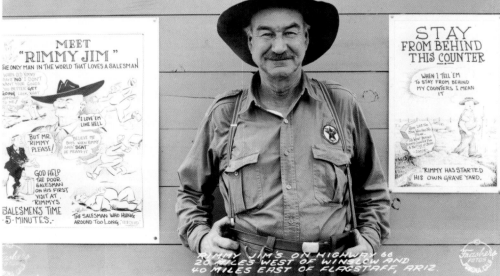

Route 66 Downtowns and Business Districts

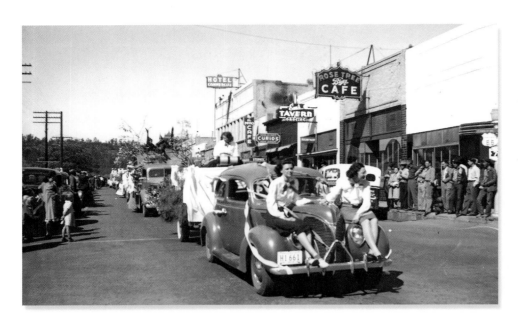

Flagstaff, U.S. Highway 66, 1958. Homecoming parade against the local backdrop of the Commercial Hotel, Rose Tree Café, El Patio Café, and Em's Tavern. Courtesy of Cline Library Northern Arizona University

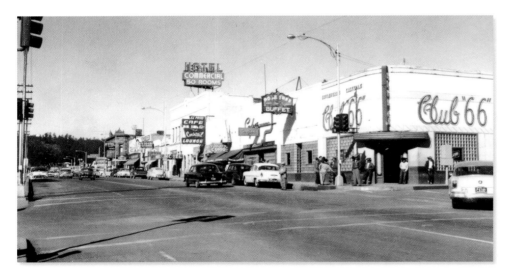

Route 66 and Sante Fe Avenue, Flagstaff, Arizona, 1958. Back in the day, establishments like the Club "66," Cooper's Liquor Store and Buffet, Rose Tree Café, El Patio Café, and Commercial Hotel kept commerce humming. Courtesy of Cline Library Northern Arizona University

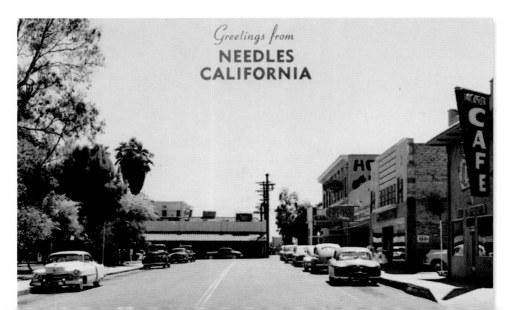

Needles, California, circa 1953. Needles was established in 1869 as a steamboat landing and supply station on the old emigrant trail. In 1883, Needles became a rail center for the Santa Fe Railroad. By 1946, overnight accommodations were plentiful there, including overnight sleeping establishments like The Palms, El Garces, Havasu Court and Trailer Camp, and the Motor Inn Motel. Courtesy Steven Rider Collection

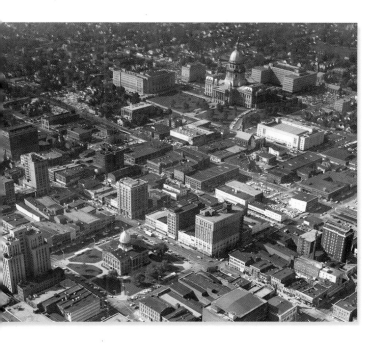

Intersection of Stanford Avenue and 6th Street (Route 66), circa 1950s. The white building is located at the northeast corner of Stanford and U.S. Highway 66 in Springfield, Illinois. Courtesy of Sangamon Valley Collection at Lincoln Library, Springfield, Illinois

Springfield, Illinois, 1960. On September 29, 1965, there was a public hearing in Springfield ordered by the federal bureau of public roads. The primary issue: whether the federal bureau should approve the governor's proposal to remove the Interstate 55 designation from U.S. Highway 66 between Joliet and Lincoln. The idea was to shift Interstate 55 south, near LaSalle to Lincoln, by way of Peoria. This plan would remove 107 miles of Route 66 from the interstate system. The severe opposition to the governor's plan led to further debates and by 1966 the proposal was in the hands of the White House. Courtesy of Sangamon Valley Collection at Lincoln Library, Springfield, Illinois

U.S. Highway 66 (Central Avenue) through Albuquerque, New Mexico, circa 1940. During the 1940s, Albuquerque was a rapidly growing city and Central Avenue was in its heyday. This began to change in 1947 when the swell of new residents, who lived mostly in the Heights, began dining and shopping near their homes. Courtesy of the New Mexico State Records Center and Archives

Amarillo was the hub of the Texas Panhandle, with four major U.S. highways merging into the city, including U.S. 66. Restaurants, tourist shops, gasoline stations, and motels flourished there. The steady flow of traffic on the "Broadway of America" is graphic evidence of how busy this city was during the heyday of Route 66. In this vintage postcard, Amarillo is touted as "The Friendly City." Courtesy Steven Rider Collection

Foothill Boulevard (U.S. Highway 66) looking east toward the San Bernardino Mountains, Rialto, California, circa 1955. Rialto was incorporated as a city in 1911, but its largest population growth occurred between 1950 and 1980 when the population increased more than tenfold. Courtesy Steven Rider Collection

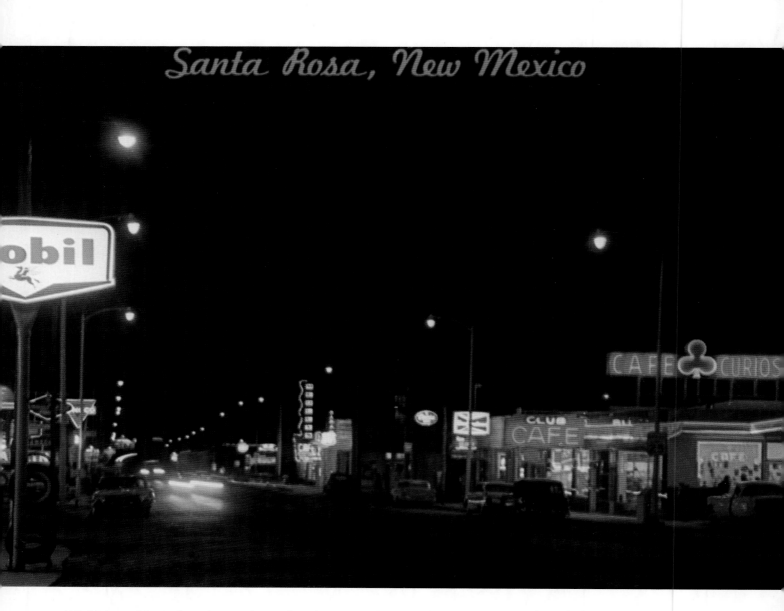

U.S. Highway 66 at night, with neon glowing through Santa Rosa, New Mexico, circa 1960s. The town provided numerous motels and fine dining, including the Club Café, built in 1935. Courtesy Steven Rider Collection

Jumping Route 66

"America's best-known highway is U.S. 66—striking a 2,200-mile arc across the nation's colorful Southwest from Chicago to Los Angeles. A song has been written about it. Movies have been filmed along its incredible route. History may well rank it with Rome's Via Appia. The fastest highway to the West Coast, it now has more than 1,500 miles of divided, four-lane pavement or its equivalent, and more is being constructed with the help of federal funds."

— Jay McMullen,
"Writer Smitten with Beauties . . ."
The Sunday Oklahoman, February 24, 1963

Left: *Oklahoma City, Oklahoma, looking east on N.W. 23rd Street (Route 66), August 1965. During the 1950s, the downtown main street of Oklahoma City was a vibrant commercial district. But the "Main Street of America" was slipping away. In 1962, The Oklahoman summarized the local zeitgeist when it wrote, "Except in the case of the gentlemen in charge of making highway designations in Washington, there seems to be strong support for keeping the '66' on the 'Main Street of America.'" But it was not to be: Despite the protests of civic groups, switching U.S. Route 66 to Interstates 55, 44, 40,15, and10 could not be stopped. Courtesy of Oklahoma Historical Society*

Right: *In 1957, the speed limit on all divided four-lane highways was raised from a pokey fifty-five miles per hour to seventy miles per hour. For the average driver, motoring along the superslab at seventy miles an hour was far more exhilarating . . . and time saving. ©2006 Pedar Ness*

utside the car window, the scenery whirls by in an indistinguishable blur. The car's driver—a thirty-year-old Chicagoan—is mindful of only one thing: speed. How fast am I going? How many miles can I rack up in an hour? If I leave the Windy City at eight in the morning and put the "pedal to the metal," can I get to Amarillo, Texas, by nightfall?

Welcome to the 1960s, where highway travel is equivalent to jet "flight time" on the ground. Now, instead of travelers "enjoying the ride," the emphasis of the motoring trip is placed on the speed of the vehicle and how swiftly it can move over the four-lane system of roadways. With their smooth surfaces, gradual curves, and occasional exits, the new expressways allow a scenery-killing speed limit of seventy miles per hour.

It all started in 1957, one year after America's interstate system was born. To take advantage of its features, officials raised the automobile speed limit on all divided four-lane highways from fifty-five to seventy miles per hour.[1] Trucks that were limited to a pokey forty miles per hour could now whip up dust devils at fifty-five miles per hour. "It's easy to do seven hundred miles a day on the gleaming ribbons of dual highways that unfurl across the Great Plains," wrote Jay McMullen in *The Sunday Oklahoman*. "If you don't

tarry, you can make Los Angeles from Chicago in three days, averaging fifty miles an hour, including time lost stopping for meals and gasoline."

In Illinois, the new interstate identified as 55 became a full-speed expressway where cars could cruise from Chicago to St. Louis at seventy miles per hour. At those speeds, stopping to use the restroom or to get a bit to eat was a major distraction. Instead of allowing motorists to exit the freeway, states built "rest areas" that provided motorists with easy on and off access. Built in pairs, the rest areas were situated on each side of the expressway. For convenience, there were rest areas stationed at least every fifty miles apart.

In 1962, the state of Illinois estimated that these relief stations would drain the tax coffers of more than ten million dollars. Despite the cost, officials insisted that the rest areas must be constructed: "We believe that the rest and comfort stops are an integral part of the motor transport facilities we are building into the interstate system," said William Payes, director of the state's public works department.[2]

Costs were a non-issue. States could afford the upscale investment in infrastructure since Uncle Sam was footing the bill. President Dwight Eisenhower's 1956 Federal Aid Highway Act had apportioned 90 percent funding for improved highway systems to link a disjointed web of roads

Cajon Pass, the "Gateway to Southern California," circa early 1960s. During the 1960s, the pass was no longer a two-lane highway. This portion of Route 66 was once part of the Old Spanish Trail. Courtesy Steven Rider Collection

During the 1960s, the "need for speed" was somewhat curtailed by these strategically placed "66 Patrolled by Aircraft" signs along the Mother Road in Arizona. Courtesy of Robert Genat

If the decision was left to the burgeoning interstate machine, U.S. 66 would be swallowed up under the unfamiliar designations of IH-55, IH-44, IH-40, IH-15, and IH-10. Before too long, civic groups and newspapers from along the roadway began to speak their minds. People argued that the fabled route, featured in books, television, films, and song, had always worn the familiar double sixes. There was just something about it—something unexplainable—that made it so difficult to let go of that number.

In 1962, a writer for *The Oklahoman* summed up the feelings of the road's defenders when he wrote, "Except in the case of the gentlemen in charge of making highway designations in Washington, there seems to be strong support for keeping the '66' on the 'Main Street of America.'" From all eight states that sought to save this national Main Street, the general consensus was that the folks in Washington knew "diddly-squat" about the road's mystique and the importance of maintaining its number.

In 1965, the *Chicago Tribune* reported that "Things Are Really Jumping Along Route 66." Unknowingly, the article was a precursor to the road's final decommissioning. "More things will be happening for the traveler along famed U.S. Highway 66 from May thru September this year than can ever be seen on television reruns at home," boasted the piece. Travelers were promised to be regaled with "road rallies, yacht regattas, Indian rain dances, rodeos, fiestas, outdoor art shows, and the Las Vegas Hellorado." It sounded as if the good times would never end.

Yessiree Bob, Route 66 was jumping! Unfortunately, the plans were already on paper to seal the fate of America's fabled Main Street forever. Soon, very soon, it would be jumping all right . . . jumping right off the map and into obscurity.

into a national network of articulated highways. "We want the roads as fast as we can get them" came the frenzied cry from supporters of the interstate highway system. The money flowed freely and the proponents of high-speed highways got their wish.

At the time, most travelers embraced the new roads, although many were frustrated over construction delays and confusing road signs that often carried several names for a single route. There were a few scandals involving toll road signs, too: More often than not, the unsuspecting motorist was guided directly into the clutches of a tollbooth and forced to take a route that they had to pay money to use.

Unfortunately, not all of the Highway 66 roadbed between Chicago and St. Louis was up to the merits of the Interstate 55 markings. Therefore, it took a clever driver to navigate the known trouble spots along the way. Along one particular 140-mile stretch of 66, maintaining any sort of high speed was inhibited by miles of cross-traffic, railroad grade crossings, uncontrolled side roads, and private entrances.

Amidst all of these changes, the appeal of taking a Route 66 journey was beginning to wane. Instead, people found it easier to see the sights of America from the comfort of their living rooms, without the hassle of buying a tank of gas and braving the traffic. In October 1960, the television show ROUTE 66 debuted on the tube, staring George Maharis and Martin "Marty" Milner. The program captivated audiences almost immediately. Instead of buckling into the driver's seat, you could relax in your La-Z-Boy and still come along for the ride. The trials and tribulation of two young men crossing the country in their Corvette became the new reality.

As the perception of Route 66 changed from a real highway into a voyeuristic television experience, the road was undergoing its own metamorphosis. Interstates came into full bloom nationwide as colorful red, white, and blue shields announced their presence. The once-familiar black-and-white shields were removed across the nation.

Los Angeles, California, freeway, circa 1950s. America's interstate system was born on June 29, 1956, out of federal legislation. This system would change the way Americans traveled and worked, creating a mobility only dreamed of. Today, there are 46,876 miles of interstate in America. National Archives

On August 27, 1960, Seymour Korman of the Chicago Daily Tribune wrote that "A heart line of the nation is Route 66, thru the southwest from Chicago to Los Angeles, and that is the title of the new CBS-TV one hour series for the cross-country adventures of Marty Milner and George Maharis. It will be seen in Chicago on Channel 2 starting Sept. 30." The buzz for this traveling duo and their Corvette convertible was big. Milner would play a lad who came from a privileged background and Maharis from one of financial challenge. The common denominator? Both were looking for a place to call home. Author's collection

The ROUTE 66 television show may have inspired this advertising headline, "Look what's happened to Route 66." Through the television show, Americans were discovering another world away from their TV trays, PTA meetings, and bridge clubs—a world filled with outsiders, misfits, and other rugged individualists who didn't fit in to the "normal" mold of society. Author's collection

Left: *During the 1960s and 1970s, the majority of Nelson Riddle's work was for film and television. It was during this time that he recorded the hit theme song for the* Route 66 *television series, a score that earned him a Top 40 single in 1962.* Courtesy Jim Ross Collection

Below: Author's collection

Cafés and Eateries along the Way

The Rainbow Café, located on Route 66s and 69 North, provided ample parking for its patrons and offered Hickory pit Bar-B-Que Ribs—and of course, the standard fare of "chicken in a basket." Postmarked 1964, this card's message related the sentiment of many drivers during the 1960s: "Made real good time, although we had 2 flats." Courtesy Steven Rider Collection

The Mark Restaurant, Weatherford, Oklahoma, featured Chicken in the Rough, steaks, seafood, and sandwiches. Every Sunday the proprietor, Chet Crownover, offered his customers a "smorgasbord," a popular term used during the 1960s and 1970s to describe a buffet. Courtesy Steven Rider Collection

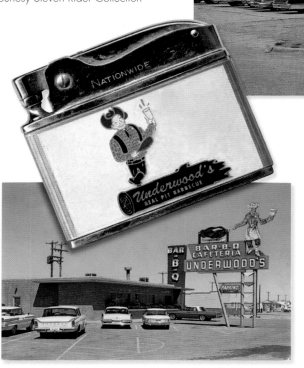

Underwood's Bar-B-Q Cafeteria, U.S. Route 66, Amarillo, Texas, circa 1962. Today, the last remaining Underwood's Bar-B-Q is located in Brownwood, Texas (in operation since 1951). Courtesy Steven Rider Collection/Lighter Author's collection

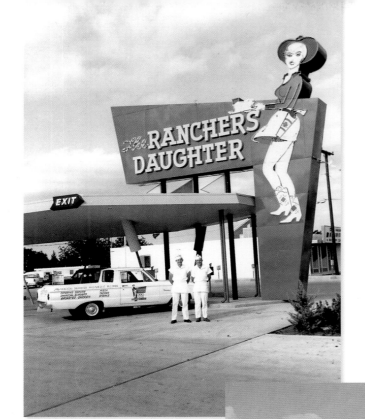

The Ranchers Daughter Drive-In, 4433 Northwest 23rd Street (Route 66), Oklahoma City, Oklahoma. This energetic curb-service restaurant with over-the-top sign featured a catering service and served car customers charcoal broiled burgers, broasted chicken, pizza, tacos, and steaks. This photograph by Meyers Photo Shop was taken in May 1961. Courtesy of Oklahoma Historical Society

Sweeney's Steak House, Route 66, Bourbon, Missouri, circa 1960. Owned and operated by R. D. Sweeney and his wife, the back of the card states "Home of good steaks and chicken. Our steers—and our guests—are well fed." Courtesy Steven Rider Collection

Tommy's Café, circa 1962, U.S. Highway 66, Adrian, Texas. On the back of the postcard (postmarked 1964) the writer reports, "Just drove 75 miles in the last 60 minutes—traffic is light right now." Courtesy Steven Rider Collection

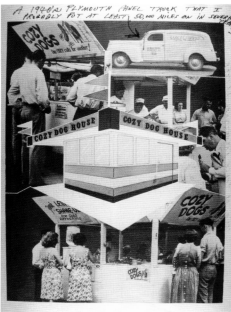

Springfield, Illinois, holds bragging rights as the official birthplace of the corn dog. The popular "dog-on-a-stick" was developed and improved by Edward Waldmire from an idea presented by his brother in Muskogee, Oklahoma. Waldmire first presented his new culinary treat to visitors at the 1946 Illinois State Fair. It was so well received that he opened an eatery dedicated to serving up the tasty treat. The first Cozy Dog House opened between Fifth and Sixth streets in Springfield, followed by another across town. By the 1950s, Springfield hosted three Cozy Dogs! Courtesy Buz Waldmire (left and center), courtesy Jim Ross Collection (upper right), courtesy of Sangamon Valley Collection at Lincoln Library, Springfield, Illinois (lower right).

The Café at Topock, interior, Arizona, 1965. Like many of the roadside greasy spoons of the era, this small restaurant featured counter service and private booths. Like countless others found along the route, it offered an assortment of foods for the hungry traveler, along with sunglasses and souvenirs. Courtesy of Cline Library Northern Arizona University

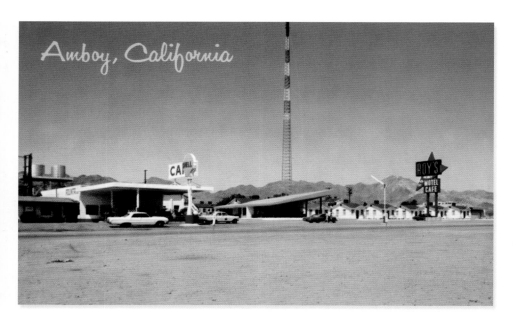

Roy's, Amboy, California, circa 1964. A bustling café with thirty heated and air cooled motel units and a private airport to boot, Roy's sold Shell products. Roy's operation was a true desert oasis for the motorist, a welcome relief from road dust and heat, smack dab in the middle of the Mojave Desert—and that was a big part of its charm. The complex debuted in 1940 when Herman Burris and Roy Crowl opened a repair shop in Amboy. It was followed by a café (built in 1945) and then some cabins. In 1948, constructing the service station, motel, and restaurant started, which was completed in 1952. The Roy's sign—now a Route 66 icon—was installed in 1959. Courtesy Steven Rider Collection

Waggoner's Greasing Place

Top left to right: *Eli & Sons at 5307 West Cermak Road sold Willys Jeeps and by 1947 switched to selling Crosley automobiles (1946). Elias Kornblith, with three sons looking on, receives a U.S. Treasury Bond given by Mobil Oil for product sales 1949). Bottom left to right: Cicero motorcycle policeman (1939). Postcard depicting Eli & Sons (1947). Elias Kornblith at his Eli & Sons Mobil station in Cicero, Illinois (1939).* Courtesy of Gordon Kornblith/Graphic art Gyvel Dagmar Berkley

Gordon Kornblith started working at his father's gas station when he was only eleven years old, a place called Waggoner's Greasing Palace #33, located in the town of Cicero, Illinois—the outskirts of Chicago. He learned to drive a car there, practicing by cruising the pickup truck around the driveway. Of course, he pumped gas and filled cars with oil, too.

"There was a speakeasy right across the street!" Gordon said, referring to those heady days of 1930s Chicago. Gangster Al Capone paid so many taxes on the bootleg liquor that he made that he could float the government. Years later, I found cancelled checks from that very same brewery . . . and gave them away to my friends as memorabilia."

Elias Kornblith's Cicero gas station wasn't located directly on Route 66, but it experienced its fair share of traffic because of the transcontinental route. "My dad's place was the last gas station in town," Gordon said. "We were catty-corner from a body shop that used to armor plate all the automobiles that mobster Al Capone drove in.

People would drive in and then ask us, 'how do we get to Route 66?' Of course, we would give them directions, and sell them a few gallons of gas, too!"

When the storm clouds of World War II gathered, Gordon left for service in France as a radio operator for Eisenhower. He came back home to Cicero in 1945. Before starting back to work at the station, he joined his cousin Dick (who was formerly in the infantry) on a trip he was making out to California to see his folks. Dick had a car, and that was all that mattered. "We stopped pretty much everywhere," Kornblith said. "We took turns driving, and for the first time in our life, rode the highway called Route 66 to see the sights and had ourselves some adventure. It took us three days to get there."

When he returned, Gordon picked up right back where he left off at the station and worked there until 1979, when it was sold. By then, Route 66 had been replaced by the interstate. The lazy, hazy, crazy days of Waggoner's Greasing Palace, Prohibition, gangsters, and old Route are now just fond memories.

Route 66 Roadside Lodging

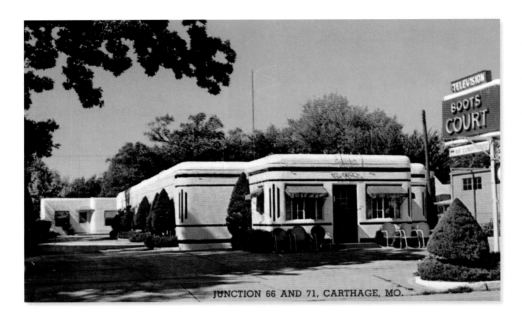

JUNCTION 66 AND 71, CARTHAGE, MO.

Postmarked in 1962, the back of this card states that the Boots Court was located "at the crossroads of America." The courts consisted of fourteen units, each with private tile shower, floor furnace heat, and air conditioning. Although the "court" was eventually changed to "motel," the original sign continues to hang outside the building. Courtesy Steven Rider Collection

The 66 Auto Courts, 8730 Watson Road, St. Louis, Missouri. Central hot water heat and free radio and television were available in each room! Courtesy Steven Rider Collection

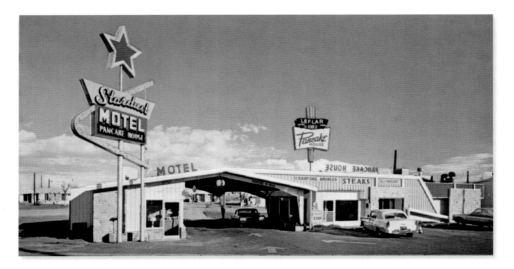

The Stardust Motel, Amarillo, Texas, located on the circle at the junction of Business Route and By-Pass Route 66, circa 1962. The twenty-one-unit motel offered guests air conditioning, telephones, free television, and a swimming pool. A twenty-four-hour restaurant served up steaks and pancakes. Courtesy Steven Rider Collection

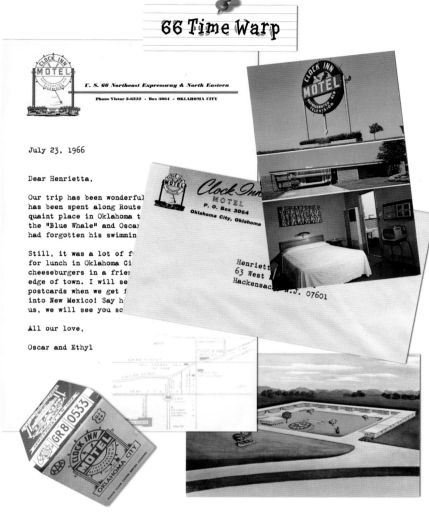

July 23, 1966

Dear Henrietta,

Our trip has been wonderful
has been spent along Route
quaint place in Oklahoma t
the "Blue Whale" and Oscar
had forgotten his swimmin

Still, it was a lot of f
for lunch in Oklahoma Ci
cheeseburgers in a frien
edge of town. I will se
postcards when we get f
into New Mexico! Say h
us, we will see you so

All our love,

Oscar and Ethyl

The Clock Inn Motel, U.S. 66 Northeast Expressway, Oklahoma City, Oklahoma, 1966. At one time, this unique motel featured a giant clock on the front lawn, making it easy to remember when the time came to pull over for the night and find a place to sleep. Accommodations for guests included the usual amenities: cozy beds, modern bathrooms, "refrigerated" air, and television. Matchbook courtesy Jim Ross Collection/Memorabilia Author's collection, Collage by Michael Karl Witzel

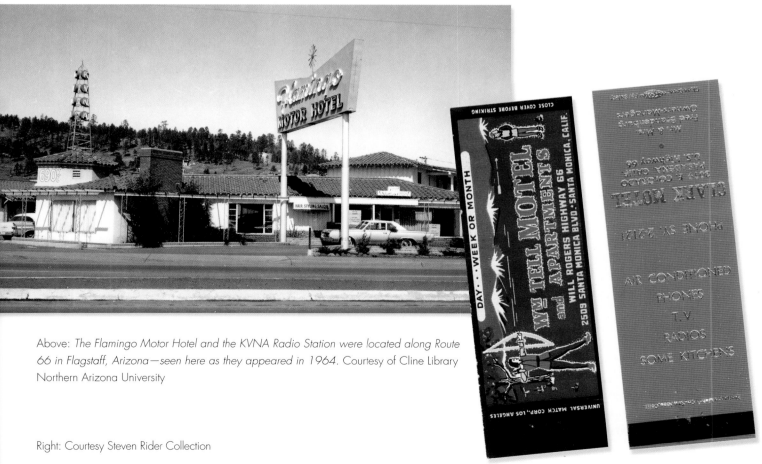

Above: *The Flamingo Motor Hotel and the KVNA Radio Station were located along Route 66 in Flagstaff, Arizona—seen here as they appeared in 1964.* Courtesy of Cline Library Northern Arizona University

Right: *Courtesy Steven Rider Collection*

John Lewis
and The Wigwam Motel

"The people of that time period—and this was the magic of Route 66—were of different ethnic backgrounds. The families were closer together and they didn't care about how much money a person made or what their net worth was. People didn't care about how many college degrees a person had. The main thing they cared about was whether or not you were a kind, decent human being . . . that's all that really mattered back then."

—John Lewis
Interview, February 23, 2006

When Chester Lewis first laid eyes on Frank Redford's Wigwam Village, he knew that he had to duplicate the same setup for his own motel business. Imagine, individual motel units built in the shape of North American Indian teepees! It was the summer of 1948 when Lewis and his family first spied the novelty motels, while driving through Horse Cave, Kentucky, on a vacation trip.

When Lewis returned home to Holbrook, Arizona, he began investigating. Apparently, Redford built the prototype of the ten-unit teepee motel location in 1936. Since then, replicas were popping up all around the country. Eager to join the tribe, Lewis came to an agreement with Redford. He got the rights to use the blueprints and the name. "Franchising" was still in its infancy, and the two sealed the deal with a handshake.

Over the next two years, Lewis turned the blueprints into action and began building. In 1950, he opened his very own Wigwam Village Motel in the desert area of Holbrook along Hopi Drive, also known as Highway 66. For maximum effect, he timed his grand opening to fall right before the peak of the summer traveling season.

By the decade's end, the Wigwam Village was a roadside attraction of the first order and a favorite stop for those traveling America's Main Street. With the heavy stream of traffic that passed by both day and night, business was good. "Around '58, all these vehicles would come through here and it was literally bumper-to-bumper traffic," recalled John Lewis, Chester's son and present-day proprietor of the Wigwams. Advertising was unnecessary; the neon sign told the whole story. The wigwam units were the billboards for fantasy and the patrons were willing participants.

But it was more than just whimsy: Despite their unconventional design, the wigwams were quite accommodating. Inside, each came with its own toilet, sink, and shower. There was no air conditioning, but steam heat provided warmth. The walls were paneled with knotty pine and the furniture was made of natural hickory with the bark still in place. Beds were appointed with Apache blankets and on the floor were authentic Navajo rugs.

At the bedside, a coin-operated radio provided one half-hour of musical entertainment for ten cents. As John Lewis noted, "the radio was an important part of the design scheme," since inventor Redford's royalties were dependent on the money that was gleaned from them. The whole deal hinged on dimes—silver dimes—that customers dropped into the coin slots. "I started out doing odd jobs by going around and collecting dimes out of the radios, which would go to my dad and then to Mr. Redford," John said. "That was how he got paid for the use of his plans."

Over the next twenty-four years, the dimes turned into dollars and the dollars transformed into dreams. Everyone involved made a living. These were the Norman Rockwell years of America—a time when milkmen delivered in the mornings, doctors made house calls, and the ice box contained a block of ice. It was a time of people, too—all kinds of people venturing forth to see America by car.

"The people of that time period—and this was the magic of Route 66—were of many different ethnic backgrounds. The families were closer together, and they didn't care about how much money a person made or what their net worth was," John said wistfully. "People didn't care about how many college degrees a person had. The main thing they cared about was whether or not you

were a kind, decent human being . . . that's all that really mattered back then."

As the years rolled on, people began to care more about themselves and less about the journey. The emphasis of travel shifted from the idea of simply enjoying the ride to the question of "Are we there yet?"

The new network of interstate highways gave succor to the speedsters, while it sucked the life out of the communities it crossed. In 1974, the concrete slab of Interstate 40 steamrolled across Arizona, bypassing businesses and lives. Chester Lewis's quaint Indian village, where people could "Eat and Sleep in a Wigwam," was outmoded.

By then, franchising was a household word and the big corporations had assumed dominion over the lodging business. Motels were advertised nationally and optimized for maximum profit. As the gas crisis raised the specter of increased travel costs, it was obvious that there was no more room for America's mom-and-pop motels.

That year, Chester Lewis switched off the neon to his beloved Wigwam Motel and shut down the business. Over the next twelve years, the teepees stood as a curiosity and their origins were probed only briefly when Lewis passed on. By then, people didn't travel on Route 66 anymore to get where they wanted go.

Fortunately, the dream of a motel fashioned after an Indian village didn't die, as was the case with its highway host, Route 66. By the mid-eighties, renewed interest developed in the Mother Road as a historic highway. Boomers who ventured out to discover the roots of their family vacations took to the old Mother Road in search of memories and their youth.

In 1988, John Lewis joined with his six siblings to respond to that yearning for yesteryear. In a fitting tribute to their father's vision, the family lovingly restored and then reopened the sixteen one-of-a-kind motel units that had been dormant for so long. On May 2, 2002, their efforts culminated with the listing of the Wigwam Motel Village on the National Register of Historic Places.

Today, the Wigwam Village is once again alive with life. "We have a little place on our patio where our guests will start a fire during the summer months. They'll have a weenie roast and they'll sing songs and sometimes someone plays guitar . . . and it's really just amazing," John said. "It's still all about the people. The landmarks along the Mother Road that are here today, like this place and others, are not here because of the state or federal government. It takes some effort. The Wigwam Village truly is a labor of love."

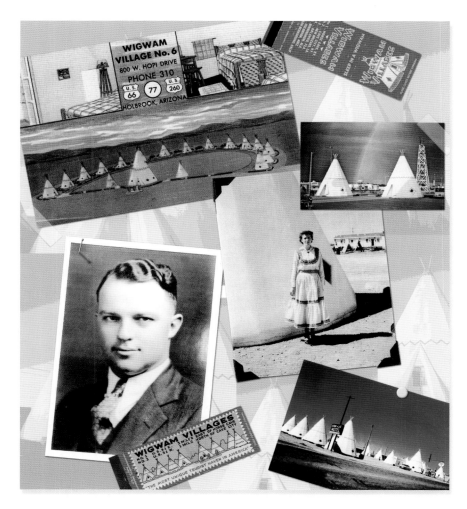

Top far right: *Rainbow Wigwam, this photo was taken by Clifton Lewis in 1955 and made into a postcard sold at the office.* Center: *Mary Lewis with wigwam, 1953.* Bottom left: *Chester Lewis, 1932.* Bottom right: *The Holbrook Wigwams with the large wigwam still in place, 1954. Chester Lewis removed the big wigwam in 1958.* Family photographs courtesy of John Lewis/Postcard courtesy Steven Rider Collection/Matchbook covers Author's collection

Businesses along Route 66

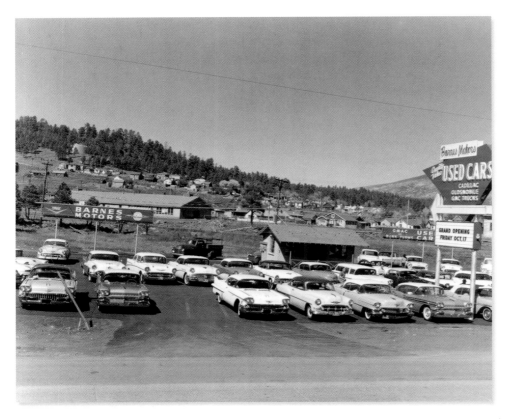

Left: *Barnes Used Cars held its grand opening on Friday October 17, 1958. The used car dealer—located along U.S. Highway 66 in Flagstaff, Arizona—specialized in Cadillac, Oldsmobile, and GMC Trucks.* Courtesy of Cline Library Northern Arizona University

Below: *Rose Bowl Lanes, 7419 East 11th Street (U.S. Highway 66), Tulsa, Oklahoma, circa 1961, shortly after it opened. It shut down in March 2005 and suffered three separate incidents of arson in a fifteen-month period. The first fires occurred July 1, 2004, and August 2, 2004. The August fire was reportedly set by Michael K. "Mickey" Sparks, who admitted that the bowling alley was too much competition for his bowling facility* (Tulsa World, *October 4, 2005*). Courtesy Steven Rider Collection

The second incarnation of the Sterling's Hillbilly Stores, this one built along the new four-lane U.S. Highway 66, Devil's Elbow, Missouri. The first store was erected along the old two-lane highway in Hooker, Missouri. This store became defunct when Interstate 44 opened. Courtesy Steven Rider Collection

Murphy Brothers General Store, Ludlow, California, 1926. Built in 1908, the Murphy Brothers took over the building from its original owner and turned it into a market that sold meats, groceries, and liquor. Now, it's an abandoned building called Ludlow Mercantile. Courtesy Steven Rider Collection

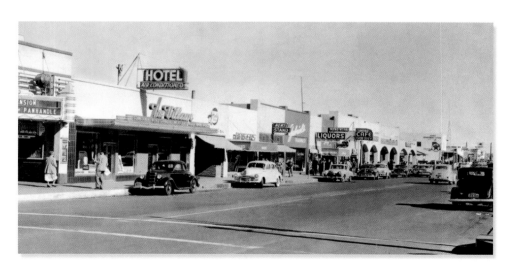

Main Street (U.S. Highway 66), Barstow, California, circa 1950. The movie Law of the Panhandle was released in 1950. Situated next to the movie theater was The Village, providing a full-service fountain and—through the door to the left—hotel accommodations. Courtesy Russell Olsen

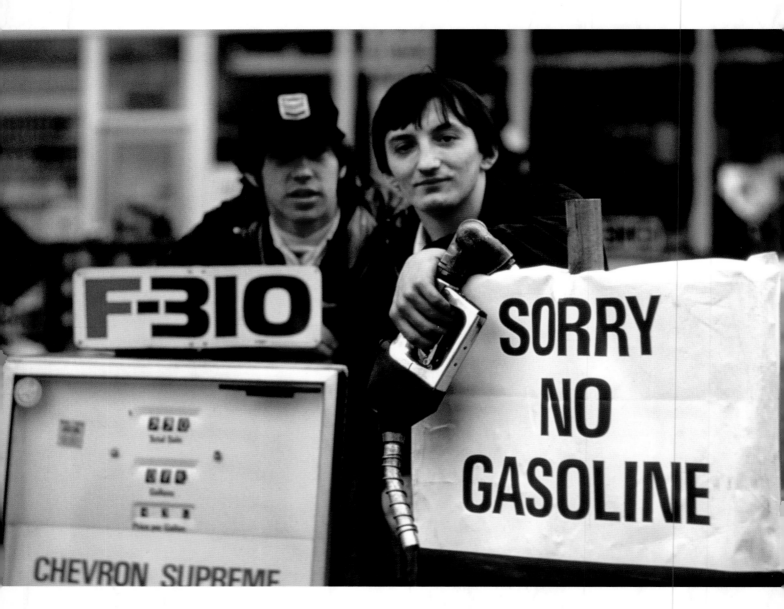

The 1970s fuel crisis brought changes to the gas station. Because of strict rationing, motorists were allowed to fill up with a ten- to fifteen-gallon limit on alternate days of the week, based on the odd or even number of their license plates. Once the gasoline station's quota was used up, motorists were turned away to seek fuel elsewhere. National Archives

Chapter Ten

Route 66 Bites the Dust

"Route 66—the highway memorialized in poetry, gasoline, song, and memories of millions of persons who traveled it or watched the television show—will be no more. Beginning January 1, Illinois is dropping the U.S. Hwy. 66 designation from its maps and road signs on the 290-mile highway between Chicago and St. Louis. It will be known as Int. Hwy 55."

—David Young,
"Route 66 on the Road to Extinction,"
Chicago Tribune, November 28, 1976

Left: In 1973, America was paralyzed by the worst fuel crisis since World War II. In a national White House broadcast, President Nixon warned rationing was necessary. As promised, rationing soon became the order of the day and long lines appeared at America's filling stations. National Archives

Below: January 17, 1977 marked the end of the legendary Highway 66 when Chicago, Illinois, street crews removed the sign on Jackson Boulevard and Lake Shore. Like it or not, Route 66 was now regarded as unnecessary. In a quiet agreement, the seven other Route 66 states soon followed, methodically removing all evidence of 66. Chicago Tribune photo. All rights reserved. Used with permission.

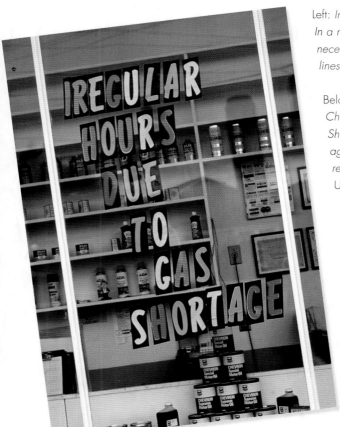

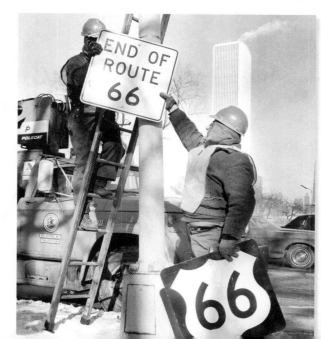

*I*n 1973, America was paralyzed by the worst fuel crisis since World War II and the wheels that were turning on Route 66 stopped. On November 8, 1973, in a nationwide broadcast from the White House, President Nixon outlined a series of mandatory and voluntary actions to reduce energy use and increase oil supplies.[1] He warned that it may be necessary to induce rationing and levy new taxes to deal with the shortages ahead.

As promised, rationing soon became the order of the day. Depending on the odd or even number of their license plate, motorists could only fill up with a ten- to-fifteen gallon limit on alternate days of the week. The result was pandemonium at the pumps: Americans who were accustomed to cheap gasoline and gas-guzzling cars were in a frenzy. With their gas gauges on "E," motorists waited in long lines or were stranded without gas when their allotment ran out.

In some cases, service stations resorted to selling what they labeled as "imported fuel" at nearly double the price of standard gasoline. Of course, at this inflated price per gallon, there was no quantity limit and anyone could purchase it. Price-gouging had reached a new level and the American motorist was paying the price.

With its dependence on foreign supply, America's de facto oil standard had imploded. The shortage was only the first domino in an unfortunate chain of events that set the economy into a tailspin. The escalating fuel costs and lack of supply prompted layoffs, cutbacks, and what some termed "temporary furloughs." By 1974, General Motors cut production at nine assembly plants in seven states.[2] Several companies tried to conserve fuel and they enforced staggered work hours to help with the efforts.

The general public was instructed to do whatever they could to conserve energy, including turning off any lights that they didn't need, riding in carpools, and reducing the settings on their home thermostats. Out on the streets, gas-greedy behemoths were parked when possible and replaced

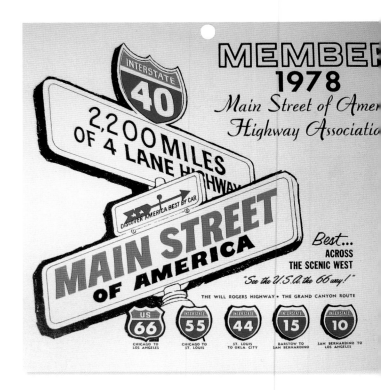

In 1978, this sign identified members of the Main Street of America Highway Association during the interstates' arrival. By November 1979, members of the national Main Street of America Highway Association and its Oklahoma counterpart, the Highway 66 Association, officially declared the deactivation of both groups. The construction of the interstate highway system and increasing apathy from business people caused their demise. Courtesy Jim Ross Collection

by smaller, more fuel-efficient imports. A few people turned to the motorcycle as an economic means of transportation. Some even went as far as riding a bicycle to and from their place of work.

To weather the storm, the United States Senate endorsed a permanent fifty-five-mile-per-hour speed limit as a "sensible" recognition of two facts: "First, that while the fuel crisis seems to have let up for the time being, we can by no means be sure it is over; and second, that the speed limit has produced an unexpected side effect—a dramatic saving in lives."[3] The bottom line was that people had to drive a lot slower. With the seventy-mile-per-hour limit gone, transportation by car and truck was hobbled.

At the Dixie Truck Stop in McLean, Illinois, the big subject of the day was the fuel crunch. While seemingly everyone else in America had bought into the idea, the truckers and employees at this Route 66 fixture scoffed: What fuel crisis?

Reluctantly, they went along with the program of rationing, although it meant that their very livelihood was held hostage. Now, the Dixie limited each big rig to a mere fifty gallons—just a fourth of what the typical two-hundred-

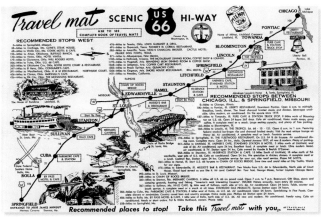

By the close of the 1970s, scenic U.S. Highway 66 was a thing of the past, part of a bygone era left behind in the pursuit of speed and the smooth ride afforded by the Interstate Highway system. Author's collection

Cartoon printed on August 14, 1979. PEANUTS: © United Feature Syndicate, Inc.

gallon tank could hold. Off and on, the truck stop also resorted to rationing its supply of gasoline to cars.

But what about the price of diesel? "Most tourists have no idea what goes on here," said one trucker. "They gas up, hit the can, maybe grab a bite to eat, and they're on their way. They don't really care about the price of gas—another buck ain't gonna kill them. But for a guy like me, it's life or death . . . and the way fuel has gone up, my expenses are twice what I was paying a year ago. But the freight rate has hardly gone up at all."[4]

The trucker knew his world, but overestimated the resources of the everyday tourist. With long gas lines and the doomsayers droning on that "this was going to last a while," there was little incentive to plan motoring vacations. Everything cost more, including groceries, clothes, electricity, natural gas, and entertainment. Staying at home and staring at the TV was a much cheaper way to forget your problems.

Finally, the people who had hunkered down in front of the boob tube over the long, winter months were rewarded in the spring of 1975 with glad tidings: The energy crisis had faded away like a bad dream. Once again, people climbed into their cars and hit the freeways to take the family on short outings here and there. The road was back in business.

Across the nation, the highway construction that promised to replace Route 66 entered a new season, too. With only 129 miles of interstate roadbed lacking, the work on the Illinois stretch of Interstate 55 was well underway and scheduled for final completion in 1979.[5] In the meantime, there was a big question about what to do with all the confusing signs. In its present state, Interstate 55 was marked by both the Highway 66 and the I-55 designations throughout much of the state.

Missouri had already completed Interstate 40 between St. Louis and Joplin, and it was impatient to drop the old Highway 66 designation. It was hampered by the rules of road numbering, which prevented any state that was in the middle of an interstate route from changing its number. In order for Missouri to get rid of the Number 66 identification and to ultimately change the name, the state of Illinois had to drop the 66 first.

Yet, the end still seemed to come all too quickly. In 1977, the Illinois highway authority finally began to remove the black-and-white Route 66 shields along Interstate 55. George Moberly, chief engineer of the highway division's traffic bureau, summed up the attitude of those in charge by saying, "The new interstates have eliminated the need for the old 66 route. To keep that number, we would have to find another place to put it, and there is no longer any need for that designation."[6]

Like it or not, Route 66 was now regarded as outmoded and unnecessary. In agreement that it had outlived its usefulness, the other seven Route 66 states soon followed the lead of Illinois and methodically removed all marked evidence of 66. Like a long, slung-out dragon, slow to die, Route 66's head fell in Illinois and it crumbled along the entire length of its body until the tip of its tail quivered at the Pacific Ocean.

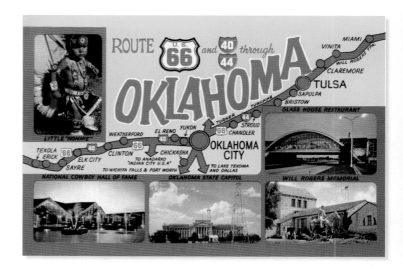

This Oklahoma postcard illustrates the schizophrenic road numbering system that was used when the interstates first debuted. Here, you have Interstate 40 and 44—right along with U.S. Highway 66—running through Oklahoma. Courtesy of the Oklahoma Historical Society

199

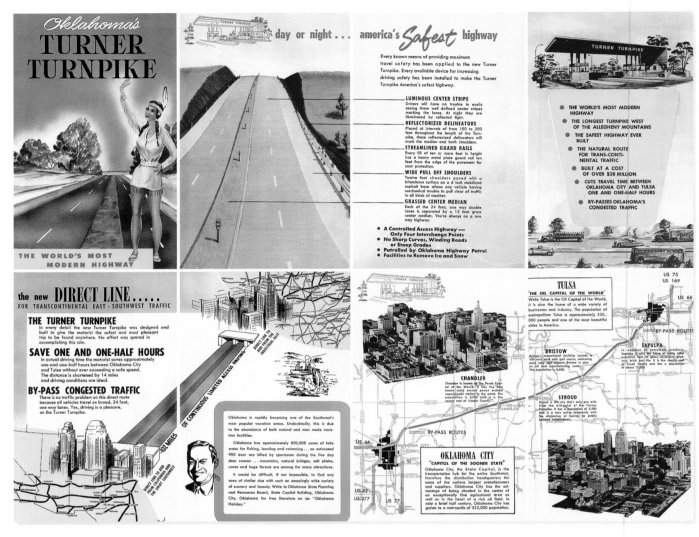

The nemesis of U.S. Route 66—a four-lane superhighway between Oklahoma City and Tulsa, Oklahoma—was completed on May 16, 1953. The five-ribbon ceremony featured simultaneous grand-openings in Oklahoma City, Tulsa, Chandler, Bristow, and Sapulpa. Author's collection

Oklahoma Governor Raymond Gary takes the platform at the official opening of the Lincoln Expressway on June 27, 1958. Courtesy of Oklahoma Historical Society

The Lincoln Expressway opening parade included groups such as the Northeast High School, Pleasant Hill and Britton schools, the Boy Scouts, the YMCA and Kiwanis club, and interested businesses and clubs. Courtesy of Oklahoma Historical Society

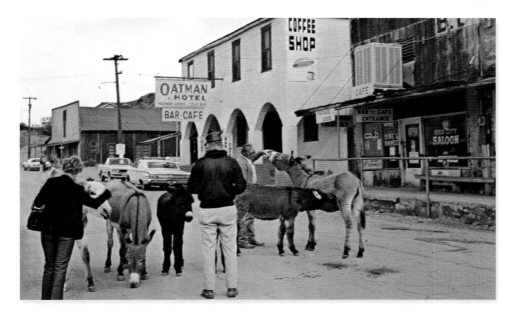

Oatman, Arizona, was bypassed in 1952 when the Yucca-to-Kingman U.S. Route 66 alignment was used to route motorists away from the treacherous mountain passes. During the 1970s, camera-toting tourists looking for a real Western ghost town trickled into this area, no doubt a spillover from the growth of the nearby gaming town of Laughlin, Nevada. Stop at the Oatman Hotel for your "grub and firewater," says the promo on the back of this card. This is the home of the Clark Gable room, said to be the place where he and Carole Lombard spent their wedding night. Courtesy Steven Rider Collection

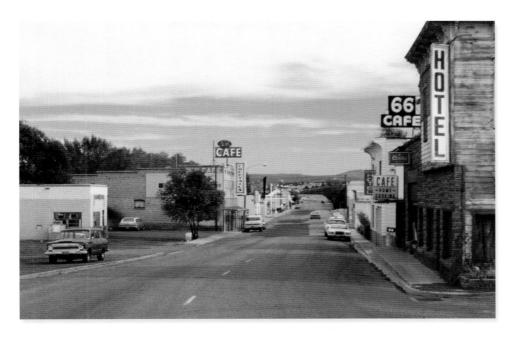

Ash Fork, Arizona, Main Street, U.S. Highway 66, circa 1970s. Ash Fork suffered an economic downturn when the Santa Fe Railroad moved its main lines ten miles north of town. But this was nothing compared to the devastating blow that came in 1979, when Interstate 40 bypassed the town completely. Courtesy Southwest Studies

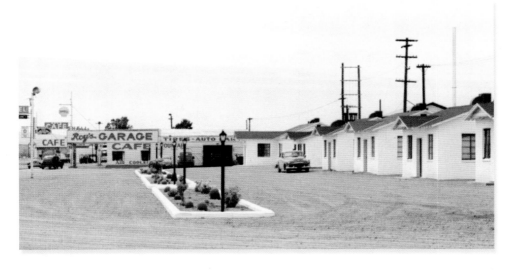

In 1975, Buster Burris offered Amboy, California, up for sale. He was asking a cool $350,000. According to a September 13, 1975, article published in the Washington Post, the town (population 20) included a 30-room motel, private airport, gas station, and café. When Interstate 40 shut off the flow of customers in 1974, Burris was eager to sell off his creation, but apparently, no one wanted to become mayor of a one-man desert town. Courtesy Steven Rider Collection

Marshall Trimble
Arizona's Official State Historian

"We drove into Ash Fork and parked the trailer house, close to Route 66, and we lived in that trailer house with a lean-to porch and an army surplus tent with no electricity, running water, or plumbing for about three years. . . . When we finally moved into a house that had a toilet that actually flushed, we thought we were living in hog heaven!"

—Marshall Trimble
Interview, May 8, 2006

Marshall Trimble—writer, historian, and educator—knows Arizona history. In fact, he knows it so well that in 1997, the state of Arizona honored him with the title of official state historian. As an accomplished cowboy singer-storyteller who has performed with Rex Allen, Waylon Jennings, Jerry Lee Lewis, and the Oak Ridge Boys, he relates what happened in the past with boundless energy.

His creative accomplishments are far too numerous to list here, but one thing is for certain: This cowboy's heart still calls the small town of Ash Fork, Arizona, home. Although Trimble was born in the Phoenix suburb of Mesa, a combination of time and circumstances caused him to adopt Ash Fork—a once-bustling Route 66 hamlet—as his hometown.

Trimble's adoration for the place took root in 1947, after his father accepted a position with the Santa Fe Railroad. The plan was to drive from Phoenix to Ash Fork and take whatever belongings they could. His parents hooked up the family trailer to the old Ford and loaded it up. Brothers Danny, Marshall, and Charlie piled in, as did the family dog and a few chickens. Unfortunately, the strain of pulling the trailer up and down the mountain roads of northern Arizona eventually took its toll on the Ford. The family found themselves stranded just outside a one-horse town called Bumblebee.

"In those days, cars only came by every half-hour, so my dad flagged down a car and then hitched a ride to a garage and ordered the parts he needed," Marshall said.

Marshall Trimble was born on January 16, 1939, in Tempe, Arizona. He is the author of nineteen books on Arizona and the West. His latest book on legendary gunfighters is Law of the Gun. *In 1997, he was appointed Arizona's official state historian, but it doesn't stop there. He's the quintessential cowboy singer-storyteller-humorist and has performed with Rex Allen, Waylon Jennings, Jerry Lee Lewis, and the Oakridge Boys. In this photograph, Marshall (still trim enough to wear his high school letterman's sweater) serves as the grand marshal at the annual Pioneer Day Parade in Ash Fork, May 2006. Courtesy of Marshall Trimble*

A happy Marshall Trimble "driving" his first car in 1942. Courtesy of Marshall Trimble

"Later, another car delivered the parts from the garage. Out there, if you stopped in for gas, the attendant might say, 'Hey, there's a car broken down at Bumblebee, take these parts and just drop them off for the man.' So we got the car fixed and went another ten miles and broke down again. The same thing was repeated over and over again. It took us nine days to get from Phoenix to Prescott!"

Eventually, the road-weary family reached their destination. "We drove into Ash Fork and parked the trailer house, close to Route 66, and we lived in that trailer house with a lean-to porch and an army surplus tent with no electricity, running water, or plumbing for about three years," Trimble said. "We finally moved into a rock house that still didn't have much for plumbing. We had a flush toilet—but we had to use a bucket of water from the kitchen sink to dump into the toilet. So it was pretty primitive. When we finally moved into a house that had a toilet that actually flushed, we thought we were in hog heaven!"

Fortunately, their simple life fit in just fine with the surroundings. With a population of only six hundred, Ash Fork, Arizona, could best be described as "quaint." It was the typical American small town that boasted its own movie theater, pool hall, drug store, motels, saloons, retail stores, and service stations. Sidewalks lined the streets and the townsfolk enjoyed the cool evenings by sitting on their front porches and exchanging conversation with passersby.

The Santa Fe railway provided the primary economic lifeline by giving ranchers a means for shipping cattle out of Ash Fork. At the same time, the railway was used to deliver the daily ration of water from nearby Prescott. Ash

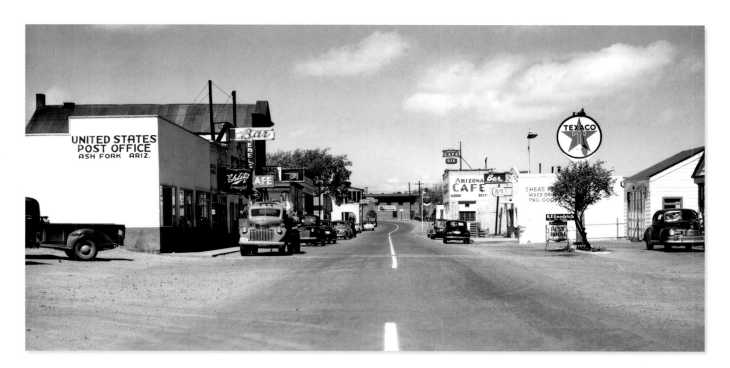

Ash Fork, Arizona, 1949, two years after the Trimble family moved there. At that time, Ash Fork's population was only six hundred, a quaint town with a movie theater, a pool hall, a drug store, some motels, saloons, stores, and service stations. Courtesy of Marshall Trimble

Marshall is shown here shortly after the family's arrival in 1947. He's dressed in full cowboy regalia; the family Ford and trailer home are in the background. As Marshall says, these were his character-building days. Courtesy of Marshall Trimble

Fork's first well wasn't drilled until the 1970s. Highway 66 echoed the railroad's importance: It was the only paved road in town and it fed Ash Fork a steady stream of tourists and truckers. As a result, the cafés were busy slinging hash and the filling stations stayed open pumping fuel.

Because of the railroad, the town was fortunate to have a fancy Harvey House, a place that was called the Escalante. Young Trimble was soon shining shoes there. He also delivered newspapers around town and had the opportunity to meet and greet most of the locals. Soon, he knew just about everybody.

By age fourteen, he landed a job at one of the local gas stations. "I remember working at the gas station on the night shift the same day that school let out in California. The boss said: 'Marshall, it's gonna hit here about midnight tonight, so be ready.' I was working by myself,and by that night, 66 and the whole town looked like a freeway. It stayed that way for almost three days before leveling off again!" Trimble said.

Marshall credits his gas jockey days along 66 with sparking his desire to go to school. "Every once in a while,

somebody's radiator hose would burst. That was knuckle-busting work. Since I worked the night shift, it was dark and you could hardly see. After a few of these incidents, I thought, 'Boy, I'm going to get an education so I won't have to do this kind of work when I get older.'" he said. "It was a good lesson for me to go out and get an education."

But it wasn't all work for Marshall. He was also involved in sports, and he played his fair share of baseball and basketball. At age sixteen, he reached the liberating milestone that all young adults yearn for: the purchase of his first car. "I'd been working at the gas station saving money for a car when I turned sixteen," Trimble recalled. "It was the most important rite of passage I can remember. I bought a 1946 Ford convertible. A car was freedom; you could go all the way to Williams! The top was mostly in shreds, so during the cold winters it was a grim ride to Williams—you really had to bundle up."

Cruising was another rite of passage for youth, but Ash Fork lacked a good stretch of street for it. Highway 66 was paved, but it only sliced a half-mile-long stretch through the center of town. That didn't deter the teenagers though, as

Marshall Trimble (front row, second from right) showing off his seventh grade number "66" basketball uniform. Courtesy of Marshall Trimble

Trimble said, "We'd go up to the Harvey House and turn around, and then down to the gas station and turn around. And, you'd do that about twenty or thirty times."

The real adventure was found in Williams, where the girls were new, the roads were paved, and the possibilities for fun seemed endless. The most exciting part was the return trip along the Ash Fork Hill. This eight-mile stretch of Route 66 quickly climbed to two thousand feet and provided the automotive equivalent of a roller-coaster ride. "We could coast halfway back to Ash Fork coming down that hill. It was a narrow, treacherous canyon road. It's a wonder we didn't get wiped out!" Trimble said.

The fun didn't last forever: In 1955, the Arizona Highway Department carved out the narrow 66 roadbed to widen it. At the same time, road crews gouged out another slice of roadside from the Ash Fork residential area. Two one-way roads remained, serving as the east- and westbound lanes of Highway 66 through town. Local business owners were shocked when they stepped out of their front doors directly into the street. The sidewalks and quaint front porches had seemingly disappeared overnight. After the Santa Fe moved its main line ten miles north, the small town of Ash Fork withered.

Shortly after, the Trimble family moved back to Phoenix. In their absence, Ash Fork was dealt a fatal blow when the interstate highway bypassed it in 1979. Shortly after, Trimble returned to find that "all the stores were closed, the windows were all knocked out, there were no doors. I stood in the doorway of a saloon and took a picture; that's all that was left of the town's business district. A month later, a hobo built a fire to keep warm and the wind picked up the embers. It burned down the whole business district on that side of the road. It was never rebuilt; the tumbleweeds are growing there now."

Despite Ash Fork's fall, Trimble's interest in the town never waned. He recognized early on that this town and its connection to Route 66 would play a pivotal role in his life. "I remember the first time I saw it . . . looking up towards Bill Williams Mountain, east on Route 66. Being there and along Route 66, I think I had a sense that history was all around me. I remember it well," he said. ". . . I guess I had a sense of its significance."

"When I went back to Ash Fork in 2006 to see the museum—since they were honoring me—I saw that they had a few of the old high school yearbooks on display that showed my junior high picture. Guess what the number on my basketball jersey was? Sixty-six! I remember choosing that number *because* of Route 66. I was only in the seventh grade, but I was already thinking back then [that] this is a piece of history here."

Truckin' for the Long Haul

Dixie Truck Stop, U.S. 66 and 136, McLean, Illinois, opened in 1928 and was operated by J. P. Walters and John Geske. In the beginning, their modest operation employed only five. By the time that the 1973 fuel crisis hit, the Dixie employed 174 year-round employees and served 5,000 customers a day! In 1976, McLean's population hit 750, with most of the workers locals. Back then, you could buy a Truckers' Special— "Our Own Meat Loaf with fries, breaded tomatoes, applesauce, rolls, and butter"—for only $1.95. Courtesy Steven Rider Collection

In 1927, Spencer Groff opened the original Diamonds Restaurant in Villa Ridge, Missouri. The original building burned down in 1948. Then, Groff and business associate Louis Eckelkamp rebuilt the establishment in an attractive, streamlined style designed by architect Frank Hayden. The roadside business included a restaurant, fuel stop, and cabins. It quickly became a popular roadside stop for motorists driving down America's Main Street. Unfortunately, the advancing interstate forced the business to relocate, closer to freeway traffic. Courtesy Steven Rider Collection

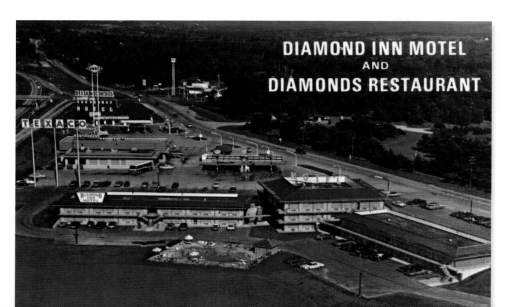

After it first opened, the Diamond Inn Motel featured 162 new motel units (and also a swimming pool) that complimented the adjoining Diamonds Restaurant and gasoline station. Today, the roadside U.S. Route 66 business that was once an island of activity has shut down. Courtesy Steven Rider Collection

Grant's Truck and Car Stop, U.S. Highway 66, New Mexico-Arizona state line, Grants, New Mexico. Circa 1970s, this postcard features an inset photo of how the business looked during the 1940s. This trucker's heaven featured a full-service air-conditioned restaurant and picturesque canyon view near the Navajo reservation. Courtesy Steven Rider Collection

Jacobs' Chevron, U.S. Highway 66, Shamrock, Texas, circa 1970. Owned and operated by W. L. Jacobs, this station provided travelers with Standard products, a trading post, trailer park, and clean rest rooms. Although U.S. 66 caused a booming population growth in the 1950s in Shamrock, the proliferation of the town's garages and service stations, motels, and restaurants came to an abrupt halt when the Interstate 40 bypass was completed during the late 1970s. Courtesy Steven Rider Collection

American Icons 66 **Oil/Gasoline**

TYPE:
Texaco Roadside "Banjo" Sign, The Texas Company

DESCRIPTION:
In 1937, designer Walter Dorwin Teague presented the banjo-style sign as part of a larger station makeover campaign. Influenced by the International Style & Streamline Moderne, he redefined station architecture as a simple box, clad in porcelain enamel panels. Replaced by hexagon logo in 1966.

©2007 Michael Karl Witzel

Ed Lentz's Mobil Service Station and Restaurant, U.S. Route 66 and 133, Richland, Missouri. By the close of the 1970s, roadside oases like this Mobil stop were outmoded, bypassed by the interstates. By then, the simple advertising messages of "Gas" and "Eat" were no longer effective. Courtesy Steven Rider Collection

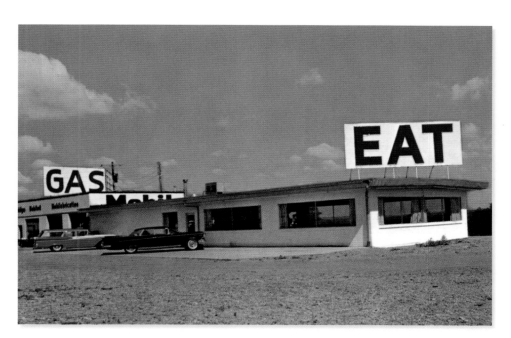

Clines Corners on

An oasis for gas and hambur

SANTA MONICA AT HIGHLAND
HOLLYWOOD

MILANI'S
HOME OF THE MILE LONG
FRENCH DIP
BAKERY
FRENCH DIP 35¢

Max ate two sandwiches here ...

Gulf

3589 E. COLORADO BLVD.
PASADENA, CALIF.

WRIGHT'S
OPEN 24 HOURS
ON U. S. HIGHWAY 66 - - WEST END OF TOWN
WEATHERFORD, OKLAHOMA

We got gasoline here ... and a grilled steak next door!

We toasted the end of our

Grabbing a Quick Bite

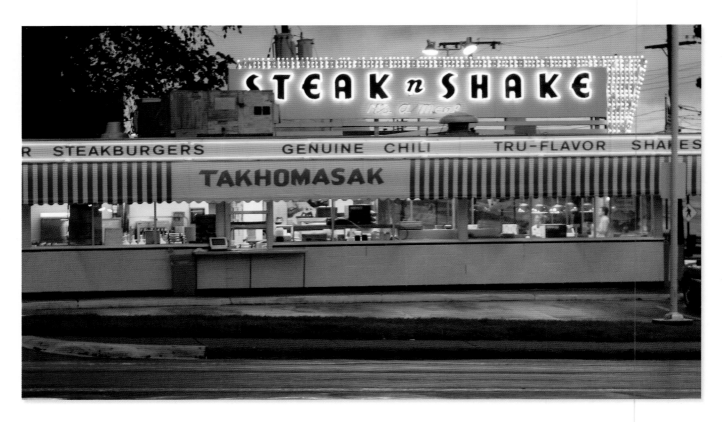

Steak n Shake, Springfield, Illinois, 2006. By the 1960s, the Steak n Shake chain of drive-in restaurants was well known throughout the Midwest. Gus Belt's original formula for serving up a complete meal of Steakburger and hand-dipped milkshake became a roadside standard. "It's a Meal" was the company's popular slogan and "In Sight It Must Be Right" the promise to customers. With food recognized by U.S. Route 66 travelers as just a few notches above the standard fast food fare, countless motorists pulled in to make an order and "takhomasak." ©2007 Jim Ross

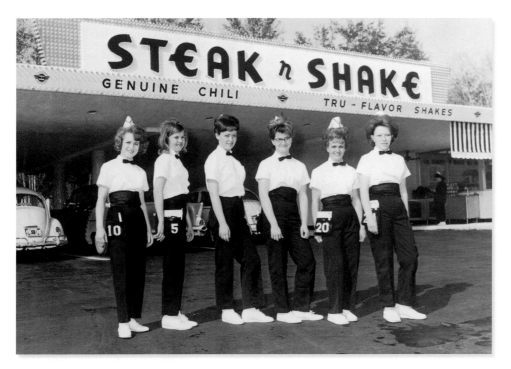

Steak n Shake carhops pose for a group photograph, circa 1950s. The U.S. Highway 66 town of Normal, Illinois, gave birth to the Steak n Shake drive-in restaurant. In 1934, A. H. "Gus" Belt introduced an innovative idea: the steak burger. It was unlike any other burger, since this was made from ground T-bone strip and sirloin and seared on both sides. When he teamed this with a hand-dipped shake, it proved to be an irresistible combination. Although the founder died in 1954, his drive-ins continued to flourish. Today the carhops are gone, but you can still find Steak n Shake restaurants where the juicy steak burger and thick homemade shake reign. Courtesy of Steak n Shake, Inc.

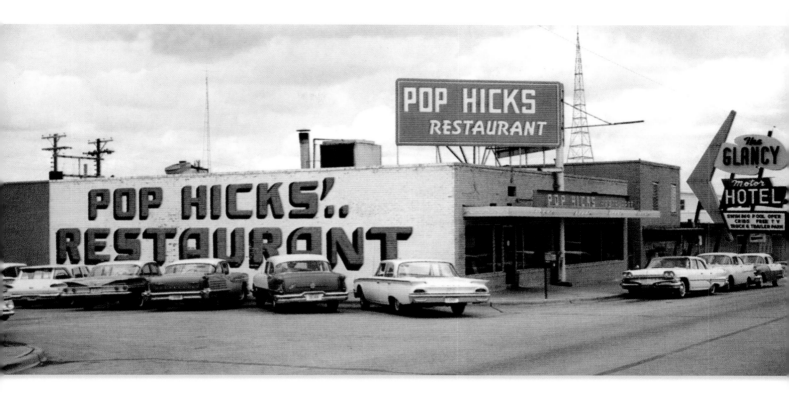

The restaurant opened by Ethan "Earl" Hicks in 1936 grew from a three-booth, seven-stool diner to a full-fledged restaurant that boasted four private dining rooms in Clinton, Oklahoma. Pop Hicks was a popular meeting place for the Lions Club and political organizations, especially during the 1950s. Hicks sold out in 1968, but never strayed far from the place he made famous, coming in often to sample the fare, making certain it was up to his standards. Courtesy Steven Rider Collection

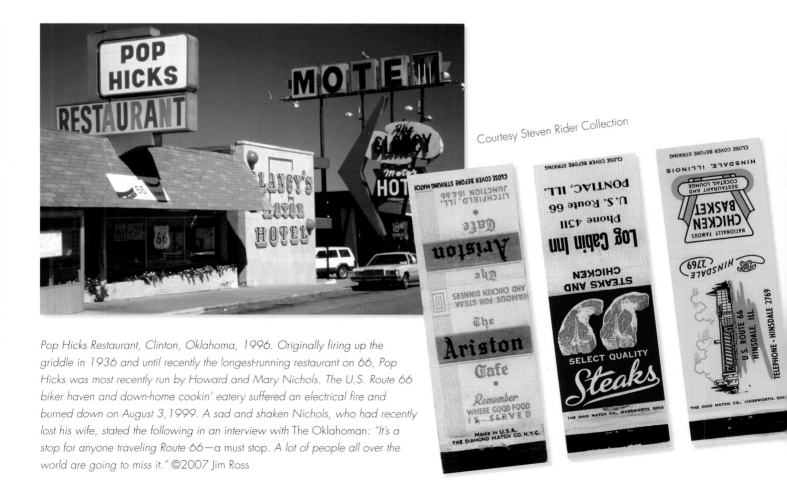

Courtesy Steven Rider Collection

Pop Hicks Restaurant, Clinton, Oklahoma, 1996. Originally firing up the griddle in 1936 and until recently the longest-running restaurant on 66, Pop Hicks was most recently run by Howard and Mary Nichols. The U.S. Route 66 biker haven and down-home cookin' eatery suffered an electrical fire and burned down on August 3, 1999. A sad and shaken Nichols, who had recently lost his wife, stated the following in an interview with The Oklahoman: "It's a stop for anyone traveling Route 66—a must stop. A lot of people all over the world are going to miss it." ©2007 Jim Ross

Still Trying to Lure 'Em In

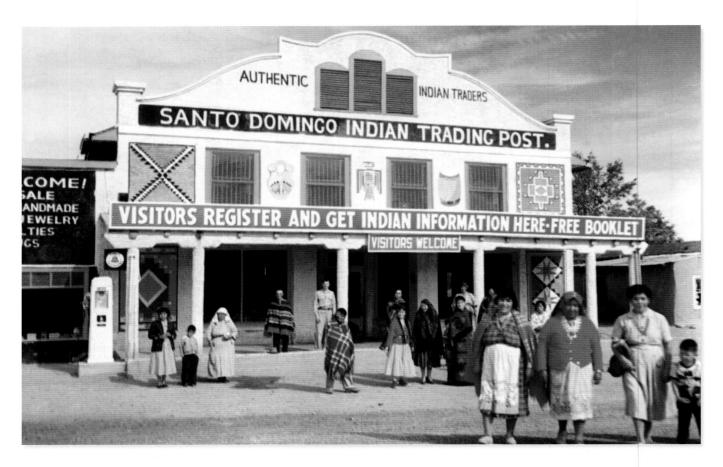

Located between Albuquerque and Sante Fe, New Mexico, the Santo Domingo Indian Trading Post (shown circa 1950s) had the advantage of being located near the crossroads of U.S. Highways 85 and 66. In 1926, the first alignment of Route 66 passed in front of the trading post, but the operation continued to thrive even after the realignment in 1937. The building was built in 1881; it was the oldest Indian trading post along the original alignment of U.S. Route 66. Courtesy Steven Rider Collection

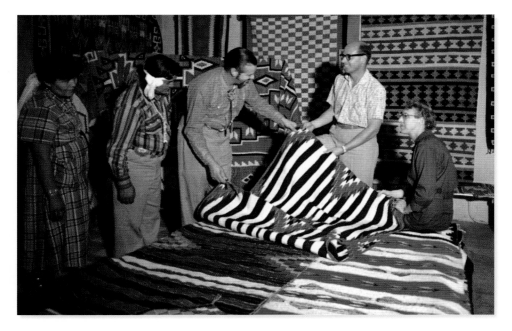

Inside the Santa Domingo Trading Post, owner Fred Thompson (third from the left) demonstrates the proper way to fold a chief's rug. Thompson purchased the trading post in 1950 and operated the U.S Route 66 tourist attraction until his death in 1994. Courtesy Steven Rider Collection

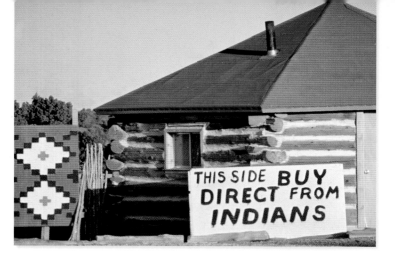

Two years after the Environmental Protection Agency (EPA) was formed (1970), it sponsored a program called Documerica to photographically document subjects of environmental concern in America. The images were made by approximately seventy well-known photographers. Subjects included junkyards, streets, buildings, air and water pollution, and people. This EPA scene was recorded in June of 1972, documenting an Indian-owned trading post challenging an Anglo-owned shop on the other side of U.S. Route 66 (the exact location was not provided). The Documerica program continued until 1977. National Archives

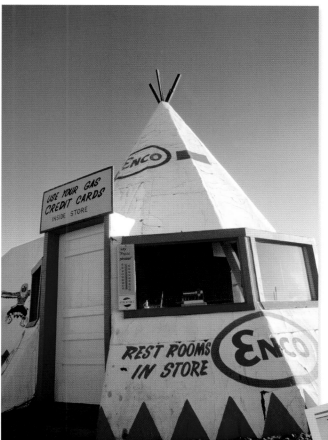

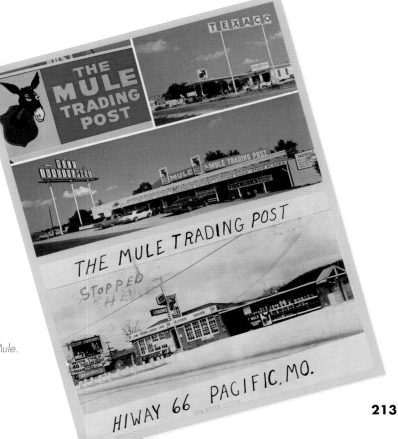

Junktique Store, 3315 West 6th Street (U.S. Highway 66), Amarillo, Texas. During the 1970s it was called "junk," now it goes by more lofty descriptions such as collectibles, Americana, petroliana, and memorabilia. Whatever moniker is used today, there's no doubt that many a Route 66 traveler would be eager to step back into time and visit this colorful emporium of roadside nostalgia. Courtesy Steven Rider Collection

Above: Stationed along U.S. Route 66, this Enco brand teepee-shaped gasoline station was frozen in time as part of the EPA's Documerica program during the 1970s. Unfortunately, this December 2, 1970, photograph is not identified by state. However, it is likely that this station is the former Indian City Exxon of Allentown, Arizona. National Archives

Right: The Mule Trading Post, Rolla, Missouri, circa 1970s. Frank Ebling opened the Mule Trading Post in 1946 in Pacific, Missouri. In 1958, he moved the store to U.S. Highway 66 in Rolla to take advantage of the tourist trade. In 1966, Herb and Jody Baden left a Stuckey's restaurant in Altamont, Illinois, to take over the reins of the Mule. Courtesy Steven Rider Collection

The Blue Whale

ugh S. Davis, former director of Tulsa's Mohawk Park Zoo, opened the Catoosa Alligator Ranch around 1967. Stocked with wild alligators from Hope, Arkansas, and other reptile ranches, his cold-blooded menagerie grew into a healthy assortment. By the end of the 1960s, he expanded the operation into what he called Nature's Acres: a park that featured nature trails, a petting zoo, snake pits, and, of course, alligators.

Davis built a concession stand, souvenir shop, and restrooms. Featuring all the necessities for visitors as well as a room reserved for private birthday parties, he named the building the ARK (animal reptile kingdom). It opened in 1970 and became a popular tourist attraction along Oklahoma U.S. 66.

Around this time, Davis began digging out a pond on his Catoosa property and came up with the idea to surprise his wife, Zelta, with a giant blue whale. With the help of a family friend and welder Harold Thomas, Davis shaped the leviathan and coated it with 126 sacks of concrete. Zelta—who was not privy to the details of the project—was appropriately surprised. "It looked to me like it was going to be an airplane," she confided in a 1997 interview. She knew her husband was up to something different, but she never imagined it would be a whale.

Above and below: *It took Hugh Davis two years to complete The Blue Whale. During the 1970s, the smiling leviathan became the star attraction along U.S. Route 66. Children of all ages enjoyed diving, sliding, and climbing on the eighty-foot wonder. The total cost for this early waterpark roadside attraction came in at $1,910.24.* Courtesy Steven Rider Collection

Zelta Davis, Catoosa Alligator Ranch, circa 1970. Zelta Davis joined husband Hugh in his reptile enthusiasm. It was her idea to install the alligator ranch on their property. Born in 1919, she passed away in 2001. When the Alligator Ranch and Nature's Acres closed (around 1973), some of the gators were returned to Arkansas while others were placed in private reptile gardens. Courtesy Steven Rider Collection

For about a year, the whale remained unfinished while Davis gathered the funds to buy the paint needed to cover the 2,520 square feet of exterior. Located right off old U.S. 66, it was a natural tourist draw. Like a magnet, it plucked people from their cars and set them down in the park-like setting of this early waterpark prototype.

In 1973, Davis had the Anchor Paint Manufacturing Company in Tulsa mix up a custom blend of blue to colorize the concrete-gray whale. When it came to getting attention, the color—now known as "Blue Whale Blue"—was more effective than neon lights. Hugh and Zelta became so busy that they shut down Nature's Acre, keeping only the ARK open as a restroom facility and snack bar.

Soon, lifeguards were hired and Davis began a new project: building a new concession stand and restroom facility closer to the pond. Sand was trucked in to create a "beach" and concrete tables and seats placed along the "shoreline." When upgrades were completed, the ARK was shut down permanently and the focus of the operation became the Blue Whale. It remained open until 1988, when Hugh's failing health forced them to close shop.

Hugh Davis, avid reptile enthusiast, shown here in the Nature's Acres snake pit with a rattler. He was born in 1909 and passed away in 1991. He served as director of Tulsa's Mohawk Park Zoo for approximately thirty-eight years. After he retired in 1966, he began building the Catoosa Alligator Ranch (which opened around 1967). He followed up with the Nature's Acres project, a reptile ranch combined with petting zoo, and the ARK. All of these animal attractions were located on his property along U.S. Highway 66 in Catoosa, Oklahoma. Courtesy Steven Rider Collection

Route 66 Motels

Wonderland Motel, 2000 East Santa Fe Avenue, Flagstaff, Arizona, 1975. The Wonderland took its name from Arizona's "wonderland" of sights, such as Walnut Canyon, Sunset Crater, the Grand Canyon, and many other attractions within close proximity to its U.S. Highway 66 location. Here, guests stayed in immaculate rooms furnished with Simmons Beauty Rest mattresses, wall-to-wall carpeting, and air conditioning. A swimming pool and a children's playground were on site, too. Courtesy of Cline Library Northern Arizona University

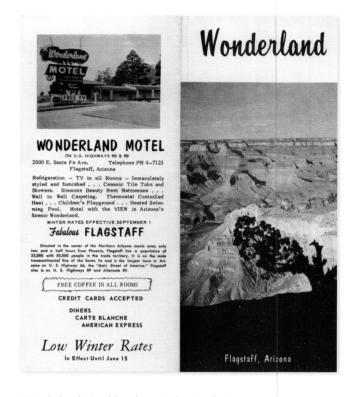

Wonderland Motel brochure. Author's collection

Caravan Motel, 620 W. Amarillo Boulevard (U.S. Route 66), Amarillo, Texas. The Caravan Motel as it looked during the early 1970s. It was once a fixture of U.S. Route 66 and operated at this location from the 1950s to the early 2000s. Courtesy Special Collections Department, Amarillo Public Library

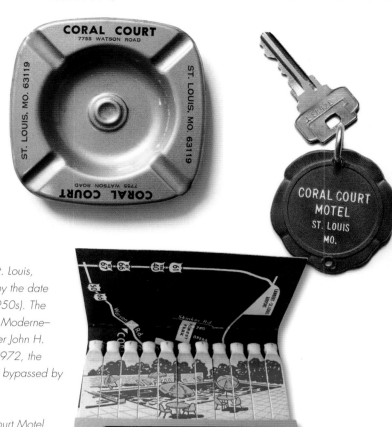

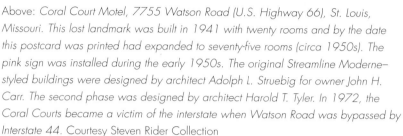

Above: *Coral Court Motel, 7755 Watson Road (U.S. Highway 66), St. Louis, Missouri. This lost landmark was built in 1941 with twenty rooms and by the date this postcard was printed had expanded to seventy-five rooms (circa 1950s). The pink sign was installed during the early 1950s. The original Streamline Moderne–styled buildings were designed by architect Adolph L. Struebig for owner John H. Carr. The second phase was designed by architect Harold T. Tyler. In 1972, the Coral Courts became a victim of the interstate when Watson Road was bypassed by Interstate 44. Courtesy Steven Rider Collection*

Right: *Ashtray, room key, and matchbook from the now extinct Coral Court Motel. Courtesy Shellee Graham Collection*

The Stardust Motel, 666 East Foothill Boulevard, Azusa, California. This motel featured the dramatic "Googie" style of architecture popularized during the 1950s. The back of the postcard describes this exaggerated modern overnighter as "a motel of charm and distinction with a large heated pool, family suites, a conference room, and individual air-conditioning units, along with telephones in each room and free television." The motel still stands today. The beautiful neon was replaced twice, the second time by a backlit plastic sign. Courtesy Steven Rider Collection

Entering Amarillo from the east, U.S. Route 66. Neon glows in the dark, as a welcoming beacon to travelers along this portion of the highway. Amarillo, the commercial center of the Texas Panhandle, was established in 1887. Between 1969 and 1986, new oil companies formed and merged with others and petrochemical plants opened in this area, and Amarillo became the "Helium Capital of the World."
Courtesy Steven Rider Collection

Da-Jo Motel, Pontiac, Illinois. This long-forgotten Route 66 sleeper typifies the motel styling of the late 1960s and early 1970s. Rife with the warm colors of avocado green and harvest gold, rooms finished with paneled walls added to the charm. This motel was located at U.S. Route 66 and 23.
Courtesy Steven Rider Collection

In 1958, Floyd Redman purchased the Blue Swallow Motel and presented it to his bride-to-be, Lillian, as an engagement gift. Around 1960, she installed what would one day become the famous blue swallow neon sign over the entrance. Lillian was inducted into the New Mexico Tourism Hall of Fame in 1998, the same year she sold the classic 66 motel to Dale and Hilda Bakke. When she died on February 21, 1999, the Mother Road lost another one of its cherished icons. Courtesy Steven Rider Collection

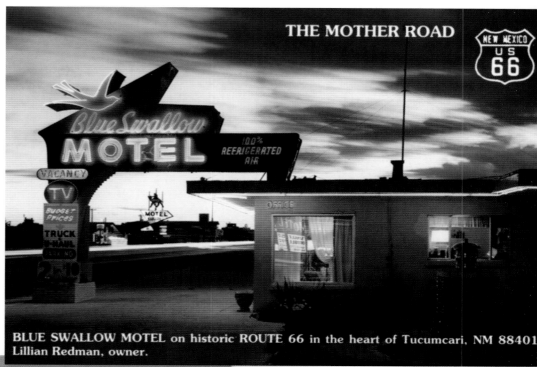

THE MOTHER ROAD

NEW MEXICO US 66

BLUE SWALLOW MOTEL on historic ROUTE 66 in the heart of Tucumcari, NM 88401
Lillian Redman, owner.

The Blue Swallow Motel, 815 East Tucumcari Boulevard, circa 1954. Built in 1939 and first opened for business in 1941, the classic American motel was built with individual garage units, typical of the 1930s-era motels, or "tourist courts." Ted Jones and his wife owned and operated the business during the 1950s. This postcard shows Jones and his wife portraying the homespun "come and stay with us" friendliness that pulled in the customers—along with distinctive Blue Swallow sign. Courtesy Steven Rider Collection

Wade's Overnight Trailer Park, U.S. 66, McLean, Texas. Here, 1970s travelers had every imaginable amenity, including showers, flush toilets, dry cleaning machines, laundry, hair dryers, RV hookups, cable television, a grocery store, and a snack bar. During the late 1970s, the threat of the Interstate 40 bypass prompted McLean business owners to band together in protest, fighting to keep the town's tourist economy alive. Even so, it became the last Texas Route 66 town bypassed by Interstate 40. Courtesy Steven Rider Collection

The historic marker known as "The Continental Divide" was once a favorite stopping point for tourists to take pictures. In 1985, it became a sad reminder of the old road's fate—a resting stop for the indigent, along this formerly busy route in New Mexico, 1985. ©2007 Anne Fishbein

Chapter Eleven

The Ghosts of Route 66

"America's former Main Street is now a broken, decaying road to nowhere . . . a string of souvenir shops lining old Route 66 sits abandoned, weathered signs advertising half-price 'bypass sales' on petrified wood, moccasins, and turquoise jewelry. Cars speed by on the interstate a frustrating one hundred yards away, but the nearest exit is miles off. Not far away, cattle graze on the weeds peeking through the old pavement. About the only things rolling on this stretch of Route 66 these days are tumbleweeds."

—Mark Potts,
*"America's Former Main Street Is now a Broken,
Decaying Road to Nowhere,"*
Washington Post, February 13, 1983

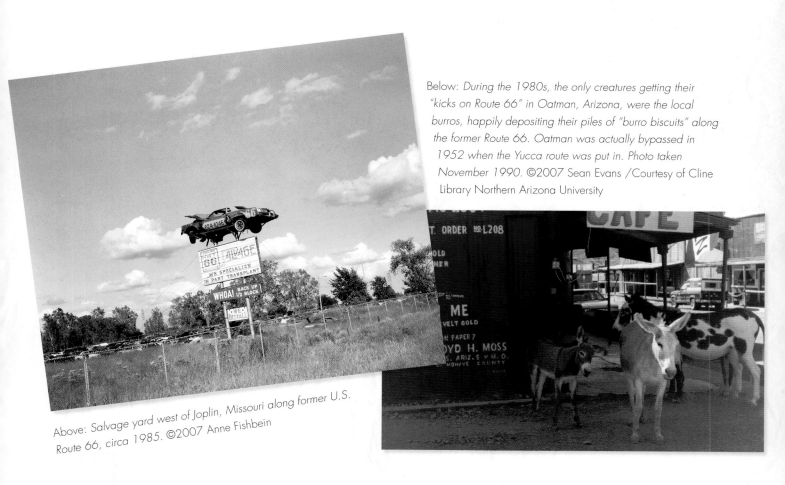

Below: *During the 1980s, the only creatures getting their "kicks on Route 66" in Oatman, Arizona, were the local burros, happily depositing their piles of "burro biscuits" along the former Route 66. Oatman was actually bypassed in 1952 when the Yucca route was put in. Photo taken November 1990. ©2007 Sean Evans /Courtesy of Cline Library Northern Arizona University*

Above: *Salvage yard west of Joplin, Missouri along former U.S. Route 66, circa 1985. ©2007 Anne Fishbein*

On one morning in May 1981, the folks living along Route 66 in Tucumcari, New Mexico, woke up to the sound of silence. While they were sleeping, the final segment of the Interstate 40 bypass was connected to the rest of the highway system.

As if someone had flipped off a switch, the traffic that used to roar through their town simply vanished. "They opened the thing and didn't tell anybody," wrote one local reporter. "They said it was a public relations foul up."[1] It was a foul up all right, one that demoted America's Main Street to the status of a forgotten side street.

Route 66 had been dealt a bad hand. Within a month, businesses in Tucumcari folded faster than a two-bit gambler who had run out of luck.

The Flying M Ranch Motel was one of the first to cut and run. The Owens family purchased the motel a short time before the freeway went in and thought they had it made. "We bought that motel a year ago, and last summer we had them sleeping on the floors," bragged Mrs. Owens in *The Oklahoman*. "I ran it for a couple of weeks, then I could see the handwriting on the wall. We couldn't even rent one room a night."

Further along in Oatman, Arizona (which was bypassed during the 1950s), the only creatures getting their "kicks on Route 66" were the local burros, happily depositing their piles of "burro biscuits" along old U.S. 66 to prove it.

In the 1930s, things were quite different. Back then, this piece of road was alive with people. Now, Oatman was a 1980s ghost town with a scant two hundred residents to its name.

Seventy-four-year-old Ray Shaw—a longtime Oatman resident—recalls the good old days of Route 66 clearly: "There were so many people on Main Street on Saturday that you had to fight your way through the crowd to get to the Honolulu Club for a drink of bootleg whiskey and a game of poker," he recollected.

"Things slowed up a lot when the mining went out, though, and they really slowed up when they put that freeway in," he said. "We had traffic going through here at all times of the day and night. Now, most of the time it's like it is right now." He then waved his arm and pointed toward the burros in the street.[2]

In Moriarty, New Mexico, motel owner F. L. Johnston looked toward the empty parking lot at his Siesta Inn, located near the freeway interchange. "There are certain nights here that you get pretty good traffic and other nights you don't get any at all. I get kind of bitter about this damn interstate system," he said.

Johnston has been a victim of the freeway on more than one occasion. His original café, service station, and tourist shop located along Highway 66 closed after the noose of the I-40 bypass strangled his traffic. "The nearest interchanges were three miles to the east and three miles to the west, and there's no way you can get tourists in there. I spent twenty-three years out there building a damn business up. I had a new Packard every two years."[3]

The man-made drought that dried up the flow of automobile traffic had the same effect on the once-popular Wigwam Motel in Holbrook, Arizona. Shuttered in 1979, its concrete teepees were left to decay along the roadside on Hopi Drive.

Now, proprietor Clifton Lewis pumps gas for the occasional car that stops at the Texaco station that used to double as the office. "Things really slowed down in that first energy crisis, and then they never picked back up again after they put the freeway in. . . ." Lewis said, "Most of the motel business is at the interchanges. The only places that are doing well are the chains."[4]

But there are no franchise stores along the old Oatman Road out past Kingman, Arizona. After climbing through a series of twisting switchbacks along a narrow strip of crumbling 66, you stumble upon Ed's Camp.

Jesus is Lord billboard, hand painted, along former U.S. Route 66, near Thoreau, New Mexico, 1985.
©2007 Anne Fishbein

Outside, a towering saguaro stands sentinel over a hodgepodge of shacks and a collection of Model T parts. A visible-register gas pump that once supplied fuel for Okies' cars sees little use, if any. Keith Gunnett, the nephew of founder Ed Edgerton, welcomes people with impromptu tours of the facilities.

These days, the visitors are few. Through the years, Ed's Camp has deteriorated into a sad museum that commemorates the troubled days of Dust Bowl flight. It's filled with the stuff Edgerton collected (and traded) during the sixty years that he ran the camp, including furniture, patent medicines, and household goods. "They were trading off anything they could get for gas," Gunnett said, "That's where most of this stuff comes from."[5]

By the mid-1980s, that's what the bypassed road called 66 had become: one long, antique store that was filled with an eclectic collection of memories, experiences, and stories of the people who were just passing through. The two-lane was an oddity; the bypass, cloverleaf interchange, overpass, exit ramp, and divided highway had become the norm.

By June 1985, the roadside businesses and attractions in other Route 66 states joined those in Arizona and New Mexico into forced retirement. That year, the "Route 66" designation was terminated by the bureaucrats in Washington, D.C.

As the "Me" generation drowned out the reality of leveraged buyouts, hostile takeovers, and mega-mergers with the sounds on MTV, the only noise heard along the forlorn roadside of 66 was the wind whistling through the shattered windows of abandoned restaurants, motels, gas stations, and tourist traps.

Along the Route 66 of the late 1980s, only the ghosts of yesterday remained to haunt the endless miles of bypassed road.

A Lonely Road

Gas station, former U.S. Route 66, vicinity of southern Illinois, 1985. Two modern, cylindrical gasoline pumps (designed by Eliot Noyes in 1968 for Mobil Oil Company–branded stations) are the only evidence of this now generic-looking service station's original brand. ©2007 Anne Fishbein

Abandoned gas station, former U.S. Route 66 in Galena, Kansas, 1985. ©2007 Anne Fishbein

The former Grant's Truck Stop was transformed into Bingo's Truck and Car Stop, located near the New Mexico/Arizona state line, Grants, New Mexico, 1985. ©2007 Anne Fishbein

Converted into a home, a former gasoline station along U.S. Highway 66 east of Bloomington, Illinois, enjoys a new lease on life, 1985. ©2007 Anne Fishbein

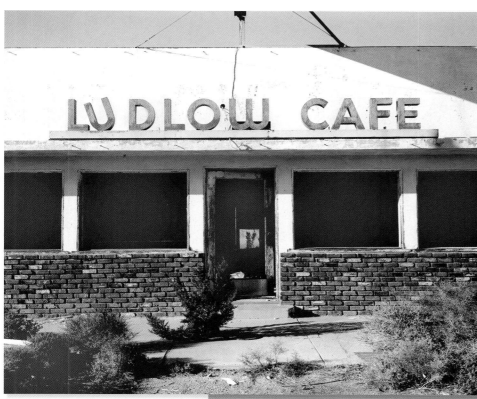

The Ludlow Café, Ludlow, California, 1985. ©2007 Anne Fishbein

Expressway Diner, former U.S. Route 66, between Cadiz and Amboy, California, June 1989. ©2007 Sean Evans/Courtesy of Cline Library Northern Arizona University

The Coral Court Motel of St. Louis, Missouri—formerly located on the busy Watson Round (former U.S. Route 66)—was bypassed by Interstate 44 in 1972. Although the motel remained open for business during the 1980s, it suffered a severe decline in business that resulted in a neglected interior and exterior. By 1988, concerned citizens joined to form the Coral Court Preservation Society. The goal was to raise enough money to help preserve the historic motel for the future, nominated for the National Register of Historic Places in December of 1988 and accepted to the register on April 25, 1989. ©2007 Anne Fishbein

Faded Places

©2007 Pedar Ness

Above: 66 Courts, Groom, Texas. Five years after Interstate 40 bypassed the town, the 66 Courts were already in shambles. It wasn't always like this: During the glory days of U.S. Route 66, Groom was a stopping point for road-weary travelers who needed to refuel their tanks or catch a few winks before hitting the road. The town was named for B. B. Groom, the first general manager of the Francklyn Ranch. ©2007 Anne Fishbein

Right: 66 Motel, Broadway Street (U.S. Route 66) Needles, California, 1985. Typical for its day, the 66 Motel featured kitchenettes, air-conditioning, and free TV. A sign pointed the way with neon and flashing lights, but by the time the coast-to-coast route was left behind, there was little traffic to see it. The general manager lived on site, shown here feeding a peachick during a quiet time of the day. ©2007 Anne Fishbein

Krahn's Truck Stop, Vega, Texas, 1983. Owned and operated by Don "Flying Dutchman" Krahn, this truck stop was once a busy place for trucker's to stop for gas and supplies along old Route 66 in the Texas panhandle region. ©2007 Jerry McClanahan

The Union 76 service station, Ludlow, California, sits directly adjacent to the Ludlow Café. But the original station—opened during the 1940s—was positioned much closer to the café. This photograph dates from 1983. ©2007 Jerry McClanahan

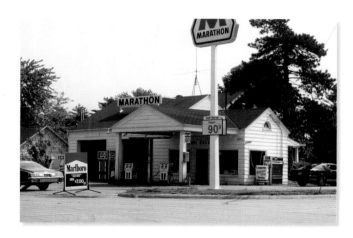

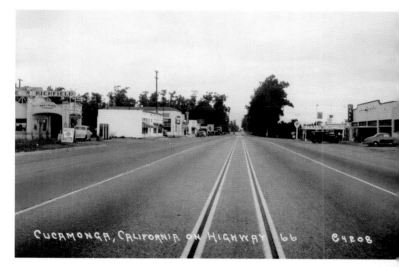

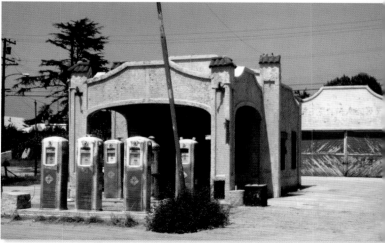

Above: Ambler's Texaco Gas Station, Illinois Route 17 and U.S. Highway 66, Dwight Illinois, 1986. Built in the house-style, this refueler was constructed by Jack Schore in 1933 and became Ambler's from 1938 to 1965 when Basil Ambler owned and operated the filling station. It was added to the National Register of Historic Places on November 29, 2001. ©2007 Jerry McClanahan

Right: Richfield Gasoline Station, Cucamonga, California. When this scene was recorded in 1940, U.S. Route 66 featured a wide, newly paved roadbed (top). But America's Main Street was destined not to last forever, bypassed by the interstates and eventually decommissioned. By 1983, the once-pristine roadway decayed into disrepair and disuse until finally the buildings that lined it were abandoned (bottom). Courtesy of Steven Rider Collection (top), ©2007 Jerry McClanahan (bottom)

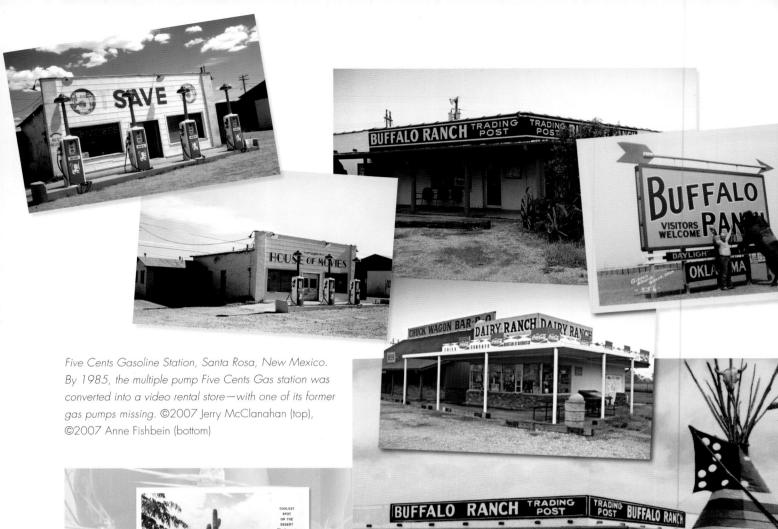

Five Cents Gasoline Station, Santa Rosa, New Mexico. By 1985, the multiple pump Five Cents Gas station was converted into a video rental store—with one of its former gas pumps missing. ©2007 Jerry McClanahan (top), ©2007 Anne Fishbein (bottom)

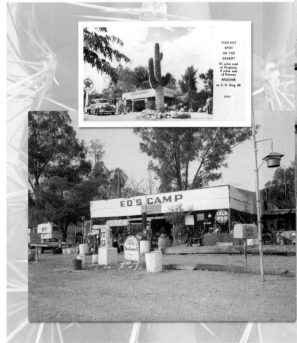

Ed's Camp, east of Goldroad, Arizona, 1985. Filled with the "stuff" that Lowell "Ed" Edgerton collected and traded during the sixty years he ran it, Ed's Camp was a hodgepodge of furniture, patent medicines, and household goods. Edgerton originally opened his campground during the 1930s with a service station and later expanded to include a grocery store, souvenir shop, and the Kactus Kafe. In 1947, a Saguaro stood sentinel over the camp and Texaco station. Courtesy of Russell Olsen (top), ©2007 Anne Fishbein (bottom)

The Buffalo Ranch was established on July 11, 1953, by Russell and Aleene Kay at the junctions of U.S. Highways 69, 60, and 66. The main building, a trading post, was part of an enterprise expanded to include a dairy ranch and a chuck wagon barbeque restaurant. Tourists were also treated to a delight of animal attractions, including performances by Black Barney, the famed buffalo. By 1958, the once-prosperous business took a financial nose dive and the Kays sold off the Buffalo Dairy Ranch to Betty Wheatley. The Kays continued operating the original business until their deaths. On April 4, 1998, the buildings were bulldozed to make way for a travel center called Buffalo Ranch.

Shown: Russell Kay with trained buffalo Black Barney, circa 1954 (top right); Genuine Indian-made medicine lodge teepee, circa 1955 postcard (bottom); Buffalo Ranch, circa 1986 (top left); Buffalo Dairy Ranch, circa 1986 (middle). Courtesy of Steven Rider Collection (top right, bottom), ©2007 Jerry McClanahan (top left, middle)

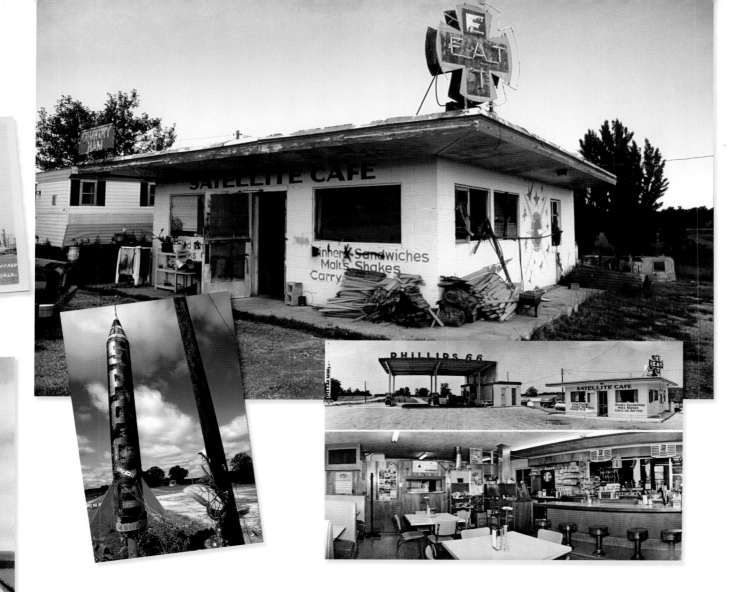

The Satellite Café and Phillips 66 Space Station, Lebanon, Missouri, circa 1960s (bottom right). Owned and operated by Mr. and Mrs. Loren Attoway, the six-stool eatery once served fried chicken, steaks, chops, and homemade pies. The service station was operated by LeRoy Hawkins. In 1983, the café was transformed into a storage shed. A house trailer was placed next to the building that was once occupied by the space station (middle). The café building was destroyed by fire in 1999. ©2007 Allen Bourgeois (bottom left), ©2007 Jerry McClanahan (top), postcard Courtesy Steven Rider Collection (postcard).

The 66 Café, U.S. Route 66, Groom, Texas, 1983. Minimalist marketing at its finest, a Coke advertising button and a "beer" sign are the only visual clues to this building's identity: food and drink inside. ©2007 Jerry McClanahan

Signs of the Times

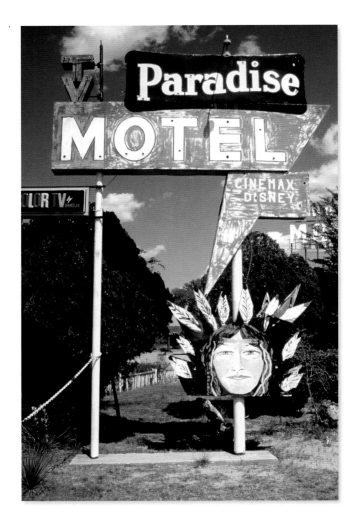

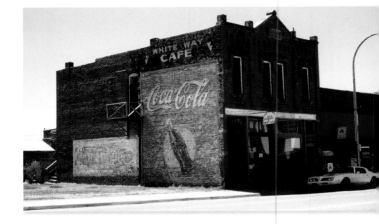

Former White Way Café and Coca-Cola ghost sign, Main Street (U.S. Highway 66), Stroud, Oklahoma, April 1980. The town of Stroud had a raucous start before statehood forced it to dry up in 1907. Its prime location near Indian territory afforded it the ability to smuggle in whisky, hidden in wagonloads of groceries. ©2007 Pedar Ness

The Paradise Motel Sign, 2202 West Tucumcari Boulevard (U.S. Route 66) Tucumcari, New Mexico, 1980. Shown here in a road-worn state before it was upgraded, the neon sign was recently restored as part of the New Mexico Route 66 Neon Sign Restoration Project, headed by the New Mexico Route 66 Association. ©2007 Pedar Ness

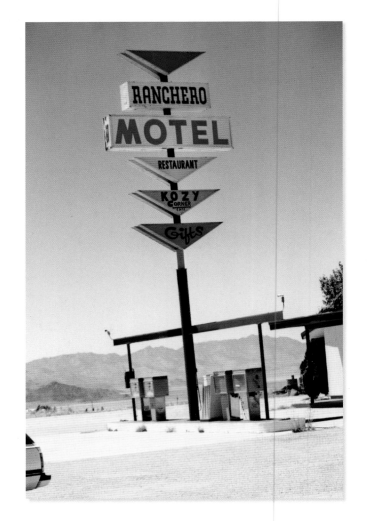

Ranchero Motel and gas station, former U.S. Route 66, east of Kingman, Arizona, June 1990. ©2007 Sean Evans/Courtesy of Cline Library Northern Arizona University

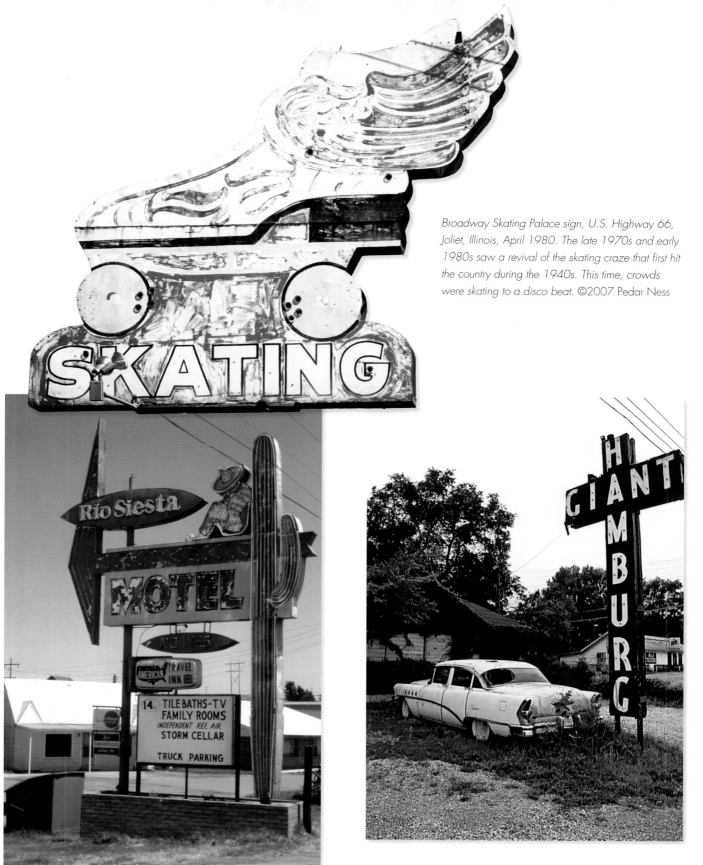

Broadway Skating Palace sign, U.S. Highway 66, Joliet, Illinois, April 1980. The late 1970s and early 1980s saw a revival of the skating craze that first hit the country during the 1940s. This time, crowds were skating to a disco beat. ©2007 Pedar Ness

Rio Siesta sign, U.S. Highway 66, Clinton, Oklahoma, 1983. Utilizing electrified neon tubing in the shape of the always-popular Saguaro cactus (a standard for motel signs out West), this motel is currently eligible for listing on the National Register of Historic Places. ©2007 Jerry McClanahan

Red's Giant Hamburg was opened by Sheldon "Red" Chaney and his wife, Julia, in 1947 and closed in 1984. This image was taken in 1986, two years after the business shut its doors. The building was an old Sinclair station with motor courts in the back that the Chaney's operated as the 66 Motel. The 1955 Buick was parked in front of the sign to keep customers from backing into the homemade structure. ©2007 Jerry McClanahan

Route 66 Soul Survivors

Juan Delgadillo's Snow Cap Drive-In, Seligman, Arizona, 1985. The amazing Delgadillo brothers have been a boon to the Route 66 town of Seligman. Juan's wonderful brand of humor—evident in every detail of the ice cream stand—has kept a smile on many a Route 66 traveler's face. It all began in the early 1950s as a plan for a Dairy Queen. When that didn't pan out, he franchised with the Snow Cap Corporation, Prescott, Arizona-based ice cream shops. Juan continued serving up creamy root beers with a smile until his death on June 2, 2004. Today, son John Delgadillo carries on the family tradition. ©2007 Jerry McClanahan

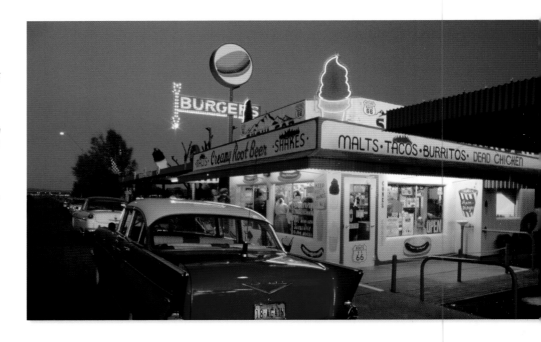

The Uranium Café, 519 West Santa Fe Avenue, Grants, New Mexico, 1983. Opened by Eugene Woo in 1956, the Uranium Café was named after the discovery of uranium in Grants in 1950. Today, it remains open for business and continues to serve "starving" customers a menu of Mexican food. ©2007 Jerry McClanahan

The Hi Way Diner, 208 West Santa Fe Avenue (U.S. Route 66) and Highway 180 (also known as North Humphreys Street), 1980. Also known as Chaunce's Diner, this eatery was a Flagstaff favorite from 1949 until 1982. Chaunce and Dave Redeker owned the diner from 1979 to 1982, but after losing the land lease, they moved the building to Page, Arizona. There, it operated as Bubba's Barbeque. Built by the Valentine Manufacturing, Inc. of Wichita, Kansas, these self-contained units were transported by truck or rail to all points across America. This model is one of seven Valentines that still exist in Arizona, including the Twin Arrows Café. ©2007 Pedar Ness

Norma's Diamond Café, 408 North Mission, Sapulpa, Oklahoma, 1986. Norma Less Hall spent fifty years working in her Route 66 café and earned a worldwide reputation for her down-home cooking. She was immortalized in at least three Route 66 films, as well as in numerous books featuring the old road. Since it first opened in 1950, Norma's has been in continuous business at the same location. Hall has been recognized as the longest café owner of anyone on the Mother Road. She passed away November 23, 2000. ©2007 Jerry McClanahan

Yellowhorse Trading Post, Arizona, 1985. This trading post's location (near the Interstate 40 Exit 355) assured its survival. Its signs offered a bygone service ethic of Route 66: "ice your jugs free." Unlike the super-fast interstate highway, Route 66 imposed a leisurely pace on its travelers, studded by trading posts and watering holes, forcing travelers to slow down and sample a real slice of America. ©2007 Anne Fishbein

Sitting Bull Trading Post, Joseph City, Arizona, 1988. This trading stop started out as Howdy Hank's Hopi Village. Hank offered U.S. Highway 66 tourists rooms for the night, a café, and a gift shop. Eventually, the business was sold to Max Ortega Jr., the son of the famous Indian trader, Max Ortega, who owned several trading posts along former U.S. Route 66 (the Ortega family continues its trading post legacy to this day). Ortega made several improvements to the property, including changing the name to Sitting Bull. ©2007 Jerry McClanahan

Angel Delgadillo
and the Resurrection of Route 66

"In the summer, there were about nine thousand cars using this road daily. But on that day . . . traffic stopped. It just stopped. And it stopped for ten long years!"

—Angel Deldadillo
Interview, February 7, 2006

On September 22, 1978, the steady stream of cars carrying tourists, traveling salesmen, and opportunity seekers along U.S. Route 66 came to a halt. This was the day that the Seligman, Arizona, stretch of Route 66 died and was bypassed by Interstate 40.

"In the summer, there were about nine thousand cars using this road daily. But on that day . . . traffic stopped. It just stopped," Angel Delgadillo said. "And it stopped for ten long years!" The town, dependent on the tourists and their discretionary spending, began to feel the strain of an economic downturn that just kept on slumping.

But Delgadillo was no stranger to hard times. He lived through the Great Depression and experienced his family's struggle to survive. His story began in 1917 when his father, Angel Delgadillo Sr., came up from Jalisco, Mexico, to find work in America. He set his sights on Seligman and immediately procured employment with the Santa Fe Railroad. Life was pretty good until the Santa Fe laid him off.

Fortunately, he had bigger ideas. In 1923, he built a pool hall on his property, which became a huge success with the ethnic population. He also noted that the Basque and Mexican sheepherders lacked a proper haircutting facility. It didn't take long for the enterprising senior Delgadillo to become an adept barber. As fast as you could snip a lock of hair, he opened up an adjoining barbershop in 1926, complete with a fancy chair that set him back $194. Both businesses thrived and his family grew.

But then trouble came: In 1933, the original Route 66 that flowed by the Delgadillo business was diverted further up the road. At the same time, a growing cattle industry drove out the sheepherders. As business dropped, the family faced ruin. They wondered if they would be forced to join the ever-increasing throng of automobiles driving west on Route 66.

Fate stepped in to answer. At the time, two of the Delgadillo boys were playing for the five-piece Hank Becker Orchestra. Both boys had told their band leader that they were leaving for California. When Becker learned that he might be losing two talented musicians, he called in a couple of old favors and got the older boy a job as a laborer on the Santa Fe. As a result, the family remained in Seligman after all. By 1939, the Delgadillos formed their very own band and traveled Route 66 providing musical entertainment along the way.

Eventually, Angel went on to fill his father's shoes when he, too, became the town barber. When asked what prompted him to carry on the family business, he said, "Well, when my father closed his shop, they asked me, 'Why don't you try to be a barber? The place is there, the building, the chair.' And so I tried it . . . for about fifty-seven years!"

He reopened his father's old pool hall and barbershop on May 22, 1950. In 1972, he moved the entire enterprise to its present location at 217 East Route 66.

"Everything was moved. I moved my dad's old barber chair, his cabinets and mirror, the Pepsi-Cola pop machine from 1951, and three new pool tables that I bought in 1951," Angel said. "You know, we upgraded then."

Six years after the move, when Seligman was bypassed by Interstate 40, Angel stood in the doorway of his shop and spied an empty Route 66. He wondered what would become of his town. For almost a decade, townspeople talked about how Seligman could be revitalized. Some wanted to attract new industry, but Angel had much grander ideas. He *was* Route 66, and the highway was his life. He knew human nature well enough to know that roots run deep and memories live long.

With that in mind, he called a meeting at the Copper Cart Restaurant on February 18, 1987. His purpose was to discuss a plan to promote and preserve the historic 66 highway. Surprisingly, people came from as far away as the California-Arizona border. The result was the founding

of the Historic Route 66 Association of Arizona, the first group of its kind.

The new group successfully lobbied the Arizona Legislature to designate and preserve Arizona Route 66 as a historic highway. The group's work bore fruit in November 1987 when the state of Arizona christened U.S. 66 from Seligman to Kingman as "Historic Route 66." Soon afterward, the remaining portion of Arizona 66 received this designation as well.

By 1997, Seligman had re-emerged from the ashes, just like the proverbial phoenix. The increased tourist traffic also prompted local entrepreneurs to open new businesses. The Aztec Motel, which had been closed down for years, reopened again. Four new residential subdivisions sprouted and retirees moved in.

Today, people in search of small town America and the real Route 66 make the pilgrimage to Seligman. Delgadillo, the unofficial spokesman and "guardian Angel" for 66, is there to greet them all. Now a recognized landmark of the old road, his barbershop turned Route 66 Gift Shop and Museum stands as a testament to faith, hope, and endurance.

"I am just so happy to see people from all corners of the United States and many parts of the world," he said. "When they walk in here, they are smiling from ear to ear. It's like they are not walking into a strange place. When they walk in here, they say, 'Angel! I finally met you! It is as though I have known you all my life I read so much about you.'"

"I am grateful for the dream I had . . . and I am not the one that did it all; I just had the dream. We just got together and did it. But I am happy that through an idea that I had, we have helped save history, and history is not only the road or the buildings. We have helped to preserve a little bit of America. . . ."

Angel Delgadillo Sr. built a pool hall on his property in 1923 and by 1926 added an adjoining barbershop. It just so happened that the property was located along a dirt road that became part of the original U.S. Highway 66 alignment (bottom left). By 2002, Angel was still busy giving customers an old-fashioned lather-up shave in his father's original barbershop chair that cost $194 in 1926, the year U.S. Route 66 became an official highway. Two of the Delgadillo boys joined the Hank Becker Orchestra, and by 1939 the Delgadillos formed their own band. This 1948 photograph (top left) shows the Delgadillo Family Orchestra: Tony Delgadillo on drums, Luc Delgadillo on piano. In the front row (left to right), Augustine, Joe, Angel, and Juan Delgadillo. Another brother, Charles Delgadillo (not shown), was acting manager. The Copper Cart Restaurant (middle left) is where Angel called a meeting at on February 18, 1987, with the goal to preserve historic U.S. Highway 66. Courtesy of Angel Delgadillo

Soulsby Service Station, Mount Olive, Illinois. The filling station was opened by Henry Soulsby in 1926, the year that U.S. Highway 66 was born. When Henry retired, two of his children, Russell and Ola, took over. The station was sold at auction in 1997 and restored by new owner Mike Dragovich and a group of volunteers in 2003. Both Russell and Ola passed away in 1999. ©2007 Jim Ross

Chapter Twelve

Answering The Road's Call

"Officially, Route 66 doesn't exist anymore . . . but a recent resurgence in interest in the road, which will be seventy this year, is turning into a boon for the tiny towns along the remains of it. More than a dozen associations in the U.S. and overseas are devoted to the lore of the highway. The National Park Service is studying how to commemorate the road. In Illinois and Arizona, champions of Route 66 got the state to put up historic markers along the old highway."

—Daniel LeDuc,
"Still a Kick: the Legendary Route 66 Finds New Life as a Nostalgia Trip,"
Chicago Tribune, January 21, 1996

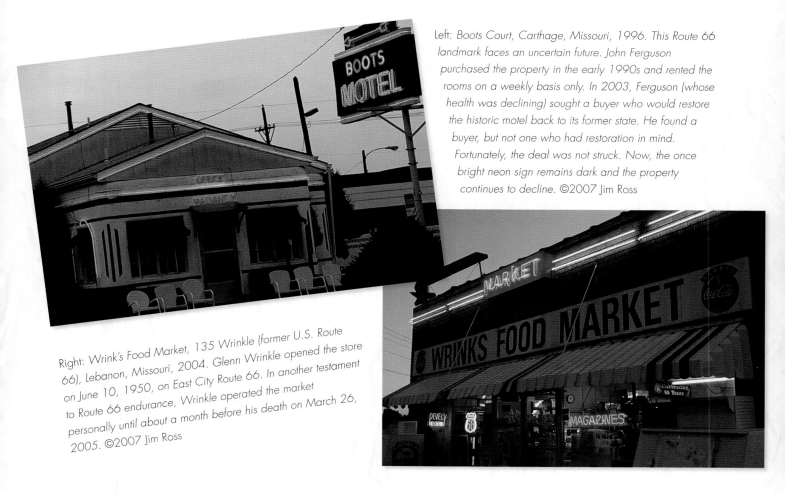

Left: *Boots Court, Carthage, Missouri, 1996. This Route 66 landmark faces an uncertain future. John Ferguson purchased the property in the early 1990s and rented the rooms on a weekly basis only. In 2003, Ferguson (whose health was declining) sought a buyer who would restore the historic motel back to its former state. He found a buyer, but not one who had restoration in mind. Fortunately, the deal was not struck. Now, the once bright neon sign remains dark and the property continues to decline. ©2007 Jim Ross*

Right: *Wrink's Food Market, 135 Wrinkle (former U.S. Route 66), Lebanon, Missouri, 2004. Glenn Wrinkle opened the store on June 10, 1950, on East City Route 66. In another testament to Route 66 endurance, Wrinkle operated the market personally until about a month before his death on March 26, 2005. ©2007 Jim Ross*

The bureaucrats stripped the shields from Route 66's proud shoulders, they tore up her roadbed, rerouted her, discharged her, and left her for dead. But the grand dame of the highway refused to die. Instead she lingered on, barely alive, somehow managing to survive. Her strong spirit was resolute; she would not, could not, disappear.

It may be that she gained strength from those early trailblazers who birthed her into existence. It may be that the spirits of those early pioneers of the paved highway refused to see their handiwork vanish. Whatever the reason, she endured long enough for a new set of visionaries to carry forth the torch of remembrance to new generations.

These pilgrims include sixty-seven-year-old Margie McCauley, who walked the 2,400 miles along former U.S. Highway 66 accompanied by her dog Lollipop. When asked in a 1996 interview why she was taking the trek of her lifetime, she said, "Some compelling force is making me do something more than just living my life. To leave the comfort of not just my home but my life, to leave my grandchildren, means there has to be a reason. I may know it when I'm done. I may never know it."[1]

The reason for the old road's appeal may elude many, but the number of travelers along the former highway known as U.S. 66 is growing yearly and the visitors are not just Americans. Today, they come from around the globe: Canada, Japan, Germany, France, Scandinavia, and even Egypt. Everyone is eager to experience the "real" America, talk to the down-home folks that live along the way, and hear for themselves some of the stories that are part of the folklore of this cult road.

In answer to the road's call, a new breed of road booster was born: the Route 66 Association. It began as a kind of fan club for an unofficial highway. Members organized with the

Bradbury-Bishop Deli, 201 North Main Street (Route 66), Webb City, Missouri. The building that houses this deli began in 1887 as a bank. In 1916, C.S. Bradbury purchased it and built a soda fountain, naming it the Bradbury Company in 1931. The Bishop portion of the name was added in 1939, when Bradbury's son-in-law, Harry Bishop joined the business. ©2007 Jim Ross

idea to preserve portions of the road for future generations. The first official group was born in February 1987 in Seligman, Arizona—spearheaded by Angel Delgadillo's historic meeting at the Copper Cart Restaurant. The organization promptly began lobbying Arizona for the historic designation of Route 66.

As a direct result of their efforts, Arizona dedicated the portion of roadway from Seligman to Kingman as "Historic Route 66" in November 1987. It was appropriate that Arizona became the first state to acknowledge the historic significance of the road, since it was the last portion of the route that succumbed to the interstate system. It was October 1984 when Interstate 40 replaced the last segment of old 66.

In 1989, the grassroots movement to save 66 spread from state to federal level when Senator Pete Domenici of New Mexico introduced a resolution before congress that proposed to authorize a study "of the feasibility of preserving the remaining portion of U.S. 66 and naming it a national scenic highway." In an interview, Domenici explained his motivation for submitting this proposal by saying: "At one time, Route 66 was the most famous highway in America. It was a modern-day Santa Fe Trail, carrying thousands of migrating Americans to the West. . . . Unfortunately, Route 66 is fast fading from the landscape of America. All that remains are vestiges of the highway and gas stations, curio shops, restaurants, motels, and other facilities that dotted the highway to serve travelers. Route 66 is perhaps the most historic highway in the entire country, so it is more than appropriate that we take action to preserve it."[2]

To the delight of the Route 66 boosters, the 101st Congress passed Domenici's proposal. The Route 66 Study Act of 1990 called for participation by representatives from each of the Route 66 states, their preservation offices, and from associations interested in preserving 66. More importantly, "persons knowledgeable in American history, historic preservation, and pop culture"[3] were called to action.

Mike Yates and Tom Teague, author of Searching for 66, emerged as vocal supporters of the study. As co-founders of the Route 66 Association of Illinois, they recognized the need to preserve the old highway and to honor the people who brought it to life. "We want to commemorate the people who helped give Route 66 such unique character—its builders, its travelers, its merchants, and its dreamers," Teague said.[4] With the opening of the Route 66 Hall of Fame (located in the Dixie Truckers Home in McLean, Illinois) in the summer of 1990, the dream was now reality.

The call for nominations went out, and in June, the official induction ceremony was kicked off with the Illinois Route 66 Motor Tour. Approximately two hundred vintage automobiles turned out for the road rally. The rally route wound through the streets of Chicago and dipped down to St. Louis via the old road, to meet up at Ted Drewes Frozen Custard stand. "There is a community out there today of people along

Turner's Barber Shop, former U.S. Route 66 in Dwight, Illinois, April 1996. A scene you won't see very often, indicative of the Normal Rockwell-like feeling you can still experience along the miles of today's rediscovered Route 66. ©2007 Howard Ande

the highway," Teague said. "They're there, and Route 66 is there today as well."[5] Finally, it was the extraordinary people of 66 that were celebrated and their history was preserved for posterity. The Mother Road was back.

Meanwhile, other Route 66 states also planned their revivals. Shortly after the Route 66 Study Act passed, Oklahoma Governor Henry Bellmon signed off on a joint resolution that designated 66 as a historic route. He pledged assistance to the route's communities and to help with restoration projects. Steering committees in each town along the roadway were asked to identify existing Route 66-era landmarks. "Oklahoma boasts many classic examples of the nostalgic period architecture for which the route is so famous," Bellmon said in a 1990 interview. "Americana has been rediscovered in the heart of Oklahoma."[6]

On June 6, 1990, the old highway was rededicated at a ceremony in Warr Acres, Oklahoma, as new "Historic Oklahoma U.S. 66" signs debuted. On June 10—concurrent with the Illinois motor cruise—a 166-mile Route 66 Cruise brought Oklahoma's Route 66 main streets back from the dead. Ed Smalley, owner of the closed Rock Café, temporarily reopened to supply food for a Greasy Hamburger Festival, cooked up by local volunteers from the Stroud Historical Society. From as far away as Ohio, thousands of classic cars poured in to participate in the cruise and poker run that was held between El Reno and Claremore. As fate would have it, the 1971 Mustang convertible "grand prize" was won with a hand boasting two pairs of sixes!

Indeed, the demise of Route 66 had been greatly exaggerated. Across eight states and three time zones, the Route 66 revival had just begun. There was a hunger for Route 66 that no greasy burger could fill and it was a deep craving that defied satisfaction.

The yearning to learn more about the route fueled a rapid succession of books and magazine articles. In 1991, Tom Snyder's *Route 66 Traveler's Guide and Roadside Companion* hit bookstores. Now, the various alignments and re-alignments of the original road were deciphered for all to explore. Soon, signs were posted up and down the route to mark old pathways. With approximately 1,920 miles of drivable Route 66 remaining, it didn't take long for the growing ranks of enthusiasts—or "roadies"—to plan vacations around a complete circuit of the historical highway.

Then on August 10, 1999, the 106th Congress passed a preservation bill (S. 292) introduced on January 21, 1999, by Senators Domenici and Bingaman. This bill was based on the results of the Route 66 Study Act of 1990. The language of the bill galvanized Route 66 supporters that were resolute in the fact that "U.S. Highway 66, popularly known as 'Route 66,' is significant as the nation's first highway linking Chicago with Los Angeles. In its day, Route 66 symbolized freedom and mobility for every citizen who could afford to own and operate a car."[7] The new act, named the Route 66 Corridor Preservation Act, appropriated a total of ten million dollars to be distributed over nine years "to preserve the cultural resources of the Route 66 corridor."

As history shows, the act prompted immediate action by local groups, historical societies, and Route 66 associations to preserve Route 66 relics. All along the old road, historic businesses and landmarks were saved from extinction. In Odell, Illinois, the Odell Standard Oil Gas Station was resurrected. In Baxter Springs, Kansas, the Rainbow Marsh Bridge saw new life. Restaurants were reborn and enhanced, including the U-Drop Inn Café in Shamrock, Texas, and the Rock Café in Stroud, Oklahoma. The Aztec Hotel in Monrovia, California, was reanimated, too—as was the Rialto Theatre, in Winslow, Arizona. Broken neon signs flickered back to life as the New Mexico Neon Sign Restoration Project worked its restorative magic on the glowing icons of the old road.

Yes, many rose to the challenge and answered the call of Route 66. Today, historic Route 66 placards adorn her shoulders like well-deserved jewelry. Her roadbed is treasured by those that carried the spark of wanderlust to see America. Listen! Can you hear it? Route 66 is calling. To take advantage of her homespun friendliness and her timeless charm, all you need is a full tank of gas and a love for the road. If you ever plan to motor west, do take the highway that's the best. Get *your* kicks on Route 66!

The Old Road

Above: *The commemorative historic U.S. Route 66 sign installed on Santa Monica Boulevard, Santa Monica, California, 1993. In the photograph are Tom LaBonge (far right), who at the time of the photograph was an aide to Councilman John Ferraro (he is currently the councilmember for Council District 4), Dave Royer (transportation engineer at the Los Angeles Department of Transportation (second from right, now retired), and Councilman Ferraro (second from left). Courtesy of Jim Fisher/Los Angeles Department of Transportation.*

Right: *66 pavement shield, Oklahoma, 1999. Some parts of U.S. Route 66 in western Oklahoma have 66 shields painted on the road surface to mark the 1932-1933 alignment. In Oklahoma, the easiest-to-find sections of old road are those still marked as State Highway 66. These areas are (east to west): west of Vinita to Catoosa (east of Tulsa); Sapulpa (west of Tulsa) to I-35/2nd Street exit (Edmond); and West Oklahoma City on 39th Street (just west of the junction of SH 66 and I-44) to the east side of El Reno.* ©2007 Jim Ross

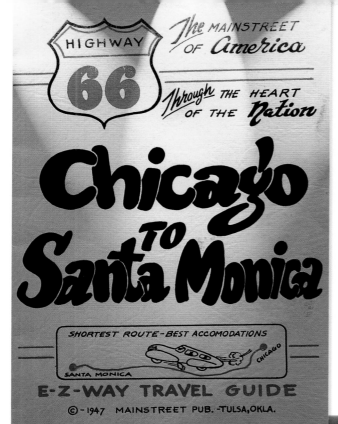

Left: *Chicago-to-Santa Monica travel guide, 1947. Published by Mainstreet Publishing of Tulsa, Oklahoma, this handy booklet gave travelers the information they need on the shortest route and the best accommodations.* Courtesy Steven Rider Collection

Below: *The old 1926 alignment of U.S. Highway 66, between Cuervo and Santa Rosa, New Mexico, September 1995.* ©2007 Jim Ros

Abandoned road segment, most likely the 1940s paved U.S. Route 66 Highway located just east of Parks, Arizona, documented in June 1992. ©2007 Sean Evans/Courtesy of Cline Library Northern Arizona University.

Cool Springs Camp
A Desert Oasis

When U.S. Highway 66 became official, businessman N. R. Dunton, of Kingman, Arizona, built what he envisioned as a way station for the early motorist in a remote region of the Arizona desert known to locals as Cool Springs (camp and station, middle left photo, 1927). The area, host to a number of underground springs, was one of the few desert watering holes along the early trails that connected Arizona and California.

The interesting fact about Dunton's idea was that he did not actually own the land, just the buildings. Another is that the service station was not his primary source income. It was the water, which he sold for a dollar a gallon!

In 1936, the stone structure was sold to James Walker of Huntington, Indiana. Walker's family—comprised of his wife Mary and four children—added a restaurant and a bar to the business. But the marriage didn't survive desert life, and within a few short years, James returned to Indiana with the children, leaving the Cool Springs business for Mary to run.

In 1939, Mary wed the Dr. Pepper route man, Floyd Spidell (middle photo). The newlyweds went to work improving the restaurant menu by adding chicken dinners, a specialty the place became known for. Under the care of Spidell, Cool Springs flourished (photo middle right, 1942) through the golden age of Route 66 into the early 1950s, when this portion of the original route was bypassed in favor of the more level terrain of the Yucca alignment, which opened up in 1952.

Unfortunately, the Spidell's wedded bliss didn't last, and Mary left Floyd to run Cool Springs. The changes continued as Spidell's niece, Nancy Schoenerr, entered the picture in 1957 to help her uncle maintain the business. By 1960, Floyd's health prevented him from actively participating, and Nancy, along with her husband Chuck, decided to purchase Cool Springs. It was then that she discovered the actual land that Cool Springs was built on did not belong to any of the parties involved! It wasn't until 1962 that the property was cleared for her to purchase, leaving her as the owner.

Unfortunately, the building at Cool Springs was destroyed by fire in 1966 and was never rebuilt. In 1997, Ned Leuchtner of Kenilworth, Illinois, discovered the property and began negotiations to purchase it from Nancy Schoenerr Waverka. By 2001, she agreed to sell the property, and Ned immediately began to rebuild Cool Springs, utilizing as much of the original foundation and structure as possible (top photo, circa 2000). The power was hooked back up on December 7, 2004, and Cool Springs was officially back in business (bottom photo, 2006).

©2007 Shellee Graham (top), Courtesy of Ned Leuchtner (all middle row, bottom)

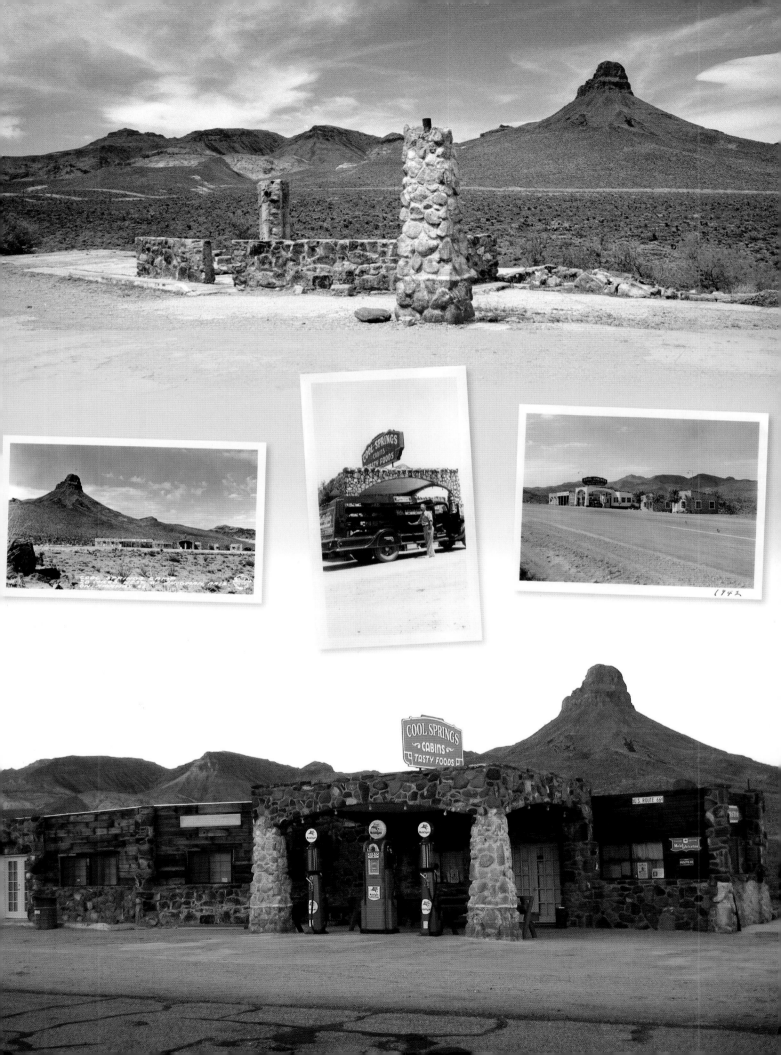

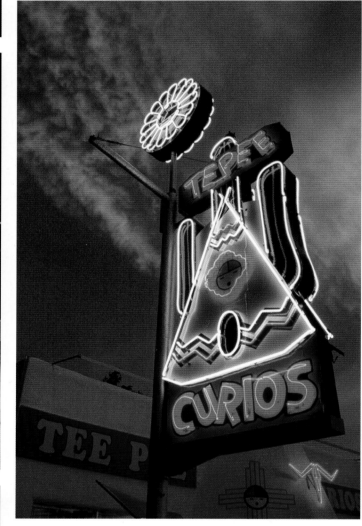

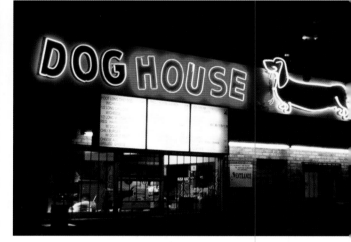

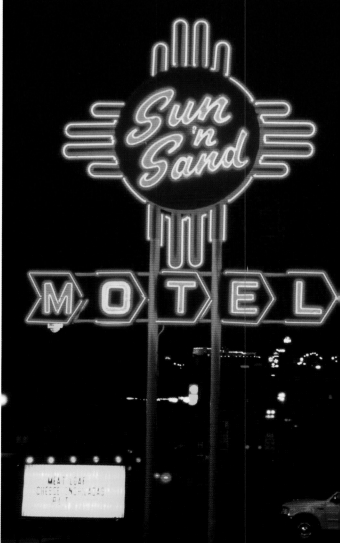

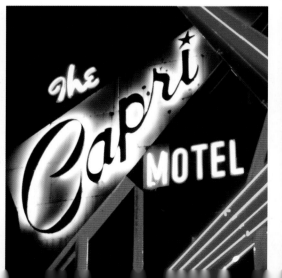

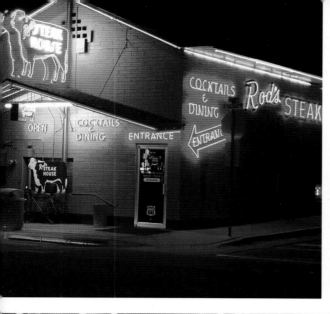

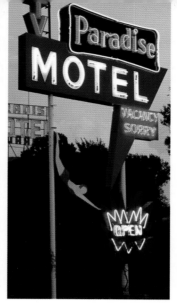

The Club Café

The Club Café closed in 1992, the victim of a McDonalds franchise and recession. For fifty-five years, it was an institution of U.S. Highway 66 and Santa Rosa, New Mexico. Ron Chavez saved the restaurant from extinction back in 1973. He first worked there during the 1950s as the morning cook, back when founders Phil Craig and Floyd Shaw were running it.

In a 1992 interview with the *Chicago Tribune*, Chavez said that back then "You just had to open the doors; we opened at five [in the morning] and by 5:15 this place was packed. It never was empty, even to change for lunch." Chavez left Santa Rosa for California, managing meat markets in Monterey and Los Angeles, but when he heard about the fate of the Club Café, he decided to invest his savings in the struggling business.

"I can count a half-dozen other times I almost went under. We always bounced back," he stated, adding,

"This time I couldn't." The days of sourdough biscuits and gravy and blue corn enchiladas were gone.

In 1995, Joseph and Christina Campos, owners of Joseph's Bar and Grill, purchased the defunct Club Café from the bank with hopes of reviving it, but the sixty-year-old building had numerous building code problems. The idea was abandoned. However, they did obtain the copyright to use the fat man logo made famous by billboard artist Jim Hall. Now, the Fat Man smiles down on patrons of their restaurant located at 865 Will Rogers Parkway.

The original fat man sign (painted by Rudolph Gonzales) resides at the Route 66 Auto Museum, located at 2866 Will Rogers Drive. The museum also houses the large Riddles of Old Route 66 sign that was once a conversation piece inside the former Club Café.

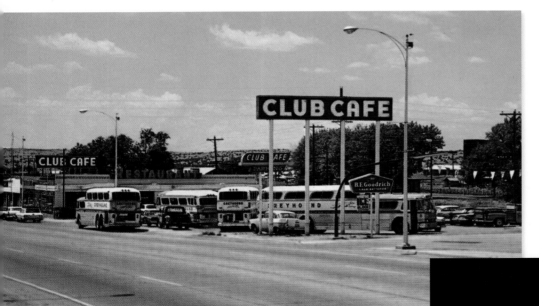

Above and right: *The Club Café, U.S. Highway 66, Santa Rosa, New Mexico. Owned and operated by Floyd Shaw and Phil Craig, the now-extinct landmark opened in 1935 and quickly became a popular stop for tourists yearning for a good meal. The smiling "fat man" was Phil Craig's idea, who hired billboard artist Jim Hall to apply the image to numerous billboards along the highway leading into Santa Rosa. The combination of a smiling man and a steaming plate of hot biscuits and gravy proved irresistible to the traveling public. Unfortunately, the restaurant fell victim to the interstate bypass in 1973. Courtesy Steven Rider Collection*

Opposite: *Club Café rooftop sign in parking lot (top), 1997; boarded up, 1997 (middle right); group of signs, 1997 (bottom right); Club Café, circa mid-1990s (bottom left).* ©2007 Howard Ande (top, middle, bottom right), ©2007 Bruce Carr (bottom left)

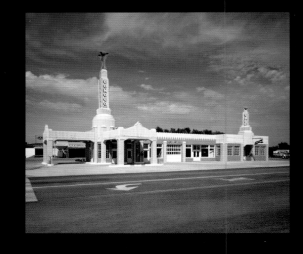

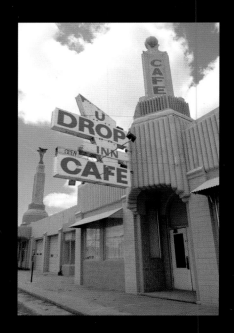

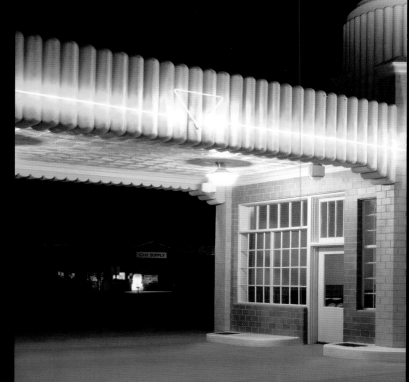

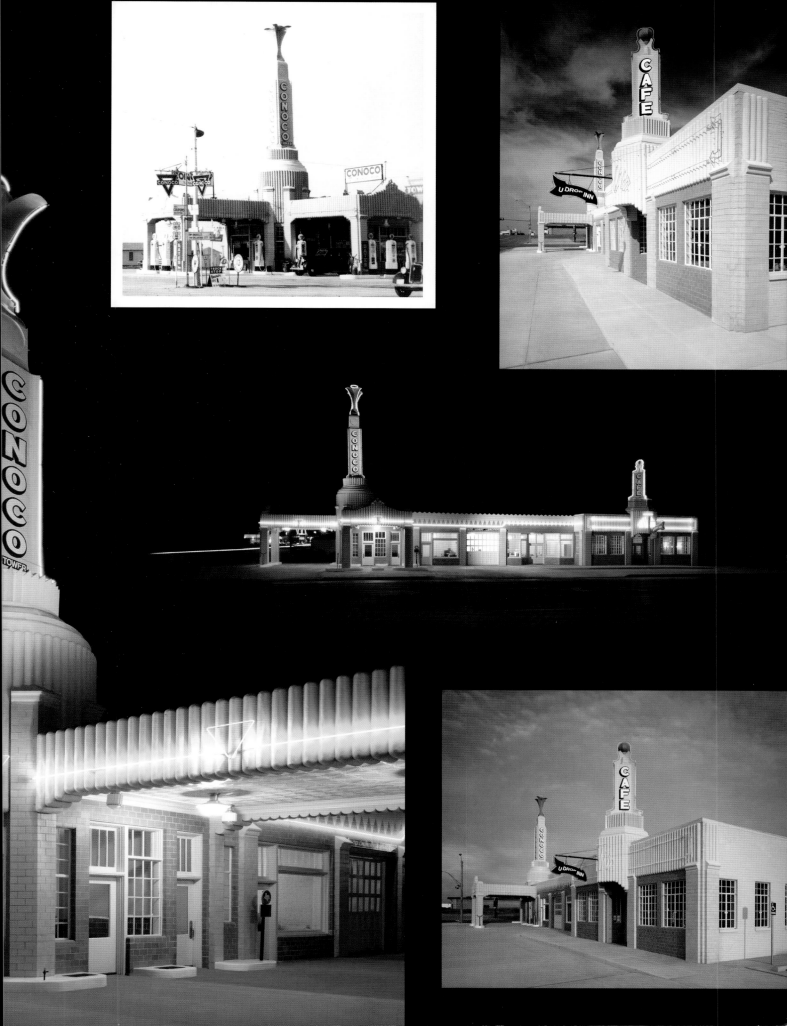

Andree Pruett
and The Bagdad Café

"It was a big challenge, but I just stood behind the counter and tried to feel myself around. At the time, there were two waitresses and a cook there, and I overhead them say, 'She won't last six months!' Well, I've been here for ten and a half years and they've been gone for quite a while now."

—*Andree Pruett*
Interview, July 27, 2006

Andree Pruett never imagined that she would be running a Route 66 tourist attraction in the middle of the Mojave Desert.

Originally, she came to Newberry Springs, California, with her husband Harold to buy land. Eventually, Harold raised ostriches and Andree worked on her freelance writing career. But that was before a little eatery called the Sidewinder Café worked its magic on both of them.

Initially, they found a small 2.5-acre plot of desert that already had a water well and it was fenced in, so they bought it. Afterward, they stopped at the Sidewinder Café to grab a bite to eat. The proprietor told Harold about how the restaurant "was in a movie," that she was trying to sell it, and the exact price she wanted for the place.

It was precisely then that the Pruetts' plans took a twist. "When my husband turned and looked at me, I said to him, 'Don't even think about it!'" Andree said. Of course, it was too late. Her husband had already been bit by the restaurant bug.

"You won't have to worry about it," Harold reassured her. He would run the café with the help of another couple who was interested in the idea and she could spend her time writing. It sounded like a grand plan to Andree, and she reluctantly agreed.

Unfortunately, the potential partners backed out of the deal and never showed up. The Pruetts took over the Sidewinder by themselves. On November 16, 1995, they ended their twenty-one year residence in Los Angeles, California, renamed their new eatery the Bagdad Café, and embarked on a new life in the desert. What an adventure!

Eventually, they bought more land—about 642 acres—and Harold got down to business raising ostriches. Meanwhile, Andree felt a little like one of the big birds. She was ready to stick her head into the sand and give up. She

owned a café, but had no real food-service experience.

"It was a big challenge, but I just stood behind the counter and tried to feel myself around," she said. "At the time, there were two waitresses and a cook working there, and I overheard them say, 'She won't last six months!' Well, I've been here for ten and a half years and they've been gone for quite a while now."

As she immersed herself in her new occupation as chief cook and bottle washer, she learned that *her* Bagdad Café wasn't the first. The original of the same name was located in the Route 66 railroad town called Bagdad, between Amboy and Ludlow. The original town of Bagdad had become a ghost town and nothing remained of the old Bagdad Café, except for a crumbling concrete slab.

Andree also learned a little bit more about her place. The old Sidewinder was built during the late 1940s and it closed around 1975. It was refurbished by Jack and Shirley Hileman in 1982. Two years later, the café was sold to Harold and Stephanie Kelly and Jerry and Kim Fessler, who leased the building from Ed Young—a local man who bought the building in 1982 as an investment.

Of course, Andree already knew the whole story about the movie that was made there. In 1987, the production company for producer Percy Adlon's film *Bagdad Café* (called *Out of Rosenheim* in Europe) swooped down on the Sidewinder and filmed the entire movie there. Against the stark backdrop of the Mojave, actors Marianne Sägebrecht, CCH Pounder, and Jack Palance served up a quirky slice of desert life that was strangely compelling. A few of the locals even appeared in the film.

The café briefly closed in 1991, but it was soon reopened by Dick Develin. He was the one who first christened the place Bagdad Café in honor of the movie. Finally, when building owner Ed Young passed away in 1994, the

Hilemans once again bought into the café. They took down the new sign and reopened it yet again as the Sidewinder.

That's where the Pruetts came in. They reopened it as the Bagdad Café, but realized that changing the name didn't guarantee a steady stream of visitors. They learned that building up clientele was going to be work. "When I first came here, the French tourists looked in the window and wouldn't come in, so I went outside and brought them in," Andree said.

But these days, the French visitors need little prodding to come inside. "They love the Bagdad Café," Andree said. "I had one French lady come in crying with her family and say, 'I dream of the Bagdad Café . . . and my children dream to come to the Bagdad Café!'" When French tourists leave Los Angeles, they shoot straight across old Highway 66 and directly out to the Bagdad Café. Viva la Bagdad!

Andree's French fans have afforded her a place of honor in many of their tours, as have admirers from other countries around the globe. These days, the Bagdad Café is an international destination: About sixty percent of the summer visitors are French-speaking and another fifteen percent come from Japan. The remainder makes the pilgrimage from Germany, Brazil, Haiti, and even French Africa. Many tour guides send Pruett a schedule at the beginning of the year and make reservations in advance.

Inside the dining room, you can plainly see the evidence from all of the international visitors. As you walk in the door, a map of France is stuffed with cards, pictures, and other mementos. There's also a map of Japan, Germany, and Italy, along with eighteen guest books to sign. Each guest book is three hundred pages long!

"They come a long way, from all over the world, to see the Bagdad Café," said Andree, adding thoughtfully: "To make them feel special and thank them for coming in, that's the least I can do. Because, if it wasn't for my tourist visitors . . . the Bagdad Café wouldn't be in business right now."

Like Jasmin in the movie Bagdad Café, Andree came to the Mojave Desert with other intentions. She stayed on, though—she fell in love with its quiet desolation and the rich tapestry of people who traveled so far to visit her from all over the world. Don't tell Andree Pruett that Route 66 is America's Main Street. For her, Highway 66 is the Main Street of the world and the Bagdad Café is at the center of it all.

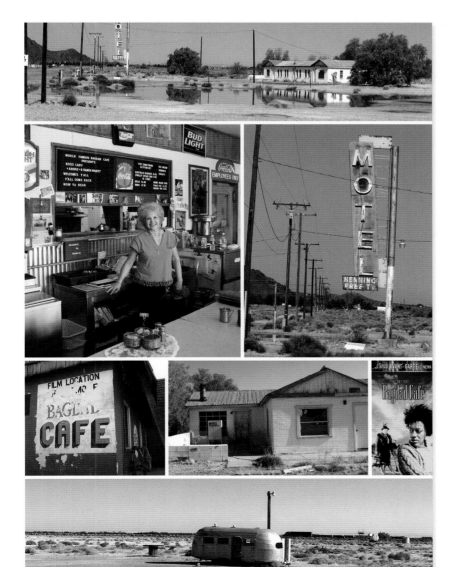

Bagdad Café, Newberry Springs, California, 2005. The café, purchased by Andree Pruett (middle left) and her husband in 1995, was previously known as the Sidewinder Café. The Bagdad Café was the site used for the filming of the 1987 movie Bagdad Café, released in 1988. It was directed by Percy Adlon and starred Marianne Sagebrecht, CCH Pounder, and Jack Palance. The west end of the motel was where Jasmin (Marianne Sagebrecht) stayed (middle). Located between the Bagdad Café and the adjacent motel is the Airstream trailer where Rudi (Jack Palance) slept (bottom). ©2007 Sean Evans/Courtesy of Cline Library Northern Arizona University

Photo Credits

Page 42: Postcards Author's collection/collage by Michael Karl Witzel

Page 104: Postcards Courtesy Steven Rider/Collage by Michael Karl Witzel

Page 166: Rock Shop, ©2007 Sylvester Allred; Gemini Giant, ©2007 Howard Ande; Blue Whale, ©2007 Allen Bourgeois; Britten Water Tower, ©2007 D. Jeanene Tiner; Big Tex, ©2007 Dan Harlow; trading post slide courtesy of Paul Pavlik; postcards Courtesy of Steven Rider Collection/Collage by Michael Karl Witzel

Page 208: Postcards courtesy of Steven Rider Collection/Collage by Michael Karl Witzel

Page 244: U.S. Route 66 could also be called "the neon road." From east to west, a colorful palette of glowing signs lights the way for those enamored with the roadside art of the neon bender. While a few beauties have been lost, a number of classics were recently restored as part of the New Mexico Route 66 Neon Sign Restoration Project, headed by the New Mexico Route 66 Association. Lincoln Motel, Chandler, Oklahoma ©2007 Michael Karl Witzel; Wagon Wheel Motel, Cuba, Missouri ©2007 Shellee Graham; Yukon Motel, Yukon, Oklahoma ©2007 Howard Ande; Rod's Steak House, Williams, Arizona ©2007 Howard Ande; Paradise Motel, Tucumcari, New Mexico (restored) ©2007 Jim Ross; Garcia's Café, Albuquerque, New Mexico ©2007 Jim Ross; Blue Spruce Lodge, Gallup, New Mexico ©2007 Jim Ross; Teepee Curios, Tucumcari, New Mexico (restored) ©2007 Jim Ross; The Dog House, Albuquerque, New Mexico ©2007 Jim Ross; Metro Diner, Tulsa, Oklahoma ©2007 Howard Ande; Munger Moss Motel, Lebanon, Missouri ©2007 Shellee Graham; Rest Haven Court, Springfield, Missouri ©2007 Howard Ande; Blue Swallow Motel, Tucumcari, New Mexico ©2007 Jim Ross; Sun n Sand Motel, Santa Rosa, New Mexico (restored) ©2007 Jim Ross; The Capri Motel, Joplin, Missouri ©2007 Michael Karl Witzel; Thunderbird Motel, Joplin, Missouri ©2007 Michael Karl Witzel; El Rey Theater, Albuquerque, New Mexico (restored) ©2007 Jim Ross; El Comedor Rotosphere, Moriarty, New Mexico (restored) ©2007 Shellee Graham.

Page 248: U-Drop Inn, Shamrock, Texas. At one time, the U-Drop Inn was touted as "the swankiest of swank eating places" and "the most up-to-day edifice of its kind on U.S. Highway 66 between Oklahoma City and Amarillo." In 1936, the building and tower were built for $23,000. James Tindal Jr. (son of the original financier) bought the building during the 1980s and repainted it with the original buff color with green trim.

In 1999, Tindal sold the historic structure to the First National Bank of Shamrock, Texas. That year, the bank donated the building to the City of Shamrock, with the understanding that it would be restored to its original condition. To help offset the cost of restoration, the Texas Department of Transportation kicked in a $1.7 million grant.

In a wonderful twist of fate, Kenneth Phillips—who performed work as the neon bender on the original green and red glass that draped the building in 1936—was called upon to work on the replacement tubing for the project. Although he didn't actually install the neon, he shaped all of the glass and with great care oversaw its installation.

By October 2003, the exterior and interior of the building was ready for tenants. Today, portions of the restaurant's banquet rooms are made available for private functions.

Shown:
Red, white, and blue variation, 1983 (bottom row, left); Conoco Tower Service Station and the U-Drop Inn shortly after it was built, 1936 (middle, far left); Conoco Tower Service Station, 1940s (top, second from right); prerestoration tower with non-original sign, circa 2002 (middle, left of tower); various views of the U-Drop Inn and Tower Service Station day/night, after restoration, September 2003. ©2007 Shellee Graham (middle, left of tower), ©2007 Jerry McClanahan (bottom row, left) Courtesy of David Rushing/©2007 Mark Trew (all restoration images), Courtesy of David Rushing (all vintage images)

Endnotes

Chapter One

1. "The Bicycles," *Chicago Daily Tribune*, March 23, 1880.
2. Ibid.
3. "Invitation Sent Out for a Congress of Good Roads," *Chicago Daily Tribune*, September 30, 1892.
4. "Good only for Funerals," *Chicago Daily Tribune*, September 19, 1906.
5. Francois Xavier Aubry, "Diary of 1853," *Exploring Southwestern Trails 1846-1854*, ed. Ralph P. Bieber, (Glendale, California: The Arthur H. Clark Company, 1938), 377.

Chapter Two

1. Bellamy Partridge, *Fill 'er Up*, (New York: McGraw-Hill, 1952), 55.
2. Herbert Ladd Towle, "The Automobile and Its Mission," *Motoring in America*, the Early Years, ed. Frank Oppel (Secaucus, New Jersey: Castle Books, 1989), 235.
3. *Chicago Daily Tribune*, February 6, 1909.
4. "Expect a Horseless City," *Chicago Daily Tribune, January* 31, 1907.
5. Horatio Earle, *The Autobiography of "By-Gum" Earle*, (Lansing, Michigan: Hallenbeck Printing Co., 1929), 65.
6. Ibid., 95.
7. Ibid., 101.
8. U.S. Department of Transportation, Federal Highway Administration, "50th Anniversary of the Interstate Highway System," http://www.fhwa.dot.gov/interstate/faq.htm (June 23, 2006).

Chapter Three

1. "Motoring from Sea to Sea," *Chicago Daily Tribune*, November 13, 1910.
2. Ibid.
3. Ibid.
4. Cyrus Stevens Avery Archive, Number 2:36, Box 1851, Oklahoma State University/Tulsa Library.
5. Cyrus Stevens Avery Archive, "History of U.S. 66," August 24, 1933, Oklahoma State University/Tulsa Library.

Chapter Four

1. "'Roads That Go Somewhere' Is Cry," *New York Times*, April 27, 1913.
2. "Federal Aid for Highways Assured," *Chicago Daily Tribune*, July 16, 1916.
3. T. Macdonald, "National Road Progress," *New York Times*, January 9, 1921.
4. "Coast to Coast Highways Offer Better Surfaces," *Chicago Daily Tribune*, December 12, 1926.

5. "Pacific Coast Motor Tour by Old Trails Highway," *New York Times*, April 6, 1924.
6. Ibid.
7. "Motor Club Compiles Auto Tour Book," *The Washington Post*, July 11, 1926.

Chapter Five

1. "Highways of Nation are now Numbered," *New York Times*, September 27, 1925.
2. L. Dickinson, "Across the Continent," *New York Times*, May 18, 1930.
3. "American Tourists Break All Records," *New York Times*, August 3, 1930.
4. "Motor Tourists Spend Billions Yearly in U.S.," *Chicago Daily Tribune*, April 6, 1930.
5. Ibid.
6. Ibid.

Chapter Six

1. Jim Ross, *Oklahoma Route 66*, (Arcadia, Oklahoma: Ghost Town Press, 2001).
2. Paul Bonnefield, *The Dust Bowl*, (Albuquerque: University of New Mexico Press, 1979).
3. N. Houston, "Residents of Sand Storm Area Use Masks So They Can Sleep in Two-Hour Shifts," *The Oklahoman*, March 6, 1935.

Chapter Seven

1. H. Foust, "Find 1,801 Miles of Deadly Roads within Illinois," *Chicago Daily Tribune*, February 28, 1939.
2. "Highway 66 Needs Improvement," *The Oklahoman*, October 4, 1941.
3. H. Foust, "Superhighways Win Full House Committee O.K.," *Chicago Daily Tribune*, June 28, 1939.
4. H. Foust, "Struggle to Put New Life Into Old Road Slabs," *Chicago Daily Tribune*, May 12, 1941.
5. Ibid.
6. R. Howard, "Illinois Plans Super-Highway to Cross State," *Chicago Daily Tribune*, July 25, 1944.
7. "Super-Highway is no Noose of Death," *The Oklahoman*, February 27, 1947.
8. Ibid.

Chapter Eight

1. T. Lesure, "U.S. Route 66 is Rewarding Holiday Route," *Chicago Daily Tribune*, November 24, 1957.

Chapter Nine

1. H. Foust, "70 Mile Limit Reduces Speed Violations on 66," *Chicago Daily Tribune*, July 28, 1957.
2. H. Foust, "State to Build 30 Rest Areas Along Roads," *Chicago Daily Tribune*, January 25, 1962

Chapter Ten

1. D. Young, "Rationing 'May be Required,'" *Chicago Tribune*, November 8, 1973.
2. "50,000 Temporary Layoffs," *Chicago Tribune*, February 15, 1974.
3. "The 55 m.p.h. Limit," *Chicago Tribune*, September 17, 1974.
4. R. Berler, "Truck Stop," *Chicago Tribune*, March 10, 1974.
5. D. Young, "Illinois Needs 129 Miles to Finish Interstates," *Chicago Tribune*, December 26, 1977.
6. D. Young, "Route 66 on the Road to Extinction," *Chicago Tribune*, November 28, 1976.

Chapter Eleven

1. J. Crewdson, "Tucumcari No Longer Getting its Kicks," The Oklahoman, July 12, 1981.
2. B. Drummond, "Once-Bustling U.S. 66 Now a Phantom Road West," *The Oklahoman*, August 30, 1981.
3. Ibid.
4. Ibid.
5. Ibid.

Chapter Twelve

1. J. Deardorff, "Margie MacCauley, 67, Says a Compelling Force is . . ." *Chicago Tribune*, May 7, 1996.
2. A. DeFrange, "Route 66," *The Oklahoman*, May 28, 1989.
3. United States Congress, Congressional Record 101-400, Section 3, para. 2, September 28, 1990.
4. "Route 66 Group Invites Public for Nominations," *St. Louis Dispatch*, February 26, 1990.
5. C. Willis, "Kicks: Old 66 Has Deep 'Routes,'" *St. Louis Dispatch*, June 10, 1990.
6. "Thousands to Get Their Kicks on Route 66," *The Oklahoman*, May 27, 1990.
7. United States Congress, Senate Report 106-020, March 17, 1999.

Index